ISFAHAN

ISFAHAN

Architecture and Urban Experience in Early Modern Iran

 Farshid Emami

THE PENNSYLVANIA STATE UNIVERSITY PRESS

UNIVERSITY PARK, PENNSYLVANIA

Library of Congress Cataloging-in-Publication Data

Names: Emami, Farshid, author.
Title: Isfahan : architecture and urban experience in early
 modern Iran / Farshid Emami.
Other titles: Buildings, landscapes, and societies.
Description: University Park, Pennsylvania :
 The Pennsylvania State University Press, [2024] | Series:
 Buildings, landscapes, and societies series | Includes
 bibliographical references and index.
Summary: "An interpretation of architecture and urbanism
 in seventeenth-century Isfahan, Iran, through the
 analytical lens of urban experience"—Provided by
 publisher.
Identifiers: LCCN 2023034338 | ISBN 9780271095523 (cloth)
Subjects: LCSH: Architecture, Safavid—Iran—Iṣfahān. |
 City planning—Iran—Iṣfahān—History—17th century. |
 Urbanization—Iran—Iṣfahān—History—17th century.
Classification: LCC NA1487.I8 E62 2024 |
 DDC 720.955/95—dc23/eng/20230825
LC record available at https://lccn.loc.gov/2023034338

Published by The Pennsylvania State University Press,
University Park, PA 16802–1003

The Pennsylvania State University Press is a member of the
Association of University Presses.

It is the policy of The Pennsylvania State University Press to
use acid-free paper. Publications on uncoated stock satisfy
the minimum requirements of American National Standard
for Information Sciences—Permanence of Paper for Printed
Library Material, ANSI Z39.48–1992.

Additional credits: frontispiece, aerial view of Isfahan
looking south (fig. 15); page 16, aerial view of the Harun-i
Vilayat shrine and the minaret of the Ali Mosque (fig. 10);
page 68, portal of the qaysariyya market on the northern
side of the Maydan-i Naqsh-i Jahan (fig. 33); page 152, Pascal
Coste, Hasanabad (Khvaju) Bridge (fig. 88).

For Jaleh and Sepand

CONTENTS

DURING THE SEVENTEENTH CENTURY the city of Isfahan, Iran, ranked among the greatest cities of the early modern world. A vibrant urban settlement from medieval times, Isfahan began to evolve into a sprawling metropolis in the 1590s, when it became the royal seat of the Safavid dynasty (1501–1722) and saw the planning and implementation of immense building projects. Throughout the ensuing century Isfahan flourished as a major emporium of Eurasia and a hub for the staggering array of commodities and humans flowing across the globe. Featuring a grand plaza, expansive gardens, and turquoise-tiled monuments, early modern Isfahan boasted of its enormous size, teeming markets, and bustling civic spaces. Home to a cosmopolitan populace of around half a million, the city spawned an urban culture whose sites, tastes, and daily rhythms appear peculiarly familiar to present-day observers.

The architecture and urban design of Safavid Isfahan dazzled contemporaneous visitors and has continued to attract scholarly attention. In recent years several studies have added to our understanding of Isfahan's urban structure, construction history, and royal palaces. My own interest in Isfahan was initially sparked, more than a decade ago, by the overemphasis of previous works on formal qualities of the built environment and aspects of courtly practice and patronage. I wanted to understand the city not as a set of grand designs or a stage for the enactment of royal power but as a social arena that fostered human experiences. At the same time, I realized that Isfahan's civic spaces were far more extensive than its central plaza and majestic monuments; the city's now-vanished residential quarters, verdant thoroughfares, and social establishments were equally fundamental to the formation of lively urban experiences.

In this book I reconstruct the spaces and senses of early modern Isfahan and narrate its story as a social living environment. I read the city's urban spaces particularly through literary descriptions—works in prose or verse that reveal a view of Isfahan from the ground up. Mapping these urban lyrics on the city's topography, the book takes the reader on journeys through Isfahan's markets, promenades, and coffeehouses, bringing to life the urban landscapes that animated the lives of urban dwellers and shaped their

perceptions of their selves, the city, and the world. Through a close reading of texts and spaces, *Isfahan* reimagines the urban experiences that imparted a distinct civic character on early modern Isfahan.

I began to contemplate the (early) modernity of Safavid Isfahan when I arrived in the United States in 2009 to study at MIT. Having completed professional degrees in architecture and urban design in Iran, I was equally mesmerized by the material form of historic towns and the experience of urban modernity, owing much to the inspiring teaching of Mahmoud Tavassoli and the late Mohsen Habibi at the University of Tehran. Lecturing in the halls of the Faculty of Fine Arts, they not only trained us students in professional practice but also opened our eyes to the intellectual depths and layered meanings of urbanism. At MIT, under the guidance of James Wescoat and Nasser Rabbat, I had the chance to broaden my horizons and hone my skills in research and writing. It was Nasser Rabbat who encouraged me to focus on Safavid Isfahan, and our conversations through the ensuing years were immensely inspiring.

I owe a profound debt of gratitude to Gülru Necipoğlu and David Roxburgh for their mentorship during my doctoral studies in the Department of History of Art and Architecture at Harvard University. Their scholarship has been my model for scholarly excellence and methodological rigor, and their incisive advice was crucial to the shaping and development of my research. I am grateful to both of them for their support and for all the opportunities they provided for intellectual and professional development. At Harvard, Justine Landau's extensive commentary was immensely helpful in enhancing literary and other aspects of my project.

I am thankful to Jesús Escobar for his interest in my project and to the editorial board of the Building, Landscapes, and Societies series for their comments on earlier drafts of sample chapters. It was a pleasure to work with Ellie Goodman and the editorial team at Penn State University Press, who steered the project through various stages of publication. I am very grateful to the two anonymous readers for their critical commentary and thorough engagement with the manuscript.

The materials used in this book were collected primarily during travels funded by the Fredrick Sheldon Traveling Fellowship and the Aga Khan Program. I am thankful to the kind individuals in charge of the following libraries and institutions for their generous assistance: Freer and Sackler Archives, Smithsonian Institution; British Library; Leiden University Libraries, Special Collections; Bibliothèque de l'Alcazar in Marseille;

Central Library, University of Tehran; Golestan Palace Library and Photo Archive; Malek Library; and Cultural Heritage Organizations at Tehran and Isfahan.

I would like to thank my colleagues at Oberlin College, especially Erik Inglis, for their support during the first years of my teaching career there. I also owe a great deal to my colleagues at Rice University, particularly Graham Bader, for their support in the process of writing and publishing this book. My thanks also go to Julie Timte and Stephen Westich, doctoral students at Rice, who helped me in preparing the manuscript in the final stages. The publication of this book was supported by generous grants from the Office of Research, the School of Humanities, and the Department of Art History at Rice University.

My parents, Fariba and Ali, raised me with much love and care through dire times. I am grateful to them for their support during all these years, and I hope that something of their love and intellect is echoed in the following pages. My father, Ali; my sister, Sepideh; and my friend Amir Hossein Khorshidfar also helped me with acquiring several books from Tehran. My sincere thanks also go to my dear friends Behzad Ayati and Hessam Khorasani, who were great sources of support throughout these years.

My son, Sepand, grew into a sweet seven-year-old boy just as my research and writing morphed into this book. He fills my days with so much joy and laughter. Finally, this book would not have come to fruition without the enduring love, constant encouragement, unwavering support, critical help, and astute comments of Jaleh. She has been a friend and companion in the joys and hardships of pursuing our dreams since we embarked on an unending journey across the globe. Her intellectual pursuit of meaningful human knowledge has inspired me to be a better scholar and person. With Jaleh, I always felt there were two hearts beating, slow and hard, on the ups and downs of the arduous path that led to the completion of this project.

With all my heart, I dedicate this book to her.

THIS BOOK FOLLOWS the transliteration system adopted in the *International Journal of Middle East Studies*. Exceptions are common place names (e.g., Herat) and familiar names of individuals (e.g., scholars who publish in Persian). For Persian and Arabic names of persons and places, diacritical marks are omitted except for the medial or final ʿayn (ʿ) and *hamza* (ʾ), which indicate a glottal stop. Frequently appearing transliterated terms are italicized and bear diacritics on their first occurrence and occasionally thereafter in notes, parentheses, and compound terms; elsewhere, they are treated like words that are commonly used in English and appear in *Merriam Webster's Collegiate Dictionary* (11th ed.): without italics or diacritical marks (e.g., madrasa, caravanserai, iwan). Titles of books and literary works are fully transliterated in the text and notes. The Persian silent *h* is transliterated as *a*, not *ih* or *eh* (e.g. *khāna*), and the *iżāfa* is rendered as *–i* (or *–yi* in words ending in silent *h* or a vowel).

Dates are given primarily in the Common Era unless it is necessary to mention a Hijri calendar date, in which case it is indicated by the small-cap abbreviation H. Since Hijri is a lunar calendar, it often corresponds to two Common Era years. Hence, if no specific date is mentioned in the sources, the two corresponding Gregorian years are mentioned.

Two kings named Abbas reigned during the Safavid dynasty: Shah Abbas I (r. 1588–1629), who was the fifth ruler, and his great-grandson Shah Abbas II (r. 1642–66). When a suffix is not given, the reference is to Shah Abbas I.

This book frequently quotes from the "Guide for Strolling in Isfahan." These quotations are all from an English translation (in the appendix) on the basis of an edited Persian version of the text prepared by myself. Unless otherwise indicated, all other translations are also my own.

Introduction

ISFAHAN AS URBAN EXPERIENCE

Sometime in the middle years of the seventeenth century, a young poet named Mir Rukn al-Din composed a letter to his friend and fellow poet Mir Muhammad Mansur Semnani (d. 1732–33). In ornate, rhymed prose interspersed with poems, Rukn al-Din wrote of his excruciating solitude since Semnani's departure from Isfahan, noting how strolling in gardens or sitting in coffeehouses evoked memories of their joint urban excursions. To entice his friend to return, Rukn al-Din also described the newest architectural addition to Isfahan's urban landscape: the Hasanabad Bridge (fig. 1). Spanning the Zayanda River, the bridge was inaugurated in the spring of 1659, when its arcaded galleries hosted a sumptuous royal ceremony followed by a month of communal feasting.[1] "If only a bit were written on the glory of the heavenly Hasanabad Bridge," Rukn al-Din wrote, "one would swiftly set off" for Isfahan.[2]

In response, Semnani composed a more substantial letter. In equally florid prose, he, too, complained about the "grief of leaving one's friends" and the "toil of separation." Yet unlike his friend, whose missive was imbued with melancholy and a yearning for reunion, Semnani confined his expressions of sorrow to a brief opening passage. In the rest of the letter, he offered a "guide" (dastūr al-ʿamal) for a one-day excursion (sayr) in Isfahan, adding that

his proposed itinerary, though only a sampling, must not be violated.

And yet, despite the claim of brevity, the "Guide for Strolling in Isfahan" (Dastūr al-ʿamal-i sayr-i Iṣfahān) offers an alluring urban experience.[3] Alternating between prose and verse, it guides the reader through the city's markets, coffeehouses, plazas, and mosques and describes Isfahan's vendors, artisans, coffee servers, performers, and prostitutes. While the incessant flow of the prose conveys a kinetic experience through the city, the verses evoke moments of lingering in time and space.

Beginning at dawn, the recommended excursion encompasses a staggering array of urban pleasures. The venues to visit include several coffeehouses, a hookah stall, and a sherbet house, among other places; the daylong journey culminates in a nocturnal tryst with a courtesan in the pleasure district of Isfahan. The chief characters of the urban tour are the city's artisans and vendors—the desired objects of a wandering observer. Following the poetic convention known as shahrāshūb, or "city disturber," these characters are described through metaphors drawn from the commodities they sell or the crafts in which they are engaged. The itinerary also includes stops at architectural monuments such as a royal palace (Talar-i Tavila), Isfahan's new congregational mosque (Shah Mosque), and the

FIGURE 1 (*opposite*)
Hasanabad (Khvaju) Bridge, Isfahan, ca. 1657–59. Photo: author.

shrine of the city's patron saint (Harun-i Vilayat). Despite the diversity of these locales, their sequence follows a fairly clear trajectory through the city; the itinerary of the tour can be traced on a map of seventeenth-century Isfahan.

The urban experience that informed Semnani's guide to the pleasures of Isfahan lies at the core of this book. What configuration of urban spaces, social institutions, and architectural monuments enabled and propelled this kind of engagement with the city? What historical forces, social ideals, and modes of urban design gave rise to a settlement where mosques, coffeehouses, and courtesans could be encountered and represented in this manner? How was seventeenth-century Isfahan perceived and imagined by contemporary individuals, and what can we learn about the city's image and culture through a study of embodied sensory encounters recorded in literary urban descriptions? And finally, what do literary representations of Isfahan reveal about the emerging conceptions of space and time, self and society, in early modern Iran?

The themes that underlie these questions—the city as a social setting, the multisensory perception of the urban landscape, and the linkage between urban experience and subject formation—have received only meager attention in the studies of Safavid architecture and urbanism. Except for brief remarks, architectural historians have primarily focused on patterns of planning and construction, the morphology of royal gardens and pavilions, and aspects of courtly conduct and patronage. This book, by contrast, shifts the analytical focus from formal concerns and imperial agendas to social and sensate experiences of the urban environment. Reading the cityscape in light of rarely studied literary descriptions and visual representations, I demonstrate how seventeenth-century Isfahan—with its promenades, coffeehouses, gardens, and markets—spawned new urban experiences and engendered novel manners of perceiving and imagining the city. The integrated scrutiny of texts and spaces reveals an intricate world in which new civic identities were fashioned through a panoply of individual and communal experiences. Isfahan did not merely represent a grandiose imperial vision; it fostered new conceptions of urbanity and modes of civic existence, ones that were intimately bound up with the formal, natural, social, and sensual qualities of the urban environment.

I approach Isfahan from the critical lens of "urban experience," with which I examine an array of visual and literary depictions to craft a new narrative of the city as a dynamic living environment. I define urban experience as a phenomenon engaging the body and mind—visceral encounters with the city that are simultaneously affected by and interpreted through cultural habits and inherited mindsets. The study of urban experience from a range of analytical angles (vision, sound, time, pleasure, etc.) and at different spatial scales (the broader urban landscape and specific urban spaces) constitutes the basis on which the cityscape of Isfahan is here reconstructed and narrated. Ultimately, I hope, this book will lead to a fuller and more textured understanding of Safavid Isfahan as a metropolis that framed and shaped urban experiences peculiar to the early modern world.

THE SOCIAL CONTENT OF AN IMPERIAL PLAN

In the mid-seventeenth century, when Semnani penned his guide to the pleasures of Isfahan, the city was at the apogee of its prosperity and splendor. Although Isfahan had been a thriving urban settlement since earlier times, it was the

massive building campaign instigated by the Safavid ruler Shah Abbas I (r. 1588–1629) that set the stage for the urban experiences echoed in Semnani's work, among other literary texts. Laid out in the south of the walled city, these new developments consisted of three major components: an enormous plaza called the Maydan-i Naqsh-i Jahan (Image-of-the-World Square), a monumental tree-lined promenade known as the Chaharbagh (Fourfold Garden), and a cluster of residential quarters and garden estates on the banks of the Zayanda River (fig. 2).

Bordered by commercial arcades, religious foundations, and imperial monuments, the Maydan-i Naqsh-i Jahan served as Isfahan's principal civic center. Adjoining the palace complex, this immense urban plaza hosted communal ceremonies, equestrian sports, and the quotidian lives of the city's inhabitants (fig. 3). Running from the palace complex to the Hizar Jarib (Thousand Acres) royal garden, the four-kilometer-long Chaharbagh functioned as a public venue for leisurely promenades and an urban thoroughfare linking the city center to extramural gardens and quarters. Settled by migrant communities, the major new neighborhoods of Isfahan were laid out on the western side of the Chaharbagh: the Abbasabad quarter was inhabited by long-distance traders who hailed from the city of Tabriz; New Julfa was home to a community of Armenian Christian merchants who had been forcibly relocated to Isfahan from their homeland in the Caucasus.

The foundation of these mercantile communities and the planning and construction of Isfahan as the seat of the Safavid throne (where the capital was established in the 1590s) were integral to the policies that Shah Abbas adopted with the aim of creating a centralized state and promoting commerce. A succession of military conquests paved the way for the enactment of these reforms; over the course of the 1590s and early 1600s, as Isfahan's urban plan was conceived and implemented, Safavid forces recaptured the domains seized by the Ottomans and Uzbeks in the preceding decades.[4] Meanwhile, to curtail the influence of the Qizilbash tribesmen (Turkmen warriors who were instrumental in the rise of the Safavid state but had become increasingly factious), Shah Abbas raised the *ghulām* (converted military slaves of Caucasian origin who were loyal to the king) to key positions in the army and administration.[5] At the same time, the shah set out to mobilize the productive forces and mercantile potential of the Safavid territory. An infrastructural network of caravanserais and roads was set up to facilitate the flow of commodities and merchants.

Isfahan's role as an emporium of the early modern world—a hub for new materials and commercial communities, as well as for the social practices and institutions that emerged in the wake of heightened global interactions—was immensely influential in shaping new urban experiences. Crammed with an unprecedented array of merchandise, the city's expansive mercantile arcades gave rise to novel manners and conceptions of leisure and consumption. As entirely new social institutions, coffeehouses engendered a distinct arena of civic existence, altered the rhythms of daily life, and transformed the meanings and uses of urban spaces. Above all, seventeenth-century Isfahan was a cosmopolitan city inhabited by an ethnically diverse, polyglot populace, and the mingling of peoples of various backgrounds transformed the perception and experience of the urban landscape.

The "Guide for Strolling in Isfahan" does not, however, portray the city from an all-encompassing viewpoint. Nor does it convey any sense of the overarching plan that integrated

FIGURE 2
Map of Isfahan, ca. mid-1600s,
showing major Safavid develop-
ments south of the city's old core:
(1) Old Maydan; (2) Maydan-i
Naqsh-i Jahan; (3) Safavid palace
complex (dawlatkhana); (4) Chahar-
bagh; (5) Allahverdi Khan Bridge;
(6) Hizar Jarib Garden; (7) quarter of
Abbasabad; (8) New Julfa (Armenian
quarter); (9) Hasanabad (Khvaju)
Bridge; (10) Saʿadatabad Garden.
Plan by author.

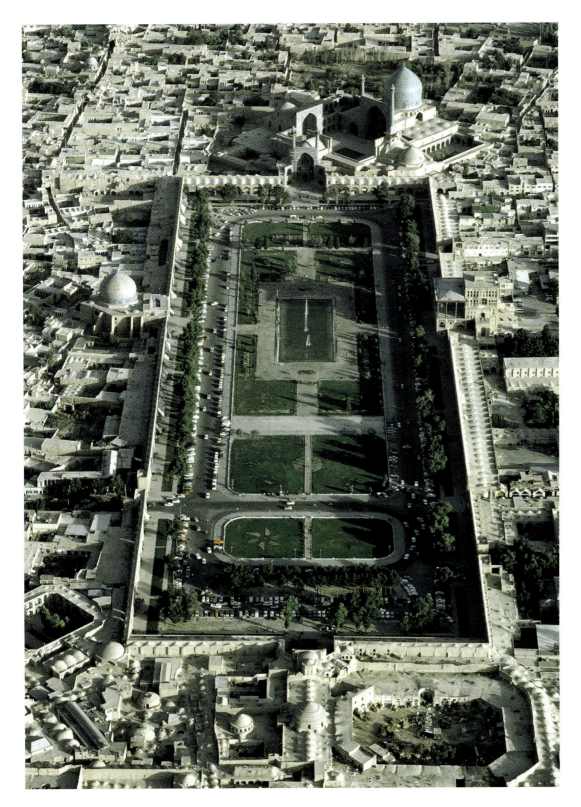

FIGURE 3
Maydan-i Naqsh-i Jahan, Isfahan,
ca. 1590–1602. Photo by Georg
Gerster, 1976. Photo © Estate
Georg Gerster, Switzerland,
www.GeorgGerster.com.

these material, social, and human components into a regimented built environment. Rather, it represents Isfahan from the perspective of a sensing human subject. In place of the planned arrangement of architectural and urban elements, here it is the act of uninterrupted bodily perception that imparts coherence to the city and its components. The visual devices that unify the constructed environment of Safavid Isfahan—the monumental axes and geometric uniformity of grand urban ensembles—play a marginal role in this multisensorial urban experience; instead of an imposing spectacle, the city appears to be a swirl of senses, places, and persons. Seemingly incongruous urban elements—mosques, palaces, coffeehouses—coalesce into a whole as perceived by an individual observer. Seen this way, Semnani's composition does not merely cast the urban scenes of Isfahan in a lyrical literary form; it reveals how the city's variegated components registered as a continuous sociospatial reality in the mind of a feeling human subject.

Understanding the ways in which new perceptions of self and society were fashioned through urban experiences is the main concern of this study. Rather than conceive Safavid Isfahan as a monocentric setting, wherein meaning emanates from a single imposing, immutable core—be it the ruling household, the royal palace, or the imperial mind—I analyze the urban structure in dialectic relation to the embodied social experiences that the city nurtured and accommodated. Expanding the scope of historical investigation to modes of engagement with the built environment leads to a holistic account of urbanism and architecture in Safavid Isfahan, a narrative that considers royal plans in tandem with solitary and collective forms of urban existence. By placing perceptual and experiential dimensions of the city at the center of

the inquiry, this interpretive approach does not discount the agency of monarchical agendas and actions. Instead, it illuminates the crucial role Isfahan's constructed spaces played in fashioning new urban identities, revealing how the city was deliberately planned, built, and embellished to elicit certain receptions and engender novel social behaviors. A nuanced comprehension of the architecture and urban form of Safavid Isfahan entails scrutiny of the perceiving human subject in conjunction with the city's spatial structure and the material and social realities that informed its experience and perception.

NARRATIVES OF ISFAHAN: FORMAL, ROYAL, AND SOCIAL PERSPECTIVES

Although much has been written about the architecture and urbanism of Safavid Isfahan, the lived experiences of its urban spaces have not been subject to sustained scholarly analysis. A strain of purely architectural studies has long concerned itself with establishing formal typologies and stylistic genealogies. Severing the built environment from its historical context, these works portray the city as an agglomeration of sterile geometric compositions. From the 1970s onward, many such formalist studies, inspired by mystically minded modern scholars such as Henry Corbin and Seyyed Hossein Nasr, have commonly been coupled with ahistorical interpretations.[6] In this essentialist approach, Isfahan is construed as the material manifestation of mystical concepts, representing the culmination of what is assumed to be a monolithic and timeless Islamic or Persian culture.

A fairly similar notion underlies the accounts of Safavid Isfahan in traditional art-historical surveys. These sweeping narratives typically cast Safavid architecture as the last great achievement of a long-standing tradition, a final florescence before the decline of a native architectural

idiom that was set to lose its vitality and presumed authenticity in the face of mounting European influence. In these surveys and other urban studies, the novelty of Safavid architecture and urbanism, particularly that of Isfahan, is commonly seen in the creation of colossal urban complexes or the deployment of an elaborate lexicon of urban design rather than in the genesis of new civic experiences.[7]

Only since the late 1980s—and based on the foundational work of Iranian scholars such as Lutfullah Hunarfar—have scholars of Safavid architecture and urbanism begun to employ historically grounded approaches.[8] The monographic study by the historian Stephen Blake was the first English-language book to offer a thorough survey of Isfahan's seventeenth-century topography and urban functions.[9] Expanding on Robert McChesney's groundbreaking study of Persian written sources, Blake also drew attention to an initial phase of Isfahan's construction that had gone unnoticed in earlier studies.[10] Nevertheless, the book's approach to "social architecture," which uncritically employs the Weberian notion of the patrimonial-bureaucratic state as its overarching theoretical framework, overlooks the shifting character of state and society in the early modern period. The typological analysis of the urban environment in accordance with rigid functional categories, furthermore, reduces the city to an inventory of discrete components and does not account for fluid urban experiences echoed in the "Guide for Strolling" and other literary descriptions examined here.

Recent scholarship on Safavid art and architecture has of course adopted a range of new critical approaches, laying the groundwork for the present study by exploring Safavid Isfahan and its architectural monuments as settings for court ceremonies and imperial representations.

Gülru Necipoğlu, in a pioneering comparative essay, has interpreted Isfahan and its palace complex in relation to Shah Abbas's informal mode of rule, which can be contrasted with Ottoman and Mughal courtly practices and hence their palaces.[11] More recently, Sussan Babaie has also examined Safavid Isfahan through the lens of royal feasts and ceremonies, analyzing the ways in which Isfahan's palaces and urban spaces reflected and accommodated a specifically "Perso-Shiʿi" discourse of kingship. In this account, it is ultimately the synthesis of the civilizational heritage (Persian kingship) and the adopted sectarian creed of the Safavid household (Twelver Shiʿism) that bestowed an exceptional character on the palace architecture and urban form of seventeenth-century Isfahan.[12]

Analyses of Safavid Isfahan in relation to the political ideology of the ruling dynasty and strategies of representing power are warranted. Planned and built as the seat of a centralized state at a watershed moment in the course of its imperial expansion, Isfahan was undoubtedly intended to represent and shape the emergent sociopolitical order. The absolutist mode of rule practiced by Shah Abbas and his successors—bolstered by an expansive bureaucracy and state mercantilism—afforded the necessary framework and resources for the planning and swift implementation of large-scale building projects emanating from an imperial vision. Shah Abbas's direct engagement in the shaping of the built environment is amply recorded in the sources; court chroniclers extol the monarch's "exquisite taste in architecture" (salīqa-yi ʿālī dar ʿimārat), attribute new architectural inventions to him (tālār dar ʿimārat), and portray him as a ruler personally involved in the design and execution of building projects.[13] Certainly the study of Isfahan's architecture and urban

form in light of royal agendas has been a fruitful line of research, and recent contributions have enriched our understanding of the city.

To fully appreciate the historical character of seventeenth-century Isfahan, however, an analysis of the kingly ethos must be complemented by a rigorously critical investigation of a wider range of factors that were instrumental in the formation, experience, and reception of the city and its monuments. The court-centered paradigm has assumed that the built environment of Isfahan projected state power primarily by creating transparent, accessible architectural settings and urban ensembles that made sovereignty palpable through ceremonies choreographed by the court. But this provides only a partial account of the nature of royal power and mechanisms of establishing authority in Safavid Isfahan, which also strove to craft new urban subjectivities through a careful arrangement of visual, spatial, and social elements in the cityscape. For instance, coffeehouses were not haphazard additions to the urban landscape but instead planned components of the city's grand urban spaces such as the Chaharbagh and the Maydan-i Naqsh-i Jahan.[14] These urban spaces were also configured in ways that prompted specific modes of viewing the cityscape, manipulating visual and bodily access to different areas of the city while situating individuals in particular viewing positions. Similarly, the figural murals and tile panels that adorned Isfahan's monuments were clearly intended to induce a leisurely, sensual ambience in urban spaces (figs. 47 and 87). Equally influential were the monumental inscriptions that graced religious edifices, which engaged urban viewers through not only their semiotic signification but also their aesthetic appearance and glittering materiality.[15] In short, the city's visual structure, pictorial program, public texts, and social institutions operated in unison to enact an array of attitudes, moods, sensations, and sociocultural behaviors. State power was not merely made manifest through the public performance of kingship; it relied equally on the fashioning of new subjectivities.

And yet, while imperial plans provided the setting for the rise of these urban subjectivities, they did not issue from state initiatives alone. Rather, new senses of selfhood were formed through a dialectical relation between physical spaces and the human subjects who inhabited them and interacted with them. As in any society, the residents and visitors of Safavid Isfahan were active, not passive, participants in the cityscape; they constantly reinforced, altered, and undermined the meanings and uses of buildings and urban spaces through their daily routines, communal actions, and literary imaginations. Tellingly, in the "Guide for Strolling," as in several other literary descriptions of Isfahan, one can find hardly any hint of a royal presence. Nor do the peregrinations of the imagined visitor follow the patterns of movement dictated by the city's monumental visual axes. As such, these literary works represent what Michel de Certeau has called "spatial stories," unique trajectories that each individual can take within the possibilities that a city offers; these tactics and strategies for "walking in the city," de Certeau argues, subvert the dominant structures of gaze and power.[16] Seen in this light, the kinetic urban experiences expressed in the literary descriptions of Safavid Isfahan were at once a consequence of and a reaction to the planned sociospatial structure of the city; they simultaneously complemented, appropriated, and transformed the city's perception and meaning as an imperial project. Excluding users/viewers from scholarly inquiry has obscured the unique character and significance of the urban form and architecture of Safavid Isfahan.

Urban experience offers a promising conceptual tool with which to fill this interpretive lacuna in the study of Isfahan's architecture and urbanism while also revealing a fuller picture of the city's links and affinities to contemporaneous early modern cities, especially those in West and South Asia.[17] In this analytical approach, I primarily draw on the philosophical tradition of phenomenology, which could be defined in "simplest terms" as "the interpretive study of human experience."[18] The unmediated perception of the physical world by a sentient body-subject was underscored particularly by Maurice Merleau-Ponty (1908–1961), who notes that "one's own body is in the world just as the heart is in the organism: it continuously breathes life into the visible spectacle, animates it and nourishes it from within, and forms a system with it."[19] In modern architectural theory, August Schmarsow (1853–1936) was one of the first to adopt a phenomenological approach: the subjective perception of the observer, he argued, is the "kernel . . . on which architectural creation is based." For Schmarsow, the human perception of space is more than visual: it is fully embodied, consisting of "the residues of sensory experience to which the muscular sensations of our body, the sensitivity of our skin, and the structure of our body all contribute."[20]

At the most basic level, a human-centered analysis of Isfahan discloses the variegated modalities of sensorial engagement with the city. Vision certainly was a fundamental sensory mode of urban experience: with its expansive vistas, rhythmic harmonies, and glittering facades, Isfahan's cityscape and architecture were clearly intended to please and dazzle the eye. Theories of vision and concepts of the gaze provide a rich analytical prism for understanding the diverse ways of seeing that the city environment enabled and harbored.[21] Particularly, a thorough study of the urban manners of viewing reveals how vision operated as not only an instrument of power but a social practice, one that relied on public participation in its meaning making. Yet intimating the phenomenology of urban experience requires attending to the whole range of sensory interactions with the built environment, beyond mere visual perception; the distinct smells, tastes, and sounds of early modern Isfahan—and the ways in which they were fused and arrayed in the city—were equally important in shaping urban experiences.[22]

Sensate, embodied experiences did not operate in isolation from the sociocultural context; rather, they mingled with thoughts, habits, and notions formed through previous experiences or inherited from the past. It is thus equally crucial to scrutinize the cultural basis of urban experience and model "the period eye," to borrow a phrase coined by the art historian Michael Baxandall, who employed this concept to examine the "stock of patterns, categories, habits of inference and analogy" that the contemporary mind brought to the experience of visual arts.[23] An examination of "the period eye" uncovers how urban experiences and sensory perceptions were occasioned by and interpreted in relation to the mental habits, modes of cultural cognition, and rhetorical expressions unique to the contemporary society. Likewise, it is important to note that in a diverse, stratified urban society such as the one hosted in seventeenth-century Isfahan, urban spaces were not equally accessible to all urbanites irrespective of their social status, gender, ethnicity, or faith. Nor were public spaces experienced by all strata of society in a similar fashion. At the same time, Safavid Isfahan was marked by an unprecedented degree of intermingling among previously discrete

sociocultural groups. This diversity not only led to new urban encounters between persons of different ethnic and confessional backgrounds but also resulted in the loosening of entrenched social hierarchies. The city indeed abounded with characters, like the wandering persona of the "Guide for Strolling," who breached—socially, spatially, and discursively—the established boundaries of class and culture, often to the ire of the elite. In seventeenth-century Isfahan, urban experience was at once informed by and constitutive of this reconfiguration of social norms and hierarchies.

The analysis of embodied urban experiences in their contemporary sociocultural context, then, composes the interpretive prism through which this book examines the built environment of Safavid Isfahan. My basic premise is that the city and the experience thereof are mutually constitutive; just as urban spaces were influential in shaping social behaviors, so too were human experiences influential in shaping the city.[24] As an intermediary concept, experience thus enables us to conceptualize the relationship between the subjective and objective perceptions of space in a dynamic, nonbinary manner.[25] This approach is particularly illuminating in the study of Safavid Isfahan, for it facilitates a shift of the analytical focus toward uses and perceptions of urban spaces without diminishing the significance of imperial aspirations; probing urban experiences reveals that the city was not merely laid out as an objective reality—an abstract representation of imperial order to be read and decoded by viewers—but also perceived and animated by way of subjective encounters. Ultimately, through this inquiry, there emerges a sensing human subject, one that is constituted in an intermediary zone continuously (re)shaped by the state agendas and by individual modes of fashioning the self.

SPACES, SELVES, AND TEXTS

All cities, whether historic or contemporary, play host to myriad personal and communal experiences. Yet the formation of full-fledged civic identities through subjective urban experiences has primarily been explored in the context of nineteenth-century European cities, as famously depicted in the poems and essays about Paris by the French poet Charles Baudelaire (1821–1867) and later conceptualized by the German literary critic Walter Benjamin (1892–1940).[26] A key figure in these works is the flâneur, an aimless wanderer who winds his way through the metropolis as an anonymous observer. Inspired by the works of Baudelaire and Benjamin, scholars have developed different conceptual models for analyzing the relations between the city, the self, and literary representations.[27] A nuanced consideration of these studies promises to offer a set of interpretive models and critical concepts for examining urban experience in Safavid Isfahan through an integrated scrutiny of physical spaces and literary representations.

In engaging with these concepts and models, one must of course take account of the differences between seventeenth-century Isfahan and nineteenth-century European megalopolises. The swiftly expanding industrial cities of nineteenth-century Europe not only were far more populous than their early modern predecessors but also contained elements that propelled a host of unprecedented urban experiences. Still, often too stark a demarcation is drawn between modern and premodern periods and especially between European and "other" experiences. The metropolises of early modern Eurasia contained multiple components—most notably consumables such as coffee and tobacco—that would become more commonplace in nineteenth-century cities. And like its contemporaneous cities across the globe,

Isfahan, too, saw the rise of distinct forms of urban subjectivity that were closely entangled with the city's novel characteristics as an early modern metropolis.

In Safavid Isfahan, urban experience was articulated through literary frameworks such as shahrashub, poems that traditionally focused on male youths engaged in crafts and trades in the marketplace. During the mid-seventeenth century, Isfahan witnessed a surge in the production of shahrashub and other forms of "urban topographical" literature.[28] By expanding, blending, and manipulating established literary themes and genres, these works created new ways of expressing urban impressions and experiences. Collectively, this body of urban literature bespeaks the formation of a novel domain of cultural production and consumption in seventeenth-century Isfahan—a social terrain nurtured by the city and largely independent of courtly circles.

This study draws particularly on this little-known corpus of literary descriptions to analyze aspects of urban experience in Isfahan.[29] Combining spatial and literary methods of analysis, I explore how the city shaped their contents and formats and how their dissemination in written and oral forms in turn affected the perception of the city. Complementing these works is a related set of materials dispersed in anthologies of poems (dīvān, jung, safīna), biographical compendia of poets (tazkira), epistolary compendia (munsha'āt), and miscellany collections (majmūʿa).[30] Although these source materials yield a wealth of new information on Isfahan's historical topography and chronology of construction, I do not mine them solely for documentary data. Poems are, after all, condensed forms of speech and thought, infused with multiple layers of meaning and association. More than any other form of language, poetic

expressions provide insights into the mental structures and shared sensibilities of a society, especially in a context such as the Persianate cultural sphere, where poetry had long been the epitome of cultural production.

A rigorous scrutiny of this largely untapped corpus of literary works can also help counter the overreliance of the existing scholarship on court chronicles and published European travelogues. Indeed, if one eschews the binary view that regards European accounts as objective representations and Persian-language literary sources as cliché-ridden verbal exercises, it becomes clear that these two types of texts share several basic traits. Seen in this light, the travel narratives of Pietro Della Valle (1586–1652), Jean Chardin (1643–1713), and Jean-Baptiste Tavernier (1605–1689) are also culturally colored accounts that were penned for the European reading public of the time.[31] Another fruitful approach is to use these European descriptions not merely as sources of factual information but also as records of phenomenological encounters with the city, perceived through the physiological sensorium shared by all human beings.[32] Though filtered through an external cultural outlook, travel narratives, too, offer vivid glimpses into urban experiences.

VISUAL IMPRESSIONS OF URBAN EXPERIENCE

A literary work consists of an intricate system of signs operating at several registers. But descriptive works that engage with a visual or spatial entity display an additional layer of significance. Merging rhetorical and referential forms of discourse, such ekphrastic works carry meanings and connotations that cannot be fully appreciated without considering the spatial reality to which they refer, a context that would have been familiar to their contemporary audiences.

Moreover, compared with literary descriptions of two-dimensional art objects, the interconnections of literature and architecture are far more complex, involving distinct notions of narrativity, temporality, and memory. Whether one proceeds from physical spaces or literary works, an inquiry into topographical literature is inherently interdisciplinary; it requires a critical appreciation of both textual and spatial systems and of the range of meanings produced when they intersect.

For instance, to better grasp why literary portrayals of Isfahan almost invariably evoke a dynamic spatial trajectory, it is essential to consider the ways in which kinetic experiences were propelled by the city's spatial structure. The seamless integration of urban spaces, markets, and monuments through elaborate liminal zones—a hallmark of Safavid urban design in Isfahan—created a flowing circulatory network that enabled uninterrupted movement through city spaces. This kinetic spatial quality can be seen in the arcades that surround the Maydan-i Naqsh-i Jahan and the pavilions that lined the Chaharbagh; these and other urban spaces were marked by a pronounced sense of fluidity and rhythm that could only be appreciated over time by an itinerant observer. To a large extent, then, the centrality of bodily movement in urban experience issued from the peculiarities of Isfahan's visual and spatial structure. The texts pulsate with the cadence of urban experience.

The analysis of literary sources as expressions of urban experience thus entails a critical appreciation of architecture and urban spaces as sophisticated three-dimensional entities that are encountered through a wide range of human senses and engage various modes of cognition. Put simply, such an inquiry requires spatial analysis—a careful examination of architectural and urban forms.[33] Yet as in other continuously inhabited cities, the physical fabric of Safavid Isfahan has disappeared, and its traces are buried beneath modern construction: the restored standing monuments constitute only a fraction of the carefully planned urban reality that shaped the seventeenth-century city experience.

In addition to engaging with extant structures, this book reconstructs Isfahan's vanished urban spaces and reimagines their embodied experiences, drawing particularly on surveys and sketches made by the German physician and botanist Engelbert Kaempfer (1651–1716),[34] who spent around twenty months in Isfahan in 1684–85, and the drawings by the French architect Pascal Coste (1787–1879), who visited the city in 1840.[35] I approach these materials not just as evidentiary representations of now-lost monuments and gardens but as visual traces of unmediated encounters with the city environment. Unlike many other European representations of Isfahan, which were produced from memory, Kaempfer's sketches and Coste's drawings were made on site while their creators walked the city and sensorially engaged with edifices and gardens. These representations are certainly mediated by specific graphic conventions—Kaempfer was adept at mensuration but had no formal training in drawing, whereas Coste was a Beaux-Arts-educated architect—but in the core experiences that shaped them, these visual impressions bear close affinities to textual representations of Isfahan.

Besides this corpus of drawings, late nineteenth-century photographs also depict scores of Safavid buildings that have since disappeared. It is one of the peculiarities of Isfahan that the introduction of photography in the late 1800s coincided with the wholesale demolition of Safavid monuments; several buildings were recorded in photographs shortly before their disappearance.[36] Upon the fall of Isfahan

in 1722 and the subsequent collapse of the Safavid dynasty, the city's size and population plunged drastically, and the decline continued during the tumultuous eighteenth century. Some renovations were made during the 1800s under the Qajar dynasty (1794–1925), but by the last quarter of the nineteenth century, Safavid buildings had fallen into disuse and disrepair; the abandoned edifices, scattered in withered gardens and deserted neighborhoods, began to provide a quarry of building materials for new structures.[37]

Old photographs (a major understudied source for the study of Safavid architecture) are obviously inflected with later viewers' understanding of the monuments, but they also convey an indexical trace of architecture, providing clues to tactile encounters with the built environment. Rather than as static images, then, I analyze photographic representations as snapshots of broader spatial and visual experiences. Likewise, the plans and architectural renderings offered in this book (many of which were prepared for this study) do not aim to represent the city in an ideal frozen status or to convey an "authentic" view of vanished edifices and urban spaces. Instead, they strive merely to present yet another form of interpretation; together with other pieces of evidence, they enable an approximation of a now-lost physical reality and its visual experience.

Finally, in analyzing urban experience, this book also engages figural representations made in Safavid Isfahan, either as stand-alone images on paper (single-page paintings and drawings, which were typically collected in albums) or as adornments to public monuments (murals and painted tiles). As scholars of Persianate painting have noted, the medium of single-page painting, which flourished in the seventeenth century, was intimately linked to Isfahan's social milieu.[38]

These works depict real individuals or idealized social types that one would have encountered across the city, while the participation of urban elites in the patronage and consumption of artworks was instrumental in the rise of single-sheet compositions as the major form of artistic expression. The study of these images in conjunction with literary representations and reconstructed urban spaces casts further light on the ways these single-page paintings and drawings were entangled with the social experiences peculiar to early modern Isfahan.

An extensive archaeology of words and images, then, forms the basis of this study. My interpretations rest upon a synthesis of visual and textual evidence: matching words with images, images with drawings, and mapping them all onto the city's topography. The primary source of this work is indeed the urban form of Isfahan itself, which is here reconstructed alongside its ecological, sensory, and social contents.[39] Pieced together from a diverse array of sources, the result is a dynamic picture of Safavid Isfahan, one that brings us closer, I hope, to understanding the city as a total life-world encompassing human experiences, physical spaces, material objects, natural elements, and social relations.

Considering spaces and experiences as a whole, the narrative of the following chapters, divided into three parts, unfolds across the full arc from the conception and construction of the city to its sensory experiences and literary representations. Laying the groundwork for the core discussions of the book, part 1 explores Isfahan's history, planning trajectory, and urban configuration. Focusing on the pre-Safavid history of Isfahan, chapter 1 outlines the urban structure of the medieval city and the notions that it came to embody over the ages. This chapter also examines early Safavid urban interventions

in Isfahan, which laid the foundation for seventeenth-century imperial projects. Chapter 2 investigates the process of planning and constructing Isfahan during the late sixteenth and early seventeenth centuries. Particularly, the chapter reexamines the chronology of the city's development under Shah Abbas, discussing Isfahan's urban image as the capital of an early modern empire. Turning to the Safavid master plan, chapter 3 outlines the modes of eco-urban design that lent Isfahan a verdant cityscape and a pronounced sense of spatial coherence.

The three chapters that constitute part 2 consider aspects of urban experience in the major constituent parts of the new Isfahan: the Maydan-i Naqsh-i Jahan, the Chaharbagh, and extramural quarters. The aural and temporal dimensions of urban experience are the main concerns of chapter 4, which concentrates on the acoustic environment of the Maydan-i Naqsh-i Jahan and its time-indicating and audiovisual components. I specifically demonstrate that, contrary to the common assumption, the mechanical clock installed on the north side of the square was an integral part of its design from the outset. Together with other elements such as the *naqqāra-khāna* (kettledrum hall) and coffeehouses, this mechanical clock and another clock pavilion built in the 1640s created a distinctive soundscape, punctuated the flow of time, and regulated the rhythms of civic life in the plaza and beyond. The socio-aesthetics of visual experience is the subject of chapter 5, which investigates the optical structure of the Chaharbagh. This chapter recreates the embodied, sensory experience of the promenade through the gaze of a mobile beholder, reconstructing its bordering pavilions, landscape elements, and social establishments. Finally, the urban form and lived experiences of the extramural quarters (Abbasabad, New Julfa,

Gabrabad) are addressed in chapter 6. Built on a rectilinear pattern and accessed by tree-lined avenues, these verdant, spacious districts contrasted with the age-old compact urban fabric of the pre-Safavid walled town. I contend that Isfahan's new developments constituted a unified cluster of planned quarters closely bound up with the new civic identities that the city fashioned and contained.

Focusing on the lyric imaginaries of poets, part 3 explores urban experience in the broader cityscape. Poetic descriptions of Isfahan date primarily from the mid-1600s, a period of dynamic urban expansion and literary efflorescence. Chapter 7 outlines these concurrent urban and literary developments before analyzing their interrelations and charting the modes of visual and verbal engagement with the built environment, the subject of chapter 8. This discussion lays the groundwork for the final chapter, which is devoted to an in-depth scrutiny of the "Guide for Strolling in Isfahan." After matching its itinerary with the city's topography, the chapter examines the text's import and effect as a literary artifice and spatial representation. Along with other sources, the guide hints at the emergence of a novel form of solitary urban experience that was closely entangled with Isfahan's material and social spaces.

In the conclusion, I reflect on the implications of my inquiry for understanding the place of Safavid Isfahan in a global context. Seen through the lens of urban experience, what Isfahan shared with contemporaneous early modern cities was not its status as the seat of a centralized state or the erection of iconic monuments as emblems of imperial authority. Rather, like its counterparts across the globe, Isfahan constituted a metropolitan setting that nurtured new modalities of living and experience. Here not only was the silver of the new world exchanged

for silk, but vibrant social and material spaces were formed around the consumption of novel substances, and new perceptions of the self and the world were fashioned through embodied, subjective, and multisensory interactions with the built environment. The analysis of urban experience thus offers a unique prism for comparative studies of early modern cities, revealing how the circulation of materials and people engendered comparable experiences across the early modern world.

PART 1

RISE OF A METROPOLIS

The Medieval City

THE LORE OF ISFAHAN AND EARLY SAFAVID DEVELOPMENTS

In an autobiographical note that opens his voluminous compendium of poets (*tazkira*), the author and poet Taqi al-Din Muhammad Awhadi (d. after 1629–30) recounts that on arriving in Isfahan in 1591–92 (1000 H), he saw that all the "city's markets [*asvāq*] and squares [*mayādīn*] were undergoing renovation and new buildings had been erected."[1] Visiting Isfahan after an absence of five years, Awhadi was ostensibly impressed by the expanse of ongoing construction in his hometown. Shortly afterward news reached the city that Shah Abbas, having returned from a campaign, would soon arrive in Isfahan. During the royal sojourn, the city's central plaza, Maydan-i Harun-i Vilayat, was illuminated with lanterns, and one night a group of poets gathered there to attend an assembly with the shah. According to Awhadi, while all the participants sat on the ground, the king stood up, leaning on a staff, as the poets vied to compose quatrains in praise of the illuminated square.

Although Awhadi does not specify the precise location of this royal audience, it was likely held on the plaza's south side, where the shrine of Harun-i Vilayat is located. Completed in 1512 under the first Safavid monarch, Shah Isma'il (r. 1501–24), the ornate portal of the shrine complex would have provided a dazzling backdrop for the assembly, its glazed mosaic tiles glittering under the light of lanterns. For the young Shah Abbas, the Harun-i Vilayat shrine offered

an emblematic arena in which to display his royal lineage; rendered in golden letters, the name and titles of Shah Isma'il were and still are prominently displayed at the center of the foundation inscription, below a pair of facing peacocks, on the shrine's portal (fig. 4). By staging a royal ceremony in Isfahan's central square, Shah Abbas evoked the memory of his charismatic forebear, who had the shrine built to represent and enact the Safavid claims to temporal and spiritual authority.

Awhadi's firsthand account underlines some of the key traits that were to influence the course and character of Isfahan's urban development in the ensuing decades. It attests to, for instance, the significance of urban pageantry and illuminated festivities for the newly enthroned monarch, hinting at his peculiar predilection for holding royal assemblies in informal urban settings instead of secluded pavilions. This account indicates, moreover, that in the early 1590s, when a massive campaign of urban renewal was launched in Isfahan, the city was already a sizable entity with markets and plazas deemed worthy of renovation. A long-standing urban settlement, Isfahan was in fact replete with the material remnants and collective memories of a vibrant city life, which had remained fairly robust and resilient despite intermittent episodes of internal turmoil and external incursion.[2] To comprehend the context and driving

FIGURE 4
Harun-i Vilayat shrine, Isfahan, detail view of the portal (dated 1512) with the foundation inscription and tile panel depicting facing peacocks. Photo: author.

forces of the developments of the age of Shah Abbas, it is thus crucial to outline Isfahan's evolution before the age-old medieval city was incorporated into an expansive urban system. Equally essential is the exploration of early Safavid building projects such as the development of the Harun-i Vilayat shrine and its adjacent square. These interventions refashioned the urban structure and image of Isfahan, prefiguring the building campaigns initiated in the late sixteenth century.

CLIMATE, COMMERCE, AND COSMOS
In their accounts of the construction of Isfahan, Safavid histories underscore geographical, demographic, and environmental features

as the key factors that motivated Shah Abbas to develop Isfahan and make it the imperial seat. Iskandar Beg Munshi, the chief chronicler of the reign of Shah Abbas, highlights the city's location, its climate, and the presence of the Zayanda River.[3] Similarly, the Safavid historian Mirza Beg Junabadi refers to the city's ample water supply, its potential for urbanization (*shahriyyat*), and its countless populace.[4] Isfahan's nodal position on the Iranian plateau was certainly a major advantage, granting the city a unique status in the imagined geography of Iran. In an anthropomorphic description, a fourteenth-century encomiastic poem thus refers to Isfahan as the "head of the Iranian land" (*sar-i Irānzamīn*), an age-old metaphor that also appears in Safavid sources.[5]

The Zayanda ("birthing") River, also known as Zinda ("living") and Zarrin ("golden") River, was Isfahan's principal natural feature and the basis of its prosperity and sustenance. In central Iranian highlands, where irrigation was possible mainly through subterranean canals (s. *qanāt*, *kārīz*), this perennial source of water enabled the creation of expansive farmlands, orchards, and pleasure gardens. Moreover, Isfahan was a center of crafts and lay in the orbit of cities such as Kashan, Yazd, Shiraz, and Kerman, which had long been loci of high-quality artisanal production. Lucrative commodities such as brocades of Yazd and velvets of Kerman were critical in the economic prosperity of Isfahan after it became the Safavid capital.

Besides agrarian production and the textile industry, Isfahan's strategic location in mercantile networks undergirded its prosperity. Isfahan was the foremost city of the province known in medieval geographical works as the Jibal ("mountains") or Iraq-i Ajam ("Persian Iraq"), which encompassed the Zagros Mountains in western Iran (fig. 5). The city lay at the junction of ancient trade arteries that traversed the Iranian plateau, especially the north-south transit route connecting the Caspian Sea to the Persian Gulf. Situated close to thriving Persian Gulf ports such as Siraf and Basra, Isfahan was also linked to the maritime trade routes of the Indian Ocean. Medieval geographers evoke its pivotal commercial role in their descriptions: "Caravans do not cease to arrive from Basra and Khurasan," notes Muqaddasi in the tenth century.[6] Likewise, Ibn Hawqal describes Isfahan as a city with great commercial traffic, adding that in all the Jibal "there was no other city that had so many camels to transport merchandise."[7]

The geographic centrality of Isfahan was bolstered by its presumed cosmic significance. According to a prevalent cosmography rooted in Ptolemaic as well as pre-Islamic Iranian notions, Isfahan lay at the nave of the fourth of the seven climes (*iqlīm* or *kishvar*) that constituted the inhabited world.[8] In this cosmographical scheme, each earthly clime was associated with one of the seven celestial spheres (*aflāk*) that girded the earth. The epithet "half the world" (*niṣf-i jahān*), a phrase by which Isfahan has been described since pre-Safavid times, was probably not merely a hyperbolic reference to the city's immense size and population; it may have been a later iteration of a homonymous phrase (*nasf-i jahān*, meaning "nave/center of the world")— an allusion to the city's nodal position on earth and in the cosmos.[9]

Whether imaginary or real, Isfahan's distinct characteristics had an enduring impact on its image and perception. Indeed, even before it became the seat of Safavid rule, Isfahan was already considered the greatest and most populous city on the Iranian plateau. Hence, Amin Ahmad Razi, who finished his geographical compendium around 1593–94 on the Indian subcontinent (that is, before the completion of

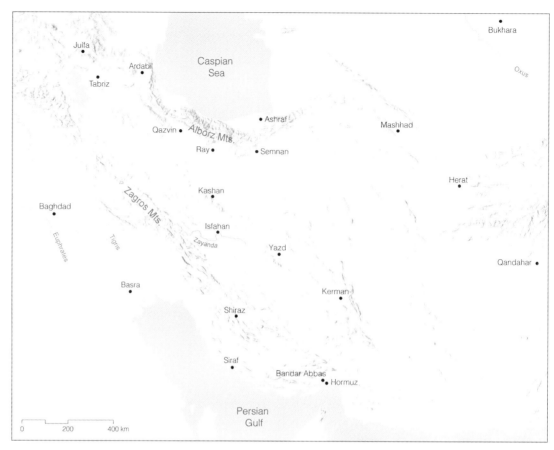

FIGURE 5

Map of the Iranian plateau, showing major cities. Map by Jaleh Jalili and Farshid Emami.

the major building projects under Shah Abbas), described Isfahan as "the largest and most developed [*ma'mūr*] city in all of Iran."[10] Razi, too, referred to the medieval province in which Isfahan lay as "the heart of Iran."[11] These urban myths and geographical imaginaries reveal a key incentive that drove the city's development under Shah Abbas: the construction of Isfahan was not a matter of creating a capital city in a provincial town; the aim was rather to turn a sizable settlement in the heart of the Iranian highlands—a city bestowed with heavenly symbolism and positioned at the midpoint of the world—into a metropolis.

THE URBAN STRUCTURE OF MEDIEVAL ISFAHAN

The distinct status of Isfahan, its urban structure, and the myths associated with it were fashioned over centuries of habitation. The city's original kernel was Yahudiyya, a Jewish settlement set up in the vicinity of Jayy, a provincial capital (*shahristān*) founded under the Sasanians (224–651). Situated on the north bank of the Zayanda River, Jayy was the chief urban settlement of the province of Spahan (as Isfahan was known in Middle Persian, or Pahlavi, the official language of the Sasanian Empire). Although no trace of Jayy remains today, textual sources

reveal that it was a circular city—a common form in Parthian and Sasanian cities, as evident in Hatra (Arbil), Gur (Firuzabad), and Darab-gird—and featured four gates named after and oriented toward specific celestial bodies (fig. 6).[12] In the eighth century, under the Abbasid caliph al-Mansur (r. 754–75), Yahudiyya acquired the status of a *miṣr*, or "comprehensive city," while Jayy gradually declined and was eventually abandoned. This change in the locus of power is reflected in numismatic evidence; while coins were initially minted at Jayy, those struck after the mid-700s bore a new designation: the city, or *madīna*, of Isfahan.[13]

The shift from a Sasanian *shahristān* to an Islamic *madīna*, and the subsequent rise of Isfahan as a thriving urban center, are emblematic of the massive urbanization of West and Central Asia in the centuries after the Arab Islamic conquests. The roles of cities as centers of tax collection and textile production, together with the gradual conversion of the local populace to Islam and migration from rural areas, were the major factors that propelled this massive urbanization.[14] In Isfahan, the Abbasids initially founded the government palace and a Friday mosque in a village called Khushinan, while the market (*sūq*) was established on the periphery of Yahudiyya (fig. 6).[15] Medieval sources name fifteen villages that merged with Yahudiyya to form the neighborhoods (*maḥallāt*) of the emerging city. The names of several of these villages endured as toponyms that were prevalent until recent times, and such continuities have enabled an approximate reconstruction of Isfahan's topography in the early Islamic period.[16] The original site of Yahudiyya, for example, corresponds to the neighborhood of Jubara ("Jewish borough"), where a Jewish community and a handful of synagogues have survived to the present day.[17]

Isfahan acquired a finite physical form in the tenth and eleventh centuries, when Yahudiyya and a number of its adjoining settlements were enclosed within fortification walls. Studded with bastions, embrasures, and battlements, these massive earthen ramparts were erected after the disintegration of the Abbasid Empire, between around 932 and 1051, when Isfahan was controlled by the Buyids and Kakuyids, dynasties that originated in the Caspian Sea littoral. Based on old photographs and maps, the overall form and contours of Isfahan's medieval walls can be reconstructed with relative precision (fig. 6). Surrounded by a moat and punctured by twelve iron gates, the city's perimeter wall was roughly ovoid in plan and "serpentine" in contour; a twelfth-century author described Isfahan as a city whose foundation was "tilted, neither circular nor square."[18]

The irregular shape of the city walls surrounding its southern parts was likely the result of later expansions, but the northern portion, as the reconstructed map indicates, appears to have been relatively round, with gates positioned at fairly equal intervals. Likely the Buyids intended to create a circular city with four quadrants delimited by arterial roads converging at a symbolic center.[19] At least in its overall layout, then, Buyid Isfahan was conceived as a round city, replicating the form of Jayy while also recalling the famed circular plan of Baghdad, the Abbasid capital and Isfahan's political and cultural rival at the time.[20] Further, it appears that the shrine of Harun-i Vilayat and the minaret of the Ali Mosque (fig. 10), the tallest extant structure of medieval Isfahan, rather than the Great Mosque, lay at the exact physical center of the quasi-circular walled city; this was perhaps a deliberate reference to the Sasanian city of Gur, which was centered on a tower and was revived under the Buyids. In any case, the urban

FIGURE 6

Below left (after Lisa Golombek): Topography of Isfahan in the early Islamic period, showing the hypothetical location and form of the Sasanian round city of Jayy alongside the wall circuit built in the late tenth–early eleventh centuries under the Buyids and Kakuyids. Above right: Plan of medieval Isfahan, enclosed by the Buyid/Kakuyid walls, showing the city's major gates, arteries, quarters, and monuments: (1) Maydan-i Harun-i Vilayat (Old Maydan); (2) Great Mosque of Isfahan (Old Mosque); (3) Harun-i Vilayat shrine; (4) old qaysariyya; (5) Tabarak Fortress. Main gates of the walled city: (A) Dardasht; (B) Tuqchi; (C) Jubara; (D) Sayyid Ahmadiyan; (E) Karran; (F) Hasanabad; (G) Dawlat; (H) Kushk (Lunban). Plan by author.

form of medieval Isfahan appears to have been a hybrid entity from the outset; with tortuous, narrow thoroughfares, the city's fabric retained the structure of the villages that it had incorporated. The result was a syncretic urban form that echoed the iconic circular cities of the past but whose texture embodied the emerging social realities of Islamic-era urbanism.

Aside from the ramparts, the other major creation of the Buyid/Kakuyid period was the Tabarak Fortress (Qalʿa Tabarak), in the southeast of the city.[21] Girded by a moat, the imposing citadel consisted of two nested enclosures encircled by bastions. The Tabarak Fortress and the city's ramparts were routinely restored, but their overall shapes seem to have remained intact. As major urban landmarks and emblems of the city's past, the citadel and fortifications accorded Isfahan the image of a massive settlement even in periods of relative decline. Even so, the medieval gates and walls ceased to function as defensive elements in the seventeenth century, as did the Tabarak Fortress, which served as a repository of precious goods (*khazāna*) and armory (*jabākhāna*) in Safavid times.[22]

The other enduring legacy of medieval Isfahan was intellectual rather than material. During the early medieval period, Isfahan was a major cultural center of the Islamic world, where some of the luminaries of the day penned their foundational scientific works. Here, for example, Abd al-Rahman al-Sufi (Azophi, d. 986) composed his *Kitāb ṣuwar al-kawākib al-thābita* (Book of the Images of the Fixed Stars), and the famed polymath Ibn Sina (Avicenna, d. 1037) compiled his compendium of sciences, *Dānishnāma-yi ʿAlāʾī* (Book of Knowledge for Ala al-Dawla), which he dedicated to the eponymous Kakuyid ruler of Isfahan. A few decades later, during the Seljuq period (1037–1157), a group of scholars headed by the mathematician-poet Omar Khayyam (d. 1131)

assembled in Isfahan to reform the Persian solar calendar and conduct astronomical studies at the imperial observatory.[23] The resultant Jalali calendar—named after the Seljuq ruler Jalal al-Din Malikshah (r. 1073–92)—fixed the start of the year at the vernal equinox (Nawruz) and set Isfahan as the reference meridian. The calendar was (re)synchronized with celestial rhythms in a cosmography that centered on Isfahan.

The urban memory of medieval Isfahan and its astronomical associations lingered in the collective imagination of the Iranian world until the beginning of the seventeenth century. Geographical works noted, for instance, that the Buyid ruler Rukn al-Dawla (r. 935–76) had the ramparts (*bārū*) built around Isfahan "on the day the moon was in Sagittarius."[24] Sagittarius (*qaws* or *kamān*, "the bow") had been considered the auspicious zodiacal house of Isfahan since early medieval times.[25] This celestial symbolism endured through the Safavid era, as the signs of Sagittarius, rendered in mosaic tiles, were prominently displayed at the portal of the royal market on the Maydan-i Naqsh-i Jahan (fig. 39). The gate of the Tabarak Fortress, too, was reportedly decorated with the astronomical sign of Sagittarius.[26]

Above its earthen ramparts, the silhouette of medieval Isfahan was dominated by an aggregate of soaring minarets and domes. To the visitor approaching from the north, the city's profile appeared as a mass of towering brick structures set against the backdrop of rugged Suffa Mountain (fig. 7). Like those of other medieval Islamic cities, Isfahan's skyline was punctuated by an array of minarets that rose above religious foundations and funerary monuments. The majority of these intricately carved minarets and their (now mostly vanished) adjoining complexes were erected from the eleventh through the early fourteenth centuries. A period of immense

FIGURE 7
Pascal Coste, Isfahan's skyline
viewed from the north, 1840.
Bibliothèque de l'Alcazar, Marseille,
MS 1132, fol. 50.

building activity occurred in the late eleventh and early twelfth centuries, when Isfahan was the capital of the expansive Great Seljuq Empire. The Seljuq ruling elite did not reside within the city, however. Rather, the sultans appear to have maintained their courts in gardens (s. *bāgh*) and encampments (s. *urdū*) set up in the environs of Isfahan.[27] Textual sources name a number of Seljuq royal gardens on the outskirts of Isfahan, but no trace of them remains today, and none can be detected in historical depictions.

Among the scores of monuments that dotted medieval Isfahan, the most outstanding was the city's congregational mosque (fig. 8). Founded under the Abbasids in the eighth century, the Great Mosque of Isfahan became known as the Old Mosque (Masjid-i Kuhna) from the seventeenth century onward to distinguish it from the Shah Mosque (Masjid-i Shah) on the Maydan-i Naqsh-i Jahan. Situated at the center of the walled city and erected on ground slightly higher than the surrounding lands, the Muslim house of worship was probably constructed on the site of a preexisting sanctuary (likely a Christian church).[28] The construction history of the Old Mosque is inextricably intertwined with that of Isfahan. Initially the Buyids modified the Abbasid mosque by adding a row of brick columns to the central courtyard. But it was under the Seljuqs that the mosque assumed an iconic form with the erection of its monumental domes and iwans.[29] Axially arranged, these colossal

FIGURE 8
Aerial view of the Great Mosque of Isfahan (Old Mosque). University of Chicago, Oriental Institute, Iran Aerial Photo: AE 589. Courtesy of the Oriental Institute of the University of Chicago.

domes and iwans bestowed a regal character on the mosque, befitting Isfahan's status as the royal seat of the far-flung Great Seljuq Empire. The Old Mosque was frequently renovated and augmented in the ensuing centuries and remained a vibrant locus of religious and urban existence. Indeed, despite the splendor of the new Safavid Friday mosque on the Maydan-i Naqsh-i Jahan, the Old Mosque never lost its status as the foremost sanctuary of Isfahan.

APPROPRIATING THE MEDIEVAL CITY:
EARLY SAFAVID ISFAHAN

Compared with the imposing monuments of medieval Isfahan and the immense developments of the age of Shah Abbas, early Safavid building activities might appear meager, but close inspection reveals that they had a crucial urban impact, laying the cornerstone for later grand projects. Safavid forces conquered Isfahan in 1503, soon after Shah Isma'il ascended the throne in Tabriz and deposed the Turkmen Aq Quyunlu (the clan of the "white sheep," 1467–1501). Descended from the Sufi shaykh Safi al-Din (d. 1334), Isma'il was the hereditary spiritual leader of the Safaviyya Sufi order (a mystical brotherhood founded by the eponymous Safi al-Din in Ardabil) that had evolved into a militant Shi'i movement during the latter half of the fifteenth century. The rise of Isma'il as a monarch-saint emblematized the "new forms of religiopolitical legitimacy" that emerged across

the early modern Islamicate empires and were spurred by the social growth of Sufism, messianism, and millenarianism.[30]

The swift rise of the Safavid house to imperial power was fueled by fervent support from their Turkmen tribal followers, who became known as the Qizilbash (literally "red heads," after the red caps with twelve-gore batons that they wore as a sign of their allegiance to the Safavid cause). These Turkic pastoral nomads—who hailed from northwest Iran and Ottoman-controlled Anatolia—revered Isma'il as a divinely ordained spiritual guide and a quasi-messianic figure.[31] Moreover, the Safavids were staunch supporters of Twelver Shi'i Islam, a branch of the sect centered on the veneration of Ali b. Abi Talib (the

son-in-law and cousin of the Prophet Muhammad) and his eleven male descendants via Fatima, the Prophet's daughter. Throughout the Safavid rule, Shi'ism was vehemently upheld as the official creed of the state and was forcefully imposed on the empire's subjects. Save for scattered enclaves, the majority of Iran's population was Sunni at the time.

In 1503, when Shah Isma'il rallied his Qizilbash warriors toward Isfahan, the city was a far cry from its glamorous days. Although urban life never ceased entirely, Isfahan had witnessed a decline, especially upon the outbreak of the pan-Eurasian plague pandemic and the devastating sack of the city by the forces of the Turco-Mongol emperor Timur (r. 1370–1405). The desolate state of Isfahan in the late fifteenth century is reflected in the account of the Venetian merchant Giosafat Barbaro, who estimated that the city housed only twenty-five thousand inhabitants and that a mere one-sixth of the walled city was occupied.[32] The Safavid conquest was no blessing for Isfahan, as it involved a massacre of the city's Sunni notables.[33] The image of power projected by the Safavids onto Isfahan's urban landscape is also manifest in the Tower of Skulls (Kalla Minar), a now-vanished tower studded with the skulls and horns of the game hunted by Shah Isma'il (fig. 9). By one account, all came from a single hunting expedition in the environs of Isfahan, during which the shah slew 6,700 animals.[34]

In the period after the Safavid capture of Isfahan, the main focus of building activity was the shrine of Harun-i Vilayat (fig. 10). Sponsored by the Qizilbash governor of Isfahan, Durmish Khan Shamlu, the domed tomb chamber and its adjoining madrasa (religious school) were constructed in 1512 by Mirza Shah Husayn, an Isfahani architect (mi'mār) who served as the deputy of Durmish Khan.[35] A decade later, in 1522–23, the Ali Mosque was built to the southeast of

FIGURE 10
Aerial view of the Harun-i Vilayat shrine and the minaret of the Ali Mosque. Photo by Rezanoor Bakhtiar. From Rezanoor Bakhtiar, *Iṣfahān, mūza-yi hamīsha zinda* (Isfahan: Shahrdari-yi Isfahan, 1372 [1993]), 74.

the shrine (fig. 11).[36] The mosque's foundation inscription suggests that it was also sponsored by Mirza Shah Husayn. Hovering above the complex was the colossal cylindrical minaret of the Ali Mosque, which predated the Safavid additions and likely marked the center of the quasi-circular walled city laid out under the Buyids, as noted above.

The role of Mirza Shah Husayn in the construction of the Harun-i Vilayat complex and

the Ali Mosque is particularly revealing of the social meaning and urban context of these early Safavid developments. A native of Isfahan, Shah Husayn descended from the city's prominent sayyid families, a class of urban notables who traced their lineage to Shiʻi imams (the epithet "shah" was also used for the sayyids). Shah Husayn subsequently rose to the highest ministerial rank at the Safavid court; the foundation inscription on the Ali Mosque refers to him as

FIGURE 11
Plan of the Harun-i Vilayat shrine
and its surroundings: (1) Maydan-i
Harun-i Vilayat; (2) portal with tile-
mosaic decoration; (3) tomb cham-
ber of Harun-i Vilayat; (4) Takhtgah;
(5) Ali Mosque; (6) minaret. Plan by
author.

with the advent of a sizable Shiʻi populace, a sectarian minority at odds with the city's predominantly Sunni inhabitants.[38] The Harun-i Vilayat shrine was not a site of royal representations alone; it also created a symbolic center for Isfahan's ascending Shiʻi community.

Nevertheless, although Safavid sources describe the shrine as the tomb of a scion of the Shiʻi imams (*imāmzāda*), it likely marked a preexisting sanctuary that was appropriated as a sectarian site of pilgrimage.[39] In the early twentieth century, the shrine was still venerated by Isfahani Jews, who maintained that it marked the grave of a Jewish saint.[40] The tomb's location in the heart of the city, next to the landmark fifty-meter-high minaret of the Ali Mosque, further attests to the site's prior significance. Indeed, contrary to the common assumption, the shrine's appellation, Harun-i Vilayat, is unlikely to be the name of a real person (Harun is the Islamic equivalent of the biblical Aaron). Instead, it was probably used in the literal sense to mean "guardian of the realm" (*hārūn* also denotes "guardian," and *vilāyat* "realm/province").[41] In the "Guide for Strolling," the shrine is praised in lofty terms as the "protector of Isfahan from disaster," suggesting that the interred holy figure was revered as the city's patron saint. This interpretation is confirmed by other accounts, which describe the shrine as a popular pilgrimage site frequented by Christians, Jews, and Muslims.[42]

The Harun-i Vilayat shrine acquired further civic significance through a reconfiguration of its surrounding urban spaces. A reconstruction of the original setting of the complex indicates that the arcaded facade of the Ali Mosque mirrored the shrine's eastern elevation (fig. 11). In the seventeenth century, the oblong space enclosed by these symmetrical facades was known as Takhtgah ("throne place") and famed for its coffeehouses; a visit to Takhtgah is one of

"the founder of the rules of kingship."[37] From the fourteenth century onward, and particularly since the Mongol Ilkhanid period (1258–1335), the sayyids had been the most influential notables of major Iranian cities. In Isfahan, the rise of these new civic leaders was concomitant

the highlights of Semnani's recommended tour of Isfahan. Yet since the structures that constitute Takhtgah date from the early 1500s, the complex was likely used for similar social functions from the outset.[43]

The shrine and Takhtgah were constructed together with an enormous square, the Maydan-i Harun-i Vilayat. According to Awhadi, Mirza Shah Husayn was also responsible for designing parts of the adjacent maydan, implying that the construction of the shrine complex was accompanied by the expansion and reconfiguration of the plaza.[44] This assumption is confirmed by the period chronicles recording that in 1509–10 Shah Isma'il ordered the "maydan of Isfahan" be broadened and that there he engaged in horseback riding and archery.[45] A later author further asserts that Shah Isma'il had "four markets" built around the Old Maydan of Isfahan.[46] Indeed, it appears that the Old Maydan (as the Maydan-i Harun-i Vilayat became known in the seventeenth century) was not a remnant of the Buyid or Seljuq periods but was rather laid out (at least in the form in which it existed in the Safavid period) in the early 1500s, alongside the Harun-i Vilayat shrine.[47] It is no coincidence, then, that sixteenth-century sources primarily refer to the square as the Maydan-i Harun-i Vilayat; the plaza was nominally and spatially tied to the shrine rather than the Old Mosque.

The civic role of the Maydan-i Harun-i Vilayat in early Safavid Isfahan is also evident in the range of buildings that bordered it.[48] To the northeast, opposite the Harun-i Vilayat shrine, lay a qaysariyya (Arabicized from Caesaria, a market for luxury textiles and other precious goods), which also featured a naqqara-khana, where music was played at sunrise, sunset, and on ceremonial occasions.[49] The source of information on this qaysariyya is Chardin, who describes it as a "high and old pavilion" where musical instruments were played before the city's chief naqqara-khana was relocated to the Maydan-i Naqsh-i Jahan under Shah Abbas.[50] An elevated building (burj) with four corner towers also overlooked the square on its western side.[51]

The (re)construction of the Harun-i Vilayat shrine and its adjacent maydan was followed by a larger building program, sponsored by the Shi'i urban notables, that gradually transformed the visual environment of Isfahan. Shortly after the completion of the Ali Mosque, the Old Mosque itself underwent a sumptuous program of ornamentation: the brick arcades surrounding the central courtyard were revetted in shimmering ceramic tiles (fig. 12).[52] The similarity between the decorative scheme of the Harun-i Vilayat complex and that of the Old Mosque reveals a close link between the two projects. The tour de force of the decorative program, dated by inscription to 1531–32, was the mosque's main iwan (the vaulted hall preceding the sanctuary dome on the qibla side of the courtyard): glazed tiles covered the pīshtāq (the rectangular screen framing the iwan), while exquisite tile panels set above a dado of carved marble adorned the iwan's inner surfaces (fig. 13).[53] The intricate geometric designs of these panels signal the involvement of the royal atelier; the inscription running atop the tile panels bears the signature of a calligrapher attached to the court of the second Safavid ruler, Shah Tahmasp (r. 1524–76).[54] The inscription, however, suggests that the ornamentation program did not issue from a royal commission but was rather sponsored by Amir Mu'izz al-Din Muhammad, a local notable who served as the naqīb (chief) of the city's sayyids and held the post of ṣadr (highest religious authority) at the time.[55]

These tile revetments fundamentally altered the visual character of the long-standing

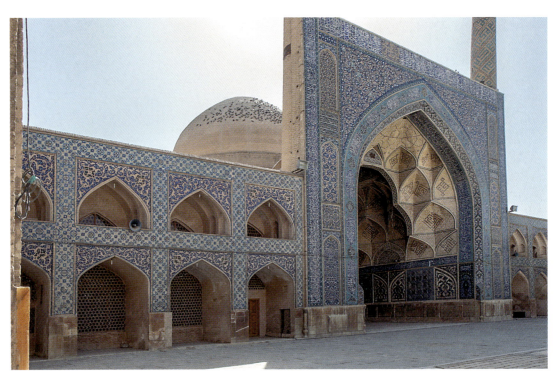

FIGURE 12
Old Mosque of Isfahan, view of the southwestern (qibla) facade of the inner courtyard, with glazed-tile decoration added in the Safavid period. Photo courtesy of Daniel C. Waugh.

congregational mosque of Isfahan. Indeed, these decorations occasioned the most drastic transformation in the mosque's appearance since the erection of its monumental domes and iwans under the Seljuqs. The revamping of the Old Mosque was followed by the construction of several small yet exquisitely decorated mosques sponsored by the local elite.[56] Even though these religious buildings were not enormous, their dazzling ornamentation enhanced their visibility in the cityscape. Unified through a coherent visual idiom, Isfahan's buff-brick monuments were sheathed with glittering tiles projecting sectarian themes and messages.

The main intervention of the early Safavid period in Isfahan, however, was not the religious edifices at the city core but rather the Naqsh-i Jahan (literally, "image, ornament, or pattern of the world") Garden. Lying in the southwestern zone of the walled town, the Naqsh-i Jahan Garden and its adjacent maydan played a key role in the subsequent development of Isfahan, for under Shah Abbas they would become the site of the royal palace and a massive commercial complex. Sixteenth-century sources describe the Naqsh-i Jahan Garden as one of the finest in Iran, naming an architect active during the reign of Shah Isma'il as its designer.[57] Earlier texts suggest, however, that the early Safavid architect had remodeled a preexisting estate of Timurid origin.[58] At least one new pavilion, known as the Mahdi Edifice (ʿimārat-i Mahdī), was also erected in the garden under Shah Isma'il.[59]

An open-air plaza, or maydan, adjoined the Naqsh-i Jahan Garden, but its original form and its relationship to the Maydan-i Naqsh-i Jahan as it was built under Shah Abbas remain uncertain. The sources suggest that at least one major structure was found on the periphery of the maydan. Known as the Khvaja Malik Madrasa and probably built during the reign of Shah Tahmasp, this religious school was the center of Shiʻi learning; to highlight the madrasa's significance, an early eighteenth-century source compared its status for the Shiʻis to that of the Nizamiyya Madrasa (the famed school established in Isfahan by the Seljuq vizier Nizam al-Mulk) for the Sunnis.[60] Located opposite the Naqsh-i Jahan Garden, the Khvaja Malik Madrasa was a sizable building, perhaps the largest around the plaza.[61] The Maydan-i Naqsh-i Jahan nevertheless did not feature any other commercial or imperial foundations before the reign of Shah Abbas; it was primarily an open-air field for equestrian exercises rather than a full-fledged civic center.

Over the course of the sixteenth century, then, Isfahan acquired a distinct civic image through the revamping of its monuments, the expansion and renovation of its urban spaces, and the erection of several ornate religious edifices. Sponsored by local notables, these building projects not only asserted the rise of the Safavid polity but also bolstered the social standing of the local Shiʻi community and its civic leaders— the *naqīb*s and sayyids—on the urban scene. While the modification of the shrine of Harun-i Vilayat and the Old Mosque manifested these messages at the city's core, the reconfiguration of the Naqsh-i Jahan Garden and its adjacent maydan created a new urban pole in the southwest of Isfahan. A bicentric urban structure, anchored by two maydans, had already formed in Isfahan in early Safavid times. When Shah Abbas embarked on developing the city, this dual nucleus set the stage for the launch of a grand building campaign.

FIGURE 13
Old Mosque of Isfahan, view of the inner wall of the southwestern iwan, with marble and tile decoration (dated 1531–32). Photo courtesy of Daniel C. Waugh.

Imperial Plans and Urban Elites

THE CONSTRUCTION OF ISFAHAN UNDER SHAH ABBAS

CHAPTER 2

The spectacular festival of lights and the nocturnal assembly of poets witnessed by Awhadi at the Maydan-i Harun-i Vilayat in the early 1590s are described extensively in the royal chronicles. According to the Safavid historian Natanzi, the people of Isfahan, during Shah Abbas's visit in the fall and winter of 1592–93, staged a dazzling display of lights, and masters of discourse (*arbāb-i sukhan*) extolled the night festival in heart-alluring verses (*naẓmhā-yi dilfarīb*). This was Shah Abbas's fourth journey to Isfahan since his accession in 1588. Having returned to the capital, Qazvin, from a failed military campaign, the shah set off for Isfahan with a select retinue, leaving the state dignitaries at the seat of the throne. The royal sojourn was fairly prolonged, lasting for three and a half months. The primary reason for Shah Abbas's visit, Natanzi writes, was his interest in the construction and planning (*ʿimārat va tartīb*) of Isfahan.[1]

The building projects commenced in the early 1590s heralded the onset of an immense campaign of urban development that in less than two decades created a metropolis extending far beyond the confines of pre-Safavid Isfahan. The foundation, in 1611, of the Shah Mosque marks the grand finale of these massive construction projects (fig. 14). Yet while the overall story of the making of Safavid Isfahan is fairly well known, key questions linger about the planning phases, construction chronology, and driving forces of the city's development. In particular, the nature and scope of the initial interventions in the Maydan-i Harun-i Vilayat, the primary locus of urban festivities and building activities in the early years of Shah Abbas's reign, remain hazy; it is unclear when and why the focus of construction shifted from this square to the Maydan-i Naqsh-i Jahan.

To a large extent, this ambiguity stems from the sources. The dearth of archival evidence (caused partly by the loss of Safavid chancellery records) has left court chronicles as the principal documentary sources on the construction history of Isfahan.[2] But official histories seldom deal with architectural projects, and their terse accounts of building activities are dispersed between narratives of military campaigns and royal banquets. The annalistic structure of court chronicles creates an additional complication, for this mode of narration is incompatible with the nature of grand architectural projects carried out over long stretches of time.[3] Still, the current gaps and discrepancies in the secondary literature arise not only from the primary sources but also from modern scholarly approaches. Poetic sources have rarely been consulted, for instance, and chronicles have been treated as transparent accounts with little consideration of their rhetorical aspects; even the verses embedded in these narratives have been glossed over as literary flourishes.

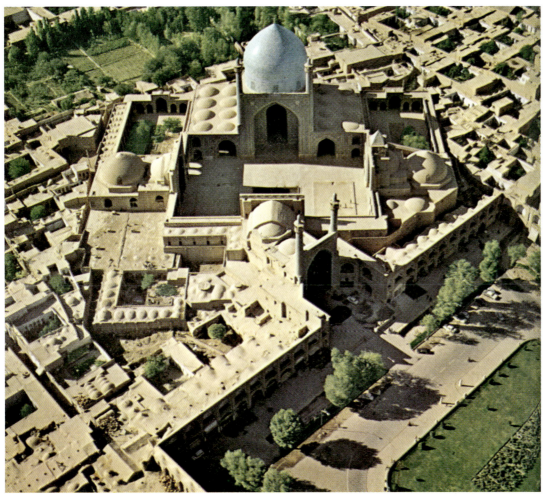

FIGURE 14

The Shah Mosque (Masjid-i Shah or New Congregational Mosque), Isfahan, ca. 1611–38. Photo by Henri Stierlin. From Henri Stierlin, *Ispahan: Image du paradis* (Geneva: Sigma, 1976), 84.

Building upon previous scholarship, this chapter offers a new textured narrative of the planning and construction of Isfahan in the late sixteenth and early seventeenth centuries.[4] Through scrutiny of evidence from untapped poetic, biographical, and historical sources, as well as fresh insights gleaned from the chronicles, my inquiry reveals that the building projects initiated in Isfahan in this period amounted to a concerted campaign with a remarkable degree of formal and social

integrity. More specifically, I argue that the three main components of Isfahan's urban plan—the Maydan-i Naqsh-i Jahan, the Chaharbagh, and the palace complex—were laid out concurrently in the mid-1590s, when the city was reconfigured and expanded to serve as the metropolitan seat of the Safavid state. Even so, this comprehensive plan came after a preliminary phase of development that lasted from about 1590 to 1595 and centered on the Maydan-i Harun-i Vilayat. A careful examination of political, social, and

commercial circumstances indicates that this two-phase development arose from the simple fact that not all aspects of the building projects issued from a singular royal vision. The imperial plans were contingent on shifting material and commercial conditions—at both local and global levels—and operated in a social matrix that affected the city's course of development.

A CITY WITH DUAL URBAN CENTERS: THE INITIAL PLAN

The accounts of expansive construction and renovations around 1591–92 imply that by that time a massive program of urban renewal was already underway in Isfahan. The earliest reference to architectural activity in Isfahan under Shah Abbas appears in the chronicle of Fazli Beg Khuzani, who recounts that during the shah's visit in the winter of 1590, he drew up "plans for buildings and gardens" (*ṭarḥ-i ʿimārāt va bāghāt*) while lodging in the Mahdi Edifice, the pavilion that had been erected under Shah Ismaʿil in the Naqsh-i Jahan Garden.[5] These plans must have comprised projects in and around the Naqsh-i Jahan Garden, for Natanzi notes that the estate had been damaged by a rebellious governor a few years prior.[6] Despite minor discrepancies in the chronicles, it is safe to conclude that a series of architectural and urban projects was launched in Isfahan in 1590, during Shah Abbas's first two successive sojourns.[7]

Mirza Beg Junabadi, who completed a chronicle of Safavid rulers in 1624, offers the most detailed account of this initial phase of construction. By his report, upon subjugating the disobedient governors of southern provinces in 1590, Shah Abbas—who had found Isfahan's "abundance of water, potential for urbanization, and countless population" agreeable to his "paradisal temperament"—turned his attention to the "planning and reconstruction" of the city. As his

first measure, the shah had the "maydan that lay in front of the Harun-i Vilayat shrine" enlarged so that it could be used for polo and mounted-archery contests.[8] Natanzi further notes that to prepare the maydan for these equestrian sports, it was leveled and then coated with sand.[9] Epigraphic evidence indicates that in 1590–91 repairs and additions were also made to the nearby Old Mosque, an undertaking probably linked to the building campaign in the square.[10]

In addition to revamping and enlarging the Maydan-i Harun-i Vilayat, the qaysariyya that stood on the north side of the plaza was refurbished. In his annals of the reign of Shah Abbas, the court astronomer (*munajjim*) Jalal al-Din Muhammad Yazdi cites a poem with a chronogram that dates the renovation of the Maydan-i Harun-i Vilayat to 1591–92. The verses describe how the filthy "maydan of Isfahan" became clean (*pāk*) and pleasant (*bā ṣafā*) after refurbishment, while another poem yields the same date for the renovation of the qaysariyya, characterizing it as a palace (*qaṣr*) reconstructed together with the "ruined maydan."[11] The swift completion of these projects is plausible, since they involved the restoration of dilapidated buildings rather than fresh construction, as the references to repairs and renovations in these poems imply.[12]

In the same period, concurrent with renovation work in the Maydan-i Harun-i Vilayat, new developments were instigated in the Maydan-i Naqsh-i Jahan. During a visit in the winter of 1590, Shah Abbas, according to Natanzi, besides "refurbishing all the old bazaars," issued an order "to erect a qaysariyya like the one that was located in Tabriz . . . and designed many shops and *chahār-sū*s [domed crossings at the intersections of market lanes]."[13] This passage is consistent with Yazdi's account stating that in November 1591 plans were prepared for "the maydan, the bazaar of Isfahan, and the qaysariyya."[14] Fazli also notes

that in 1591 the shah "drew up plans for a lofty edifice [*'imārat-i rafī'a*], the bazaar, the maydan, and the qaysariyya."[15] Although the two latter chroniclers report the planning of these projects as occurring a year later than Natanzi does, it seems that the three authors describe the same building campaign. Moreover, the mention of the preparation of plans (*ṭarḥ*) suggests that these descriptions concern not merely renovations of standing buildings but also new construction. This is confirmed by Fazli's note that in addition to preparing plans for new edifices, the shah had the "old qaysariyya" (*qaysariyya-yi kuhna*) demolished. Therefore, even though the chronicles do not specify the exact locations of the maydans and bazaar that were constructed or renovated, this statement suggests that a key component of the developments planned and begun around 1590— namely, the new qaysariyya—was undoubtedly located in the Maydan-i Naqsh-i Jahan.

A careful inspection of textual evidence thus indicates that the construction of the Maydan-i Naqsh-i Jahan (including its peripheral markets and qaysariyya) began around 1590. This means that the renovation of Isfahan's existing urban square (Harun-i Vilayat) and the construction of a new civic-commercial center (Naqsh-i Jahan) were initiated simultaneously as twin components of a single campaign of urban renewal. Moreover, considering the references made to the building of numerous shops and *chahār-sūs*, it is reasonable to assume that the renovation and construction of the covered market running between the old and new maydans (what is today known as the Grand Bazaar of Isfahan) was an integral part of the plan from the outset. The creation of these two poles of commerce would have incited further commercial development along the artery that linked them (fig. 15).

What prompted Shah Abbas to invest in the commercial infrastructure of Isfahan at this

time? Natanzi's allusion to the qaysariyya in Tabriz as the model for the new one in Isfahan hints at geopolitical factors. After referring to the shah's order for the founding of such a qaysariyya, Natanzi notes that the buildings were completed "in a short span of time" and that "Isfahan became a full-fledged city [*miṣr-i jāmi'*], so that Tabriz, in spite of its ample beauty and its numerous people of fine appearance and character, appeared like a despicable village in comparison."[16] This is certainly more than a mere rhetorical utterance. A major emporium of Eurasia since the fourteenth century, Tabriz was the first Safavid capital, and despite the transfer of the royal seat to Qazvin in the mid-1500s, it had remained prominent as the foremost metropolis of the empire. Yet the city had been seized by the Ottomans in 1585 and was officially ceded to them in the peace treaty signed in Istanbul in March 1590; the truce ended the prolonged war between the two states but forced the Safavids to relinquish a vast swath of their holdings in western Iran.[17] Elsewhere in his chronicle, Natanzi notes that upon taking Tabriz, Ottoman troops demolished its qaysariyya and other landmarks.[18] Although in 1603 Tabriz was finally wrested back from the Ottomans, in December 1590, when Shah Abbas founded a new qaysariyya in Isfahan, Safavid fortunes were anything but certain. Wrecked by a protracted civil war between factious Qizilbash tribes, some of the most strategic Safavid provinces (Khurasan and Azerbaijan) had been captured by the Uzbeks and Ottomans. Considering this geopolitical context, it appears that the development of Isfahan in this initial stage was primarily intended to create a new emporium—an alternative magnet for the commodities and merchants that had been dispersed in the aftermath of the Ottoman invasion. The investment in commercial infrastructure at this date also suggests that

FIGURE 15
Aerial view of Isfahan looking south, ca. 1935–37, showing the old city and the bazaar leading to the Maydan-i Naqsh-i Jahan, with the new Safavid developments appearing in the background. University of Chicago, Oriental Institute, Iran Aerial Photo: AE 53. Courtesy of the Oriental Institute of the University of Chicago.

promoting trade through state mercantilism was an integral part of Shah Abbas's policy from the outset of his reign.

Compared with the refurbishment of the long-established Maydan-i Harun-i Vilayat, the development of the Maydan-i Naqsh-i Jahan required significantly more fresh planning. Even so, the square itself was not an entirely new creation. As noted, an open-air plaza of uncertain form appears to have adjoined the Naqsh-i Jahan

Garden since at least the early sixteenth century, when the estate was redesigned under Shah Isma'il. During the 1590s, while the construction of the Maydan-i Naqsh-i Jahan was still in progress, Shah Abbas continued to use the recently refurbished Maydan-i Harun-i Vilayat for public ceremonies and equestrian exercises. In 1591–92, for instance, the festival of lights was held in the Maydan-i Harun-i Vilayat, and in 1600–1601 the shah played polo there.[19] After the

inauguration of the Maydan-i Naqsh-i Jahan, in 1602, however, no royal event is reported to have taken place in Isfahan's old square.

In their accounts of the construction of Isfahan, court chronicles expectedly underscore imperial plans and actions. Yet the same sources betray that in implementing his plans, the shah had to collaborate—and contend—with the city's notables. Among these urban elites, Mirza Muhammad Amin, the *naqīb* (hereditary chief of the sayyids) of Isfahan, was a particularly influential figure.[20] Historically, *naqīb*s were closely linked to guilds and crafts and thereby played a key role in the economic and artisanal activities of medieval towns.[21] During the sixteenth century, owing to deepening ties with the Safavid ruling household (bolstered by marriage alliances, tax remissions, and stipends), the influence and riches of Isfahan's leading sayyid families had grown considerably: they now acted as de facto civic leaders.[22] The surging affluence of these patrician families was particularly manifest in their living quarters, Husayniyya. Located to the north of the Old Mosque and named after Imam Husayn (the third Shiʿi imam, to whom the sayyid/*naqīb* families residing in that quarter traced their lineage), Husayniyya contained the city's loftiest residences.[23]

Considering this background, it is no surprise that a notable such as Muhammad Amin was a major actor in urban affairs.[24] According to Fazli, he was among the provincial dignitaries who journeyed to Qazvin to congratulate Shah Abbas on his accession. Moreover, in 1590, at the urging of Muhammad Amin and another notable, Shah Abbas issued an order that "the people of Isfahan demolish the Tabarak Fortress."[25] Iskandar Beg, who recounts this occasion in detail, states that the shah decreed the destruction, despite his own belief, for the sake of "pleasing Isfahan's inhabitants."[26] Although

this order was likely never carried out, the anecdote signals that the local elite could mobilize the city's populace and had a say in urban transformations. More important, Junabadi asserts that Muhammad Amin was, among Isfahan's notables (*aʿyān*), one of the proprietors of markets (*asvāq*) and estates (*mustaqillāt*), who were "suspicious that [by renovating the city's markets] the shah intended to gain possession of their commercial holdings."[27] In Junabadi's account, this opposition eventually prompted Shah Abbas to give up on refurbishing the old city markets.

These accounts not only hint at the wealth, stature, and influence of the urban elites of Isfahan but also imply that the urban-renewal projects begun in 1590 had been launched, at least in part, on the initiative of local notables; the latter probably sought to take advantage of the young king to promote their own mercantile interests and those of the urban community they represented. It is no coincidence that in Junabadi's narrative of the refurbishment of the Maydan-i Harun-i Vilayat, the involvement of the people of Isfahan (*Iṣfahānīyān*) is highlighted. This emphasis contrasts with the descriptions of the construction of the Maydan-i Naqsh-i Jahan, which commonly refer to the recruitment of masters of the arts and architects from across the Safavid realm rather than to the city's indigenous populace.[28]

Careful scrutiny of the sources sheds new light on the nature, scope, and social dynamics of the first phase of Isfahan's development. The building projects initiated around 1590 were anchored on two urban nuclei: while the Maydan-i Harun-i Vilayat and its nearby qaysariyya and markets were renovated, the maydan that adjoined the Naqsh-i Jahan Garden was planned as a mercantile center featuring another qaysariyya. The renovation of the Maydan-i

Harun-i Vilayat and its markets does not mean, however, that Shah Abbas intended to establish his headquarters there. Rather, from the outset, the Naqsh-i Jahan Garden and its adjoining maydan were to be the epicenter of royal presence and patronage. Overall, it appears that the ultimate objective of urban renewal was to turn Isfahan into a mercantile hub by upgrading and expanding its commercial infrastructure. Supported by local notables, the renovation projects in the Maydan-i Harun-i Vilayat were completed fairly swiftly, while the building of the Maydan-i Naqsh-i Jahan was still underway. Soon afterward, though, Isfahan's development took on a different character.

ENVISIONING THE IMPERIAL CITY

Despite the awe that Isfahan aroused in visitors such as Awhadi, there was nothing extraordinary about the first phase of its development. Building activity was confined to the boundaries of the walled city, and except for minor additions to the Naqsh-i Jahan Garden, the projects were primarily commercial. Construction was a local affair too and partly prompted by urban elites. The initial vision was ostensibly based on the notion of a symbiosis between a preexisting commercial center (Maydan-i Harun-i Vilayat) and a new state-sponsored mercantile complex (Maydan-i Naqsh-i Jahan). In the same period, Shah Abbas made several architectural additions in cities such as Qazvin, Natanz, and Herat, and the construction projects in Isfahan, while somewhat unique in their commercial function, were not the sole focus of imperial patronage.[29]

Sometime between 1594 and 1596, however, an urban plan of far grander scale was envisioned: the renovation of the old city center was halted, the Maydan-i Naqsh-i Jahan assumed a new form and character, and, more significantly, expansive developments were planned in the southern environs of Isfahan. Within a fairly short period, these building campaigns gave rise to a metropolis that was unprecedented in the magnitude of its planning, the harmony of its urban spaces, and the splendor of its civic and religious monuments. In 1590 Isfahan was a town bounded by its centuries-old walls; by the 1610s it had morphed into an unwalled sprawling city with a verdant urban landscape.

There can be little doubt that all these developments were carried out with the intention of establishing the Safavid capital in Isfahan, to which the seat of government was officially transferred in 1597–98.[30] A range of pragmatic considerations propelled the capital's relocation, as noted previously and further explained below. The planning of the imperial city is also significant for the dual urban structure that it precipitated. In his account of the construction of Isfahan, written in 1617, Junabadi notes that "now they call the former Isfahan [*Iṣfahān-i sābiq*] the old city [*shahr-i kuhna*] and the [recently developed] districts and residences the new city [*shahr-i naw*]."[31] Within less than two decades, the long-standing medieval town became a mere component of an expansive urban system. An old city, fixed in the past, was engendered along with the new Isfahan. In an all-encompassing approach to urban planning, the city's new developments, existing urban fabric, and natural environment were planned in concert to form a metropolis.

PLANNING THE NEW ISFAHAN AND ITS MAYDAN

Although the sources do not explicitly speak of an overarching urban scheme, the concurrent launching of several architectural and urban projects signals that they constituted a cohesive master plan. The inception of this new phase is most clearly related by Fazli, who notes that in 1594, Shah Abbas:

drew up the plan [*ṭarḥ*] for the Chaharbagh together with the Guldasta edifice. In this journey, his highness brought [the Shiʿi cleric] Shaykh Lutfallah from Qazvin to Isfahan, and a plan was prepared for an elevated and richly ornamented mosque opposite the lofty gateway of the royal residence [*ālā qāpū-yi dawlatkhāna*]. . . . The qaysariyya and the four markets [*chahār bāzār*], which had been founded beforehand, were half-finished [*nīma-kār*]; new designs [*bāz-ṭarrāḥīhā*] came to the mind of the noble one. And they designed a bathhouse [*ḥammām*] in the Guldasta [Garden].[32]

The leitmotif of this account is the term "design" (*ṭarḥ, ṭarrāḥī*), which is used in reference to varied building projects: a tree-lined avenue bordered by gardens (Chaharbagh), a royal pleasance equipped with a pavilion and bathhouse (Guldasta), and a mosque built in honor of a Shiʿi cleric (Shaykh Lutfallah Mosque). A study of the urban configuration of these projects reveals that they surrounded the Naqsh-i Jahan Garden, which was redesigned to serve as the royal residence, or *dawlatkhāna* (literally, "house of state"): the Chaharbagh ran along its western flank; the Guldasta Garden abutted its southern border; and the Shaykh Lutfallah Mosque lay opposite the Ali Qapu, the "lofty gateway" of the palace complex. In this passage the design of the Chaharbagh signals the expansion of building activity beyond the confines of the walled city.

Fazli's account is remarkable for the new insights it provides into the trajectory of developments in the Maydan-i Naqsh-i Jahan (fig. 16). The most intriguing information in this regard is the "half-finished" status of the qaysariyya and the "four markets" around the square. By this account, these projects were only partially completed by around 1594, when "new designs"

FIGURE 16
Plan of the Maydan-i Naqsh-i Jahan: (1) Shah Mosque; (2) Shaykh Lutfallah Mosque; (3) Mulla Abdallah Madrasa; (4) Ali Qapu; (5) Tawhidkhana (Sufi chantry); (6) qaysariyya portal. Plan by author.

occurred to the royal mind.[33] This passage confirms that the construction of the Maydan-i Naqsh-i Jahan (including its surrounding markets and the qaysariyya) had already begun in the early 1590s as part of the initial plan for the development of Isfahan. Moreover, the mention

FIGURE 17
Axonometric view of the arcades of the Maydan-i Naqsh-i Jahan, showing the two stages of construction. Model and rendering by Jessie Li and Shree Kale.

of new designs provides a more plausible chronology for the two-phase development of the Maydan-i Naqsh-i Jahan suggested by Eugenio Galdieri, whose study of the physical fabric of the maydan's peripheral arcades revealed that they were constructed in two stages: in the first phase, a one-story arcade fronting a single row of stores encircled the plaza; an additional ring of shops facing the plaza and an upper-level tier of balconied chambers (*bālākhānahā*) were added during a second stage of construction (fig. 17).[34] These additions created what Yazdi calls a "double-sided market" (*bāzār-i du-rūya*), featuring an additional row of stores that also opened directly onto the maydan.

In his pioneering work, Robert McChesney has proposed a chronology for this two-phase development, concluding that in the first phase, finished before 1595, the maydan was primarily intended for ceremonies and equestrian exercises, and that in the second phase, completed by 1602, the plaza took on a commercial character.[35] New evidence makes it possible to refine the sequence and nature of the building work in the Maydan-i Naqsh-i Jahan. First, the reference to "new designs" (*bāz-ṭarrāḥīhā*) suggests that the inception of the second phase can be dated to the mid-1590s rather than about 1602. The latter date marks the time when the maydan and its shops were inaugurated, and it is implausible that such a massive project should have commenced in the same year. Moreover, it can be seen that the maydan was designed as a commercial center from the outset; the plaza already featured a qaysariyya and a row of shops fronted by a single-story arcade.[36] The major shift that occurred in the second stage was an amplification of the maydan's commercial (and revenue-generating) capacity by the addition of a second ring of stores and of upper-floor chambers, which provided lodging for merchants (*tujjār*) and artisans (*ahl-i ḥirfa*).[37]

And yet, a study of other elements of the maydan indicates that the new designs involved more than a mere augmentation of trading spaces. In particular, the idea of encircling the plaza with a pedestrian walkway was probably part of the same campaign, motivated by the construction of the outward-looking shops. Paved with cobbles and raised above the ground, this walkway was originally demarcated from the sand-covered ground of the plaza by a stone-edged water channel (fig. 18), which Safavid chronicles describe as a "massive stream" (*nahr-i ʿaẓīm*) resembling "the stream of paradise" (*salsabīl*).[38] The two-meter-wide channel was lined with a row of regularly planted trees—plane trees (*chinār*) alternating with willows (*bīd*) or elms (*nārbud*)—that separated the walkway from the square.[39] These natural and masonry elements were harmoniously arrayed: the equidistant shady trees mirrored the modular configuration of the arcades; the rhythmic arrangement of the trees and the flow of water in the channel echoed and enticed pedestrian movement around the square. The walkway bestowed a human scale on the massive plaza, while the stream integrated a pleasant sensual quality—a reflecting surface, the sound and sight of flowing water—into the stern, sand-covered space of the maydan. This engendered an utterly new way of experiencing a marketplace. If the "four markets" evoked the traditional vaulted bazaars of the old town, strolling on the shaded, shop-fronted walkway of the maydan was akin to the experience of the Chaharbagh and the tree-lined avenues of the new Isfahan.

In addition to these landscape elements, the now-lost paintings that reportedly graced the maydan's peripheral walls were probably created in tandem with the construction of the two-story arcades. Natanzi notes that in 1595 masters of the crafts (*arbāb-i ḥirfat va aṣḥāb-i ṣanʿat*), art

FIGURE 18
View of the Maydan-i Naqsh-i Jahan with the water channel that ran around the square. Detail of a photograph by Ernst Höltzer, ca. 1880s. The poplar trees seen here were late nineteenth-century additions. In Safavid times a row of trees bordered the other edge of the channel to provide shade for the paved walkway. Photo provided by the Cultural Heritage Organization of Iran, Tehran.

practitioners (*hunarmandān*), and geometer-architects (*muhandisān*) were assembled in Isfahan; "the maydan's peripheral walls and buildings, which were of varying heights (*past u buland*), were leveled and smoothed," and dexterous painters covered those walls with "pictures of wondrous creatures and marvelous beings."[40] Natanzi's mention of the leveling of the maydan's vertical surfaces corroborates the hypothesis that the "new designs" noted by Fazli involved the remodeling of the peripheral arcades. The reference to an assembly of artisans and artists confirms that an architectural campaign on a grander scale was initiated in the mid-1590s.

In the new form of the maydan, one can also discern a certain theatricality, which distinguished it from the urban squares of the preceding centuries. Natanzi captures this theatricality

in his vivid description of a performance that occurred in 1596, shortly after the completion of the maydan's perimeter: first, four artificial gardens—with trees made of wood, flowers fashioned from colorful fabrics, and fruits cast from wax—were laid out in the four corners of the maydan; then, as night fell, elaborate fireworks were set off, and a mock battle was staged between Uzbek and Safavid armies stationed in four castles, each filled with one hundred puppets of soldiers; finally, cannons were fired and the castles were set alight, covering the sky with smoke and dust.[41] Filled with spectators, the upper-floor balconies served as viewing places (*manẓar*) on such festive occasions.[42] Those who occupied the balconies were not just onlookers but part of the pageantry as well. During a 1611 celebration, for instance, Shah Abbas ordered that the rooms above the shops be allocated to the city's courtesans (*favāḥish-i shahr*) so that the latter would cover the floors with carpets, bring in good singers, and proceed to drink wine, dance, and play games.[43] For these ceremonial events, the maydan's arcades would have been decked out in colorful textiles and carpets, enlivening the square with bright hues. The double-storied arcades not only augmented the square's sense of spatial enclosure but were crucial to establishing the maydan's role as a stage for urban spectacles.

THE SACRED AXIS OF THE MAYDAN

Encircled by markets and anchored on its northern side by the qaysariyya, the Maydan-i Naqsh-i Jahan, in its initial phase of construction, was primarily a commercial complex. But in the revised plan of the mid-1590s, this mercantile ensemble was complemented by two facing monuments: the Shaykh Lutfallah Mosque and the Ali Qapu (fig. 16). In the first stage, the Ali Qapu was a fairly modest two-story entry to the Naqsh-i Jahan Garden. In the second phase, however, a lavishly decorated reception hall was raised above the gateway.[44] The additional block provided the maydan with a royal viewing loggia crowning the balconies that encircled the square (fig. 19). A hitherto unnoticed poem with a chronogram indicates that the Ali Qapu's top floor, the so-called music room, was erected in 1607–8, shortly after the maydan's inauguration in 1602.[45] Writing in 1615, Iskandar Beg thus described the Ali Qapu as the "five-story gateway of the dawlatkhana."[46] A multifunctional edifice, the Ali Qapu was also a site where the affairs of the state and the administration of justice were conducted.[47]

Fazli's account suggests that the construction of the Shaykh Lutfallah Mosque (fig. 20) also began in the mid-1590s, together with the remodeling of the maydan and the erection of the reception hall atop the Ali Qapu. Featuring a forecourt revetted in glazed tiles and a brick dome adorned with interlaced scrolls, the mosque was conceived as a house of worship where the eponymous jurist Shaykh Luftallah al-Maysi al-Amili (d. ca. 1622) taught, lived, and led the Friday and daily congregational prayers. According to Fazli, Shah Abbas asked the shaykh to oversee the construction of the mosque, set the stipend for worshippers and ascetics, and perform the Friday prayer and other religious duties (*farāʾiż*) upon its completion.[48] This information is corroborated by an allusion in a theological tract penned by Shaykh Lutfallah to the shah's intention to build a congregational mosque for the cleric.[49] These sources, as well as the mosque's formal precedents and epigraphy, do not support the assumption that the Shaykh Lutfallah Mosque functioned as a royal "chapel-mosque" or a "private mosque for the royal household."[50] Rather, the dome chamber of the mosque can be more accurately described

as the worship hall of a socioreligious complex that included a madrasa and also catered to the transplanted Shi'i community attached to the Safavid state; the Turkic Qizilbash (*al-atrāk*) and *ghulāms* (*al-ʿabīd*) are named in Shaykh Lutfallah's tract as the groups that would benefit from visiting the mosque.[51] Here this congregation would be indoctrinated in the normative beliefs and practices of Shi'ism under the care of the clerical establishment.[52]

Within the space of the maydan, the mosque's positioning opposite the gateway of the palace complex signaled the deepening of ties between the Safavid polity and a class of Twelver Shi'i clerics, like Shaykh Lutfallah, who hailed from the Arabic-speaking regions

of the Ottoman Empire.[53] Yet the pairing of the Ali Qapu and the Shaykh Lutfallah Mosque did not signify a strict dichotomy between the secular and religious spheres, for the Ali Qapu also marked a sacred locus. The sources reveal that the palace gateway contained an inviolable threshold, a sanctified relic from a Shi'i shrine that was venerated by the populace. Moreover, beyond the Ali Qapu stands a polygonal domed structure known as the Tawhidkhana (Hall of Unity), which was dedicated to the performance of the Sufi ritual of *zikr* (literally, "remembrance," a form of prayer that involves incessant chanting of a litany). Home to Sufi disciples, who also served as royal bodyguards (*qūrchī*) and wardens of the Ali Qapu, the

FIGURE 19
Reconstructed view of the Ali Qapu as completed in ca. 1608, before the addition of the *tālār* (pillared hall) in the 1640s. The Tawhidkhana is shown in the background. Model and rendering by Jessie Li and Shree Kale.

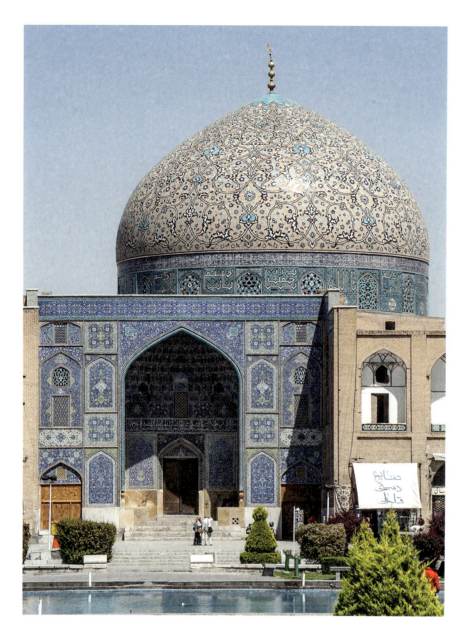

FIGURE 20
Shaykh Lutfallah Mosque, view of
the portal and dome. Photo cour-
tesy of Daniel C. Waugh.

intended to host and fashion. From the chant-
ing of the Sufis to the sacred threshold of the Ali
Qapu to the ornate worship hall of the Shaykh
Lutfallah Mosque, devotional experiences were
mediated through a panoply of rituals, sounds,
objects, and texts. Carefully choreographed in
space, these affective and material emblems
of spirituality blended mystical and normative
forms of piety to create a sacred realm strad-
dling imperial and religious spheres. Prayer at
the Shaykh Lutfallah Mosque was only one ele-
ment of this variegated religious landscape.

THE RISE OF THE NEW CITY, THE ECLIPSE OF OLD ISFAHAN

On the broader urban scene, the construction
of the Maydan-i Naqsh-i Jahan as the new civic
heart of Isfahan came at the expense of the old
city center. Junabadi offers the most detailed
account of the causes and circumstances of
this strategic shift in planning. In his telling,
Shah Abbas originally intended to develop the
Maydan-i Harun-i Vilayat, but the opposition of
notables such as Muhammad Amin, who were
suspicious of the royal intentions, led the shah
to pursue a different course of action.[55] As noted,
Fazli reports that Shah Abbas even had the old
qaysariyya, which had been renovated earlier,
demolished.[56] Further evidence for the concep-
tion of the Maydan-i Naqsh-i Jahan as a replace-
ment for the old city square is provided by Yazdi,
who reports that upon the former's comple-
tion in 1602, the tradesmen (*ahl-i bāzār*) of the
Maydan-i Harun-i Vilayat relocated to the new
plaza.[57] The equilibrium that underlay the initial
vision was relinquished as Shah Abbas asserted
his absolute dominance over mercantile affairs.
It was in this period that the Maydan-i Harun-i
Vilayat became known as the Old Maydan.

That the Maydan-i Naqsh-i Jahan managed to
sideline the Old Maydan and function effectively

Tawhidkhana embodied the mystical lineage
of the Safavid dynasty and remained in use
throughout the seventeenth century.[54]

Encompassing Sufi and Shiʿi forms of piety,
the sacred axis of the Maydan-i Naqsh-i Jahan is
emblematic of the diverse spiritual experiences
that the urban design of Safavid Isfahan was

as Isfahan's principal plaza was due not just to its formal or functional components but also to its central location within the city's emergent spatial configuration. Adjoining the Safavid palace complex, the square now served as a royal arena and the symbolic heart of the empire. Meanwhile, with the development of extramural gardens and residential quarters, the new maydan became the focal point of the rising metropolis, a meeting zone between the old and the new Isfahan. The pivotal position of the Maydan-i Naqsh-i Jahan further marginalized Isfahan's old city center in the emerging urban system.

The dates given in the sources for the onset of the extramural projects confirm that they were planned concurrently with the remodeling of the Maydan-i Naqsh-i Jahan. All the chronicles date the layout of the Chaharbagh to the mid-1590s; a half-verse quoted by Yazdi yields the year 1005 H (1596–97) for the design (*ṭarḥ*) of the promenade, while another poem suggests that the construction of the Allahverdi Khan Bridge, at the intersection of the Chaharbagh and the Zayanda River, was launched in the same year.[58] The Hizar Jarib Garden, too, was laid out together with the Chaharbagh; another chronogram gives the year 1006 H (1597–98) for the digging of a canal to bring water to this garden.[59] Overall, the dates offered in the sources for the design or commencement of building work on the Chaharbagh, the Maydan-i Naqsh-i Jahan, the palace complex, and their components range from 1594 to 1597. These discrepancies, however, are not a major concern, for the authors either summarized or reported the building projects in the annal of a specific year or else referred to the moments of envisioning a project, preparing the design, or initiating construction. A careful inspection of the sources thus confirms that the major elements of the new Isfahan were planned synchronically

in the mid-1590s as integral components of a concerted campaign. The conception of a new urban plan for Isfahan undoubtedly coincided with the transfer of the Safavid capital.

And yet, despite the eventual triumph of the royal will, the construction trajectory of Isfahan demonstrates that a broader range of factors were influential in the shaping of the cityscape. To conceptualize the urban plan of Isfahan as the act of a single man and a pure creation of the shah's mind—as the chroniclers would have us believe—is to lose sight of the agency of the individuals, communities, and materials that were crucial to the formation of the built environment. Indeed, it is likely that the city's community leaders prompted the idea of a massive program of urban renewal centered on commercial infrastructure, even though these local stakeholders were eventually sidelined during the realization of the idea. Through their participation and resistance, the notables of Isfahan played a part in the gestation of new conceptions and forms of urban development.

In the closing months of 1602, the building projects planned and begun in the late sixteenth century were nearing completion. According to Yazdi, on November 12, 1602, the Maydan-i Naqsh-i Jahan was inaugurated at an auspicious hour, and the tradesmen of the Maydan-i Harun-i Vilayat moved to the new plaza.[60] Yazdi attributes the design of the entire complex to a single geometer-architect (*muhandis*), whom he hyperbolically praises as an unparalleled and innovative designer but whose name he does not mention. The qaysariyya, too, was inaugurated around the same time—definitely before 1604, when an exhaustive endowment deed (*vaqfnāma*) was drawn up for the qaysariyya and the maydan's commercial complex.[61] Epigraphic evidence indicates the tile-clad forecourt of the Shaykh Lutfallah Mosque had also been partially

completed by around 1602.[62] Following the official opening of the maydan, the shah urged the swift completion of the Chaharbagh and its pavilions, which were finished on December 26, 1602. Yazdi recounts that the shah spent the evening of the Chaharbagh's opening in a coffeehouse, where he composed a poem with a chronogram yielding the year 1011 H (1602–3) for the completion of a Sufi hostel (*takiyya*) that lay along the promenade.[63] This implies that the main public edifices of the Chaharbagh—namely, the coffeehouses and Sufi convents—had been completed by this date. The two grand urban spaces of the new Isfahan—the Maydan-i Naqsh-i Jahan and the Chaharbagh—were now open to the public, though work on individual buildings lasted for another decade or so.

THE IMPERIAL SANCTUARY

The Shah Mosque (fig. 14), the last and most splendid work of architecture that Shah Abbas commissioned in Isfahan, is perhaps the only major monument of the capital that was purported primarily to project imperial might. Founded in 1611, two decades after Isfahan's development had begun, this spectacular sanctuary was erected at a time when the political realities of the Safavid realm were drastically different from those of the early 1590s. After years of victorious campaigns, Isfahan was now the seat of an expansionist state rivaling the neighboring Ottoman and Mughal Empires. Soaring above the royal plaza, the turquoise-tiled minarets, iwans, and dome of the Shah Mosque monumentalized the cityscape, endowing the new Isfahan with a majestic profile commensurate with its newly acquired status as the metropolitan capital of a reinvigorated Safavid empire.

As a monument that at once celebrated and capped two decades of relentless architectural campaigns, the Shah Mosque conveyed a range of messages through its urban setting and its architectural scheme, decoration, and epigraphy. Erected on the south side of the Maydan-i Naqsh-i Jahan, it completed the design of the square by enhancing its sense of visual harmony and aesthetic balance; the maydan now featured two pairs of symmetrically arranged structures, granting it the appearance of a massive courtyard with cross-axial iwans (fig. 21). Interestingly, Fazli cites only the absence of an edifice opposite the qaysariyya as the motive for the erection of the new congregational mosque: "there was a mosque opposite the Ali Qapu for the teaching of Shaykh Lutfallah," he notes, "but no counterpart [*qarīn*] existed for the qaysariyya."[64] The five-sided recess in front of the mosque's entrance, dominated by an enormous iwan, in fact mirrors the forecourt and iwan of the qaysariyya on the north side of the plaza.

On the broader urban scene, the Shah Mosque was also conceived as a counterpart to the Old Mosque. Lavishly decorated and capable of hosting a large congregation, it was certainly meant to outshine—and supersede—Isfahan's age-old sanctuary as the primary locus of Friday prayer. The competition between the city's old and new religious edifices is attested by the sources. Chardin reports, for instance, that before the discovery of a quarry, Shah Abbas intended to transfer the marble panels of the Old Mosque to the Shah Mosque.[65] Likewise, in his above-mentioned tract, Shaykh Lutfallah castigates the city's traditional elites, including the son of Muhammad Amin (who had apparently inherited his father's mantle as *naqīb*), for questioning the congregational status of the mosque that Shah Abbas had built in his honor.[66] Socially and spatially, Isfahan's new religious foundations were conceived and perceived in opposition to the city's long-standing pious center and its affiliated notables.

FIGURE 21
Pascal Coste, view of the Maydan-i Naqsh-i Jahan, with the Ali Qapu (right), Shah Mosque (center), and Shaykh Lutfallah Mosque (left). Bibliothèque de l'Alcazar, Marseille, MS 1132, fol. 14.

With regard to its architectural form and decorative program, the Shah Mosque was also a conscious response to the iconic Friday mosques of Timurid times. Built on the four-iwan scheme—consisting of a courtyard surrounded by four axial iwans, a sanctuary dome on the qibla side, and two small-scale domes behind the lateral iwans—the mosque's overall blueprint reached back to the eleventh century. In its particular form, however, it was modeled after the Friday Mosque of Samarqand (Bibi Khanum Mosque), built in the early fifteenth century.[67] Through this reference the Shah Mosque evoked the imperial charisma of Timur and the aesthetic sophistication associated with the patronage of Timurid princes.

As a religious foundation officially dedicated to the performance of the Friday prayer service,

the Shah Mosque enhanced the image of the Safavid capital as an Islamic city. It thus represented the Shi'i empire as a veritable Islamic polity, especially in the eyes of the Ottomans, whose state-sponsored Sunni clerics had frequently branded the Safavid Shi'i creed a heresy for allegedly abandoning the Friday prayer.[68] Nevertheless, even in a religious monument such as the Shah Mosque, material benefits were by no means absent. With its extensive endowed properties, the mosque was also meant to stimulate commerce, channeling the revenue from agricultural lands to Isfahan's imperial center, and eventually to the royal coffers.[69]

THE IMAGE AND FUNCTION OF A CAPITAL CITY

While the initial phase of Isfahan's development was driven primarily by commercial interests,

the conception of a grand urban plan in the mid-1590s and the construction of monuments such as the Shah Mosque no doubt arose from a complex set of impulses and can be interpreted from different angles. In one strand of scholarship, Isfahan's urban plan reflects the emerging religious and political agendas of the Safavid state under Shah Abbas. According to this narrative, the Safavid state was in desperate need of restructuring itself, and Isfahan offered a unique site for crafting a new form of political legitimacy fashioned through a synthesis of normative Shi'ism with age-old traditions of Persian kingship.[70]

The timing and circumstances of the imperial master plan and the transfer of the capital lend a measure of credence to this interpretation. In the late sixteenth century, Safavid dominions were not only riven by civil infighting and foreign incursion but were also embroiled in a spiritual crisis spurred by the rise of the Nuqtavi movement. Denounced as heresy by mainstream Shi'i clerics, Nuqtavism was an agnostic sect originally formed in the fifteenth century as part of a pan-Islamic millenarian wave. Upholding a cyclical cosmology, the Nuqtavis maintained that the advent of the Islamic millennium in 1591–92 would precipitate a new prophetic cycle, which would conclude the mission of Muhammad, abolish Arab dominance, and revive Persian authority.[71] In the latter half of the sixteenth century, a charismatic Nuqtavi leader named Darvish Khusraw attracted a substantial following in the capital, Qazvin. Meanwhile, Yazdi presaged an inauspicious planetary conjunction, prompting the shah to be cautious. Hence, in July 1594, Shah Abbas abdicated the throne for three days, and a Nuqtavi disciple, in a sham coronation, was enthroned to fend off the impact of astral forces; Darvish Khusraw and other leaders of the group were then detained, tried, and executed.

In this narrative Isfahan was constructed as a millennial city to augur a new era of Safavid rule, the capital of a divine kingdom wherein the messianic rhetoric and folk piety of early Safavid times was to give way to a new sociopolitical order bolstered by a legalistic narrative of Shi'ism. According to Fazli's account, Isfahan's urban plan was envisioned in late 1594, shortly after the eradication of the Nuqtavi movement. Fazli also names Shaykh Lutfallah, in whose honor the shah built an exquisite mosque in Isfahan, as one of the jurisconsults (s. *mujtahid*) who presided over the inquisitorial trial that condemned the Nuqtavi leaders. The promotion of a cleric through such lavish architectural patronage no doubt signals a turn toward orthodox Shi'ism.

Even so, in endorsing the official religious establishment in tandem with creating a centralized imperial apparatus, Safavid policy does not present an exception. Institutionalized sectarian religion was a cornerstone of imperial power in several other territorial states that emerged across Eurasia in the early modern age (England and Spain are comparable European cases). Moreover, it would be misleading to describe this moment as an absolute triumph of normative Shi'ism and a wholesale rupture with other forms of religiosity. Although one can discern expansion in the state patronage of the clerical establishment in the Isfahan phase of Safavid rule, Alid loyalty (the devotional veneration of Imam Ali) remained central to the imperial persona that Shah Abbas cultivated throughout his reign. In his chronicle, Yazdi repeatedly refers to the king as "the dog of Ali's threshold." To display his personal devotion to the cult of the Shi'i imams, Shah Abbas also performed a pedestrian journey from Isfahan to Mashhad to visit the holiest site of the Safavid territories: the shrine of Imam Riza (the eighth Shi'i imam).[72]

It even appears that Shah Abbas was initially swayed by Nuqtavism, and his attraction to the movement suggests that the political aspirations of the Nuqtavis, rather than their presumably heretical beliefs, led to their suppression.

A careful reconstruction of the sacred topography of Isfahan also reveals that the city was deliberately designed to host diverse pious practices under the rubric of Twelver Shiʿism. The construction of the Tawhidkhana, for one, signals that the dynasty did not wish to disengage itself from its Sufi heritage. Further, antinomian dervish groups received lavish imperial patronage in Isfahan; one of the twin monumental Sufi hostels that Shah Abbas built on the Chaharbagh (and personally inaugurated in 1602) was dedicated to Haydari dervishes, who openly engaged in transgressive social behaviors.[73] As a system of beliefs and practices, Shiʿism was espoused—in the full gamut of its lay and intellectual dimensions—to create a cohesive society and variegated spiritual experiences.

Nevertheless, the disproportionate attention that modern scholarship has paid to the religious and doctrinal aspects of early modern Iran does not paint a balanced picture of the Safavid society and polity and its transformations over the course of the sixteenth and seventeenth centuries. From a broader perspective, cultural systems and spiritual discourses appear as mere overlays atop the shifts in material conditions that were the main driving forces of societal and political transformation. As the chronology of Isfahan's development reveals, Isfahan was, for the Safavid polity, first and foremost an emporium, an economic apparatus for generating wealth and swelling imperial revenues. Under Shah Abbas and his successors, Isfahan not only served as the hub of a territorial mercantile infrastructure but was also planned as a center of production: silken textiles, knotted-pile carpets, and glazed ceramics were manufactured in centralized workshops for domestic consumption as well as an increasingly global market. And a few years after completion of his construction endeavors in Isfahan, Shah Abbas established a monopoly on the production and export of silk, the chief merchandise of Safavid territories, whose principal market and center of exchange lay in Isfahan.[74] Equally, if not more, fundamental to the spatial conception of Isfahan—and bolstering its mercantile function—was its social landscape: a carefully planned network of civic spaces, sensuous gardens, and pleasurable venues that, as I hope to demonstrate, enticed an elaborate culture of public entertainment. More than a religious center, Isfahan was a global entrepôt and a locus of cosmopolitan social existence.

Across early modern Eurasia, regardless of the religious affiliation of the ruling household, constructing a cosmopolitan capital was central to solidifying territorial empires. From Madrid to Istanbul to Delhi, capital cities were consciously designed, expanded, or reconfigured to reinforce and embody the emerging imperial states.[75] In the late sixteenth century, the Safavids could draw inspiration from various imperial projects in the neighboring regions. Having conquered Constantinople in 1453, the Ottomans had turned the former Byzantine capital into a majestic city adorned with spectacular monuments and inhabited by a cosmopolitan populace.[76] Between 1571 and 1585, the Mughal emperor Akbar (r. 1556–1605) likewise set up a new capital city, Fatehpur Sikri, where a utopian, ecumenical society was to be represented.[77] In the same period, the city of Bukhara, the capital of the Shaybanid Uzbek rulers in western Central Asia, was embellished with majestic religious and commercial monuments, especially under the rule of Abdallah Khan (r. 1557–98).[78]

The Indo-Islamic polities that dominated the Deccan (south-central India) also constructed geometrically planned capital cities such as Hyderabad and Nauraspur to serve as their seats of power.[79]

The construction of Safavid Isfahan as the headquarters of a centralized, mercantilist, and territorial state falls within these regional and global patterns. Clearly, what Isfahan's urbanism strove to create was not a royal seat inhabited by nobles and grandees alone but a cosmopolitan metropolis. Rather than build an entirely new city from scratch, Shah Abbas selected the largest urban settlement in the heart of the Safavid realm, augmented its civic spaces and neighborhoods, and populated it with mercantile communities of various ethnicities and origins. Creating a metropolitan capital like Isfahan was particularly crucial for the Safavids, since the dominions that the rulers controlled were relatively deficient in human and natural resources, particularly in comparison to the larger and more prosperous Mughal and Ottoman Empires. Even if the Safavid territories on the Iranian plateau were barren, sparsely inhabited, and religiously homogeneous, Isfahan was monumental, verdant, and cosmopolitan.

A GLOBAL EMPORIUM

Focusing on the two decades that spanned the year 1600, the foregoing discussion has reexamined the construction history of Safavid Isfahan, assessing the motives, phases, and social dynamics of the city's development. Driven by commercial concerns, the building activities were initially centered on Isfahan's urban core and were carried out with the support and involvement of the city's patricians. Yet the notion of a symbiosis between local and imperial mercantile interests, which underpinned the initial plan, soon yielded to a totalizing plan that subordinated the old city to a grand royal scheme. Devised in the mid-1590s, this master plan encompassed a vision for the city in its entirety, including the maydan, the Chaharbagh, the palace complex, and suburban gardens.

Beyond local politics, the shifting of the empire's center to Isfahan was significant in the context of emerging patterns of global trade. Even before the transfer of the capital, it appears that commerce had begun to flourish anew in sixteenth-century Isfahan, and this mercantile revitalization was linked to a momentous transformation in the world economy: the advent of European seaborne empires and the ascendency of their trading companies in interregional commerce. The revival of Indian Ocean trade in the sixteenth century—stimulated by the advent of Portuguese colonies and the flow of silver from the Americas—had a major impact on Isfahan's economy, enabling the city to attain prominence in trade.[80] This global shift in mercantile relations was thus a key factor that, directly or indirectly, prompted the transfer of the capital from the now marginalized northwestern regions of the Safavid realm to Isfahan, a city whose notable families were already engaged in maritime trade on the Persian Gulf coast.[81] The benefit of the forced relocation of Armenian and Tabrizi merchants to Isfahan can also be understood in the context of the shifting patterns of long-distance trade. Once pivotal to pan-Eurasian commercial networks, Azerbaijan was no longer significant in the age of the ascendency of sea trade. Late medieval emporiums such as Tabriz were ultimately abandoned in favor of Isfahan, a city more closely linked to the emergent magnets of global maritime trade.

With the establishment of Isfahan as a mercantile hub came an influx of new commodities and people, senses and materials, that acted as essential components of the physical and social

fabric of the city. Integrated into the urban plan for Isfahan, these novel communities (Armenian merchants, Hindu traders, Catholic missionaries) and materials (coffee, tobacco, and so forth) created an image of a cosmopolitan capital city while also engendering novel conceptions of civic existence, new manners of urban sociability, and, ultimately, fresh senses of self and society. The chronology of the construction of Isfahan confirms that the city's development was not simply a reflection of shifting political realities; it was a deliberate means of state-building, societal reconfiguration, and economic expansion. In other words, it was not the prestige or wealth accrued through imperial expansion that propelled the development of Isfahan; rather, the construction of a metropolitan capital was in itself a driving force and a constituent part of the plan for rejuvenating commerce and re-creating the social order. Majestic and cosmopolitan at once, Isfahan's urbanism defined and fashioned the global image of an empire and the civic selves of its human subjects.

The New Isfahan

THE SAFAVID GARDEN CITY AND ITS ECO-URBAN DESIGN

CHAPTER 3

During the seventeenth century, most visitors caught their first sight of Isfahan toward the end of the road that led from the Persian Gulf coast to the Safavid capital. In contrast to the drab profile of brick minarets and domes that greeted travelers approaching from the north, Isfahan's southern prospect was a boundless, verdant landscape. Reaching the crest of a hill, one could observe a city spread out in the cultivated valley of the Zayanda River—a vast settlement lush with orchards, tree-lined avenues, flowing streams, and planted estates. As an early nineteenth-century British traveler put it with a tinge of romantic hyperbole, "the first view which the traveller has, on coming from [Shiraz], of this great metropolis, is from an eminence, about five miles from the city, when it bursts at once upon his sight, and is, perhaps, one of the grandest prospects in the universe."[1]

Safavid Isfahan has frequently been described as a garden city, and this designation is not an entirely modern invention; several European travelers noted that abundant greenery rendered Isfahan more like a forest than a city.[2] Even the Maydan-i Naqsh-i Jahan, with its channel of running water and rows of regularly planted trees, had the air of a formally planned garden. Considering the city's natural environment is thus essential to comprehending the civic character of Safavid Isfahan and the urban experiences that it framed and engendered.

Nevertheless, more scholarly emphasis has been placed on the typology of gardens and their paradisal connotations than on the ecological, social, and experiential implications of the city's carefully designed landscapes. Further, the study of Isfahan's urban structure has tended to analyze it in terms of functional categories such as palatial, mercantile, and religious. This taxonomic approach obscures the ways individual projects were integrated into a flowing urban system interweaving natural elements with material structures and social establishments.

This chapter outlines the intertwined modes of urban and garden design that undergirded Isfahan's verdant cityscape and fashioned its ecological character. More specifically, the following pages offer a bird's-eye view of the city by exploring the modes of eco-urban design in three major undertakings in which formal gardens and natural systems played crucial roles: the expansion and reconfiguration of the Naqsh-i Jahan Garden and its surrounding pleasances; the construction of the Chaharbagh promenade and other tree-lined avenues; and the development and regulation of a network of urban rivulets branching off the Zayanda River. Exploring the antecedents of these undertakings reveals the distinct ecology of early modern Isfahan, while considering similar Safavid developments underscores the broader territorial significance of the city's natural landscape.

THE PALACE COMPLEX AND ITS GARDENS

Laid out on the grounds of the Naqsh-i Jahan Garden, the new Isfahan's palace complex, or dawlatkhana, was a key urban component that was planned in a verdant environment. In order to create a royal compound suited to the ceremonial and bureaucratic functions of the state, public halls for audiences and receptions (*divānkhāna*), pavilions for private assemblies (*khalvatkhāna*), living quarters for the imperial household (*ḥaram*, *andarūn*), and service facilities such as stables (*ṭavīla*), kitchens (*maṭbakh*), and workshops (*buyūtāt*, *kārkhānahā*) were constructed.[3] The floor area allotted to each of these functions was likely specified at the outset of the planning; an account of the construction of Farahabad, a city founded in the Caspian Sea region in 1611, indicates that the size of each component of the royal complex was dictated by Shah Abbas.[4] Fazli relates that in Farahabad, the shah himself "held the [measuring] rope [*ṭanāb*]" to implement the plans on the ground, and later accounts suggest that the same had occurred in Isfahan.[5]

The various components of the palace complex were arranged concentrically. In this nested configuration, the innermost zone was devoted to ceremonial and residential functions, which were in turn encircled by service facilities, administrative offices, and auxiliary gardens (fig. 22). Three interlinked gardens constituted the core of the palace complex. The largest enclosure, the Divankhana, served as the principal locus of festivities and receptions; its limits appear to correspond to the garden where the Chihil Sutun is now located. Situated to the south of the Divankhana, the residential quarter (the harem, or *andarūn*) was the other major precinct of the dawlatkhana. One of the most densely built-up areas of the royal compound, the harem was an immense complex that included apartments for the female members of the ruling household (the king's mother, wives, aunts, and sisters, as well as their young male and female offspring) and for hundreds of eunuchs and concubines who served the royal ladies and princes.[6] In the late nineteenth century, when vestiges of the harem complex (called *bihisht āʾīn*, or "paradisal") were still visible, a local Isfahani author described it as an "infinite sea."[7] The Bagh-i Khalvat (Garden of Seclusion/Retreat), a rectangular enclosure recorded in a sketch by Kaempfer, mediated between the private (*andarūn*) and public (*bīrūn*) zones of the palace complex. Featuring an elaborate pavilion on its western border and later provided with a wooden pillared hall (*tālār*), the Bagh-i Khalvat hosted private banquets and intimate audiences, as its name suggests (*khalvat* means "seclusion" or "retirement").[8]

The area between the tripartite core of the palace complex—Divankhana, harem, and Bagh-i Khalvat—and the western flank of the Maydan-i Naqsh-i Jahan was devoted to service and administrative departments. In the north lay the chancellery (*daftarkhāna*), housed (at least from the mid-1600s onward) in a building known as Talar-i Taymuri (Timurid Hall).[9] The chancellery overlooked a square, the Maydan-i Chahar Hawz (Square of Four Pools), which was accessed from the Maydan-i Naqsh-i Jahan via a vaulted market. To the south of the chancellery lay a series of storehouses for food, drink, garments, books, and precious items. The Sufi chantry (Tawhidkhana) and the royal stables (*ṭavīla*) flanked the Ali Qapu, the principal portal of the palace ensemble. Further south was another gateway (Sardar-i Khurshid) that led directly to the harem. Finally, royal workshops (*kārkhānahā*, *buyūtāt*) and kitchens (*maṭbakh*) were arranged in the southeastern zone of the palace complex and were accessed via a gateway known as the Kitchen Gate (Dar-i Matbakh).

These administrative and service facilities formed a buffer zone between the palace and the maydan—a liminal arena mediating between the state and the public. The creation of a carefully organized domain for governmental offices and public affairs that was spatially demarcated from the monarch's residence appears to have been a distinctive feature of the palace complex in Isfahan. Late Safavid manuals of administration reflect an elaborate state machinery organized in various departments.[10] Together, this administrative zone and the porous boundary of the royal complex projected an image of an accessible state—and Safavid monarch—in the urban landscape.[11]

While this administrative/service zone defined the public face of the palace complex on the Maydan-i Naqsh-i Jahan, the

FIGURE 22

Plan of the Safavid palace complex and its surroundings. (A) Maydan-i Naqsh-i Jahan; (B) Chaharbagh. Main gates: (a) Gate of [the Maydan-i] Chahar Hawz (Square of Four Pools); (b) Ali Qapu; (c) Harem Gate (Sardar-i Khurshid); (d) Kitchen Gate (Dar-i Matbakh). Residential/ceremonial core: (1) residential quarter, or harem; (2) Bagh-i Khalvat (Garden of Seclusion/Retreat); (3) Divankhana (Chihil Sutun Garden). Administrative buildings and service facilities: (4) daftarkhana (chancellery), Maydan-i Chahar Hawz; (5) Tawhidkhana (Sufi chantry); (6) stables (*ṭavīla*, later Talar-i Tavila); (7) kitchens (*maṭbakh*); (8) royal workshops (*kārkhānahā, buyūtāt*). Gardens and pavilions: (9) Guldasta Garden, or Bagh-i Gulistan (Rose Garden); (10) Nightingale (*bulbul*) Garden; (11) Tent (*khargāh*) Garden; (12) Grape Garden (*angūristān*); (13) Almond Garden (*bādāmistān*); (14) Bagh-i Farrashkhana / Cypress Grove? (*sarvistān*). Plan by author.

residential-ceremonial core of the dawlatkhana was bounded by a string of gardens on the other three sides. To the southeast, beyond a pathway that ran along the old city walls, lay the Guldasta Garden, also known as the Gulistan (Rose Garden).[12] This garden featured a series of intricately designed edifices, including the sixteen-sided Guldasta pavilion, which lay at the center of an octagonal enclosure subdivided by radial walkways.[13] Abutting the Guldasta Garden on its western side, and linked to it via a gateway, was the Nightingale (*bulbul*) Garden, eco-instantiating the time-honored metaphor for the beloved and lover (*gul u bulbul*) in Persian poetry. To the north of the Nightingale was the Tent (*khargāh*) Garden, which bordered the Chaharbagh. Although these three gardens were separated from the palace complex by a diagonal route, the king could enter these gardens through a door in the back of the harem.[14] Moving clockwise on the plan, three additional gardens—the Grape Garden (*angūristān*), the Almond Garden (*bādāmistān*), and a garden to the north of the Chihil Sutun—ringed the palace complex on its western and northern sides (fig. 22).[15] In late nineteenth-century sources, the garden to the north of the Chihil Sutun was named after a pavilion called *farrāshkhāna* (carpet house) or *chīnīkhāna* (China house), where the accoutrement of royal ceremonies was stored.[16] This pavilion, and the garden that extended to the north of it, likely marked what Safavid sources referred to as the Sarvistan (Cypress Grove).[17] The palace complex was thus bordered to the west by a verdant band of contiguous gardens, each named after its principal botanical character: roses, grapes, almonds, and cypresses.

In the overall plan of the new Isfahan, this belt of gardens blurred the boundary between the city and the palace. Interwoven into the urban fabric, the palace quarter acted as a hinge between the Chaharbagh and the Maydan-i Naqsh-i Jahan and, by extension, between the walled city and the extramural quarters. Though laid out within the perimeter of city walls, the Maydan-i Naqsh-i Jahan was thus spatially linked to the estates and gardens placed beyond those walls. The access to and movement through the imperial compound followed the spatial logic of the city. Just as frequenting the urban spaces of Isfahan allowed the Safavid king to represent himself as an accessible ruler, so the visual and spatial penetrability of the palace complex enabled the public to experience and perceive the royal spaces as accessible.[18]

THE CHAHARBAGH AND THE HIZAR JARIB GARDEN

Even though the Safavid palace complex occupied a symbolically prominent site, it was merely part of a larger configuration that included the Chaharbagh and the Hizar Jarib (or Abbasabad) Garden (fig. 2). About four kilometers long and forty-seven meters wide, the Chaharbagh was the main axis of Safavid developments in Isfahan, creating a monumental spine along which garden estates and residential quarters were arranged (fig. 23). Featuring elaborate pavilions, the Hizar Jarib Garden was used as a pleasure estate by the king and the imperial household. Yet it functioned as more than a mere royal pleasance. Kaempfer's sketches and old aerial photographs indicate that the garden enclosed a massive square area (approximately 1,200 meters on each side) covered by a checkerboard grid of plots planted with fruit trees.[19] "This garden belongs to the King," Della Valle notes, "but is open to all, and produces such abundance of fruit as to enable all the inhabitants of the town, who frequently resort hither, to lay in store."[20]

Stretching between the Dawlat Gate and the Hizar Jarib, the Chaharbagh passed over the

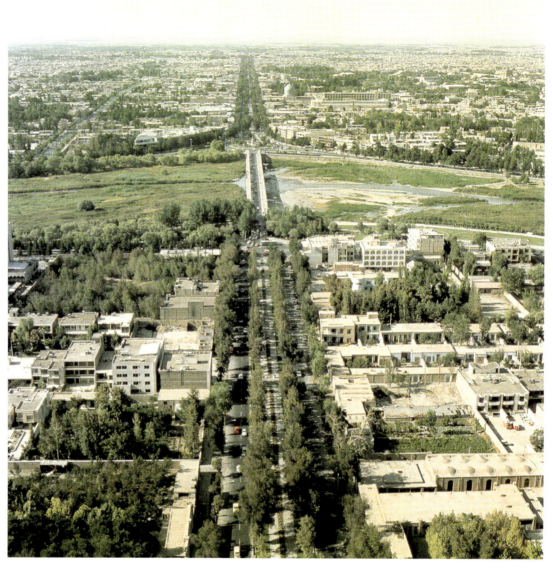

FIGURE 23
Aerial view of the Chaharbagh, looking north. Photo by Abdol Hamid Echragh, ca. 1970s. From Mehdi Khansari, M. Reza Moghtader, and Minouch Yavari, *The Persian Garden: Echoes of Paradise* (Washington, DC: Mage, 2004), 90.

Zayanda River via the Allahverdi Khan Bridge, which divided the Chaharbagh into two sections of similar forms and lengths but relatively distinct characters. Abutting the palace complex and bordered by public institutions such as coffeehouses, pastry shops, and Sufi convents, the northern section was designed as a site of social interaction and day-to-day urban leisure. The southern section, by contrast, appeared as a forecourt for the Hizar Jarib Garden. Bordered by gardens sponsored by and named after military and bureaucratic elites, this section of the

Chaharbagh had a more regimented layout than its counterpart across the river (fig. 24).[21]

In its overall conception, then, the Chaharbagh was a straight, paved, and planted promenade linking the walled city to a suburban pleasance. The origin of this configuration can be traced back to Samarqand and Herat, Timurid capital cities in Central Asia. In Samarqand, a tree-lined thoroughfare ran from a city gate to a suburban garden called Bagh-i Dilgusha (Heart-Exhilarating Garden).[22] It was first in fifteenth-century Herat (the royal seat of Timur's successors), however, that the term *khīyābān* (which originally referred to a paved walkway within formally planned gardens) came to designate monumental planted roads outside city walls.[23] Extending from the city gates toward the northern foothills, the two khiyabans of Herat served as sites of leisurely promenades. Even so, the nature of the social life that occurred on these Timurid extramural routes was not fundamentally different from that of the adjacent walled city; the buildings that lay along the khiyabans of Herat were primarily religious and funerary.[24] Indeed, large portions of these roads were bordered by tombs, giving them the appearance of "funerary promenades" rather than deliberate sites of urban life and leisure, as the Chaharbagh was in early modern Isfahan.[25]

The immediate precursor of the Chaharbagh (and the model for the overall conception of Isfahan as a garden city) appears to have existed in Qazvin, which became the seat of the Safavid throne in the mid-1500s under Shah Tahmasp. Although little of Safavid developments in Qazvin has survived, the versified descriptions by the court poet Abdi Beg Shirazi (d. 1580) offer glimpses of the city's royal edifices and urban configuration. Abdi Beg's verses (composed in 1559–60) suggest that the principal artery of Safavid Qazvin was a khiyaban that ran from the gate of the imperial residence (*sarāy-i shāhī*, or *dawlatkhāna*) to a royal garden named Saʿadatabad (Abode of Felicity).[26] Abdi Beg compares this khiyaban favorably to the one in Herat, implying that the former was the model for the latter.[27] The poem further indicates that a portion of the Qazvin khiyaban was bordered by fourteen gardens sponsored by state dignitaries, a scheme also deployed in the southern portion of Isfahan's Chaharbagh.[28] In terms of formal genealogy, then, the Chaharbagh was modeled on these prototypes in Herat and Qazvin: it was a verdant route linking the urban seat of government, the dawlatkhana, to a suburban garden that served as an auxiliary royal residence.

This function of the Chaharbagh is clearly expressed in the Safavid chronicles, which describe the project as a khiyaban stretching between the Dawlat Gate and the Hizar Jarib Garden. The sources are less explicit, though, on why the promenade became known as the Chaharbagh (literally, "four gardens"). Typically the term designated a geometrically planned garden, especially (but not exclusively) a garden subdivided into four quadrants by intersecting paved walkways.[29] European visitors commonly offer a literal meaning for the name; Chardin notes that it referred to four vineyards that existed in the area, and a similar explanation is given by almost every other traveler.[30] Yet this literal meaning certainly stemmed from the travelers' imaginations or popular lore. Indeed, as Mahvash Alemi has noted, the term *chahārbāgh* (at least from the late Timurid period onward and particularly in Safavid Iran) seems to have specifically designated a formally planned garden with one major axis.[31] The spatial construction and landscape components of the Chaharbagh indeed gave it the appearance of an "elongated garden" enclosed by high walls.

FIGURE 24

Plan of the Chaharbagh and its adjoining gardens. (1) Sweet-Smelling (*musamman*) Garden; (2) Tent (*khargāh*) Garden; (3) Throne (*takht*) Garden; (4) Nightingale (*bulbul*) Garden; (5) Sufi convents (*takāyā*, s. *takiyya*); (6) menagerie, or lion house (*shīr-khāna*); (7) aviary, or peacock house (*ṭāvūs-khāna*); (8) Allahverdi Khan Bridge. Gardens of state officials and commanders (*bāghhā-yi umarā ʾī*): (9) Ganj Ali Khan; (10) Allahverdi Khan (Safi?); (11) Qurchi Bashi? (head of royal guards); (12) Mir Shikar Bashi? (master of the hunt); (13) Barberry (*zirishk*) Garden; (14) Iʿtimad al-dawla (grand vizier); (15) Divan-begi (chief justice); (16) Vaqayiʿ-nivis (chronicler, "second vizier"); (17) Sufrachi Bashi (chief butler); (18) Darugha-yi Daftar (head of the chancellery); (19) Qullar [Aqasi] Bashi (commander of *ghulām* corps); (20) Ishik Aqasi Bashi (chief chamberlain); (21) Tushmal Bashi (chief royal cook); (22) Nazir (steward of the royal household); (23) Tufangchi Bashi (head of the musketeers); (24) Mir Akhur Bashi? (master of stables); (25) Muhrdar (keeper of seals); (26) Mashʿaldar (head of the lighting department); (27) Mihmandar (guest keeper general); (28) Hizar Jarib, or Abbasabad, Garden. Plan by author.

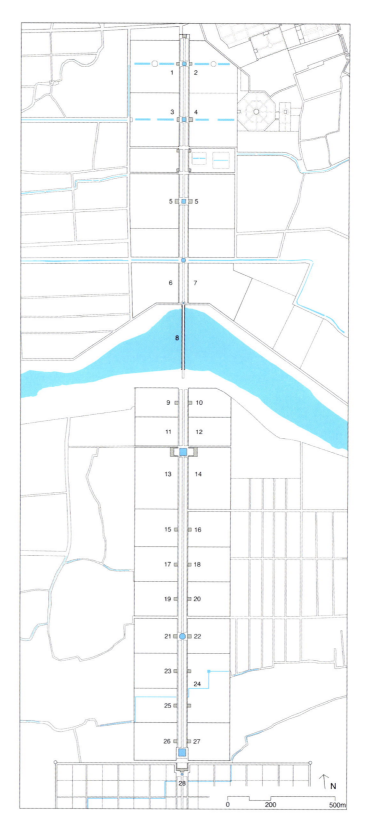

This definition illuminates Iskandar Beg's and Junabadi's descriptions, which seem to characterize the Chaharbagh as a khiyaban consisting of two chaharbaghs laid out axially on either side of the river.

From a formal perspective, what distinguished the Chaharbagh from its antecedents was a heightened sense of order and harmony. This sense of regularity and uniformity is particularly evident in the pairs of facing edifices that were constructed along the Chaharbagh at the main entrances to the bordering gardens. The arrangement of these monumental gateway pavilions—two-story structures measuring around fifteen to twenty meters on a side— on such an enormous scale appears to have been unprecedented. Moreover, while retaining a degree of their literal function as entryways to gardens, the Chaharbagh's bordering edifices took on a wide range of new functions. Socially and architecturally, these edifices belonged to the Chaharbagh; there was no other masonry structure within the confines of most of the gardens.[32]

The Chaharbagh's grand scale also rendered it suitable for a host of communal activities and ceremonial rituals that were unprecedented in their grandiosity and sumptuousness. And yet the main feature that differentiated the Chaharbagh from its precedents was neither its monumentality nor its ceremonial uses but its social functions as a public urban space. Even if the plan of Isfahan built upon the model of Qazvin, the latter was the product of different social and political circumstances. Unlike Isfahan, Qazvin was inhabited primarily by the nobility and state grandees; it contained neither coffeehouses nor tobacco; there were no substantial communities of Armenian or Hindu merchants, no Catholic missionaries, no agents of European trading companies. It was in the cosmopolitan context of Safavid Isfahan that the khiyaban was transformed into a constituent part of the public sphere and a locus of new urban experiences (as I discuss at length in chapter 5).

TREE-LINED AVENUES

The Chaharbagh and its bordering gardens were not the only areas where a planned landscape was created in the environs of Isfahan. To the north of the city, a similar tree-lined avenue bordered by gardens stretched outside the Tuqchi Gate (see fig. 27). Known as the Chaharbagh-i Qushkhana, this khiyaban was anchored on a now-lost monumental mosque (constructed ca. 1300s), which faced the Bagh-i Qushkhana (Garden of the Abode of Falcons).[33] Pascal Coste's 1840 drawing indicates that the Chaharbagh-i Qushkhana featured pairs of facing gateways, and the meager traces in the background suggest that its enclosing walls were decorated with blind arcades (fig. 25).

Stretching in front of the Tuqchi Gate, this khiyaban served as a forecourt for those who entered the city from the north. Like the Chaharbagh, it provided a formal setting for welcoming visitors at a distance from the city (*istiqbāl*), a ritual of hospitality frequently described in Safavid sources. At times, the shah took up residence in the Bagh-i Qushkhana before setting off on a campaign or lingered there for the arrival of an auspicious hour to enter the city.[34] In the mid-1600s a similar khiyaban, known as Khiyaban-i Khvaju, was also laid out in front of the Hasanabad Gate, to the southeast of the city. Radiating from the major city entrances, these tree-lined routes followed the Timurid model in their basic conception. Yet in Isfahan khiyabans were more than mere verdant forecourts for entering the city; they also served as anchors for extramural developments.

During the seventeenth century, elongated chaharbaghs and paved khiyabans proliferated

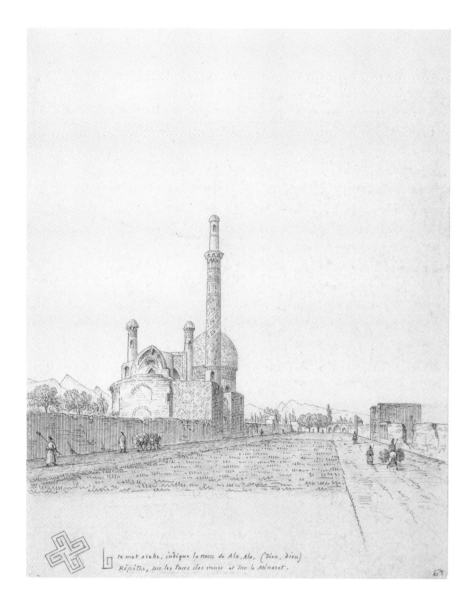

tree-lined roads as well.[36] The central portion of this road—a causeway stretching for twenty-five kilometers through the desert—was known as Khiyaban-i Sang ("stone-paved road").[37] The northern segment of this road, which led to Farahabad, was a sixteen-kilometer stone-paved khiyaban lined with gardens.[38] Dotted by regularly spaced lodging facilities and royal pavilions, this highway served as the empire's principal economic conduit, linking the capital to the silk-producing province of Mazandaran, where the mild and humid climate was apt for sericulture. Chaharbaghs were also created in Qumishe (Shahreza) and Najafabad (fig. 26), in the hinterland of Isfahan.

Constructed in and around major cities or serving as the backbones of new developments, these stone-paved roads and tree-lined avenues were components of an expansive plan for restructuring imperial territories. The centrally positioned capital was linked to the major urban centers of the empire through a verdant infra-structure. Contemporaneous visitors perceived the verdant avenues stretching outside Isfahan's gates as part of a broad scheme for reorganizing the landscape and infrastructure of the Safavid domains—Isfahan was the symbolic center and microcosm of the empire.

RIVULETS

An essential component of citywide planning in Safavid Isfahan was the expansion and recon-struction of an immense network of canals fed by the Zayanda River; sustaining the city's gar-dens and trees required an elaborate hydraulic system. This web of rivulets had long been har-nessed for the irrigation of agricultural fields; a tenth-century author dated the foundation of this water system to Sasanian times.[39] From early on, these streams were also integrated into the urban fabric; the Central Asian traveler

across Safavid territories. In the holy city of Mashhad, Shah Abbas had a three-kilometer-long khiyaban built in 1611. Traversing the city's entire length, the paved tree-lined avenue fea-tured a central water channel and was anchored by a monumental courtyard (ṣaḥn) that defined a new forecourt for the shrine of Imam Riza.[35] Substantial segments of the route connecting Isfahan to the province of Mazandaran, in the Caspian Sea region, consisted of paved and

FIGURE 26
Cornelis de Bruyn, the chaharbagh at Najafabad. From Cornelis de Bruyn, *Voyages de Corneille le Brun par la Moscovie, en Perse, et aux Indes Orientales* (Amsterdam: Freres Wetstein, 1718).

Nasir-i Khusraw, who visited Isfahan in 1052, remarked that canals flowed through the city.[40] Moreover, the level of underground water in Isfahan was relatively high, and the moats that surrounded the city walls and Tabarak Fortress were partially filled by natural springs.[41]

The primary documentary source on the regulatory system of the Zayanda River in Safavid times is a copy of a scroll (*ṭūmār*) attributed to Shaykh Baha'i. This document suggests that the city's hydraulic regime was revived and systematized in the sixteenth century under Shah Isma'il or Shah Tahmasp, though the text seems primarily to reflect the seventeenth-century practice.[42] According to this regulatory scheme, which encompassed the city and its hinterland, in the warm months of the year the distribution

of water in the canals (known as *mādī* in the local parlance of Isfahan) was closely controlled in time and quantity. The temporal regulation was attained by means of clepsydra bowls (*pangān*); the time it took the bowl to sink determined the span allocated to a district. The management of the hydraulic system fell under the jurisdiction of the *mīrāb* (master of water), a high-ranking official who oversaw the annual cleaning of the "canals (*mādīhā*), the streams (*anhār*), and the rills (*jadāvil*)" and appointed individual supervisors for each *mādī*.[43] The work of these supervisors was essential to the upkeep of the hydraulic infrastructure, including the dikes (*band*) and diffusion nodes (*lat*), which controlled the flow and distribution of water.[44] The construction of Isfahan entailed the expansion, maintenance, and regulation of a hydraulic system linking the city to its natural environment (fig. 27).

In addition to revitalizing the existing canals, the development of Isfahan involved the construction of at least two new ones for the irrigation of imperial estates: one was dug in the 1590s to water the Hizar Jarib and the gardens that lay along the south Chaharbagh;[45] another, known as Juy-i Shah ("royal stream"), irrigated the royal gardens in and around the palace complex.[46] The role of canals as organizing elements of the urban landscape is particularly evident in the spatial configuration of Juy-i Shah: the canal flowed down a tree-lined avenue (Khiyaban-i Juy-i Shah) and passed through the Throne Garden (Bagh-i Takht), on the western side of the Chaharbagh, before entering the gardens of the royal complex.

Meandering through the city like a web of living veins, these streams accorded a distinctive character to the cityscape of the new Isfahan. Spreading the gentle flow of the river into the built landscape, they defined the city's main axes while also creating a separate network of pedestrian movement interlaced with the rectilinear

FIGURE 27
Plan of Isfahan with its principal
canals (s. *mādī*) and tree-lined ave-
nues (s. *khīyābān*). Plan by author.

Bagh-i
Qushkhana

Chaharbagh-i
Qushkhana

Tiran

Juy-i Shah

Fadan

Farshadi

Niyasarm

Chaharbagh

Khiyaban-i
Khvaju

Shayej

Nayej

↑N

0 200 500m 1km

pattern of gardens, residential quarters, and civic spaces. In Safavid Isfahan, the streams flowed not only through garden estates but also in the courtyards of mosques, madrasas, caravanserais, and mansions. While irrigating the gardens and cooling the urban environment, water channels were used to generate sensory delights and aesthetic effects in the urban landscape, as their placement along vistas or on the axes of edifices indicate. Baths, water mills, icehouses (*yakhchāl*), and paper mills were also sited along the canals to harness their flow and water.[47] Throughout its entire route, each *mādī* was known by a specific name; this consistency suggests that these canals were perceived as discrete components of the cognitive map of Isfahan, threading the urban elements that lay along them. In this way, these streams played a key role in unifying the city and shaping urban experiences.

MODES AND AESTHETICS OF URBAN DESIGN

The interwoven fabric of urban rivulets and tree-lined avenues bestowed a remarkable sense of spatial cohesion on Isfahan. This sense of uniformity was enhanced by deploying a concerted vocabulary of urban forms and design strategies. Based on the consistent use of these forms and strategies at micro and macro levels, Mohsen Habibi has suggested that Safavid urban planning was underpinned by a systematic approach that can be analyzed as a school, with a coherent set of principles.[48] Chief among the formal principles of urban design were modular planning, axial arrangement, and bilateral symmetry—an inherited repertoire of compositional schemes that Safavid architects and designers substantially expanded to fashion new cities and civic complexes. Particularly crucial to creating a sense of spatial cohesion and fluidity were

elaborate intermediary spaces that knit individual buildings into the spatial flow of the surrounding urban spaces. In the new Isfahan, the ways edifices were integrated into the broader urban scheme and corresponded to one another were as crucial to shaping their meanings and perceptions as were their discrete formal features. By creating an urban architecture of integration—achieved by means of visual transparency, elaborate thresholds, and articulated liminal zones—the city engendered a distinctive kind of spatial fluidity (between the natural and the masonry, the royal and the ordinary, the sacred and the profane) that was central to the ways in which it was experienced by mobile sensing bodies.

To what extent did the developments that constituted the new Isfahan arise from a concerted campaign? As discussed in chapter 2, Isfahan was developed, after an initial phase of construction focused on the dual urban cores of the city, according to an overarching plan laid out in the mid-1590s. Even so, it would be unreasonable to assume that every component of the city was part of a preconceived vision. Like any large-scale urban project, revisions and additions were made in the process of planning and construction; the preparation of plans only marked the beginning of the design process. For instance, as noted previously, the uppermost floor of the Ali Qapu was erected in 1607–8. Apparently, only after the completion of major components of Isfahan was it deemed worthwhile to raise the height of the tower so that it would afford an expansive view of the city from its ornate fifth-story hall and its rooftop terrace.

The use of specific compositional formulae also enabled the city to preserve a remarkable degree of harmony and cohesion with each new addition. This kind of urban design is manifest, for instance, in the northeast area of

the Maydan-i Naqsh-i Jahan, where the main market approaching from the old town reaches the square. Here all the newly built edifices branch off from the linear, continuous lane of the market, linked to the bazaar via setbacks. The Mulla Abdallah Madrasa, built on the northeast corner of the maydan in 1598, was connected to the bazaar through a similar spatial device—an extension of the main lane of the market branching off at a domed intersection (see fig. 16). By order of Shah Abbas, an offshoot of the water channel that runs around the Maydan-i Naqsh-i Jahan was also to flow through the madrasa.[49] This is another example of the deliberate use of Isfahan's streams as elements of design.

Another compositional device that was instrumental in preserving formal uniformity in urban spaces was the integration of existing structures into broader symmetrical schemes. An example of this approach can be seen in the Chaharbagh-i Qushkhana (fig. 25), where an existing mosque was paired with the entrance pavilion of a garden to form the centerpiece of an elongated space. Yet another common method for achieving uniformity was the symmetrical arrangement of buildings across open-air spaces. An example of this compositional mode is the positioning of the Shah Mosque on the south side of the Maydan-i Naqsh-i Jahan. The aesthetic harmony of the city arose from simple yet consistently deployed organizational devices: pairing, rhythm, and symmetry.

These modes of eco-urban design did not merely generate harmonious urban spaces; they also spawned distinctive modalities of sensing and apprehending the city environment. To be sure, the sight and experience of

Isfahan's two major topographical elements—the Zayanda River and Suffa Mountain—were integral elements of urban design. Yet these natural features constituted only a part of the city's visual structure. In the absence of other topographical features, a multisensory universe was constructed through the geometric interlacing of physical and natural elements: water was experienced in the form of stone-rimmed channels, trees were mathematically ordered, and vistas were generated by arraying verdant and masonry elements. And just as nature was (re)created in the geometric forms of architecture, the tiled surfaces of edifices echoed the city's vegetal world in mimetic and idealized forms.

Formally planned gardens were constituent components of Isfahan's cityscape: they encircled the palace complex, defined the major urban axes, and engendered a grid for new residential quarters. But the significance of the natural environment was not confined to the planimetric features of formal gardens. Nor was nature manifest in greenery and water alone; air, soil, light, and nonhuman living creatures were equally integral to the city's carefully designed ecosystem. Social, aesthetic, and ecological concerns converged to form the cityscape. Ultimately, to fully appreciate the import of Isfahan's natural ecology, it must be examined together with the city's other two ecological registers—social relations and human subjectivity—as Félix Guattari has noted.[50] The novelty of the urban plan of Isfahan did not solely rest in its grandiosity; it also arose from the ways these imbricating ecologies formed new urban experiences, topics explored in the ensuing chapters.

PART 2

URBAN SPACES AND EXPERIENCES

Sensing Time and Sound

CLOCKS AND THE RHYTHMS OF URBAN LIFE

As the civic heart of a metropolis and the emblem of an empire, the Maydan-i Naqsh-i Jahan figures in virtually every literary portrayal of Safavid Isfahan. Whether in prose or verse, these works extol the square's surrounding monuments, describe its variegated markets, and capture its bustling social atmosphere. But even when a generic description is offered, a sense of time pervades spatial representation. Commonly, for instance, a specific moment of the day is evoked: the sunset. The itinerary of the "Guide for Strolling" ends with a foray into the Maydan-i Naqsh-i Jahan at nightfall, when its immense grounds—bursting with makeshift stands and booths set up by vendors, performers, and storytellers—appeared as a massive urban spectacle (fig. 28). In the evening the daily round of urban activities on the maydan reached the peak of its human dynamism. As dusk settled over Isfahan, the "agitated veil" of the crowds transformed spatial perception.[1]

The intertwined temporal and aural qualities of the Maydan-i Naqsh-i Jahan figure prominently in the "Sāqī-nāma" (Book of the Cupbearer), a poem of rhyming couplets (maṣnavī) composed in the 1670s by the Safavid statesman and poet Muhammad Tahir Vahid Qazvini (d. ca. 1700). In a section of his work titled the "Description of Evening and Sunset" (ṣifat-i ʿaṣr va ghurūb-i āftāb), Qazvini sets out by painting a vivid picture of the maydan as it was engulfed in the shifting hues of nightfall:

> O heart, when the day reaches its end,
> Go to the world-illuminating maydan.
> From saffron bloomed the flowers of the red-
> bud tree (arghavān),
> The dark-blue sea was concealed in pearls.[2]

The verses then describe the naqqara-khana (kettledrum hall) at the qaysariyya portal and the various instruments—drums, cymbals, trumpets—that were played there daily, at sunrise and sunset, and on ceremonial occasions. Meanwhile, amid the songs of the naqqara-khana, "a sound issues from the clock [vaqt-i sāʿat]." With this sonic signal, the poet turns to the clock pavilion, which he then describes at length, in thirty-three couplets.[3]

What Qazvini refers to as the vaqt-i sāʿat (literally, "time of the hour") was a mechanical hourly clock featuring automata figures. It was set up in an edifice erected in the 1640s on the maydan's eastern flank, as shown in an engraving that appeared in the travel narrative of the Dutch painter Cornelis de Bruyn, who visited Isfahan in 1704 (fig. 29, C). In the accompanying text, De Bruyn describes the device as a "pavilion of the machines or of the clock, which moves some wooden puppets in a wheel."[4] But this was not the maydan's first clock. Initially, during the

FIGURE 29
Cornelis de Bruyn, view of the Maydan-i Naqsh-i Jahan, detail. (B) Shaykh Lutfallah Mosque; (C) clock pavilion (*vaqt-i sāʿat*); (D) qaysa-riyya portal, with the bell on the roof. From Cornelis de Bruyn, *Travels into Muscovy, Persia, and Part of East-Indies* (London: A. Bettesworth et al., 1737), vol. 1, plate 76.

reign of Shah Abbas I, another mechanical clock, equipped with a striking bell and dial, stood at the entrance to the qaysariyya market. The belfry that surmounted the earlier timepiece is also rendered in the background of De Bruyn's engraving, on the rooftop of the qaysariyya portal (fig. 29, D). The now-lost pillared galleries that housed the naqqara-khana extended outward on either side of the bell (fig. 30).

The naqqara-khana; the first clock, with its attendant bell; and the second clock, with automata figures, were all sonic markers of the passage of time. Lodged in conspicuous architectural forms, they were also major visual components of the Maydan-i Naqsh-i Jahan,

frequently described by European visitors. Yet these were not the only elements that shaped the maydan's spatiotemporal environment. Here the naqqara-khana and the clocks were joined by an array of auditory and social experiences—such as hearing the call to prayer and drinking a morning coffee in the coffeehouse—that structured the temporal patterns of work, prayer, and leisure. The moments that punctuated the daily urban rhythms—sunrise and sunset, the passage of hours, the midday worship—were nowhere in the city as palpable as they were in the Maydan-i Naqsh-i Jahan. Together, these features modulated the flow of time and spawned a distinct form of sonorous urban experience—novel

senses of time and space that were ingrained in the material fabric of early modern Isfahan.[5]

THE SENSORY WORLD OF THE MAYDAN

Discussions of the Maydan-i Naqsh-i Jahan have concentrated primarily on its royal ethos and formal antecedents, interpreting the plaza as a stage for imperial spectacles and an index of the shifting political and religious orientation of the Safavid polity. To a large extent, the effect and character of the maydan arose from the visual configuration of its surrounding monuments. In his versified description, Qazvini thus invokes the panoramic view of the square from the talar (pillared hall) of the Ali Qapu:

On one side is the ornate congregational
 mosque;
On the other, the spring-resembling
 qaysariyya.

[The maydan] contains devotion and sin,
It stretches from this world to the hereafter.[6]

And yet, as the rest of Qazvini's poem also makes plain, vision was just one sensory element that shaped the maydan's experience. The plaza's surrounding arcades constituted a highly ordered market with separate lanes dedicated to sundry trades and crafts—booksellers, confectioners, coppersmiths, and so forth—each with its own sounds, tastes, and smells.[7] The maydan also harbored a range of social venues, which engendered distinct sensory experiences. The soundscape of the Maydan-i Naqsh-i Jahan and the sense of temporality that it generated were enmeshed in this multisensory environment.

In its overall physical form, the open-air, sand-covered field of the maydan functioned as a ground for equestrian exercises, particularly polo. The size and proportions of the maydan

were likely informed by the requirements of these games.[8] The still-extant marble goalposts (fig. 30) and the high pole raised in the middle of the square (the shooting target in the mounted archery contest known as *qapaq*, visible in fig. 28) were conspicuous material emblems of these sports activities. According to Della Valle, the naqqara-khana instruments were played during the polo and archery contests, a practice frequently depicted in manuscript paintings (fig. 31).[9] During these games, "the shouts of players and the neighing of horses" blended with the sounds of drums and trumpets, creating a raucous auditory experience for the spectators.[10]

On a day-to-day basis, the maydan's enormous terrain hosted a panoply of civic activities and urban experiences. Hence, Qazvini's poem dwells primarily on the teeming human scene of the plaza, comparing it to a sea: the movements of crowds resemble waves; the circles set up by entertainers and performers (*ḥalqahā-yi maʿārik*) appear as whirlpools (*girdāb*); and the row of cannons that lined the maydan on the side of the palace complex evoke whales perched on a rocky shore.[11] An impression of such elements— crowds, caravans, booths, cannons—is captured in a 1703 drawing by the Dutch painter Gerard Hofstede van Essen (fig. 28). Spreading over a massive field, these swirling material and human elements turned the maydan into a dynamic urban spectacle.

This ongoing spectacle was framed by the maydan's enclosing arcades, which heightened its theatrical character. And the place where these everyday urban activities pulsated with the greatest vigor was the north end of the maydan. Here the modular plan of the double row of shops gave way to a more complex configuration accommodating a host of commercial facilities and social establishments (fig. 32).[12] In addition to the qaysariyya market, this area

was home to public amenities such as the Royal Bathhouse (Hammam-i Shah), the mint (*żarrāb-khāna*), and a hospital (*dār al-shifāʾ*). Through continuous market lanes, this sociocommercial complex mediated between the new plaza and old Isfahan, blending the city's preexisting fabric into the rectilinear blueprint of Safavid

FIGURE 31
Garshasp Playing Polo in the Presence of Zahhak. Folio from a manuscript of Firdawsi's *Shāhnāma* (Book of Kings), 1582. Florence, Biblioteca Medicea Laurenziana, MS Or. 5, fol. 665v. Reproduced with permission of MiC. Further reproduction by any means is prohibited.

FIGURE 32

Plan of the northeast corner of the Maydan-i Naqsh-i Jahan:
(1) coffeehouses (known today as Bazar-i Sarrafha, or "Money-
Changers' Market"); (2) Bazar-i Qannadha (Confectioners' Mar-
ket); (3) Chaharsu-yi Shah (Royal Domed Crossing); (4) sherbet
houses; (5) qaysariyya market; (6) domed crossing (*chahārsū*)
of the qaysariyya; (7) Saray-i Shah (Royal Commercial Complex);
(8) mint (*żarrāb-khāna*); (9) Hammam-i Shah (Royal Bathhouse);
(10) Mulla Abdallah Madrasa. Plan by author.

developments. For the visitor arriving from the Old Maydan via the meandering route of the bazaar, a domed crossing, Chaharsu-yi Shah, defined a vestibule from which to enter the maydan's peripheral arcades, or the "four markets" (*chahār bāzār*).

The focal point of the socioeconomic complex on the north side of the maydan was the portal to the qaysariyya market (fig. 33). Overlooking a five-sided recess carved out of the peripheral mass of the maydan, this ornate portal was originally flanked by the wooden galleries of the naqqara-khana. Situated on the longitudinal axis of the square, the qaysariyya portal did not function as the entrance to the royal market alone; it also served as the principal iwan of the Maydan-i Naqsh-i Jahan and its main vantage point, whence the square could be viewed in its entirety and in full harmony. According to a late seventeenth-century source, a person "stationed in the vicinity of the qaysariyya" claimed that "Iran is the essence [*khulāṣa*] of the world, Isfahan is the essence of Iran, and the qaysariyya is the essence of Isfahan, and I am stationed there."[13] The visual program of the qaysariyya portal (discussed below) further confirms that it was conceived as a microcosm of astronomical, social, and commercial ideals that Isfahan embodied and represented. It is no surprise, then, that the unknown architect of the maydan also left a mark for posterity near the qaysariyya portal:

> The wish is that a trace [*naqsh*] of us survives,
> As I see no permanence in existence.
> One day, maybe, a sage mercifully
> Prays on behalf of the paupers.

Since the fifteenth century, these verses— derived from the *Gulistān* (Rose Garden) of Saʿdi (d. ca. 1292)—had frequently been inscribed by

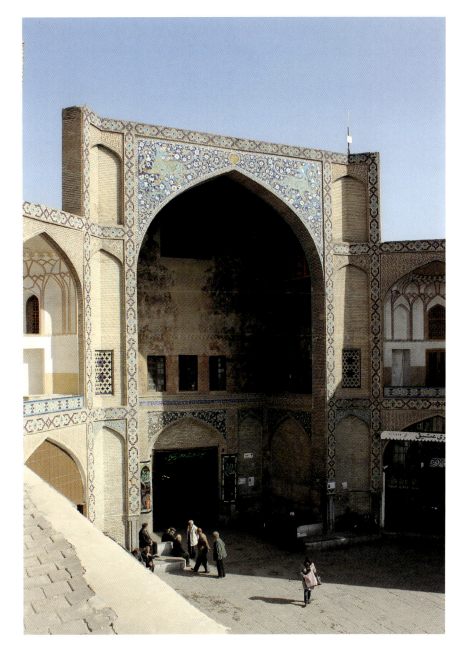

artisans and architects as a memorial to their work, couched in a spirit of morality and humility.[14] Cast in square Kufic script (a modular, grid-based form of writing) in two facing panels, the poem gave voice to the maydan and its designer, elevating the status of the architect's work to

FIGURE 33
Portal of the qaysariyya market on the northern side of the Maydan-i Naqsh-i Jahan. Photo: author.

FIGURE 34
Sectional axonometric view of the northeastern arcades of the Maydan-i Naqsh-i Jahan, showing a reconstructed view of the coffee-houses. Model by author.

that of an eternal masterpiece of literature. Here the use of the term *naqsh* is doubly significant: it references the maydan's epithet while underscoring its character as an enduring artifact destined to withstand the vagaries of time.

The qaysariyya portal also served as a civic landmark around which a host of quotidian activities unfolded. Chief among the venues that hosted social pastimes were the coffeehouses, "the most beautiful and spacious" ones in Isfahan.[15] Occupying the eastern side of the square's northern arcades, these consisted of six domed halls alternating with barrel-vaulted alcoves;

each containing a platform, the alcoves served as the shared seating area of the adjacent establishments (fig. 34).[16] Yet coffee was just one consumable among a host of intoxicants and stimulants that were available there. Adam Olearius, the secretary of the embassy of Frederick III, Duke of Holstein-Gottorp, who visited Isfahan in 1637, also mentions the "Chinese teahouse" (*chāy-i khaṭāʾī-khāna*).[17] Moreover, directly behind the coffeehouses was the Market of Confectioners (*bāzār-i qannādhā*), offering sweets (such as *nabāt* or *ḥalvā*) that were commonly consumed with coffee. It was the concentration of these

pleasures that turned the north end of the maydan into the primary hub of leisure in Isfahan.

In his travel narrative, Della Valle vividly describes the lively nighttime ambience of coffeehouses and shops in and around the qaysariyya. In June 1619 Shah Abbas invited foreign emissaries to an excursion and reception on the Maydan-i Naqsh-i Jahan. The envoys first strolled around the illuminated square; then, as night fell, the shah led his guests into the coffeehouses. "The coffeehouse chambers are large and whitewashed," Della Valle notes, "seamlessly linked to one another, which makes them appear like one complex."[18] The rooms were brightly lit by lamps suspended from the ceiling, resembling a starry night. These lighting fixtures were in fact recognized as one of the most impressive elements of the coffeehouses. According to Fedot Afanasiyev Kotov, a Russian merchant who journeyed to Isfahan in 1624, "above the height of a man is stretched plaited iron wire like a net or a chessboard, and in every hole is placed a glass bowl and in these is poured rosewater with oil and they light these."[19] For the clients who visited the maydan's establishments in the evening, the taste and scent of coffee mingled with the fragrance of roses.

After dining and drinking wine in the coffeehouses, the shah and the ambassadors proceeded toward the qaysariyya, passing through the light-filled halls of interconnected coffeehouses. Reaching the forecourt before the qaysariyya portal, the group lingered for a while to behold the reflection of the torches in the pool and the channel running around the maydan. They then entered the market and visited the mint before stepping into the Sara-yi Shah (Royal Commercial Complex).[20] There Shah Abbas paused to imbibe and converse with tradesmen: first with the chief of the Tabrizi émigré traders, one of the wealthiest merchants

of Isfahan; then with Alessandro Studendoli, a Venetian who sold Italian pictures and mirrors (for a price much higher than one would pay in Rome); and finally with the leading Armenian merchant, Khvaja Nazar.[21] The qaysariyya was the site of daily encounters between individuals of various ethnicities and religions.

Della Valle's account yields an intriguing glimpse into the ambiance of the qaysariyya and its surrounding environment. Here, in the cosmopolitan markets and bustling establishments, one could experience, day and night, whatever was new and exotic in Isfahan, from coffee to Italian pictures. Each material came from a different place: sugar from India, coffee from Yemen, printed images from Venice. And just as variegated as the commodities was the human makeup of the merchants who offered them for sale. It is in this setting that the import of the qaysariyya's mechanical clock—itself a novelty of the early modern age—can be appreciated.

THE CLOCK TOWER OF THE QAYSARIYYA

Looming over the qaysariyya portal, the now-vanished bell and clock were among the major visual components of the maydan depicted in European representations. The earliest of these depictions is an engraving, published in Chardin's travelogue, which illustrates the bell hanging inside a cubical structure on the rooftop (fig. 30). The belfry is also rendered in De Bruyn's engraving (fig. 29) and in Hofstede's drawing (fig. 28). Only in Hofstede's rendition, however, is the clock dial depicted. The dial face is also illustrated in a nineteenth-century view (fig. 35) made by an Armenian priest from Istanbul, Vrdanis Eiwziwk'chean.[22] It appears that by the 1840s the bell had disappeared, though the dial's remnants were still in place.

While these images convey a fairly clear picture of the form and position of the bell and

FIGURE 35
View of the north side of the Maydan-i Naqsh-i Jahan, showing the clock dial and naqqara-khana. From Vrdanis Eiwziwk'chean, *Nkaragrut'iwn Parskastani ereweli shinuatsots'* (Constantinople: I Tparani Hovhannu Miwhēntisean, 1854), 24.

dial, written sources offer conflicting accounts of their origin. The earliest mention of the qaysariyya clock appears in Kotov's 1624 travel narrative. According to the Russian merchant, high above the portal located at the end of the maydan stood "a clock, and the place where the clock [stood was] also ornamented with gold and made fine, and the clock [had] a Russian mechanic."[23] Olearius, who visited Isfahan in 1637, relates that the clock was set up under Shah Abbas, adding that since there were "neither bells nor such big city clocks in all of Persia, it was seen as a miracle." But instead of a Russian mechanic, Olearius names an Englishman called Festy (or Fesli, according to other editions) as its maker, stating that the clock had been out of order since Festy's death.[24]

Later European accounts offer yet further alternative provenances for the clock and bell. The French merchant Jean-Baptiste Tavernier,

who journeyed to Isfahan several times between 1630 and 1668, reports that the clock was transferred to Isfahan from the Persian Gulf island of Hormuz but was "of no use, nor [was] ever likely [to have been]."[25] (Colonized by the Portuguese in 1515, Hormuz was captured through a joint Safavid-English campaign in 1622.) Chardin, who first arrived in Isfahan in 1666, offers a more detailed description. He notes that on top of the rear wall of the qaysariyya portal,

> [t]here is a large clock, three feet on a side, which is currently defunct, perhaps because of the want of a clockmaker for its maintenance, or because all kinds of ringing are abominable to Persians, whose religion prohibits the sound of clocks. This clock nevertheless has a large bell elevated high atop the portal, yet it no longer rings. It weighs about eight to nine hundred pounds. The bell's rim

has an inscription that reads: "Sancta Maria, ora pro nobis mulieribus" [Holy Mary, pray for us women]. This has led to the belief that the bell was at a convent of nuns in the city of Hormuz, whence it was transported.[26]

Finally, while visiting Isfahan in 1694, Gemelli Careri remarked that the bell had belonged to the clock of Hormuz, adding that it was given to Shah Abbas by the Augustinians, the first Catholic mission to establish a compound in Isfahan, in the early 1600s.[27]

These accounts make it clear that a mechanical public clock with a large dial graced the qaysariyya portal and that it operated for a while, although the origin of the device, the identity of its maker, and the exact date and circumstances of its installation remain ambiguous. A recent study has argued in favor of the Portuguese origin, concluding that the clock and bell were likely installed sometime between 1622 (the conquest of Hormuz) and 1629 (the death of Shah Abbas).[28] It has also been posited that the qaysariyya portal was conceived as a "victory monument" for the representation of battles—a mural depicting the Safavid conquest over the Uzbeks is painted on the portal's rear wall—and hence it afforded an apt locus for displaying the bell and clock as trophies of war.[29]

The assumption that the clock and bell were exhibited as victory spoils is implausible, however. For one, this hypothesis privileges the later accounts of Chardin and Tavernier over those of Kotov and Olearius, who observed the clock closer to the time of its installation and unequivocally described it as a custom-made device operated or made by a foreign mechanic. Indeed, other sources indicate that European clockmakers were in the service of Shah Abbas from the early years of his reign. Abel Pinçon, who accompanied the English adventurers

Anthony and Robert Sherley on their 1598–99 journey to Iran, reports that an old French clockmaker was among the king's artisans; he had joined the Safavid court after working for some years in Istanbul.[30] European clockmakers, watches, and clocks were in fact highly prized at the courts of Shah Abbas and his successors: the Discalced Carmelite missionaries in 1608 reported that Shah Abbas had expressed his desire for a clockmaker to be sent to Iran; the agents of the East India Company in 1618 listed "a clock and watches" on the inventory of the English goods that the shah requested.[31] More interestingly, in 1624–25 Shah Abbas sent to the Mughal emperor Jahangir a clock gifted to him by a European king.[32] That the old French clockmaker mentioned by Pinçon had moved from Istanbul suggests that the installation of a clock in Isfahan was likely linked to contemporaneous developments in the Ottoman capital; sixteenth-century Istanbul was home to a number of clockmakers. Moreover, the astronomer-engineer Taqi al-Din (d. 1585), for whom the Ottoman sultan Murad III (r. 1574–95) had an observatory built in the city, had composed an Arabic treatise on clockmaking and produced a clock himself.[33] According to a European note, Murad III had also intended to build public clocks, "as in Venice," though none had apparently been realized.[34]

Beyond the written sources, the primary evidence that installation of the qaysariyya clock was part of the original conception of the portal comes from the physical form of the portal itself, which has been overlooked in previous discussions. A close inspection of the portal's architectural configuration indicates that the clock and the bell were not displayed at random; the clock dial sat in an arch on the rear wall of the portal, and it is unlikely that the structure on the rooftop was built solely to showcase a

FIGURE 36
Reconstructed view of the qaysariyya portal with the now-lost belfry and the wooden pillared halls of the naqqara-khana. Model and rendering by Shree Kale.

bell as a trophy with no intention of ringing it. Rather, it appears that the qaysariyya portal was originally conceived as a clock tower. As is evident in the three-dimensional section drawing, a three-story tower was embedded behind the arched iwan of the gateway (fig. 36). On the ground floor, the "tower" contains the entrance to the market, while the second floor consists of an ornate room featuring muqarnas vaulting, niches carved in the forms of drinking vessels, and two rows of windows overlooking the maydan and the double-storied row of shops within the qaysariyya (fig. 37). The clock mechanism was installed on the third floor, where the clockface would have been visible in the arched opening below the portal's ornate vault. Finally, the belfry probably lay atop the roof of the tower's third story (rather than the iwan), where it could be connected to the clock mechanism.[35]

The vault form and decorative scheme of the qaysariyya portal were also devised in harmony with its function as a clock tower. Here, in place of the customary semidome, the arched iwan

preceding the gateway is crowned by a barrel vault. This form of vaulting would have allowed for the display of the dial in the arched aperture on top of the back wall, and it appears that the size and shape of the ceiling's sunburst motif (*shamsa*) matched those of the clockface (fig. 38). The ceiling's intricate design—the concentric rings of white stars flanked by descending tiers of muqarnas—clearly represents a celestial image. This scheme, though, offers more than a generic image of the heavens: encircled by twenty-four stars, the sunburst would have echoed the clock face by visualizing the twenty-four-hour division of the day. The movement of the clock's hour hand would in turn have animated the design as a symbolic representation of the circular rotation of heavenly bodies. The revolving firmament, or *dawr-i falak*, was an established metaphor for the passage of time.

The other visual element of the qaysariyya portal that accorded with the clock was the astronomical imagery of its glazed tile decoration. Mounted on the arch spandrels, the two

mirror images of the zodiac sign of Sagittarius—a centaur with the body of a tiger shooting an arrow at his dragon-headed tail and hovering amid blooming scrolls—flank a human-faced sun disk at the apex of the arch (figs. 33 and 39).[36] This astrological motif certainly referenced the auspicious zodiacal house of Isfahan and the city's foundation myth under the Buyids. The depiction of Sagittarius in mirrored images issues from a long-standing tradition in Islamic astronomical tracts, wherein the zodiacal signs were typically illustrated on facing pages, one as viewed from the earth and the other as if seen on the celestial globe. This astronomical association is also echoed in Semnani's "Guide for Strolling," which describes the qaysariyya portal as the "auspicious zodiac house [burj-i sharaf] of the star of felicity."

Yet in addition to representing the mythic symbol of Isfahan, the portal's glazed tile decoration was in harmony with the function and appearance of the clock. In particular, the depiction of the solar/Sagittarian motif suggests a sense of time by evoking the passing of the sun through its ninth yearly station, in the month of āzar/qaws of the Persian/Jalali solar calendar. In Isfahan, the beginning of āzar marked the time when the water of the Zayanda River began to rise and hence the regulatory restrictions on water distribution were lifted.[37] Meanwhile, astronomically, the end of āzar coincides with the winter solstice, when the sun begins to rise again. Sagittarius was thereby doubly significant as the harbinger of renewal—in waters and the heavens. If the clock signaled the hourly sequencing of the day, Sagittarius epitomized the monthly cycle of the year, while the sunburst and its surrounding stars represented the circling of celestial bodies in the firmament. The qaysariyya portal was decorated with the visual emblems of the passage of time.

Architectural evidence thus renders it implausible that the clock and bell were later, incidental additions to the qaysariyya portal. Instead, the gateway appears to have been devised from the outset with an embedded clock tower—a three-tiered shaft capped by a belfry.

FIGURE 37
Upper-floor room of the qaysariyya portal, decorated with niches carved in the forms of bottles and vases (chīnī-khāna). Photo: author.

FIGURE 38
View of the qaysariyya portal's vault, with sunburst (*shamsa*) and hanging stalactites (*muqarnas*). The arched opening where the clock was located is below the vault. Photo: author.

Placed at the threshold between the square and the market, the clock was thus an integral component of the original design of the qaysariyya and the maydan as they were built at the turn of the century. Hence, the clock's installation can tentatively be dated to around 1602, when the maydan and its commercial establishments were inaugurated. By that time at least one French clockmaker had been in the shah's service for a couple of years.

Another likely scenario is that the clock mechanism, dial, and bell each had a different provenance. For instance, while the clock could have been created by an Englishman (per Olearius), the bell may have been provided by the Augustinians (per Gemelli Careri). Augustinians first arrived in Isfahan in 1602 (twenty years before the conquest of Hormuz) and were granted permission to establish a church-convent in the city; completed in 1608 in the Husayniyya quarter (north of the old town), the missionary compound featured a bell tower.[38] If the Augustinians transferred a bell to Isfahan for their own complex, they could well have provided one for the qaysariyya. In any event, the qaysariyya bell tower was not the only structure of its kind in early seventeenth-century Isfahan. The church of the Discalced Carmelites (built about 1608 on the Maydan-i Mir, in the vicinity of the Old Maydan) must have included a bell tower too. The churches of New Julfa, the Armenian quarter, also featured belfries.[39] Bell ringing was a familiar sound across Isfahan.

FIGURE 39
Tile panel with the zodiac sign of Sagittarius installed on an arch spandrel of the qaysariyya portal. Photo: author.

MECHANICAL CLOCKS IN SAFAVID IRAN

While the qaysariyya clock may have been
made and operated by a European clockmaker,
it must be noted that the erection of a public
timepiece in Isfahan did not mark the first time
a mechanical public clock was set up in a Safa-
vid city. Invented in Italy in the early 1300s (the
exact date and location of its invention remain
unclear), the mechanical clock was introduced to
West Asia in the late fifteenth century.[40] The evi-
dence for this comes from a treatise penned in
the early 1500s by Muhammad Hafiz Isfahani.[41]
Known as an "inventor" (*mukhtari*ʿ) and engineer
(*muhandis*), Isfahani was a native of Isfahan,
though little is known about his life, save for
what can be gleaned from the above-mentioned
treatise, which is included in a book that deals

with three of his contraptions.[42] This treatise
not only sheds light on the perceptions of the
mechanical clock at the time but also evinces
an attempt to adopt and localize the novel
technology.

In Isfahani's account, the introduction of
the mechanical clock reached back to the reign
of the Timurid ruler Sultan Husayn Bayqara
(r. 1469–1506), when an Ottoman envoy (*īlchī*)
arrived in Herat, the Timurid capital, bringing a
clock as gift. The envoy related that the Ottoman
sultan Bayezid II (r. 1481–1512) had dispatched
ambassadors to Europe (*farang*) to procure a
clock, but they all returned empty-handed, for
Europeans were "determined to keep this novelty
exclusive to Europe." Eventually, when the third
or fourth Ottoman mission managed to aquire

FIGURE 40

Muhammad Hafiz Isfahani, schematic plan for a proposed clock pavilion, ca. 1530s. From Muhammad Hafiz Isfahani, *Sih risāla dar ikhtirāʿāt-i ṣanʿatī: Sāʿat, āsiyā, dastgāh-i rawghan-kishī, natījat al-dawla*, ed. Taqi Binish (Tehran: Bunyad-i Farhang-i Iran, 1350 [1971]), 69.

a clock, the sultan summoned the learned men to investigate this "astonishing novelty" (*amr-i badīʿ-i ʿajīb*), so that "it would not remain exclusive to [Europeans]," for it could be put to good use in "determining the times of prayer." These learned men, however, were unable to untangle the clock's system or reproduce it. Intent on making "this innovation prevalant among Muslims," Sultan Bayezid then dispatched an envoy to Khurasan with a large sum of money; the envoy was to summon residents and scholars at each major city so that all could see and investigate the timepiece. Isfahani claims that at the request of the Timurid court, he deciphered the secret of this (probably portable) clock in the span of forty days and made a copy.[43]

In the rest of his treatise, Isfahani offers not only detailed directions and diagrams for fashioning the complex gears and wheels that make up a mechanical clock—particularly the so-called escapement apparatus—but also instructions and drawings for assembling a clock in an edifice. Intended for architects (*miʿmārān*) and geometer-engineers (*muhandisīn*), Isfahani's architectural design (*ṭarḥ-i ʿimārat*) consists of a three-story building, square in plan and fronted by an iwan. The ground floor features two rooms, each equipped with a stove (*bukhārī*) and intended to lodge wandering dervishes (fig. 40). Isfahani recommends that the clock be decorated with representations of calendrical systems, including solar and lunar months. This suggestion reveals that the hourly sequencing of time offered by the mechanical clock was perceived as part of a multilayered temporal system encompassing the cycles of months, seasons, and years.

Although the qaysariyya portal does not fully correspond to Isfahani's design, it follows its overall shape and some of its details. Built in three stories, the qaysariyya clock tower is square in plan, with the third floor used for clockwork. The inclusion of ornate rooms and elaborate residential units also resonates with Isfahani's design. Here, though, the residences were obviously not intended for dervishes; the second-floor room of the "clock tower" (fig. 37) was likely designed for royal use, while the adjacent units may have been rented to merchants.[44] The depiction of the sign of Sagittarius also evokes Isfahani's recommendation to include tile panels representing calendrical systems and zodiacal symbols.

Surviving in a unicum manuscript, Isfahani's treatise was previously regarded as an isolated attempt with no practical outcome. Written evidence, however, indicates that during the sixteenth century a number of public clocks were built in Safavid cities. In Kashan a mechanical clock was erected by Isfahani himself on the city's main public square, Maydan-i

Sang, replacing a water clock that had been built as part of a late fifteenth-century complex. About a century later, however, Isfahani's contraption became defective, and hence a taciturn semiliterate person named Mulla Inayat set up a new clock.[45] In his annal of the year 1611, Fazli offers a vivid description of this clock, which indicated the hours and minutes through a two-color visual system: "The twelve hours of the day had been engraved in red and the twelve hours of the night in black on two stones. . . . By day the red stone came into motion. When an hour had elapsed, a part of it became black and a part turned red and the hour came to an end."[46] The clock also featured automata figures: "two drummers, two flautists, two horn players and a cockerel." Made of cardboard (*muqavvā*), the automata played metal musical instruments when the "sixty minutes were completed . . . in such a way that the whole town was aware, day and night, that an hour had passed." Moreover, atop the clock hung a bell (*nāqūs*), which, "after [the automata] had finished playing, spontaneously chimed out the number of hours that had passed, so that it was known what hour it was."[47] That a bell struck the hours in the civic center of a provincial city makes it all the more unlikely that the one in the Safavid capital was intended to be displayed as a nonfunctional object.

The clock in Kashan is reminiscent of an analogous device attested in Tabriz in the early 1500s, when the city served as the Safavid capital. According to the Italian traveler Michele Membré, who was in Tabriz in 1542, a clock pavilion stood on "the square where the *naqqāra* sounds" and was made by "an old Persian" who claimed to have learned the craft from books. The clock consisted of "a square casing of painted boards" topped by "a little bell, from which the hours were struck with a stick."

It also featured moving automata, including two men with horses and lances who played at "jousting with each other" as many times as the bell struck the hours.[48]

These two descriptions of public timepieces signal the emergence of an indigenous technology of clockmaking that adapted the newly introduced weight-driven mechanical device to the long-standing timepieces with moving figures. The automata were a hallmark of public water clocks in the Islamic lands, as famously described and illustrated in the *Kitāb fī maʿrifat al-ḥiyal al-handasiyya* (The Book of Knowledge of Ingenious Mechanical Devices) by Ismaʿil al-Jazari (d. ca. 1206).[49] Yet the inclusion of hour-striking bells in Safavid clocks suggests that they indicated the hours through traditional theatrical devices as well as the aural signals peculiar to a new age.[50] The qaysariyya's bell was not the first to chime in the cities of early modern Iran.

The existence of a large dial and the absence of automata are the key features that distinguish the qaysariyya clock from those in Kashan and Tabriz. In his study of the mechanical public clocks in late medieval and early modern Europe, Gerhard Dohrn-van Rossum draws a distinction between "striking tower clocks" and those that featured "figure automata, carillons, and astronomical indications," which were still ubiquitous in European towns in the early modern period. Although one could "determine the time of the day" with the latter, he notes, "this was at best a secondary purpose."[51] Regardless of the validity and utility of this dichotomy, the qaysariyya clock falls within the category of striking clocks; it indicated the hours—aurally and visually—in the space of a public plaza. Indeed, the erection of the clock tower at the entrance to a market might have been inspired, directly or indirectly, by European prototypes such as the Torre dell'Orologio, completed in

1499 in the Piazza San Marco, Venice (fig. 41). Set on the lateral axis of the square, the Venetian clock featured automata and was decorated with astrological, devotional, and celestial imagery. It stood, moreover, at the entrance to the main commercial artery of the city, the Merceria, an arrangement reminiscent of the qaysariyya portal's situation at the threshold of Isfahan's central marketplace.[52] And like the qaysariyya clock, which bore the auspicious astrological sign of Sagittarius, the Torre dell'Orologio, too, was embellished with an auspicious marker, the winged lion of Saint Mark, the mythological emblem of Venice. Knowledge of the Venetian clock may have reached Isfahan through the oral accounts of traveling merchants or the printed images that Alessandro Studendoli offered for sale inside the qaysariyya.[53]

In the absence of evidence, we can only speculate about how the qaysariyya clock was used, if at all, for civic, ritual, or commercial activities during its brief span of operation. Olearius's observation that people marveled at the device suggests that the public was conscious of its presence, though no reference to the qaysariyya clock has come to light yet in contemporary Persian sources. Still, the clock's proximity to the naqqara-khana, the traditional instrument for signaling the daily routines and urban rituals, implies that the clock was likely meant to operate as a means of regulating urban activities. In particular, its placement at the commercial heart of the Safavid capital suggests that it was probably intended to function in relation to mercantile affairs. In theory, the more precise temporal system offered by the clock would have been useful for merchants active in and around the qaysariyya or for temporal regulation of the market by the state. Tavernier relates that the nearby coffeehouses were typically visited "between seven and eight in the morning," and

there a mullah installed by Shah Abbas would "entertain those tobacco whiffers and coffee quaffers." But after the entertainment had lasted two or three hours, the mullah would rise up, crying to everyone in the coffeehouse: "Come my masters, in good time, let's now retire every man to his business."[54] This action hints at a kind of state-sponsored temporal regulation of the public sphere, to which the clock could have contributed as well.

The bell's presumed association with Christianity would not have made it anathema to Shah Abbas, who, Chardin notes, "sought to please all nations, particularly Europeans, due to their industry and rich commerce, which he wanted to attract to his state."[55] Placing a bell in the civic heart of the capital, then, also catered to the Christian subjects of the empire, particularly the Armenian merchants (who conducted business in the qaysariyya) as well as agents of European trading companies (who had established factories in Isfahan). As such, the clock signaled an all-embracing cultural outlook, creating a visual beacon of openness toward the world. Indeed, the pairing of a bell/clock tower at the northern end of the maydan with the Shah Mosque at the southern end—a longitudinal axis stretching from "this world to the hereafter," in Qazvini's words—may have issued from a deliberate decision to project an ecumenical stance and thus "please all nations" in the cosmopolitan Safavid capital.

This connection between the one end of the maydan and the other is also manifest in a peculiar similarity between the architectural form of the belfry and that of an architectural-aural element of the Shah Mosque: the *guldasta* (literally, "flower bouquet"), or *ma'zana* (literally, "place of the call-to-prayer"), a wooden structure with a tiled pyramidal roof where the call to prayer (*azān*) was announced by the muezzin in Safavid

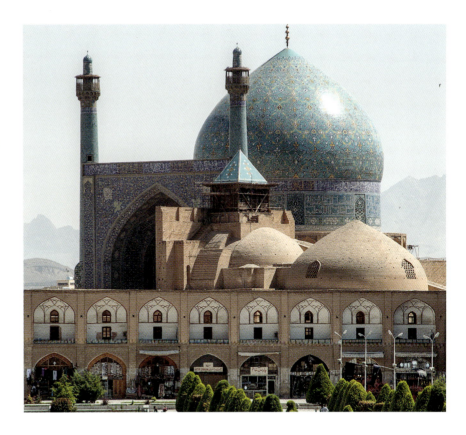

FIGURE 42
View of the Shah Mosque, showing the wooden structure with tiled pyramidal roof (*guldasta/ma'zana*). Photo courtesy of Daniel C. Waugh.

times (fig. 42). Built atop a lateral iwan of the mosque and visible from the maydan, the guldasta of the Shah Mosque appears to have been conceived as a counterpart to the qaysariyya belfry. As the drawings by De Bruyn (fig. 29) and Grélot (fig. 43) indicate, a similar guldasta originally stood atop the Shaykh Lutfallah Mosque too. Although such wooden elements were common in royal pavilions, their positioning in mosques for the purpose of calling to prayer has no precedents in pre-Safavid architecture. Indeed, the guldastas on the mosques of the maydan—an element that would become ubiquitous in Safavid religious edifices—were the first known examples of their kind. The practice of giving the call-to-prayer from rooftop kiosks may have been revived based on a Shi'i tradition; the peculiar pyramidal roofs of these guldastas,

FIGURE 43
Guillaume-Joseph Grélot, drawing of the eastern side of the Maydan-i Naqsh-i Jahan, 1674, detail showing the Shaykh Lutfallah Mosque (left) and the clock pavilion (right). From Ambrosio Bembo, "Viaggio e giornale per parte dell'Asia di quattro anni incirca fatto da ma Ambrosio Bembo Nobile Veneto," Italy, ca. 1676. University of Minnesota Libraries, James Ford Bell Library, MS 1676 fBe.

though, seem to have been devised in dialogue with the qaysariyya belfry, with the human voice taking the place of a striking bell.[56] The architectural affinity between these three elements around the maydan—the guldastas of the two mosques and the belfry—suggest that the clock tower was a deliberate component of the maydan that was harmonized with its context.

CLOCK PAVILION WITH AUTOMATA
Whatever the precise origin of the qaysariyya clock may have been, it appears that it had ceased to function by the late 1630s, likely due to a lack of expert maintenance after the death of its maker or operator. This partly explains why a new clock pavilion was erected on the maydan in the 1640s. Chardin dates the second clock to

the coronation of Shah Abbas II (r. 1642–66), describing it as a "childish game" erected for the king's entertainment.[57] The date given by Chardin is plausible, but his account of the clock's purpose is likely a conjecture. (Since Shah Abbas II was a minor when he ascended the throne, Chardin seems to have assumed that the clock was set up for the young monarch's entertainment.)

The published pictorial representations of this clock pavilion (two views of the maydan by De Bruyn, the engraving in Chardin's travelogue), alongside Grélot's rendering (fig. 43) and an unpublished sketch by Kaempfer, convey a general sense of its overall architectural form and location. Occupying three bays on the eastern side of the maydan, the pavilion stood to the

FIGURE 44
View of the Ali Qapu, with the pillared hall (*tālār*) added in the 1640s. Photo courtesy of Daniel C. Waugh.

south of the Shaykh Lutfallah Mosque. Two stories high, it consisted of a domed hall fronted by a pillared porch raised atop a masonry base that projected outward from the arcades. It appears that the clock pavilion echoed, on a smaller scale, the form of the Ali Qapu (fig. 44), which was provided with a talar (wooden pillared hall) in 1644.[58] These two structures were no doubt part of a coordinated campaign to reshape the maydan during the early years of the reign of Shah Abbas II.

The new clock pavilion contained a mechanical system that signaled the hour through the sound of music and the movement of puppets. Qazvini refers to it as a "miraculous palace" (*kākh-i u ʿjūba-kār*) and the "essence of the book of the world" wherein a new image (*ṣūrat*) appears every moment.[59] Chardin remarks that the clock animated "several large puppets (their heads, arms, and hands), which [were] attached to

figures painted on the wall and play[ed] musical instruments."[60] In Grélot's drawing these "puppets" are rendered around what seems to be a circular dial (fig. 43). Kaempfer relates that the pavilion showed the spectator "scenes of war, with automatons which, after payment of a few coins, imitate[d] living scenes."[61] This was likely a form of augury that was also observed by Membré in the clock in Tabriz.[62] Knowing the auspicious hour (*sāʿat-i saʿd*) was central to the astrological beliefs prevalent at the court and among commoners alike.[63]

The installation of a new clock pavilion with automata—which was likely seen as a more elaborate device than its predecessor—hints at the reasons why the qayasariyya clock had been left idle. From a local perspective, this replacement is suggestive of a return to a hybrid, indigenous type of clock that probably originated in Isfahani's invention a century prior; equipped

with automata, the second pavilion was more in line with traditional water clocks. Still, the new clock did not necessarily diminish the sense of the hourly passage of time in the maydan; after all, it was known as a *vaqt-i sāʿat*, or an "hourly clock," and might have been used for coordinating daily, commercial, and ceremonial activities. The sound of music arising from the clock linked it to the naqqara-khana; if the latter was attuned to natural and calendrical rhythms, the former signaled the abstract, hourly division of the day. Hence, in his poem, Qazvini shifts from the sound of the naqqara-khana to that of the clock pavilion, drawing an aural link across the maydan.

THE URBAN SENSES OF TEMPORALITY

As the primary hub of social life in Isfahan, the Maydan-i Naqsh-i Jahan integrated a host of urban activities in a uniform ensemble. And the diversity of these activities could be felt in the maydan's soundscape—in the hustle and bustle of the market, the sundry noises of the crafts, the steady hum generated by the chatter of the coffeehouses. This constant cacophony of everyday life created an acoustic background for a series of codified sounds that emanated from the mosques, naqqara-khana, and clocks, generating a sonorous temporal order. Three times per day (according to the Shiʿi custom), the call to prayer resounded in the square, summoning the faithful to worship; the time of the midday prayer was likely determined by a stone sundial that is still extant at the Shah Mosque.[64] A long-established emblem of civic time, the naqqara-khana employed forty musicians who played "each day at sunset and two hours before sunrise" as well as on occasions such as "the new moon and religious festivals."[65] The daily natural cycles of time were signaled by the naqqara-khana.

The maydan also harbored a range of materials that occasioned novel regimes of urban temporality. In particular, the presence of coffeehouses and the intake of caffeine—a stimulant—altered the pattern of daily activities and the rhythms of work and leisure in public spaces. The sources reveal that the coffeehouses were particularly crowded in the morning and after dusk, extending the urban life of the square into the darker hours of the night. Active around the clock, the maydan's illuminated coffeehouses, then, exerted a major impact on the experience of nightlife in Isfahan. Integrated into the physical fabric of the city, coffee and other new comestibles heightened the density and intensity of urban life and accelerated the tempo of civic existence. The compact temporal structure of the "Guide for Strolling"—which lays out a tightly scheduled excursion unfolding over the course of a single day—echoes this shift in the urban perception of time and space.

The import of the maydan's two successive clocks emerges in relation to these urban experiences. The timepieces each added a temporal-acoustic register to the polyphony of tones that pervaded the square. In the civic heart of the Safavid capital, at least for a while, the sound of a bell mingled with the call to prayer, as it did in the central squares of Kashan and Tabriz. Rather than supersede natural or religious cycles of time signaled from the naqqara-khana and the guldastas of the mosques, the hourly secular time unfolded in harmony with other temporal sequences. If Isfahan was an early modern city, it could be felt in this characteristic merger of sounds—and in the distinctive patterns of civic existence that the city's material realities engendered. Together, these elements transformed the texture of urban life in accord with the temporal rhythms of a new age, creating a distinct sense of time in the cosmopolitan civic center of Isfahan.

The Visual Order of the Promenade
THE CHAHARBAGH AND ITS SENSORY LANDSCAPE

In his travel narrative, Pietro Della Valle relates that on June 26, 1619, his Nestorian Christian wife joined Safavid royal ladies and Isfahan's noblewomen for an all-female excursion on the city's grand promenade, the Chaharbagh (fig. 45). On Wednesdays, he noted, the promenade and its adjoining gardens were used exclusively by women, who would amble there and amuse themselves past midnight.[1] Della Valle's narrative is corroborated by Yazdi, who recounts that on Wednesdays, beginning in the spring of 1609, the Chaharbagh and the Allahverdi Khan Bridge were reserved for women. According to Yazdi, this weekly urban ritual was ordained by Shah Abbas, who allegedly worried that women were "deprived of strolling [*sayr*] and conversing [*ṣuḥbat*] on the Chaharbagh." On such days, men were barred from entering the area, and only "female vendors" were allowed in.[2]

To the women who strolled its tree-lined walkways, the Chaharbagh offered a plethora of sensual pleasures. During the sweltering summer days and nights of Isfahan, its leafy trees, pools, and streams created a climatically pleasant environment, while its coffeehouses and taverns furnished additional delights—drinks to stimulate or inebriate the senses, venues where they could linger and converse. The Chaharbagh was no doubt the primary locus of urban leisure for the residents of Safavid Isfahan, female and male alike. Whereas commodities and markets were integral to one's experience in the Maydan-i Naqsh-i Jahan, landscape elements played a fundamental role in the Chaharbagh. Here the prolonged leisurely experience of time and space—an intimate encounter with the cycles of nature—supplanted the rapid beat of daily life that pervaded the royal square.

Monumental and verdant yet intricately planned and ornamented, the Chaharbagh spawned manifold urban experiences by engaging its visitors in a carefully choreographed array of sensory, social, and aesthetic pleasures. A reconstruction of the promenade's spatial configuration and architectural components—the now-vanished pavilions, Sufi convents, and drinking establishments—is thus essential to appreciation of its variegated functions.[3] My aim in reconstructing the physical layout of the Chaharbagh, though, is neither to conduct a rigid formal analysis nor to establish a taxonomy of gardens and pavilions. Rather, I seek to uncover the holistic experience of the Chaharbagh and intimate its phenomenological character. More specifically, I strive to reimagine and expound the promenade's embodied optical experience: that is, the ways in which architectural and landscape elements were designed and arrayed to stage, frame, and enact various modes of vision in a dynamic social environment. The socio-aesthetic analysis of the Chaharbagh's visual structure reveals how it constituted a

by ornate pavilions, the Chaharbagh repre-
sented and embodied a panoptic gaze. This
all-encompassing view is manifest in the grand
geometric order of the promenade. The creation
of this massive ensemble of gardens—and all
their hydraulic, botanical, and masonry compo-
nents—had required considerable planning and
coordination. Seen as a whole, the regular layout
of the gardens, the seemingly infinite array of
pavilions, and the flow of water in channels run-
ning for hundreds of meters all suggest a ruler
capable of accruing sufficient financial, mate-
rial, and human resources for the construction
of such a large-scale complex.

The sense of cohesion and uniformity that
characterized the Chaharbagh was certainly
achieved through a concerted design process.
Indeed, a planimetric rendering of the ensemble
is not merely a modern-day form of represen-
tation; likely, the overall scheme of the project
(or at least portions thereof) was first worked out
on paper, though in accordance with different
graphic conventions. There is ample evidence
that in the Persianate world, especially from
the fourteenth century onward, architectural
drawings (referred to as *ṭarḥ*, or "design") were
commonly prepared for building projects com-
missioned by the ruling elite.[4] As a means of
conceiving and imagining urban and architec-
tural projects, graphic representation was thus
intelligible to builders, patrons, and erudite fig-
ures of the day. Moreover, one could clearly per-
ceive the overall layout of the Chaharbagh from
the slopes of Suffa Mountain, on the southern
fringe of Isfahan, where belvederes were built
for gazing at the cityscape. Seen from afar or
above, the sheer monumentality of this immense
artificial landscape conveyed the notion of domi-
nance over the natural world; this was undoubt-
edly a key message that the project in its entirety
was intended to express.

unique civic arena for individual and commu-
nal encounters. The weekly strolls of Isfahani
women represent just one example of the
myriad new urban experiences that the grand
promenade of the Safavid capital enabled and
harbored.

PANOPTIC VISTAS AND KINETIC ENCOUNTERS

Extending for more than four kilometers, cov-
ered with pools and greenery, and bordered

Conveyed through planimetric features, this message, however, constituted only a layer of the overall meaning of the Chaharbagh. For an orthogonal projection—the diagrammatic representation of an imagined or constructed building project—is an abstract portrayal that reduces a three-dimensional spatial reality to a flat assemblage of lines. Highlighting order and layout, it emphasizes planimetric features over perceptual qualities of space. As D. Fairchild Ruggles remarks with respect to the tomb complex of the Mughal emperor Humayun, "two-dimensional representations assume that the viewer is external to the system, and that the system consists of the patron, his agenda, and the stylistic genealogy of the building." It is through a consideration of the optical perception of the viewer, Ruggles notes, that "the garden system" can be analyzed as an expression of "sovereignty and dominance."[5] In the case of the Chaharbagh, the analysis of the spectator's perception has broader social implications, for it was neither an enclosed estate like Humayun's funerary garden nor a secluded imperial pleasance; it was a public promenade that served as the backbone of an urban system. Here visual encounters were intimately intertwined with the social experiences and day-to-day deeds of the city's inhabitants, who assumed the roles of onlookers and participants alike in an ongoing urban spectacle.

In the Chaharbagh, vision was made palpable through various architectural devices. As a linear space, though, the promenade was apprehended primarily by a mobile observer; continuous, kinetic perception was more central to one's experience than the static viewing of a singular vista from a fixed stance. It is thus not coincidental that period descriptions evoke a sequential itinerary. This spatial trajectory also informs the narrative that follows, which reimagines the experience of the Chaharbagh through the gaze of a moving beholder.

THE WORLD-REVEALING PAVILION

The Chaharbagh lay outside the boundaries of medieval Isfahan. Its northern end was marked by the Dawlat Gate (Darvaza-yi Dawlat), a major entrance to the walled city that was associated with the palace complex (*dawlatkhāna*). Modern urban interventions have eradicated the original layout of this area, but earlier maps and historical photographs permit a reconstruction. Based on these documents, it appears that the Chaharbagh was accessed from the Maydan-i Naqsh-i Jahan through a route that abutted the north side of the palace complex. This pathway terminated in the area behind the northern entrance to the Chaharbagh, an urban juncture where the routes of the old city and extramural avenues converged (see fig. 22). In its original context, then, the Chaharbagh was experienced as a distinct, self-contained urban space. Its sense of order and monumentality was dramatized by the prior experience of the narrow, barren alleyways that led to it.

On entering the promenade, one would have encountered a pavilion known as the Jahan-nama ("world-revealing/-displaying"). Because of its prominent location, the building was captured in several photographs before its demolition in the late 1890s. Taken from the southwest, within the Chaharbagh, the earliest photograph (fig. 46) depicts the Jahan-nama as a cubical three-story structure pierced with multiple balconies and windows on all sides. The pavilion was built on the long-standing cross-in-square (*chahār ṣuffa*, "four alcoves"), or ninefold (*hasht bihisht*, "eight paradises"), scheme, which consisted of a central hall with four axial iwans and four rooms in the corners, forming a cross-shaped space at the center.

FIGURE 46
Southwestern view of the Jahan-nama, with the Dawlat Gate at left, as seen from the Chaharbagh. Photo by Joseph Papazian, ca. 1880–85. Gulistan Palace Photo Archive, Album 199, no. 8.

In the Jahan-nama, the cruciform scheme was modified to accommodate the views of the surrounding landscape. Overlooking the Chaharbagh, the main elevation contained a large central iwan flanked by two smaller ones. The four rooms at the corners of the top floor featured diminutive windows that were originally covered with wooden screens.[6] Based on evidence from similar edifices, the roof terrace must also have been used as a lookout for gazing on the cityscape and adjacent gardens.[7] With its loggias, windows, and screens, the Jahan-nama thus encompassed varied modes of viewing.

It appears that the building's solid first floor was meant to provide a platform for a porous upper-story block articulated with various architectural elements mediating the gaze.

The Jahan-nama was not a freestanding pavilion but rather was integrated into the spatial structure of the Chaharbagh. As is evident in the photograph (fig. 46), a row of arched recesses adjoined the building on its western side. This arcade contained what the sources refer to as the Dawlat Gate. The gate's position is confirmed by contemporary accounts reporting that a city entrance lay on the side of the palace that

stood at the northern end of the Chaharbagh.[8] Chardin notes that another gate, on the opposite side of the Jahan-nama, led to the living quarters of the palace complex and was used solely by "women and eunuchs of the harem and the king."[9] Likewise, Tavernier remarks that only the shah and his family could enter the Chaharbagh through the pavilion; ordinary people had to pass through the adjoining gate.[10] These accounts indicate that the Jahan-nama was originally flanked by two gates: one served as the public entrance to the promenade, while the other provided direct access to the palace complex. Indeed, from the area behind the pavilion, a diagonal route—what Della Valle called a "corridor" and Kaempfer a "closed route"—led directly to the Harem (see fig. 22). On the all-female Wednesdays, this private route (which was apparently built along old city walls) provided the court ladies with convenient access to the Chaharbagh.

The name of the pavilion, meaning "world-revealing/-displaying," evoked the legendary cup of Jamshid, a mythical king who could observe the entire universe in his "world-revealing goblet" (*jām-i jahān-namā*). A recurrent metaphor in poetry, Jahan-nama also evoked a ubiquitous type in Persianate palace architecture from the Timurid era onward.[11] In the former Safavid capital Qazvin, for example, a tower of the same name stood on the threshold of the palace complex, overlooking a plaza known as the Maydan-i Asb.[12] The Jahan-nama of Qazvin was also built atop a gateway of the palace complex and featured a talar, whence the prospect "from the east to the west [was] visible."[13] These precedents suggest that *jahān-namā* designated a type of high pavilion—a belvedere "displaying the world" to those who occupied it. According to a local history of Isfahan compiled around 1882–85, the Jahan-nama at Isfahan carried

this name because, "from its top, all the gardens, the Chaharbagh, and [other] buildings are revealed [*namāyān*]."[14] The viewing function of the Jahan-nama is also highlighted by Della Valle, who describes it as a square building, "full of balconies and windows," that was erected "for the sole purpose of viewing from there, and revealing from there, the entire length [of the Chaharbagh]."[15] Della Valle apparently alludes to the name of the building—world-revealing—by describing its main function as revealing the promenade's entire length.

In his travel narrative, Chardin notes that Shah Abbas erected the pavilion so that the women of the harem could view spectacles such as the arrival of ambassadors.[16] Because of its proximity to the harem, the Jahan-nama was clearly associated with the private residence of the shah and the royal ladies. Even so, it is implausible to assume that it was built solely or primarily for the use of the harem women. Rather, as its design and location suggest, the Jahan-nama was principally conceived as an entrance (*dargāh*) to the palace complex. In overall form and function, the pavilion resembles the other gateway of the palace complex, the Ali Qapu, which, in its initial stage of construction (i.e., before the talar was added in the 1640s), was also a square-based tower (see fig. 19).[17] As in the Ali Qapu, the lower level of the Jahan-nama likely served as an atrium for entering the palace grounds, while the upper-floor halls provided a setting for receptions. Overlooking the two main urban spaces of Isfahan, these two towers embodied the royal gaze in the major interfaces of the palace complex.

The Jahan-nama also engaged its users and viewers through its figural tile panels, which are now scattered in museums. Old photographs reveal that an intricate scene, executed in polychrome glazed tiles, was mounted in

FIGURE 47

A tile panel installed on the western facade of the Jahan-nama. Detail of a photo by Albert Hotz, 1891. Platinum print. Leiden University Libraries, Hotz Album 10 ("A Collection of Photographs taken in Persia, Turkey and in the Caucasus, during a seven months' journey in 1891," vol. 2), no. 9.

the arch spandrels of the central bay on the western facade of the building, on the side of the Dawlat Gate (fig. 47). Measuring around 5.4 meters in length, this panel consisted of two mirrored scenes of elegantly garbed female and male figures scattered in a verdant setting. Salvaged fragments, including a set of tiles depicting a cupbearer (sāqī), convey a clearer sense of the panel's color palette and formal details (fig. 48). The panel's stylistic elements—curved postures, arching willows, reclining women—recall the work of the famed painter Riza Abbasi (ca. 1565–1635), who may have been involved in its production; according to Iskandar Beg, the Chaharbagh's lofty edifices were adorned with "images [created] by innovative painters" (ṣuvar-i muṣavvirān-i nādira-kār).[18] One

such wonderous motif, rendered in the upper corners of the panel, shows a kneeling man in European costume offering a piece of fabric to a lavishly dressed woman reclining on cushions; the same imagery appears in another panel, now at the Metropolitan Museum of Art, New York, that was once installed elsewhere within the Jahan-nama.[19] This motif visualized the global connections of Isfahan while also evoking a number of erotic notions that came to be associated with the European figure in Safavid times.[20] With its bold design, saturated colors, and sensual imagery, the panel and its "curiously painted men and women in European dresses" caught the eye of any visitor entering or exiting the Chaharbagh via the Dawlat Gate (fig. 49).[21]

The placement of this panel at the Chaharbagh's gate is emblematic of the ubiquity and visibility of sensuous figural imagery in the urban spaces of Safavid Isfahan. Here, as in many other examples, the figural scene did not embellish a secluded royal pavilion but was deliberately placed at the public entrance to the city's grand promenade. The panel's location at the threshold of the Chaharbagh is indeed consistent with the urban design of Isfahan, where portals were commonly adorned with paintings that echoed the city's pleasures.[22] Depicting paragons of male and female beauty in a garden setting, this panel visualized the Chaharbagh's atmosphere as an earthly paradise, evoking the Qur'anic description of the heavenly garden filled with houris and youthful servers.

To the elite inhabitants of Isfahan, however, the elegant women represented, first and foremost, the city's courtesans, who ambled through the Chaharbagh, while the youthful male figures embodied the coffee and wine servers that one would have encountered at the Chaharbagh's drinking establishments, just a short walk south of the Jahan-nama. As pedestrians set foot in the promenade, the panel induced a leisurely mood in its beholders—a lyrical eroticism couched in a metaphor of the heavenly garden.

THE VISUAL RHYTHM OF THE PROMENADE
After dealing with the Jahan-nama, period descriptions of the Chaharbagh turn to its landscape elements. Beginning at the small square basin that lay directly before the pavilion, they follow the stream of water in the channel that ran down the central walkway. Made of cobbles rimmed with cut stones and elevated slightly above the ground, the central walkway and its waterway, meager though they may seem in the plan, were fundamental to shaping the visitor's perception: they structured the visual space of

FIGURE 48
Tile panel with cupbearer, salvaged from the Jahan-nama, ca. 1602. Painted and polychrome-glazed stonepaste, *cuerda seca* technique. Each tile approx. 22.5 × 22.5 cm. Gift of Jane M. Timken, class of 1964, Smith College Museum of Art, Northampton, Massachusetts, SC 2021.26.

FIGURE 49
Reconstructed axonometric view of the Dawlat Gate and west/south facades of the Jahan-nama, at the northern end of the Chaharbagh, showing the location of the tile panel in the spandrels (fig. 47). Model by author.

the Chaharbagh and bound its various components together.

The perceptual prominence of the central walkway is evident in a photograph that captures the view of the Chaharbagh from the raised standpoint of the Jahan-nama (fig. 50). Water flows in a stone-edged channel carved into the pavement, which is here interspersed with the elongated shadows of plane trees, or chinars, cast by the setting sun. Other elements of the promenade are dwarfed by the bold presence of the perspectival corridor formed by the double rows of soaring trees. The photograph represents the Chaharbagh from a vantage point that, as Della Velle put it, reveals its entire length—an uninterrupted vista that emanates from a royal pavilion and evokes a dominant gaze.

Although from an elevated standpoint the Chaharbagh appeared as a unified space, the visitor proceeding on foot would have had a more variegated sensorial experience. Striding in the shade of the foliage, one would emerge into a bright space occupied by an enormous octagonal pool. This dramatic shift in spatial qualities would have rendered the encounter with the pool especially striking: during the day, the sudden sight of flickering lights on the surface of the water created a scene distinct from the shaded walkway. As the flowing water came to a standstill, a sense of tranquility prevailed.

FIGURE 50
View of the Chaharbagh from the southern iwan of the Jahan-nama. Photo by Joseph Papazian, ca. 1880–85. Gulistan Palace Photo Archive, Album 199, no. 21.

A visitor who glanced northward while standing in the area of the octagonal pool could regard a distant view of the Jahan-nama, as is evident in Kaempfer's sketch, which conveys an impression of the perceptual composition of the Chaharbagh's north view (fig. 51). The rapidly drawn lines of Kaempfer's doodle capture how the Jahan-nama's elevation, the central channel, and double rows of trees presented a unified prospect to the observer. The arch of the pavilion's upper iwan echoes the shape of the trees' spreading crowns, framing the "revealing" eye of the building. The visual presence of the pavilion was, in turn, augmented by its positioning at the vanishing point of a perspectival prospect. During ceremonial processions, which commonly commenced at the Hizar Jarib Garden, the Jahan-nama would have provided a terminus for the royal parade. The pavilion at once generated a view and marked the end point of a vista.

The sight of the Chaharbagh's tree-lined walkway figures in Qazvini's versified description of the promenade and the Hizar Jarib Garden.[23] The poet takes his readers to the Chaharbagh in the fall, when the green leaves of the chinar trees turned amber, yellow, and red,

FIGURE 51
Engelbert Kaempfer, sketch of the Jahan-nama viewed from the Chaharbagh. British Library, MS Sloane 5232, fol. 38r. © The British Library Board.

it lifeless / It is alive, water flows in it. When it reaches the pool, it stops moving / For it is difficult to let go of its pool."[26] If flowing water propels movement, the pools are sites that cause the visitor to linger.

The configuration of pools and pavilions in the northern part of the Chaharbagh is recorded by Kaempfer and Coste (figs. 52 and 53). Each drawing is informed by a different graphic convention—Kaempfer's plan represents scale and proportions fairly accurately, while Coste highlights symmetry and rhythm—but both convey a sense of the overall layout of the Chaharbagh: the bold presence of the pools and the sequential array of pavilions arranged in pairs at the entrances to the bordering gardens. Coste's plan also depicts the four rows of plane trees that were planted at regular intervals along the edges of sunken flower beds. These four rows of trees defined the three walkways of the Chaharbagh. Containing a watercourse punctuated by pools and cascades, the central lane—shaded by a *ṭāq-i sabz*, or "green vault"—was the main venue for leisurely strolls.[27] Delimited by a row of trees and the walls of the gardens, the side walkways were, by contrast, used primarily by those who wished to go about their business, whether on foot or on horseback.[28] The major physical element that unified the entire four-kilometer length of the promenade was the uninterrupted stone pavement.

Mapping these drawings and other pieces of photographic and architectural evidence onto a present-day plan of the Chaharbagh reveals a fuller picture of the northern section of the promenade (fig. 54). Stretching from the Jahan-nama to the river, this portion of the promenade—approximately 1,230 meters long and 47 meters wide—was clearly conceived as a geometrically planned garden; it is not only composed of flower beds, pools, and cascades

floating in the air and tumbling on the ground. With the injunction "Behold the chinars arrayed on both sides!," Qazvini sets up his portrayal of the Chaharbagh. Yet one is not to become absorbed in this "initiatory verse" (*maṭlaʿ*), for "every hemistich [*miṣraʿ*] of it is salient."[24] The promenade is clearly likened to a poem, its rhythmic composition compared to the rhymes that modulate a work of verse. A ubiquitous metaphor for poetry was *naẓm* (literally, "joining [pearls] into a string"), and the serial arrangement of paired edifices on the Chaharbagh evokes the syntactic structure of couplets (s. *bayt*) with pairs of hemistiches (s. *miṣraʿ*).[25] To convey the promenade's spatial flow, Qazvini highlights the sequential experience of the stone-edged channel (*jadval*) and pools (s. *hawż*): "If you see that the channel is still, do not call

FIGURE 52 (above)
Engelbert Kaempfer, plan of the northern part of the Chahar-bagh, detail. British Library, MS Sloane 5232, fol. 42r. © The British Library Board.

FIGURE 53 (right)
Pascal Coste, plan of the Chaharbagh, 1840, detail. Marseille, Bibliothèque de l'Alcazar, MS 1132, fol. 47b.

but also symmetrically arranged on both axes,
as in a classical quadripartite garden. (Note how
the shapes and positions of the pools are mir-
rored along the lateral axis.) It is as if a four-part
garden has been lengthened along one axis to
form an "elongated" chaharbagh, as Alemi has
noted.[29] The bordering walls, which were likely
articulated by blind arches, amplified the sense
of an enclosed garden. The walls nonetheless did
not block the view; according to Chardin, they
featured perforated brickwork that made it pos-
sible to peek into the adjacent gardens.[30]

The reconstructed plan also reveals the basic
spatial structure of the Chaharbagh, character-
ized by a rhythmic alternation between tree-
lined walks and nodal spaces each composed
of a pool and two facing pavilions. Reaching
each pool, the cobbled pavement expanded to
the edges, directing the gaze toward the twin
pavilions that, in Qazvini's words, "opened their
eyes of bewilderment on the pools."[31] Bordered
by the ornate facades of the confronted edifices,
these nodes induced a host of aesthetic and sen-
suous pleasures. The sight of these huge pools
and their flanking pavilions in fact informed
the quintessential scene of the Chaharbagh,
frequently noted in period descriptions. The
English traveler John Fryer, for instance, wrote
of "the ravishing Sight of the delicate Summer
houses by each pond's side."[32]

The alternation between movement and sta-
sis spawned by the dual spatial sequence of the
Chaharbagh was not intended merely to induce
a kinetic aesthetic experience; it also accommo-
dated the two main functions of the promenade,
best captured by the terms *sayr* and *ṣuḥbat*.
Derived from the Arabic root *s-y-r* (literally,
"to move," "to go around"), *sayr* connotes a lei-
surely stroll. By contrast, the term *ṣuḥbat* comes
from the root *ṣ-ḥ-b*, which denotes companion-
ship and conversation and is typically stationary.

Thus, when Shah Abbas wanted to institute the weekly reservation of the Chaharbagh for women, he underscored that women were "deprived of *sayr* and *ṣuḥbat*" on the promenade. If the linear walkway was intended for strolling, the nodes formed by the pools and confronting pavilions were loci of repose and social interaction.

Each node along the Chaharbagh offered a new sensation and enabled distinct experiences. Adjoining the palace complex, the four gardens on the northern side served as royal estates but were accessible to the public. According to Della Valle, everyone was allowed to enter the king's gardens and "eat of the fruit of infinite sorts which they contain, by making a trifling present to the gardener."[33] The heart of the promenade, meanwhile, was dedicated to coffeehouses and at least one wine tavern. Further south lay a pair of Sufi convents, and the gardens abutting the river served as menageries of wild animals and exotic birds. If landscape elements created a unified experience throughout the promenade, social, material, and sensual components rendered each node the site of a new encounter.

ROYAL GARDENS AND PAVILIONS

The Jahan-nama was the crowning monument of four royal pavilions that were arranged in pairs on either side of the northern section of the Chaharbagh. Flanking an octagonal pool, the first pair marked the entrances to the Tent (*khargāh*) and Sweet-Smelling (*musamman*) Gardens.[34] Kaempfer's survey indicates that the latter garden was laid out on the classical chaharbagh ("quadripartite" garden) scheme; it consisted of perpendicular tree-lined walkways that intersected at an octagonal platform, dividing the garden into quadrants planted with aromatic herbs and flowers (fig. 55). A water channel entered the garden from the east, encircled the central terrace, and flowed through the gateway,

FIGURE 55
Engelbert Kaempfer, plan of the Sweet-Smelling (*musamman*) Garden. British Library, MS Sloane 2910, fol. 102. © The British Library Board.

This building is one of the few components of the Chaharbagh that has partially survived, offering a glimpse into the intricate interior design of the promenade's now-lost edifices (fig. 57). With a perimeter approximately thirteen by fourteen meters, the two-story building is entered through a recessed porch that gives access to a domed hall, beyond which an iwan opens onto the garden. Although the upper floor (bālākhāna) is not preserved in its original form, later sources suggest that it featured "a talar overlooking the garden and its building as well as the landscape of the Chaharbagh."[37]

The pavilions that flanked the octagonal pool probably also contained stores offering sweetmeats and food to the public. The Spanish ambassador Don García de Silva y Figueroa, who visited Isfahan in 1619, reports seeing shops selling fruits and preserves on the Chaharbagh.[38] In his account of the Chaharbagh's inauguration in 1602, Yazdi also refers to the construction of a chahār ṣuffa, next to the harem (janb-i ḥaram), that consisted of "three pools with fountains." Yazdi then describes the gustatory delights furnished by the "shops" (s. dukkān) that the edifice contained. One shop offered "varieties of delicious foods [aṭʿama] and types of appetite-whetting cooked dishes [maṭbūkhāt] that far surpassed what the sweep of imagination could comprehend." It was a "mine of graciousness" (kān-i niʿmat) that had opened its eyes for "the sustenance of the world" (rizq-i ʿālam), Yazdi asserts in a couplet. In the other shop, meanwhile, "master confectioners prepared all kinds of sweets [ḥalviyyāt], preserves [murabbiyyāt], as well as nuts and dried fruits [tanaqqulāt]."[39] Considering the overall layout of the Chaharbagh and Figueroa's description, these sweets- and food-serving establishments were likely part of the entrance pavilion of the Tent Garden (and perhaps its counterpart on the other side of the

which apparently was the garden's only masonry structure.[35] Judging from Safavid paintings, the planted quadrants were likely fenced in by red wooden railings (miḥjar), and a wooden canopy may have graced the garden's central platform.

Facing the Sweet-Smelling Garden was the Tent (khargāh) Garden, named after the enormous khargāh, or "big round tent" (khayma-yi buzurg-i mudavvar), that stood at its center.[36] Kaempfer's sketch depicts a tent with a conical roof pitched atop an octagonal platform borne up by an arcade and accessed by a flight of steps (fig. 56). This textile edifice may have been the centerpiece, but the principal structure of the Tent Garden, as in the Sweet-Smelling Garden, was the pavilion raised at its entrance.

Sweet-Smelling
(*musamman*)
Garden

Tent (*khargāh*)
Garden

Pastry
Shop?

Pastry
Shop?

↑N

0 5 10m

0 2 5m

promenade).[40] This hypothesis is strengthened by Tavernier's observation that in the pavilion to the east of the first pool (the entrance to the Tent Garden) was "a low vaulted room with a water basin in the middle, where people would go to drink coffee."[41] By the time of Tavernier's visit, the pastry shops had likely added coffee to their services.

Striding southward from the octagonal pool, one reached another massive tank of water. Square in plan, this pool offered an elaborate setting for those who wished to linger: an octagonal platform, raised one foot above the water and surrounded by "a beautiful balustrade," stood in the middle of the pool.[42] The pool's elegant design matched the prominence of the gardens that lay to either side—namely, the Throne (*takht*) and Nightingale (*bulbul*) Gardens. The Throne Garden stood out for its distinct layout, based on its two pavilions: one along the promenade, another on the opposite side, overlooking a tree-lined avenue (*khīyābān*) that ran westward, perpendicular to the axis of the Chaharbagh, and functioned as the principal artery of the

newly developed Safavid quarter of Abbasabad.[43] (Both pavilions and a portion of the Abbasabad avenue are represented in Kaempfer's drawing reproduced in figure 52.) The design of the Throne Garden thus exemplifies how the gardens of the Chaharbagh were laid out as integral components of a broader urban scheme. The position, form, and configuration of the pavilions were determined by the garden's relationship to the surrounding urban landscape.

The Nightingale Garden was probably named after the songbirds bred and lodged there; a court official (ʿandalībchī bāshī) was in charge of nightingales and other songbirds in later Safavid times.[44] The chirping of birds above the grounds of the Nightingale Garden would have created a distinct soundscape in this area of the Chaharbagh. On the garden's pools, Kaempfer also saw "frolicking ducks with gilt plumes and very numerous swans."[45] The Nightingale Garden is better known today, however, for the Hasht Bihisht ("eight paradises") pavilion (fig. 58), constructed in 1669–70.[46] Yet originally the garden's main and only edifice was its now-lost

FIGURE 58 (*left*)
Pascal Coste, interior of the Hasht Bihisht, with the entrance pavilion of the Nightingale Garden in the background. From Pascal Coste, *Monuments modernes de la Perse* (Paris: A. Morel, 1867), plate XXXVIII. Private collection. Photo: The Stapleton Collection / Bridgeman Images.

FIGURE 59 (*above*)
Engelbert Kaempfer, entrance pavilion of the Nightingale (*bulbul*) Garden. British Library, MS Sloane 2910, fol. 103b. © The British Library Board.

gatehouse, whose garden facade, sketched by Kaempfer (fig. 59), matches the edifice depicted in the background of Coste's engraving of the Hasht Bihisht (fig. 58). The two-story gatehouse appears to have followed the typical *chahār ṣuffa* scheme, with multiple balconies overlooking the garden and the Chaharbagh.

As their names and setting indicate, the four gardens that stood at the northern end of the Chaharbagh were associated with royalty; the tent and the throne were the insignia of imperial power in the Turko-Mongol ethos of kingship on which the Safavids relied as one of their main sources of legitimacy. On the Chaharbagh, the Tent and Throne Gardens were paired—in a lyrical move—with the Sweet-Smelling and Nightingale Gardens. These estates certainly contained the olfactory and aural delights suggested by their names; even

the aural utterance of their names would have suffced to evoke these sensations. Moreover, it appears that the gardens originally contained no structures except for the entrance pavilions, which were primarily conceived as constituent parts of the Chaharbagh rather than of the gardens that lay behind them. Animating the promenade through their sensual contents, these gardens and pavilions were integral components of an urban landscape that had been planned and built by the state and deliberately made accessible to the public.

COFFEEHOUSES AND TAVERNS

Departing the pool that lay between the Nightingale and Throne Gardens, one would have grown accustomed to the rhythmic alternation between the two principal views of the Chaharbagh: the vista of the tree-lined walkway and that of the large pools flanked by monumental edifices. But as one approached the heart of the northern section of the Chaharbagh, midway between the Jahan-nama and the river, a different arrangement prevailed. One first reached a stone-paved area, where two gates led to the

FIGURE 60
Pascal Coste, view of the madrasa of Shah Sultan Husayn, with the Chaharbagh in the foreground. From Pascal Coste, *Monuments modernes de la Perse* (Paris: A. Morel, 1867), plate XVIII.

FIGURE 61
A coffeehouse on the Chaharbagh, ca. 1880s. Stephen Arpee Collection of Sevruguin Photographs, FSA A2011.03 A.12b. Freer Gallery of Art and Arthur M. Sackler Gallery Archives. Purchase, 2011. Photo: Antoin Sevruguin.

neighborhood of Abbasabad, in the west, and the palace complex, in the east.[47] Currently, this portion of the Chaharbagh is dominated by a madrasa-mosque complex (fig. 60), erected in the early 1700s by Shah Sultan Husayn (r. 1694–1722).[48] Yet before the erection of this religious foundation, this area had a very different social atmosphere: throughout the seventeenth century, coffeehouses and at least one wine tavern thrived here. The structure incorporated into the madrasa's northeastern corner (fig. 61), which functioned as a coffeehouse through the early twentieth century, is indeed a remnant of the original drinking houses that were built here as part of the original building program of the Chaharbagh under Shah Abbas. Constructed at the heart of the northern portion of the promenade, these pairs of establishments lay at the corners of the adjacent gardens (fig. 54).[49]

The knowledge that these structures functioned as coffeehouses and wine taverns comes from literary sources. In his entry on a certain Baba Shams-i Tishi of Shiraz, Awhadi relates that in 1603–4 Shah Abbas had a wine tavern (*maykhāna*) set up for Shams in the Chaharbagh.[50] Shams was free to behave as he would in that royal tavern, Awhadi notes, and "whoever drank wine in that tavern was exempt [from punishment]."[51] A later source refers to Shams as a common person (*avāsiṭ al-nās*) and an expert in music but claims that what was built for him was a coffeehouse (*qahvakhāna*), with a wine house (*sharābkhāna*) set up beside it.[52] It seems that upon the introduction of the coffeehouse in the early 1600s, both the newfangled establishment and the wine tavern were incorporated into the Chaharbagh.

The character of Shams-i Tishi—his expertise in music and his libertine manners—was central to the allure of the Chaharbagh's drinking establishments. He not only hired good-looking youths as wine and coffee servers but also composed new songs with lyrics of his own in praise of each server. For the revelers of Isfahan, listening to the latest tunes composed by Shams was part and parcel of the experience of the Chaharbagh. According to Awhadi, Shams also wrote poems addressed to Mulla Abdallah Shushtari, the Shi'i jurist who taught at the madrasa that Shah Abbas built for him adjacent to the Maydan-i Naqsh-i Jahan. Castigating the clergyman for his insincere sanctimoniousness, Shams's verses are reminiscent of the anticlerical poems of Hafiz and his polemics against the hypocrite ascetic (*zāhid*). In Safavid Isfahan, Shushtari and Shams—the ascetic and the libertine—were both patronized by the Safavid ruler; they were integral components of a carefully planned city that strove to accommodate and balance opposite social elements in a unified urban environment.

The coffeehouses and taverns of the Chaharbagh were laid out in tandem with its landscape.

Here there were no large tanks of water; instead, diminutive octagonal basins, preceded by carved water slides, stood between the facing pavilions. These small basins were flanked by platforms that functioned as outdoor sitting areas for the patrons of the establishments. Kaempfer notes that the owners of the shops covered these platforms with carpets, where people could sit, watch shows, and listen to poets and storytellers while drinking and smoking.[53] Likewise, De Bruyn observed that this area of the Chaharbagh was covered with "benches, wooden-chairs, and tables" and that "in the evening you always [saw] a great number of Persians, smoking and drinking coffee."[54] Sitting in the shade of the trees, clients would sip wine or coffee and smoke tobacco while enjoying the richest sensory experience that the Chaharbagh landscape had to offer. Located in the heart of the promenade and accommodating novel social pastimes such as drinking coffee and smoking tobacco, the coffeehouses played a key role in turning the Chaharbagh into a new kind of public space.

SUFI CONVENTS

To the south of the drinking houses was another square pool flanked by a pair of structures. These edifices and their adjoining gardens belonged to two Sufi confraternities: Haydariyya and Niʿmatallahi.[55] Founded by Qutb al-Din Haydar (d. ca. 1221–22), the Haydariyya was an order of antinomian dervishes known as Qalandars (literally, "uncouth"). The Qalandars, who first emerged in the early Islamic period but flourished particularly from the thirteenth century onward, were mendicant itinerant Sufis who shunned social and religious customs. They wore distinctive garments (typically a single piece of sheepskin), shaved their bodily and facial hair (except for the moustache), practiced celibacy (some even wore iron rings on their genitals),

and deliberately engaged in transgressive social behaviors such as rampant consumption of wine and cannabis.[56] Since the thirteenth century some of these "deviant Sufis" had been organized into orders (s. *ṭarīqa*) such as the Haydariyya. The Niʿmatallahi order, by contrast, represented a mainstream form of Sufism.[57] Established by the mystic Shah Niʿmatallah Vali (d. 1431), the order enjoyed an amicable relationship with the Safavids, and a garden in Qazvin had already been dedicated to its members.[58] What united these two orders was their denominational adherence to Shiʿism, which turned them into Safavid sectarian allies as well as tools of the state agenda for converting the masses to the imperial creed. While several Sufi orders were brutally suppressed under Safavid rule, the Haydariyya and Niʿmatallahi enjoyed a measure of royal support, and their members were provided with state-sponsored lodges in the heart of Isfahan's grand promenade. The Chaharbagh's royal hostels were undoubtedly intended to institutionalize, urbanize, and control a potential source of sociopolitical unrest.[59]

In Safavid times, the terms "Haydari" and "Niʿmatallahi" (Niʿmati) connoted more than mere mystical confraternities. From the 1570s onward, the neighborhoods of Tabriz were reportedly associated with one or the other of these two factions, and feuds would break out between affiliated urban quarters, especially during Ashura, the annual mourning rite commemorating the martyrdom of Imam Husayn (the third Shiʿi imam).[60] It appears that over the course of the sixteenth century, with the spread of Shiʿism and the integration of these two dervish groups into urban society, they came to epitomize civic factionalism across Safavid domains. According to Yazdi, Shah Abbas in 1595 staged a battle between the Haydari and Niʿmatallahi factions in the Maydan-i

FIGURE 62
A Sufi convent on the Chaharbagh. Photo by Joseph Papazian, ca. 1880–85. Gulistan Palace Photo Archive, Album 199, no. 19.

Saʿadat in Qazvin.[61] A similar sense of theatricality certainly underlined the housing of these two groups in confronted pavilions on the Chaharbagh. The Sufi lodges were indeed integral to the overall program of the promenade. As noted previously, Shah Abbas, to celebrate the completion of the Chaharbagh in 1602, composed a poem in praise of one of these convents (ostensibly the Haydari one). The verses call the building a *takiyya* hosting "the dogs of [Imam] Ali," a "heart-rejoicing abode" (*khāna-yi dilgushā*) built by "the dog of Ali's threshold."[62] The term *takiyya* (literally, "rest" or "place to rest") designated a type of Sufi lodge that was particularly associated with itinerant Qalandars.[63] Yazdi

reports that on the night of the inauguration of the Chaharbagh, while Shah Abbas was in the coffeehouse, a certain Avaz Beg, who wished to become a Qalandar, was initiated by the shah, who himself "put the ring in his ear."[64]

The institutional and social significance of the Sufi convents was manifest in their elaborate architecture. The sole source of information on the architectural form of the convents is an old photograph (fig. 62); a close examination of visual and textual sources reveals that this photograph depicts one of the Chaharbagh's twin convents shortly before its remodeling in 1884–85 and subsequent destruction.[65] Taken from the northwest, the picture illustrates the

FIGURE 63
Reconstructed view of the Chaharbagh Sufi convents. Model and rendering by Shree Kale.

edifice as it appeared to a person walking down the Chaharbagh toward the river. (Note the ruins of the stone blocks that rimmed the walks and the square pool in front of the pavilion.) Located on the eastern side of the promenade, the convent must have belonged to the Haydariyya order. With four corner rooms and axial iwans, the convent's architecture is clearly based on the ninefold plan, conforming to the style of the royal pavilions along the Chaharbagh. The pavilion was open on all sides, but the facade facing the Chaharbagh was more elaborate. Decorated with glazed tiles and muqarnas vaulting, it consisted of two projecting blocks that were carved with balconies and framed the building's entrance (fig. 63).

The socioreligious activities that animated the convents and their surrounding landscape are vividly described by the Russian merchant Kotov, who refers to them as two facing "mosques" occupied by *abdāl*s (young Qalandars). Kotov describes the Chaharbagh convents in the context of a spectacular celebration marking Shah Abbas's arrival in Isfahan after the Safavid conquest of Baghdad in 1624. During the ceremonial procession, as the shah made his way through the Chaharbagh, he lingered at the convents. There the "mullahs" brought out "something like an image case with their [painted] idol in it," and "the Shah kissed the book and the mullahs and *keshi* [*sic*] [stood] and [sang] and in their hands they [held] tall candles alight." The buildings were indeed filled with religious icons and relics. In the opposite convent, Kotov saw "four Russian pictures" depicting scenes from the life of Jesus as well as a painting of "their idol, the image of a man" (perhaps an icon of Imam Ali).[66] Tavernier notes that one of the

convents held "the relics of Ali or some other prophet," which were kept under an arch and were revered by passersby.[67] Likewise, De Bruyn saw a great number of "bucklers, bows, and arrows" deposited in the hostels.[68] As hubs of Shi'i rites, the convents were also filled with "poles with flags," which were "carried on festivals with the ikons," and "candelabras of peculiar designs with snakes' heads cast in copper."[69] These pieces of paraphernalia were (and still are) used during the festival of Ashura by mourners parading through the city. The hostels were not merely residential lodges; they constituted sacred spaces where hallowed pictures and ritual objects were displayed and venerated.

The residing dervishes lived in a kind of fraternal, hierarchically organized brotherhood. The lodges were run by a master who carried the epithet *bābā* (literally, "father"), a term that especially referred to the mystical leaders of Qalandar Sufi groups. In Safavid Isfahan, however, these spiritual masters were directly appointed by the state; Shah Abbas installed a certain Baba Sultan of Qum, who was conversant in "dervish rules and expressions" (*qavā'id-i darvīshī va iṣṭilāḥāt*), to the post of *bābā'ī* of the Haydari *takiyya* and set a stipend for him. The post was later passed on to a certain Haydar and his sons, all of whom carried the epithet *bābā*.[70] During the day, the Qalandars wandered throughout the city, going about "the maydan and the streets and the bazaars and tell[ing] stories about the lives of their 'damned' [saints], how they lived and died." Their appearance made them stand out from the populace: "[T]hey go naked and barefoot, only covering their privates with a sheepskin, and they wear a sheepskin with their hair outward over their shoulders, and on their heads they wear hideous caps, and in their hands they carry sticks and spears and axes, and in their ears they wear big crystal stones."[71]

The two convents of the Chaharbagh, then, were loci of pious rituals that revolved around icons, relics, and popular rites of Shi'ism. The proximity of the convents to the wine taverns and coffeehouses (and probably to a food-distribution establishment farther north) reveals that the Qalandars were essential to the social program of the Chaharbagh. The drinking of wine had long been rampant among antinomian dervishes. In fourteenth-century Baghdad, for instance, a *qalandar-khāna* (house of Qalandar), sponsored by Jalayirid rulers, hosted wine-drinking assemblies.[72] Kotov notes that at night the dervishes of the Chaharbagh convents drank wine and fornicated.[73] Moreover, the use of the epithet *bābā* for Sham-i Tishi, who ran the Chaharbagh tavern and self-identified as a *rind* (libertine), indicates that he, too, was likely a Qalandar. As a socioreligious arena, the Chaharbagh was clearly conceived as a counterpart to the Maydan-i Naqsh-i Jahan; while the latter's religious foundations harbored the theologians, here antinomian Sufis took center stage. In both urban spaces, architecture made manifest the link between power and piety: on the maydan, the Shaykh Lutfallah Mosque was paired with the Ali Qapu, while the Chaharbagh's Sufi convents were deliberate architectural analogues of the nearby royal edifices. The construction of the Chaharbagh convents thus indicates that the promulgation of Shi'i orthodoxy in the age of Shah Abbas was accompanied by a comparable level of support for devotional practices deemed deviant or transgressive by the clerical establishment. The inclusion of a range of pious foundations in the main urban spaces of Isfahan points to a religious policy in which clerical and lay forms of piety were to operate in harmony under the aegis of the state.

The presence of the Sufis kept the promenade active around the clock. Day and night,

they were seen—garbed in woolen cloaks, half naked, inebriated—lounging around the pools or on the balconies of the convents, praying, slumbering, drinking, and smoking. It was indeed the presence of dervishes in urban spaces such as the Chaharbagh that made them a favorite subject of single-page paintings. Young and old dervishes of various persuasions, distinguished by their differing headgear and garments, were a fixture of the Chaharbagh, suggesting that such paintings were inspired by the the urban scene of Isfahan (fig. 64). The Sufis of early modern Isfahan were integrated into a metropolitan setting as urban characters.[74] Part and parcel of the Chaharbagh's spectacle, they not only orchestrated the cycle of devotional rituals for the masses but were also a source of urban pleasure for the leisured class of the Safavid capital.

THE MENAGERIE AND AVIARY

Passing the Sufi hostels, one reached an octagonal pool fed by a stream (*mādī*). The two estates that lay between the gardens of the dervish groups and this stream (Madi Niyasarm) were probably known as the *tūtistān* (Garden of Mulberries) and the *tākistān* (Vineyard), per Kaempfer's plan, which corresponds to what Chardin refers to as the Mulberry and Grape Gardens to the sides of "the fifth pool" of the Chaharbagh.[75] Here the taste of Isfahan's "delicate and sweet fruits," for which the city had been renowned since earlier times, complemented the sensory delights of the Nightingale and Sweet-Smelling Gardens.[76]

Further south the two gardens that bordered the promenade by the river housed wild animals and birds. In the menagerie (likely known as *shīr-khāna*; literally, "lion-house") were a range of wild and exotic creatures, including leopards, lions, tigers, lynxes, and rhinoceroses.[77] Many

FIGURE 65
Mu'in Musavvir, *Tiger Attacking a Youth*, 1672. Ink and watercolor on paper, 14.1 × 21.1 cm. Museum of Fine Arts, Boston. Bartlett Collection—Museum purchase with funds from the Francis Bartlett Donation of 1912 and Picture Fund, 14.634. Photo © 2024 Museum of Fine Arts, Boston.

of these animals were acquired as diplomatic gifts, and displaying them on the Chaharbagh signaled the global connections of the Safavid capital and its access to the fauna of the world. Facing the menagerie was the aviary, which since 1657–58 had been known as the Tavuskhana (Peacock House): it was "covered with a net made of metal wires" held aloft by "columns made of cypress and boxwood" so that "peacocks, partridges, and other birds could fly [inside]."[78] Taming feline creatures was a long-standing royal tradition, and abodes for wild beasts and exotic birds were common components of palace complexes. In Safavid Isfahan, separate departments existed for breeding and

keeping various species of beasts and birds—falcons, singing birds, dogs, and elephants.[79] It was also common to display and parade wild animals during royal ceremonies and receptions.[80] Constructed in a public space, the Chaharbagh's animal houses were sites of public entertainment.

Animals were encountered daily, as well as during royal banquets and hunting expeditions. One such encounter, recorded in a drawing by Mu'in Musavvir (active ca. 1635–97), involved a tiger that had been gifted to the shah by an ambassador from Bukhara (fig. 65).[81] According to the "journalistic" text written on the page by the artist, at the Dawlat Gate the feline "jumped

FIGURE 66

View of the Chaharbagh, looking north from the Allahverdi Khan Bridge. Photo by Albert Hotz, 1891. Platinum print. Leiden University Libraries, Hotz Album 10 ("A Collection of Photographs taken in Persia, Turkey and in the Caucasus, during a seven months' journey in 1891," vol. 2), no. 14.

up suddenly and tore off half the face of a grocer's assistant," who died within an hour.[82] The caption suggests that Muʿin made the drawing after the fact, from memory, though he also attempted to offer a realistic picture of the scene's physical context by depicting the Dawlat Gate in background (see fig. 46). Probably kept at the menagerie, the tiger had likely been paraded through the Chaharbagh before reaching the gate, where the tragic event transpired.

THE BRIDGE AND RIVERINE EXPERIENCES

Flowing past the drinking establishments, dervish convents, and animal houses, the Chaharbagh's axial stream poured into a square basin (fig. 66), beyond which one could step onto the Allahverdi Khan Bridge (fig. 67). Sponsored by the eponymous Allahverdi Khan (d. 1613)—a *ghulām* of Caucasian origin and the commander-in-chief (*sipahsālār*) of the Safavid army—the bridge was built atop thirty-three

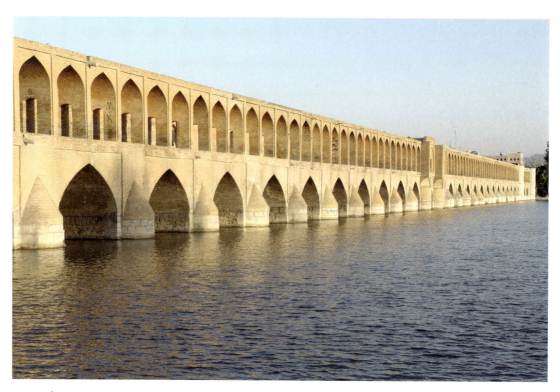

FIGURE 67
Allahverdi Khan Bridge. Photo: author.

bays on the lower level and hence has been called the "Bridge of Thirty-Three Arches" since the seventeenth century. The traffic roundabout presently at the north end of the bridge makes it appear like a detached, stand-alone edifice. In its original setting, though, it was fully integrated into the spatial sequence of the Chaharbagh: the stone-paved walkway that ran the entire length of the promenade passed across the bridge, seamlessly linking the promenade's two portions.[83] Yet the Allahverdi Khan Bridge offers more than a mere passage across the river. Composed of multiple galleries arranged in three levels, it engenders a range of visual and tactile encounters with the river at different scales.

The play on views begins upon stepping onto the bridge. First, one encounters a longitudinal passage, open to the sky and bordered by blind arches. Only after proceeding forward does one notice the open arches; set at the intervals of five bays, these openings link the central passageway to the flanking arcaded galleries overlooking the river (fig. 68). To the visitor entering these side galleries from the main passage of the bridge, the river thus appears rather abruptly as a succession of framed views. Indeed, the lateral arcades have no practical function but to provide shaded spots for beholding the riverscape. "Men are there secure from bad weather or the heat of the Sun," notes the French traveler Jean de Thévenot, who visited Isfahan in 1664, "and yet have an open Air and fair prospect."[84] Here the circumscribed visual field of the promenade was inverted, incorporating the vista of the riverscape into its sequential experience.

FIGURE 68
Axonometric view of the Allahverdi Khan Bridge showing the lower gallery with vaulted rooms interconnected by stepping stones. Model and rendering by Shree Kale.

Displaying the riverscape through the frame of the arcades was not the only way the architecture of the bridge engaged the river. Originally, the tops of the flanking galleries were bordered by balustrades and served as elevated platforms whence spectators could relish a panoramic vista of the riverscape or witness the communal ceremonies that were staged on riverbanks. Moreover, through embedded staircases, one could descend to the chambers carved into the lower-level piers (fig. 68). Interconnected by stepping stones, these archways formed "a little vaulted Gallery" that crossed "all the Arches from one end of the Bridge to the other."[85] Here, when the water level subsided in summertime, "people could find refuge from the exhausting heat of the sun and take pleasure in the breeze that wafted from the surface of water."[86] In the lower-level gallery, the ocular encounter with the river yielded to an intimate haptic experience: the feeling of moist air on the skin, of cool water on one's feet.[87] In a modular structure attuned to natural cycles, the Allahverdi Khan Bridge accommodated both visual (panoramic and framed) and tactile engagement with the river.

Those who observed the bridge from the riverbank perceived it as a colossal monument stretching across the river (fig. 69). Qazvini likens the bridge to "a dragon sleeping in the midst of the Chaharbagh," a simile that captures the positive form of the bridge as a massive masonry edifice.[88] Likewise, the poet Mir Nijat extols the bridge as the locus of the "masters of the gaze" (*arbāb-i naẓar*) and the edifice that is the city's bulwark (*pusht u panāh*).[89] If the intricate architecture of the bridge rendered it a site of social

FIGURE 69 (*above*)
Pascal Coste, Allahverdi Khan Bridge, viewed from the south bank of the river. From Pascal Coste, *Monuments modernes de la Perse* (Paris: A. Morel, 1867), plate XLVI.

FIGURE 70 (*left*)
View of the southern section of the Chaharbagh showing the pool in front of the Barberry (*zirishk*) Garden in the foreground and the Allahverdi Khan Bridge in the background. Photo by Albert Hotz, 1891. Platinum print. Leiden University Libraries, Hotz Album 10 ("A Collection of Photographs taken in Persia, Turkey and in the Caucasus, during a seven months' journey in 1891," vol. 2), no. 18.

and sensory experiences, its sheer size and nodal position turned it into an iconic monument of the Safavid capital.

THE UPPER CHAHARBAGH AND HIZAR JARIB GARDEN

At the south end of the bridge, a ramp descended onto the riverbank, where the vista of the tree-lined promenade punctuated by paired edifices reappeared before the pedestrian's eyes. Here the paved surface of the walkway sloped down, stretching toward a large pool (fig. 70). Water flowed in the opposite direction, falling into the pool on a waterslide and flowing toward the bridge. Judging from Kaempfer's drawing (fig. 71), the area between the bridge and this pool was bordered by two pairs of gardens with facing pavilions, though they seem to have disappeared by the nineteenth century, when Coste made a survey (fig. 72). Kaempfer's plan records the layout of the gardens along with the titles of the state officials after whom the gardens were named. Unlike the promenade's northern section, which proffered an elaborate social

FIGURE 71 (*left*)

Engelbert Kaempfer, plan of the Chaharbagh, ca. 1680s. British Library, MS Sloane 5232, fol. 42r. © The British Library Board.

FIGURE 72 (*above*)

Pascal Coste, plan of the southern portion of the Chaharbagh, 1840. Bibliothèque de l'Alcazar, Marseille, MS 1132, fol. 48b.

FIGURE 73
Entrance pavilion of the Barberry
(*zirishk*) Garden on the Chahar-
bagh. Photo by Joseph Papazian,
ca. 1880–85. Gulistan Palace Photo
Archive, Album 199, no. 31.

program, the southern portion was dedicated to
bureaucratic and military elites; these gardens
constituted what Junabadi describes as "pleasant
gardens" laid out by "the great khans, generals,
viziers, religious dignitaries, and bureaucratic
officials . . . each to his own tastes and tempera-
ment."[90] The first two gardens belonged to Ganj
Ali Khan and Allahverdi Khan, chief generals/
governors of the age of Shah Abbas, who were
both from the ranks of the *ghulām*s. The rest of
the estates were organized in a fairly hierarchical
manner from north to south, proceeding from
military commanders to the grand vizier and
chief justice, down to officials in charge of court
ceremonies, stables, and kitchens (see fig. 24).

The massive pool that lay at a short distance
from the bridge marked the first node of the

south Chaharbagh. Two monumental edifices
flanked it: the pavilion to the west (fig. 73) led to
the Barberry (*zirishk*) Garden, while its counter-
part marked the entrance to the Garden of the
Grand Vizier (i ʿtimād al-dawla, literally "pillar
of the state").[91] Although this pairing conforms
to the pattern employed throughout the Chahar-
bagh, these two structures were distinct: they
featured double-storied blocks projecting from
the central building, forming U-shaped fore-
courts on the sides of the pool. In the broader
scheme of the Chaharbagh, these facing edifices
defined a kind of vestibule for the final section of
the promenade (fig. 74).[92]

On either side of the pool that lay in front
of the Barberry Garden, two flights of stairs
led up to the final segment of the promenade:

FIGURE 74
Reconstructed view of the pavilion
at the entrance to the Barberry
(*zirishk*) Garden and its counterpart
across the Chaharbagh. Model and
rendering by Shree Kale.

an elongated rectangular space bordered at regular intervals by seven pairs of pavilions.[93] As is evident in Coste's drawing (fig. 72), a pool stood in the middle of this section. Indeed, compared with its counterpart across the river, the southern segment of the Chaharbagh was marked by a stricter sense of symmetry and regularity. Ascending the stairs, one faced a perspectival view terminating at the portal of the Hizar Jarib Garden.

And yet, although they were relatively uniform in design and function, the gardens and edifices of the southern Chaharbagh were as elaborate and monumental as those of the northern section. Kaempfer's drawings suggest that the pavilions erected at the entrances to the gardens, like their counterparts in the rest of the promenade, constituted the gardens' chief masonry structures. An old photograph (fig. 75) not only reveals the sheer size of these now-lost pavilions but also indicates that no two of the fourteen pavilions that lined the south Chaharbagh were identical. While conforming to a general blueprint, each pavilion featured a unique design—a subtle variation on a prototype—representing a formal diversity reminiscent of the variety of ornamental patterns deployed in the revetment of a single building. Like the decorators of ornate vessels, the architects of the Chaharbagh could have boasted of creating "one thousand designs" (*hizār naqsh*) in an immense three-dimensional architectural complex.[94]

A clearer picture of one of these pavilions can be seen in the photograph shown in figure 76.[95] Carved with recessed arches and balconies, the pavilion's facade consists of two identical blocks that project out on either side of a central entry, forming a recess before the doorway. The facade's deep articulation bestows a sense of grandeur on the monument. The visual appeal of the edifice arises from its clear geometric lines, the harmonious disposition of similar units—pointed arches of various sizes and depths—and a proportional module-based

FIGURE 75 (above)
View of the now-vanished pavilions on the southern portion of the Chaharbagh. Photo by Ernst Höltzer, ca. 1880s. Leiden University Libraries, Hotz Album 12, 26B.

FIGURE 76 (right)
Pavilion on the east side of the southern portion of the Chaharbagh. Photo by Ernst Höltzer, ca. 1880s. From Ernst Höltzer, *Hizār jilva-yi zindagī: Taṣvīrhā-yi Irnist Hūlstir az ʿahd-i Nāṣirī* (Tehran: Sazman-i Miras-i Farhangi, 1382 [2004]).

FIGURE 77

Cornelis de Bruyn, engraving showing the southern end of the Chaharbagh. From Cornelis de Bruyn, *Voyages de Corneille le Brun par la Moscovie, en Perse, et aux Indes Orientales* (Amsterdam: Freres Wetstein, 1718), plate 80.

relation between larger and smaller compartments. During ceremonial processions such as the one witnessed by Kotov in 1624, the upper floors of these pavilions were filled with spectators keen on catching a glimpse of the passing royal retinue. Decked out in colorful textiles, the balconied facades of the Chaharbagh's pavilions would have magnified their visual presence, creating theatrical stages for observing and participating in ceremonial spectacles.

The array of paired edifices on the south Chaharbagh culminated in the massive entrance portal of the Hizar Jarib Garden (fig. 77). Here, beyond a square pool, two terraces led up to a forecourt dominated by a colossal iwan and

flanked by arcades (fig. 78). The Hizar Jarib Garden lay on sloping terrain in the foothills of Suffa Mountain, and the portal was situated at the point where the land begins to take on a steeper slope. Junabadi relates that Shah Abbas ordered the garden to be laid out so that it would dominate the entire land of Isfahan.[96] From the city, in turn, the garden appeared as an immense swath of greenery cascading over the foothills. These reciprocal urban views—toward and from the city—were central to the conception and planning of the Hizar Jarib Garden.

With its monumental iwan, the gateway of the Hizar Jarib struck a grandiose visual finale for the promenade (fig. 79). Yet for those who

FIGURE 78

Cornelis de Bruyn, portal of the Hizar Jarib Garden, at the southern end of the Chaharbagh. From Cornelis de Bruyn, *Voyages de Corneille Le Brun par la Moscovie, en Perse, et aux Indes Orientale* (Amsterdam: Freres Wetstein, 1718), plate 81.

wished to advance further, the excursion did not halt there. The Hizar Jarib, too, was accessible to the public, and its central walkway was conceived and perceived as an extension of the promenade. Thus, in his processional poetic description, Qazvini glosses over the pavilions that lay along the Chaharbagh's southern portion and proceeds directly to the Hizar Jarib Garden. After describing its lofty portal—which "would not fit in the trap of an eye"—the poet turns to the garden's expansive grounds:

> To speak of the palace [*kākh*] and the garden's lawns [*chaman*]

Is like a discourse within a discourse [*sukhan dar mīyān-i sukhan*].
Do not be stunned by its width and breadth,
As spring cannot exit it.
Its field resembles the [legendary] Iram Garden,
Like [the garden of] paradise, they are ordered above one another.

Laid out on sloping terrain, the Hizar Jarib Garden was terraced into nine levels. While the estate's overall plan made it appear like a quadripartite garden divided by two perpendicular axes, the north-south walkway was

FIGURE 79

Reconstructed view of the portal of the Hizar Jarib Garden, at the southern end of the Chaharbagh. Model and rendering by Shree Kale.

more elaborate. Featuring ornamental pools, fountains, cascades, and pavilions, this terraced axis was designed and perceived as an extension of the Chaharbagh. But here the sense of enclosure that characterized the promenade yielded to an open space with delicate greenery and waterworks: the central channel of the Hizar Jarib Garden contained a row of fountain jets and was punctuated by intricate basins, some with marginal borders carved in the form of lotus foliage, as is evident in Kaempfer's sketch (fig. 80). On the terraced grounds of the Hizar Jarib, water gushed down the channels and slides more rapidly than in the Chaharbagh, creating a dramatic hydraulic spectacle and an enticing auditory experience. Equally enchanting were the garden's plants and trees, which were, in the words of the English traveler Sir Thomas Herbert, "for medicine, for shade, for

fruit: all so greene, so sweet, so pleasant, as may well be term'd a *compendium* of sense-ravishing delights."[97]

The Hizar Jarib Garden featured an elaborate two-story central pavilion, two pairs of kiosks that flanked the octagonal pools, and pigeon towers (*kabūtar-khāna*) at the corners. These colossal dovecotes, two of which are still extant today and constitute the most elaborate examples of their kind, were built for the functional purpose of collecting the pigeon manure as fertilizer; hundreds of such structures dotted the Zayanda River basin, housing birds that were indispensable to the city's ecosystem.[98] Lodging thousands of birds, these avian houses drew legions of fluttering pigeons to the sky above the Hizar Jarib Garden.

The most remarkable edifice of the garden was the now-vanished pavilion that stood at its

functioned not only as an ancillary gateway to the estate but also as its crowning belvedere. Herbert describes this gateway as a "pile of pleasure" divided into "foure or six chambers," with marble basins on the lower floor. The pavilion's upper floor was richly decorated with figural paintings, but what seemed "most excellent" to Herbert was "the view [they] enjoyed from her [terraces], which affoorded [them] a dainty prospect of most part of the City."[99] Commanding the central axis of the garden on one side and facing the mountain on the other, the pavilion afforded a sweeping vista of the Hizar Jarib, Chaharbagh, and the cityscape beyond. Kaempfer's rendition suggests that the architecture of the pavilion closely resembled that of the Jahan-nama, providing a counterpart for the edifice that defined the entrance to the Chaharbagh. Like the concluding rhyme of a poem, here the promenade came to a close by circling back to its "initiatory verse."

SOCIAL AESTHETICS OF VISUAL EXPERIENCE

Commencing at the northern entrance to the Chaharbagh, the foregoing narrative proceeded along the promenade's tree-lined walkway, through the portal of the Hizar Jarib Garden and to the top of its uppermost belvedere, exploring landscape and architectural components as they unfolded before the eyes of a kinetic spectator. Gazing down at the ensemble from the summit of the ultimate pavilion of the Hizar Jarib Garden, the observer could discern an immense designed landscape laid out with a pronounced sense of mathematical precision. Greenery and water were subordinated to a grand geometric order, as were the facing edifices harmoniously arranged across the open-air spaces that lay between them. Integrating physical and natural elements, this modular framework was

FIGURE 80
Engelbert Kaempfer, drawings of the central walkway of the Hizar Jarib Garden. British Library, MS Sloane 5232, fol. 45. © The British Library Board.

southern threshold; Kaempfer rendered this pavilion in frontal view at the end of the central walkway and labeled it the "Hizar Jarib portal facing Takht-i Sulayman" (fig. 80). Perched atop the garden's uppermost terrace, the pavilion

fundamental to the creation of the sense of a uniform space.

Rhythm was another key factor that informed the visitor's visual experience on the Chaharbagh. Like the recurring refrains of a poem, the repetition of architectural and land-scape arrangements—the rhythmic arrange-ment of pavilions, pools, and trees in analogous configurations—induced a sense of harmony that was appreciated over time by moving bod-ies; natural and masonry elements were fully synchronized. Anchored by two monumental edifices (the gateway of the Hizar Jarib and the Jahan-nama) the sequence of paired structures rendered the Chaharbagh an ideal setting for ceremonial and carnivalesque processions unprecedented in their grandiosity and sump-tuousness. On such occasions the royal retinue would temporarily sojourn in the Hizar Jarib Garden until the proper time arrived for a public parade to be staged. Such was the ceremony, for instance, when Shah Abbas returned to Isfahan from Qazvin in 1619 and from a campaign in 1624: he entered the walled city through the Cha-harbagh.[100] A similar triumphal entry is recorded from the reign of Shah Abbas's successor, Shah Safi.[101] During such processional parades people lined up along the Chaharbagh and the Allah-verdi Khan Bridge as the king and his retinue marched toward the palace. The bridge was the ceremonial heart of the Chaharbagh; during the procession held in the time of Shah Safi, can-nons were prepared to fire as the king reached the bridge.[102] But the Chaharbagh was not solely, or primarily, designed for such ceremonial purposes. The social establishments and sensu-ous elements of the promenade—painted tiles, singing birds, fragrant herbs—enticed slow and leisurely movement to discern and consume its enchantments. In its overall urban design, the Chaharbagh struck a delicate balance between a

grand setting for ceremonial processions and an enticing public arena for recreational ambles.

The sense of visual harmony spawned through modularity and rhythm was bolstered by symmetry. Yet while bilateral symmetry was observed in individual edifices—each facade was strictly symmetrical along a central verti-cal axis—the facing elements of the promenade were rarely mirror images of each other; rather, they were primarily conceived as counter-parts, as evident in pairings such as throne and tent, coffeehouses and taverns, opposing Sufi groups, and birds and beasts. Similarly, in his description of two kiosks that flanked an octagonal pool on the main axis of the Hizar Jarib Garden, Qazvini likens them to the sun and moon: "Surrounding the pool are two beautiful buildings / Linking the earth to sky. They explore the lake from both sides / Like the facing of fate [iqbāl] and fortune [ṭāliʿ]."[103] Whether in formal conception or social function, or both, each component was ideally paired with its perfect foil; the balance of opposites, rather than full parity, was construed as the ultimate source of harmony in urban design. The reflecting pools not only enhanced the sense of symmetry but also contributed to the aesthetics of the counter-parts. As wide as the facing pavilions, these huge tanks of water were clearly designed to reflect the bordering buildings in their entirety (fig. 73).

The aesthetic of reciprocal planning and counterbalancing has a long-standing ana-logue in verbal arts: the rhetorical device called "antithesis" (muṭābaqa) or "observance of the counterpart" (murāʿāt-i naẓīr), the practice of using conceptually contrary or complementary terms to achieve harmony in a poem. In Persian letters, the use of binary forms became particu-larly prevalent during the fifteenth and sixteenth centuries, when in some works the "observance of the counterpart" was "pushed to an extreme

in the pursuit of thoroughness and structure."[104] In its symmetrical, binary form, the Chaharbagh partook of this cultural trend.

The sequential experience of counterparts along the Chaharbagh is also akin to the visual experience of another key cultural artifact of the period: the *muraqqaʿ* (literally, "patchwork"), an album of calligraphic works, paintings, and drawings. Beginning in the sixteenth century, Persianate albums acquired a more formal appearance, with facing pages bearing pairs of related or contrasting artworks.[105] The aesthetic experience of strolling on the Chaharbagh and encountering its confronted pavilions is comparable to that of leafing through an album with facing folios that bear images of a binary nature. The fusion of fluidity and rhythm with order and proportionality also characterized the most cherished calligraphic style of the time: *nastaʿlīq*, a cursive script that emerged in the late fourteenth century but was codified and systematized during the sixteenth.[106] In the absence of treatises on architecture and urban planning, literary theories and calligraphic manuals yield insights into the aesthetic sensibilities that informed the urban design of the Chaharbagh and Isfahan in general.

Still, while these sources—and the affinities between the built environment and visual and verbal arts—make it possible to infer the aesthetic codes that governed the Chaharbagh's design, they fail to explain its embodied experiences, which involved the entire human sensorium. More specifically, they reveal little about the sophisticated ways the modular, rhythmic space of the promenade animated a multivalent optical system encompassing a range of imbricating modes and habits of seeing. Clearly, the Chaharbagh was not laid out to manifest a singular, dominant gaze but was rather conceived as a social space where all could take the positions of the viewer and the viewed. Placed on the threshold between the promenade and the gardens and carved with balconies and windows on all sides, the Chaharbagh's airy edifices were designed to capture pleasant views in all directions. Even the axially positioned Jahannama was not a dominating monument; it commanded a perspectival vista but did not mark a particularly ideal viewpoint. Reflecting no rigid visual hierarchy, royal authority and social distinctions were made palpable through diffused, imbricating modes of vision in a dynamic urban environment. These scopic encounters were of course fully embodied and mingled with a carefully planned array of nonoptical sensory pleasures. Olfactory and aural perceptions were as integral to one's experience as was the tactile sense of walking on cobbled pavements. As one reached the heart of the north Chaharbagh, these natural sensations merged with the chatter of the coffeehouses, the scent of coffee and tobacco, and the sound of tunes emanating from the drinking establishments. The multisensory environment of the Chaharbagh was closely tied to its social experiences.

Although promenading on the Chaharbagh was accessible to people from all walks of life, this does not mean that it was experienced by all urbanites similarly. For the upper reaches of Safavid urban society, the promenade provided a public stage for self-display. Thus, Fryer compares the Chaharbagh to London's Hyde Park—both were places "to see and be seen"—noting that at nightfall all the "Pride" of Isfahan were met there: "the Grandees were airing themselves, prancing about with their numerous trains, striving to outvie each other in Pomp and Generosity."[107] Clad in the fashionable apparel of Isfahan—high-heeled shoes, tight leggings, layered brocaded garments—the privileged men of the Safavid capital enacted their tropes of taste

on the Chaharbagh, in view of the urban society. Sartorial presentation complemented performative feats to project the wealth and stature of the well-to-do classes in the public domain.

Women's weekly outings provide an intriguing glimpse into urban experiences that are scantily recorded in the sources. Their novelty and social significance, however, are evident. Although Yazdi describes the practice as the shah's idea, it is more likely, judging from other events, that the ritual was initiated by the court ladies; it was at least upon the women's initiative that Setti Ma'ani, Della Valle's wife, was invited to join the excursion. In its overall conception, the practice might hark back to the notion of *quruq* (literally, "ban/restriction"), a Turco-Mongol custom of providing a male-free space for women's outings.[108] But the Chaharbagh ritual was unprecedented in following a weekly schedule in a specific urban setting. Among the women who strolled on the Chaharbagh were certainly influential figures such as the Safavid princess Zaynab Begum (d. 1641–42), Shah Abbas's aunt and confidant, who was the chief lady (*bānū*) of the royal harem and, like many other female members of the imperial household, was a major actor in state affairs.[109] The presence of Safavid princesses, Isfahan's noblewomen, members of other faiths, and female vendors suggests that on the Wednesdays of the early seventeenth century, the domain of women was relatively extensive; the Chaharbagh provided a rare venue for women to socialize regularly in a public urban setting. It is in light of these social functions that the Chaharbagh can be appreciated as a novel kind of urban public space—a civic domain where new forms of sociability and self-fashioning were enacted.

Inhabiting a Cosmopolis

URBAN QUARTERS AND CIVIC SELVES

In the late 1950s the American urban-planning firm F. H. Kocks was commissioned by the Point Four Program—a US "technical assistance" initiative for "developing countries"—to prepare a master plan for the city of Isfahan. The final outcome of the effort appeared as a book, published in 1961, to set a model for urban planning across Iran. Illustrated with portraits of typical inhabitants and scenes of daily life, the book offers "scientific" analyses of the city's economy, history, and geography, culminating in a series of plans and recommendations for refashioning the urban environment according to the modernist planning precepts. In an overview of Isfahan's history, the book also makes mention of "a German by the name of Nimmesgern who is said to have made a town plan" for the city in the 1930s. Although no trace of his activities was detected in the municipality archive, it was surmised that the German "was responsible for the checkerboard street pattern in the area south of Khiaban Sheikh Bahai."[1]

This conjecture about the origin of the "checkerboard street pattern," however, is mistaken. The rectilinear urban scheme of this area did not date from the 1930s; it was rather a remnant of the neighborhood of Abbasabad, laid out in the early 1600s as part of the Safavid plan for the development of Isfahan.[2] The orthogonal configuration of Abbasabad is evident in several cartographic documents that predate modern urban interventions, including the plan drawn by Pascal Coste in 1840 (fig. 81) as well as the survey made by a group of Russian cartographers (1851) and the map of Sayyid Riza Khan (1924).[3] The period descriptions (discussed below) also clearly underscore the modularity and checkerboard plan of the city's Safavid quarters. While segments of Isfahan's street network were regularized and widened for traffic circulation during the 1930s–40s, the rectilinear layout of the area mentioned in the Kocks report reached back, undoubtedly, to Safavid times.[4]

The planned quarters of seventeenth-century Isfahan were constituent elements of the city's urban structure and image. And yet, aspects of their planning and civic forms—particularly the nature, origin, and components of their orthogonal patterns—are not adequately appreciated. Through an inspection of cartographic and textual evidence, this chapter demonstrates how the new quarters of Safavid Isfahan were laid out concertedly as autonomous yet interlinked civic entities, which were unified by a grand plan and a shared lexicon of urban design. Yet a contextual understanding of these quarters also entails scrutiny of their formal *and* social structures, for as Spiro Kostof reminds us, "architectural meaning is ultimately always lodged in history, in cultural contexts."[5] Hence, the spatial form of Isfahan's extramural quarters are here examined together with the sociocultural practices, urban

experiences, and communal rituals that bound the quarters to one another and to their broader metropolitan and environmental contexts. Ultimately, this holistic analysis reveals how the urban form and social content of Isfahan acted in tandem, fostering a setting wherein new civic identities were fashioned.

PLANNING A TETRAPOLIS

Writing in 1617, Pietro Della Valle described the new Safavid developments in Isfahan as "a very beautiful tetrapolis of four cities" contiguously built in the vicinity of one another and separated only by "the Chaharbagh and the width of the river."[6] In Della Valle's characterization, the Chaharbagh and the Zayanda River were the axes that formed the cross-axial plan of the tetrapolis, and the Allahverdi Khan Bridge marked its center: Isfahan starts off at the northeast corner of the bridge, he notes, and extends to the east of the Chaharbagh; to the west of the avenue lies the neighborhood of Abbasabad; New Julfa is situated to the south of the river, opposite Abbasabad; and facing Isfahan lies Gabrabad, which was inhabited by Zoroastrians, or Gabrs (as the adherents of the ancient religion of Persia were called in the Islamic period). Noting that much had already been built, the Roman traveler relates that the shah wanted the three new quarters to become united with Isfahan as soon as possible.[7] Other accounts confirm that by the late 1610s, the new Isfahan appeared as an immense settlement comprising three major quarters. In 1618–19 Figueroa observed that altogether the colonies of Tabriz (Abbasabad), New Julfa, and Gabrabad encompassed "around ten thousand houses," adding that the gardens and orchards accorded them "such a large size that they seem[ed] to contain many more inhabitants than they actually possessed."[8]

The sources are unclear, though, on whether these quarters were conceived as part of the original plan of the new Isfahan from the outset; to my knowledge, there is no explicit mention of their planning in the 1590s alongside the Chaharbagh and the Hizar Jarib Garden. Chronicles refer to the foundation of the quarters for the émigré merchant families from Tabriz and the Armenian town of Julfa in the period after 1602. The Armenian inhabitants of New Julfa arrived in Isfahan only in 1605, after Shah Abbas had wrested the province of Azerbaijan and parts of the Caucasus from the Ottomans and coerced the community to migrate.

The most detailed account of the establishment of the neighborhoods is offered by Fazli, who reports that in March 1605 Shah Abbas decreed that a group of Armenian merchants from Julfa be settled "on the other side of the Zayanda River, opposite the Tabrizi community." Fazli then describes the construction of Abbasabad, the Tabrizi neighborhood, which he notes had begun two years prior (that is, about 1603). At that time, two state officials were tasked with

gathering the Tabrizi people who were scattered in [the province of Persian] Iraq and drawing up the plan [*ṭarḥ*] for Abbasabad. Each member of the aforementioned group was allocated 3, 10, or 20 *jarib*s (each *jarib* being 62 cubits) for building according to his needs. His highness had purchased the area for development from the Isfahani owners of nearby Shamsabad, Bidistan, and other villages and had granted the land [to the newcomers]. Each, according to his circumstances, spent from 100 to 3,000 *tuman*s on construction, and two thousand houses or more were laid out according to a plan [*ṭarḥ*] comprising streets [*khīyābān*], most of them having water running through the middle

of the houses; bathhouses and gardens were designed, and they strove to bring it to completion.[9]

Further on, the chronicler notes that near the city, "lands and building materials were given also to those who were capable of agriculture and cultivation, and houses were planned for them."[10] This is certainly a reference to the Zoroastrian residents of Gabrabad, who were primarily engaged in agriculture and gardening.

The sources thus indicate that the planning of Isfahan's new quarters was part of a concerted plan rather than the result of a series of random, improvised decisions. Although none of the chronicles explicitly refers to the foundation of a tetrapolis, Iskandar Beg describes Abbasabad as a city (*shahr*), implying that the notion of a cross-axial configuration of "four cities" was not Della Valle's personal interpretation.[11] The Chaharbagh was probably laid out from the outset with the intention of establishing a four-quartered settlement—a massive cross-axial scheme generated by the intersection the Chaharbagh and the river—although the decision to populate the quarters with specific groups (Tabrizis, Armenians, and Zoroastrians) came about later.[12] The manner in which the Chaharbagh intersects with the river to create a nearly perfect cross hints at such an intention. A careful examination of the formal structure of the quarters reveals how they were created through an elaborate planning system and with shared sociospatial components.

THE NEIGHBORHOOD OF ABBASABAD

Laid out across from the palace complex on the western side of the Chaharbagh, Abbasabad (literally, "developed by [Shah] Abbas")—also known as Tabrizabad or the New Tabriz (*Tabriz-i naw*) in reference to the hometown of its inhabitants—was the most prestigious quarter of the new

Isfahan. Fazli's narrative and other contemporary sources suggest that the construction of Abbasabad had the character of a state-sponsored mass housing project. Della Valle notes that in order to populate the new developments and unify them with Isfahan, Shah Abbas "helped those who need land and money to build."[13] Likewise, in his account of the construction of Abbasabad, Yazdi relates that "one thousand *jarib*s of land was purchased for 3,000 *tuman*s," and it was decided that "five hundred houses would be built with the shah's money." The shah would also provide "up to 1,000 *tuman*s as aid in the form of interest-free loans [*qarż-i ḥasana*], which they would repay over a period of five years."[14]

As noted previously, Iskandar Beg refers to Abbasabad as a city, and the quarter was indeed outfitted with the common amenities and institutions of an urban settlement. Among the public buildings planned for the quarter, Yazdi refers to a market equipped with commercial structures and facilities such as a *chahārsū* (domed crossing), a *tīmcha* (covered mercantile establishment), a bathhouse, and a mosque.[15] Abbasabad also had its own judge (*qāżī*), naqqara-khana, and hospital (*dār al-shifā'*).[16] The residents of Abbasabad were primarily merchants, but the sources also make mention of highly skilled artisans, especially goldsmiths. It appears that the Tabrizi merchant community originally had a hierarchical social organization, comprising a chief/mayor (*kalāntar*) and several wardens (s. *kadkhudā*) representing subquarters.[17] The spatial structure of the neighborhood likely reflected this social structure. The quarter harbored a self-contained community that administered its internal affairs and set its own quotidian rhythms.

In terms of spatial configuration, the neighborhood consisted of a series of tree-lined avenues whose intervals were subdivided into

FIGURE 81 (*opposite*) Pascal Coste, map of Isfahan showing the layout of Safavid quarters, 1840. Bibliothèque de l'Alcazar, Marseille, MS 1132, fol. 1.

FIGURE 82
Plan of the Safavid quarters of Isfahan. Plan by author.

plots arranged in an orthogonal pattern interwoven with streams (fig. 82). The main arteries, or khiyabans, ran east-west, parallel to the river's course and perpendicular to the axis of the Chaharbagh. These avenues, in turn, gave access to a secondary network of north-south alleyways. The southernmost avenue, which followed Madi Niyasarm, was probably known

as the Khiyaban-i Taqnama (Avenue of Blind Arches).[18] The northern zone of the quarter was accessed by the Khiyaban-i Khushk (Dry Avenue), which stretched westward from the Dawlat Gate. The avenue was called "dry" (khushk) because it did not contain plants and streams, which ordinarily were essential components of a khiyaban.[19] Thus, it can be considered an

urbanistic novelty, perhaps the earliest example of a khiyaban laid out as a straight urban street (the word's primary meaning in contemporary Persian). The central avenue of the quarter was the Khiyaban-i Juy-i Shah (Avenue of the Royal Canal), which ran from the Chaharbagh's Throne Garden to a domed crossing, or *chahārsū* (named Chaharsu-yi Shiraziha in later sources); according to Coste's plan, the area to the north of this avenue was known as Shamsabad, which together with Abbasabad constituted the New Tabriz in the tetrapolis. Covered by a now-lost massive dome, the *chahārsū* also marked the center of the district's local market (*bāzārcha*), which stretched in the north-south direction and was described in a nineteenth-century source as the "only unroofed market in Isfahan."[20]

The Tabrizi quarter was not planned on entirely vacant ground. The cultivated environs of Isfahan were dotted by farmlands and villages (such as Lunban, Marnan, and Sichan), and the *mādī* network traversed the terrain. Yazdi notes that the residences of the people of Tabriz were laid out on the bank of the Zayanda River "in such a way that four massive streams [*nahr-i ʿaẓīm*] flow[ed] through their quarters and houses."[21] The existence of these settlements and natural elements explains why the neighborhood took this peculiar form: the Safavid rationalist plan engaged with these preexisting topographical features, integrating the water system into the urban environment.

Inhabited by the most well-to-do residents of the new Isfahan, Abbasabad was particularly known for its luxurious mansions. An early eighteenth-century historian notes that the neighborhood contained "twelve thousand houses, all with exquisite gatehouses and ornamented."[22] The figure twelve thousand is also mentioned by a late seventeenth-century visitor from Central Asia, Maliha of Samarqand, who

further notes that the grandest mansion of the neighborhood belonged to the court poet Saʾib Tabrizi, whose father was a leading merchant (*kadkhudā*).[23] The loftiest estates of Abbasabad bordered the river, and it appears that some of them featured elaborate pavilions with upper-floor loggias, as is evident in Guillaume-Joseph Grélot's panoramic drawing of Isfahan (fig. 83).

NEW JULFA

New Julfa was home to a community of merchants who hailed from Julfa, a town on the Aras River in the southern fringe of the Caucasus.[24] During the second half of the sixteenth century, old Julfa's tradesmen amassed huge fortunes through the export of raw silk from the Caspian Sea littoral to the eastern Mediterranean markets in Aleppo and Bursa. The rise of this mercantile conduit was intimately linked to global transformations in the world economy—namely, the mounting flow of silver from the Americas in the 1500s and the emergence of a consumer market for luxurious fabrics in early modern Europe. During his campaigns against the Ottomans in 1603–4, Shah Abbas ordered that old Julfa be evacuated and razed to the ground (in accordance with the scorched-earth policy that both the Ottomans and the Safavids practiced in this contested region). Afterward, around five thousand residents of old Julfa, along with hundreds of thousands of Armenian inhabitants of other towns and villages, were forcibly transplanted to Isfahan and other locales in central Safavid lands.[25] Among these groups, the merchants of Julfa—already "known for their mercantile activity and abundant wealth"—were settled in a quarter especially planned for them in Isfahan.[26] Like the New Tabriz, which took its name from the former home city of its inhabitants, Isfahan's Armenian quarter became known as New Julfa.

La CITTAD ISPAHAN ME

FIGURE 83
Guillaume-Joseph Grélot, *City of Ispahan, Metropolis of Persia*, 1674. From Ambrosio Bembo, "Viaggio e giornale per parte dell'Asia di quattro anni incirca fatto da ma Ambrosio Bembo Nobile Veneto," Italy, ca. 1676. James Ford Bell Library, University of Minnesota Libraries, MS 1676 fBe.

The Armenian merchants of New Julfa continued to engage in the export of silk, which was central to the economic policy that Shah Abbas pursued throughout his reign.[27] Enjoying unprecedented privileges, they gradually established a far-flung trading network centered on Isfahan and stretching from northwestern Europe to Southeast Asia.[28] As Sebouh Aslanian notes, the Armenians of New Julfa were "arguably the only Eurasian community of merchants to operate simultaneously and successfully across all the major empires of the early modern world."[29] Multilingual and Christian yet familiar with local customs, these merchants acted as intermediaries between the Safavid court and European missionaries, merchants, and diplomats and were dispatched as official Safavid envoys to European courts.

Safavid chronicles reveal that New Julfa was laid out and constructed in a process similar to the one that produced Abbasabad. On the arrival of the Julfans, Junabadi notes, Shah

Abbas issued a decree ordering Mirza Muhammad, the vizier of Isfahan, "to divide up the land on the side of the Chaharbagh and on the bank of the Zayanda river among Armenians so that they would build houses and churches according to their own tastes."[30] According to Fazli, "each of the Armenians built a house in accordance with his circumstances and ability and set up his trade and management of his affairs. Khvaja Safar and Khvaja Nazar, who were mayors/chiefs [*kalāntar*] and nobles among the Julfans, on entering Isfahan came opposite the Tabrizi community, and they, too, built lofty edifices."[31] Armenians were likewise provided with interest-free loans, and Shah Abbas decreed that "workers and master builders" (*'amala va ustādān-i bannā*) assist Armenians in construction.[32] The impact of local "master builders" is evident in the architecture of Julfa's churches and mansions, which blend Persian and Armenian aesthetics and building techniques.

New Julfa was also laid out on land that was occupied by farmlands and villages, such as Sichan and Marnan (Marbanan). A 1605 royal decree suggests that soon after the arrival of the Armenians, a brawl broke out between the newcomers and the inhabitants of the village of Marnan, apparently over some agricultural products. In the decree, Shah Abbas castigated the villagers for "mistreating their guests" and extolled the Armenians as a people who "had abandoned their homeland of two to three thousand years for Our sake . . . leaving behind loads of gold and silk."[33]

Like Abbasabad, New Julfa was conceived as a self-contained, autonomously administered urban quarter. Pedros Bedik, an Armenian traveler who visited Isfahan around 1670–75, described New Julfa as a "complete city," with "public buildings and shops for artisans."[34] The civic leader of the community, the *kalāntar* (also known as *shahrīyār*, or "assistant of the city," according to Bedik), was chosen from the rich merchants and mediated between the community and state.

Modern studies commonly describe New Julfa as a "suburb" situated on the "outskirts" of the city. Yet these designations are misleading, as they belie the degree to which the neighborhood and community were socially and spatially woven into the fabric of the new Isfahan. Regardless of the exact timing of its founding and the circumstances of the deportation of Armenians, there can be little doubt that New Julfa was planned as an integral component of a cluster of unified urban quarters including Abbasabad and Gabrabad. That Fazli mentions that these neighborhoods were opposite the Tabrizi community is indicative of the degree to which they were conceived and perceived as complementary entities. New Julfa was not an isolated enclave built at a distance from the

city. Rather, a contiguously built urban landscape connected the quarter to the rest of the metropolis.

The linkage between New Julfa and the rest of the new Isfahan is manifest in the former's urban design. The main artery of the quarter was Khiyaban-i Nazar—a tree-lined avenue named after Khvaja Nazar—which ran perpendicular to the axis of the Chaharbagh. According to the nineteenth-century historian Harut'iwn Ter Hovhaniants', Khiyaban-i Nazar was enclosed by two gates, each named after a prominent Armenian family.[35] Tavernier notes that the avenue was lined on both sides with rows of chinars, whose roots were refreshed by channels of water.[36] The central artery of New Julfa, then, was a verdant khiyaban closed at both ends by gatehouses. From the east, Khiyaban-i Nazar could be accessed from the Chaharbagh; at the opposite end, it was linked to the Marnan Bridge. Sponsored by an Armenian merchant (*khvāja*) and completed in 1629, the Marnan Bridge connected New Julfa to a principal avenue of Abbasabad.[37] These bridges created a continuous network of circulation traversing the river.

The lands bordering Khiyaban-i Nazar were divided into ten plots, or *tasnaks* ("one-tenth" in Armenian), each headed by a warden, or *kadkhudā*. The approximate contours of these urban blocks are detectable on the earlier maps of New Julfa. According to Ter Hovhaniants', the houses of the wealthier families were located along the river's edge because of its pleasant climate.[38] This is confirmed by Chardin, who notes that most of the luxurious residences of New Julfa lay along the river and that some of them were as exquisitely decorated as palaces.[39] No trace of these mansions remains today, but it appears that the north side of New Julfa was lined with garden estates with elaborate pavilions on the riverbank, mirroring those on

FIGURE 84

Pascal Coste, view of the Mets (Great) Maydan, New Julfa, with the church of Holy Bethlehem (Surb Betghehem) in the background, 1840. Bibliothèque de l'Alcazar, Marseille, MS 1132, fol. 60.

the opposite bank, in Abbasabad (fig. 83). This urban layout apparently reflected a hierarchical social structure wherein twenty wealthy merchant families served as representatives of their respective districts in the council that administered the community's affairs. Initially, the main core and built-up area of New Julfa lay on its northern side, and it was only in later times that the southern zones were developed.

The main communal spaces of New Julfa—including two maydans and a *chahārsū*—were arranged along Khiyaban-i Nazar. The civic heart of the quarter was the Mets (Great) Maydan, which lay on the southeastern side of the avenue, closer to the Chaharbagh (fig. 82). Here the first sanctuary of the community, St. James

Church, was established in 1607, followed by the more elaborate churches of Holy Mother of God (1612–13) and Holy Bethlehem (1628), both sponsored by leading Armenian merchants.[40] An 1840 drawing by Coste illustrates the Mets Maydan and Holy Bethlehem Church (Surb Betghehem), whose bulbous double-shell dome is the largest among New Julfa's thirteen extant churches (fig. 84).[41] Surrounded by arcades and dominated by a monumental house of worship, the Mets Maydan looked like a miniature version of the Maydan-i Naqsh-i Jahan, its domed sanctuary echoing that of the Shaykh Lutfallah Mosque.

The interior of the Holy Bethlehem Church was as lavishly decorated as Isfahan's imperial

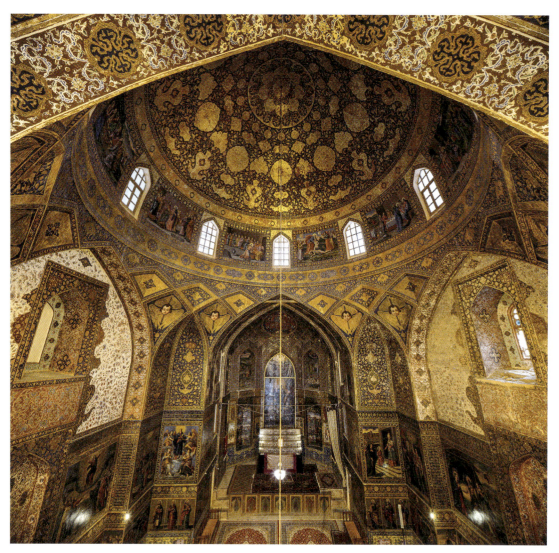

FIGURE 85
Interior of the church of Holy Bethlehem (Surb Betghehem), 1628. Photo: Amir Pashaie / Wikimedia Commons (CC BY-SA 4.0).

mosques (fig. 85). Here, though, the Safavid decorative modes and techniques of construction coalesced with a program of paintings illustrating biblical narratives. As Amy Landau notes, the murals of the Holy Bethlehem Church contain some of the earliest works in Isfahan that incorporate post-Renaissance techniques of perspective and chiaroscuro, features that later appeared in the wall paintings of royal palaces such as the Chihil Sutun.[42] The Armenian merchants who sponsored these sumptuous churches were certainly aware of the global prestige of Europeanizing styles, preferring the new artistic idiom over traditional pictorial modes "to project a sense of modernity and of the cosmopolitan nature of New Julfan merchants."[43] This visual modernity was not, however, experienced by Christians alone; writing on All Savior's

(Vank) Cathedral, Chardin notes that Muslims came to the church "as if to a theater, to amuse themselves by looking at the paintings."[44] As the heart of a far-flung mercantile network, the Armenian quarter was a conduit of global connections, linking the urban experience of Isfahan to the world via the circulation of commodities, images, and people.

In terms of the architecture of its monuments, its spatial structure, and its urban experiences, New Julfa was thus intimately linked to the broader cityscape of the new Isfahan. As the reconstructed plan of the neighborhoods (fig. 82) indicates, a remarkable cohesion existed between the blueprints of Abbasabad and New Julfa; it appears that the two neighborhoods were conceived as one contiguous unit with the river flowing through it. Not only were the two quarters planned with a shared repertoire of urban forms and patterns—the tree-lined avenue and the grid plan—but they also appear to have been laid out according to an analogous social hierarchical organization. Facing each other across the river, the gardens and mansions of the affluent tradesmen of both communities created a visual connection between the two quarters, which were unified and separated at once by the flowing expanse of water that lay between them.

GABRABAD AND THE CONCEPT OF URBAN QUARTERS

The final quarter of the new Isfahan, Gabrabad (or Gabristan), was laid out next to New Julfa, on the south bank of the river. Like the residents of New Julfa and Abbasabad, the Zoroastrian inhabitants of Gabrabad were migrants, forcibly relocated to Isfahan from the cities of Kerman, Shiraz, and Yazd in central Iran. Under Shah Abbas, Shi'i jurists granted Zoroastrians the status of *dhimmi*, or protected religious minority, a status hitherto reserved for Jews and Christians, which led to an era of relative peace for the community.[45] In a 1618 versified text, a Zoroastrian thus describes Shah Abbas as a just ruler under whose reign "the gate of tyranny was blocked," relating that the Zoroastrian families were granted land and money to build a settlement in Isfahan.[46] This statement confirms that the migrant households of Gabrabad, too, received financial assistance from the state.

Della Valle describes Gabrabad as a well-built neighborhood with "very wide and straight streets . . . much more beautiful than those of Julfa." The reason for this higher measure of regularity, Della Valle notes, was that it was constructed after New Julfa and Abbasabad, with more experience and attention. The Zoroastrian quarter, however, was of a different physical and social character: unlike the houses in the socially stratified, merchant-inhabited neighborhoods of New Julfa and Abbasabad, none of the houses of Gabrabad had "more than a ground floor," and they were "devoid of ornament, corresponding to the poverty of their inhabitants. . . . The Gabrs follow no trade, but earn their livelihood by rustic occupations with much labor and fatigue."[47] Other accounts corroborate Della Valle's characterization of the community: unlike the well-to-do residents of the adjacent quarters, Zoroastrians were primarily engaged in menial tasks such as agriculture and gardening.[48]

The urban layout of Gabrabad is less clear than those of the other two quarters, for Zoroastrians were forced to relocate to the south of New Julfa about 1660, when the Sa'adatabad royal garden was built in the area and the neighborhood was allocated to nobles.[49] Even so, the regularly laid-out plots to the west of the Sa'adatabad complex seem to have been a remnant of the original Zoroastrian settlement. The reconstructed plan indeed confirms Della Valle's

description, indicating that Gabrabad consisted of comparatively smaller parcels of uniform shape and size that were arranged in a checkerboard pattern with no broad avenues (fig. 82). The differing physical layouts of the three neighborhoods thus corresponded to the differing socioeconomic statuses of their residents; the strictly geometric pattern of the Gabrabad echoed its relatively homogeneous population and their "working-class" status.

The diverse origins of the new communities suggest that a driving force of the plan of the new Isfahan was a desire for ethnic and confessional cosmopolitanism. People of all faiths, it seems, lived in harmony in the capital of the Safavid Empire. Still, the inclusion of a Zoroastrian quarter was not just meant to complete the religious mosaic of the tetrapolis. The upkeep of the city's vast gardens and orchards no doubt required an immense workforce, so if Zoroastrians were indeed engaged in gardening and agriculture, their labor would have been indispensable to the sustenance and maintenance of the city's expansive natural landscape. Even if royal designers laid out Isfahan's gardens, it was the Zoroastrian community that nurtured and preserved the estates as living environments.

The creation of the Zoroastrian quarter opposite the Armenian Christian settlement of New Julfa signals that the arrangement of Isfahan's new quarters followed the binary model that was employed in the design of the Chaharbagh's facing pavilions. Initially, though, these quarters were not demarcated along strict confessional lines. In the first half of the seventeenth century, several Christian and Armenian groups deported from the Caucasus were settled in other areas of Isfahan. For instance, the Armenian historian Arak'el of Tabriz (ca. 1590s–1670) relates that a community of Armenian artisans

from the village of Dasht lived "among the Muslims" in the neighborhood of Shamsabad (north of Abbasabad).[50] It was only after 1655 that the non-Muslim communities who lived in other parts of the city were coerced to move to the southern outskirts of New Julfa, where new subquarters, named after their original hometowns (Erevan, Tabriz, etc.), were established for them.[51] In other words, socioeconomic status was as important a factor as ethno-religious affiliation in determining the place of residence for migrant and deported inhabitants. Overall, it appears that in the original conception of the new Isfahan, urban quarters were meant to evoke geographical spaces—microcosms of the geography of Azerbaijan and the Caucasus—rather than articulate insular confessional enclaves.

Christian and Zoroastrian quarters of Safavid Isfahan, then, cannot be described as segregated ghettos, at least in the initial phase of their existence. Even after the relocation of non-Muslim communities to the southern fringe of New Julfa, there occurred a remarkable degree of intermingling among faith groups across the city's public spaces. Nor can the status of the non-Muslim communities be explained according to the traditional notion of *dhimmi*. There is scarcely any precedent or parallel for the privileges bestowed on Armenian merchants of New Julfa, and Zoroastrians had seldom received official legal protection by a sovereign Muslim state. A harmonious cosmopolis, it seems, underlay the plan of Isfahan's new quarters.

THE GRID PLAN
The settlement of different ethno-religious communities in a capital city was not unique to Isfahan. After the conquest of Istanbul, the Ottoman sultan Mehmed II (r. 1444–46, 1451–81) also

populated the city with a deliberately diverse group of peoples.[52] Indeed, the resettlement of communities was a ubiquitous practice in the early modern period, and the policies of early modern Islamic empires share some affinities with the contemporaneous measures of European imperial powers in their colonies across the globe. Compared with regional examples in West and South Asia, what is distinctive about the tetrapolis created in Isfahan is the sense of spatial order carried out on a grand scale. In Ottoman Istanbul, for instance, symmetry and regularity characterized mosque complexes that were perched on the city's hilltops.[53] In the Safavid capital, however, orthogonal configuration was a totalizing element of urban design; it was harnessed as a sociopolitical instrument, signifying civic order and social control. As discussed previously, the origin of straight verdant streets (khiyabans) as elements of urban design extends back to Timurid Herat and Safavid Qazvin. But what were the precursors of the grid plan of Isfahan's new quarters?

The rectilinear urban plan is of course one of the most ancient and pervasive models of urban development. In the history of Islamic urbanism, the best-known example of the use of orthogonal patterns in urban planning is the city of Samarra, the ninth-century capital of the Abbasid Empire. Stretching along the east bank of the Tigris River, the urban fabric of Samarra consisted of a series of unwalled rectilinear urban units, which were inhabited primarily by the mercenary corps of the Abbasid caliphs. Straight avenues constituted the major arteries of Samarra. The urban layout of Samarra provides a remarkable case of the use of a grid plan as a means of social control on a large scale.[54] Yet as Kostof notes, the ubiquity of the grid plan does not mean that it carried the same connotations across time and space; only a careful consideration of the formal character of the grid would "go to the heart of the motivation of grids, the kind of life the grids are designed to play host to."[55]

Like the tree-lined avenue, the checkerboard plan of Isfahan's new neighborhoods may have derived from garden design. Formally planned gardens were typically subdivided into square plots in a checkerboard pattern, as is evident in the Hizar Jarib Garden. The combination of the grid plan with khiyabans, especially in Abbasabad, further highlights the link between garden and urban design. Indeed, it has been shown that, contrary to the Orientalist assumption about Islamic cities, several settlements on the central Iranian plateau (particularly in the environs of Yazd) had an orthogonal configuration, and their grid patterns were closely associated with their irrigation systems.[56]

And yet, the rectilinear blueprint of the new quarters of Isfahan was not the result of a gradual development; it emanated from a deliberate planning process. The layout of Abbasabad, in particular, reveals a tiered street system, with khiyabans giving access to secondary alleyways. This degree of regularity should have been mediated by drawings; gridded plans were widely used for generating architectural plans on paper, as evidenced by both extant drawings on paper and the material fabric of standing monuments.[57] Even the orthogonal pattern of rural areas in the Yazd environs did not necessarily issue from irrigation systems; according to a seventeenth-century history of Yazd, a local official in 1636–37 (1046 H) decreed that "wise architects and master builders design an entirely equilateral [mutasāvī al-aẓlāʿ] village [qarya] containing several khiyabans."[58] It is also likely that Safavid planners were familiar

with the post-Renaissance European modes of orthogonal planning, which were employed in colonial cities across the globe and were probably available in Isfahan through prints. The cross-cultural dimensions of Safavid urbanism merit fuller investigation.

RIVERINE RITUALS AND COMMUNAL EXPERIENCES

The inhabitants of the new Isfahan lived in separate quarters, but they were not socially segregated in insular communities. Armenian merchants plied their trade in the qaysariyya alongside their Tabrizi counterparts.[59] The Venetian traveler Ambrosio Bembo noted that although Armenians lived in New Julfa, "they [had] shops in Isfahan, where they stay[ed] during the day."[60] Christian women, too, socialized with the Muslim elite during their weekly all-female excursions on the Chaharbagh. Armenians were neither confined to their neighborhood nor engaged solely with the court; like all inhabitants of Isfahan, they were encountered daily in the public domain. Moreover, the sacred loci of old Isfahan, such as the shrine of Harun-i Vilayat, the city's patron saint, were venerated and frequented by all faith groups. Isfahan contained an array of public venues where members of the city's diverse communities commingled.

Apart from these regular daily encounters, a series of annual festivals, carefully choreographed in urban spaces and around civic landmarks, unified the city's communities. These festivals were not necessarily new, but they were celebrated with an unprecedented level of pomp and scenography that tremendously changed their social significance. And the hub of these rituals was the banks of the Zayanda River, especially the area anchored by the iconic node of the tetrapolis: the Allahverdi Khan Bridge.

The spring festival of Nawruz, the greatest annual ceremony of the Persianate world, unfolded, over many days and nights, before and after the vernal equinox (March 20–21), at the palace and throughout the city and bazaars. In Isfahan, a key component of the Nawruz festivities—the feast of the roses, or *gulrīzān*—was staged at the Allahverdi Khan Bridge during the river's springtime flooding. For the celebration, rose petals plucked from Isfahan's gardens were sprinkled on the bridge to create an immersive olfactory experience, which was enhanced by the dazzling effect of the light festival (*chirāghān*). Celebrated since pre-Islamic times, the Nawruz festivities would have attracted the Zoroastrian community as well.

The most spectacular of all riverine rituals, however, was the summer festival of Ab-pashan, or Ab-rizan (literally, "water-sprinkling"). Held on the riverbanks and the Chaharbagh during the summer solstice, it appears to have been a minor ceremony that was deliberately revived under Shah Abbas. Iskandar Beg refers to the festival as a "Persian custom" (*ʿurf-i ahl-i ʿajam*) that was "common among Persian kings [*mulūk-i furs*]" and regarded by the shah "as an auspicious occasion." In his description of the celebration in 1611, the chronicler notes that "more than one hundred thousand people from all classes gathered on the Chaharbagh, throwing water at each other," creating a "wondrous spectacle" (*tamāshā-yi gharīb*).[61] Della Valle and the Spanish ambassador Figueroa, who attended the festival in 1619, convey a similar impression of a jubilant urban ceremony attended by an immense crowd. During the water festival, the Allahverdi Khan Bridge served as the ceremonial heart of the festivities and the primary locus of spectatorship. In 1619 the shah and his guests witnessed the ceremony from one of the lower chambers

of the bridge, while women thronged the upper-level galleries.[62]

Another elaborate festival that was staged on the river edge was the Feast of Sacrifice (*ʿīd-i qurbān*), a major Muslim ceremony celebrated during the hajj season. In Safavid Isfahan, this religious feast evolved into a highly ritualized celebration orchestrated in the urban spaces and attended by the shah and grandees. In the first stage of the rites, a camel was paraded through the city for a few days. Then, on the feast day, the animal was led to the south side of the river for slaughtering.[63] During the final phase of the ceremony, the public observed the spectacle from the arcades of the bridge and the quays on the river's north bank. In 1624 Kotov witnessed women in several rows sitting along the top of the bridge, wailing as loud as they could. At the closing of the ceremony, the shah and the dignitaries passed through the bridge, proceeding on the Chaharbagh.[64] Marching behind the sovereign and his retinue "in one continuous line" were representatives of city quarters, carrying their allocated portions of the slaughtered camel "as in triumph, accompanied by a piercing noise of the drums and the cymbals."[65] During the ritual, the old and new districts of Isfahan were unified as integral elements of a social collective.

The riverine festivals of Isfahan were not confined to Muslim or Persian occasions. The water-blessing rite (known as *khāj-shūrān*, or "lustration of the cross") of the Julfa Armenian community was also held on the riverbank annually, on January 6, the Christmas/Epiphany day for the majority of Orthodox Christians.[66] Traditionally performed on the Aras River, the ceremony involved the ritual cleansing of crosses in the river. In Isfahan, the festivity was carried out with great pomp and was attended by the shah and the non-Christian urban populace.[67]

The Carmelite missionaries report that during the 1619 celebration "more than a hundred crosses of silver and rock-crystal escorted by the clergy of the ten Gregorian churches in Julfa and two in Isfahan, no cross with an escort of less than four clerics in copes of cloth of gold of various colors, attended by bearers of candles, were brought in procession to the bank of the river and thence to a small islet in the midst of the shallow water, while a large concourse of Armenians and Persians from the city lined the banks and watched the ceremony."[68] For the Armenian community, the (re)enactment of this religious rite invoked the memory of their lost homeland on the bank of the Aras; it was a vehicle to cultivate a sense of belonging in a remote place—a means of survival in the face of a ruthless deportation and a forced migration. At the same time, the performance of the ritual in a communal civic arena transformed it into part and parcel of the ceremonial cycle and collective memory of the new Isfahan.

Throughout the year, then, Isfahan's communities were bound together as a mass of social bodies in festivities that were staged on the banks of the "life-giving" river. This cycle of secular and religious rituals was devised along with the construction of urban spaces; physical and ritual planning were the dual components of a concerted campaign to fashion a new civic ethos. Attuned to the solar and lunar rhythms, these calendrical events nurtured a distinct sense of selfhood in the urbanites, enabling new forms of mingling and intimacy among the city's confessional groups. The meanings and perceptions of these communal festivals were inextricably linked to the setting in which they were enacted. The Zayanda River was more than a mere waterway meandering through the new neighborhoods of Isfahan; it was a major axis of

the city that complemented the Chaharbagh. The annual ceremonies transformed the river into an iconic locus, a receptacle of civic memories unifying city dwellers through ritual engagement with the natural environment. The water of the Zayanda River—its scenery, materiality, seasonal rhythms, and cleansing function—was central to these riverine festivals, as was the Allahverdi Khan Bridge. Bodily immersive and visually enchanting, the riverine rituals cemented the status of the Allahverdi Khan Bridge as the symbolic heart of the tetrapolis—and the *axis mundi* of the new Isfahan.

THE SELF AND THE CITY: OLD AND NEW ISFAHAN

The urban structure of the new Safavid developments presented a stark contrast to that of old Isfahan. Developed over the ages like a palimpsest, the old city consisted of twisting alleyways and dead ends that meandered through a tightly knit fabric of courtyard houses. On the pedestrian level, though, these seemingly disordered pathways formed a fairly legible spatial structure. Bordered by public buildings and punctuated with covered passages that served as local markets (*guzar* or *bāzārcha*), the major routes constituted a recognizable network of circulation. In this compact maze of paths, what distinguished principal arteries from secondary alleyways was not their width or appearance; rather, it was the presence of public buildings such as mosques, markets, shrines, and bathhouses.

Consisting of a clear, geometricized visual order, the new city was informed by a very different spatial logic. In the new Isfahan, urban spaces were arranged in an orderly way, street patterns were orthogonal, and vistas were typically linear and continuous. Water and greenery were constituents of the urban environment. Although the houses of the new city were also

inward looking, many mansions featured elaborate gatehouses with view-commanding loggias, which lent the new neighborhoods a degree of openness.

The discrepancy between the old and the new Isfahan was as conspicuous in social realities as it was in physical form. The indigenous inhabitants of the walled city—save for the long-established Jewish community—were ethnically and linguistically homogeneous (Persian was the primary language of everyday life, even for the Jews); the settlers of the new city were multilingual, multiethnic, and multiconfessional. Literate, affluent, and cosmopolitan, the incoming denizens dressed differently and socialized in distinct public settings. They were not only the primary beneficiaries of the economic and political reforms of the age of Shah Abbas but also the makers and consumers of a nascent culture of urban leisure made possible by the influx of commodities and by Isfahan's public spaces and social institutions. It was the city that allowed them to enact their social status through novel sociocultural practices. The Safavid quarters were distinguished by a dichotomous physical layout as well as by the new codes of behavior and social habits of their denizens.

In the seventeenth century the juxtaposition of the seemingly irregular, compact urban fabric of medieval Isfahan with the rectilinear, spacious structure of the Safavid developments created a dichotomy that carried a range of social implications. Set adjacent to the new city, the old fabric was perceived as particularly labyrinthine; it was likely in Safavid times that a particularly crooked alleyway of the old Isfahan became known as "alley of eleven twists" (*kūcha-yi yāzdah pīch*).[69] Other hints in the sources suggest that the inhabitants of the new Isfahan, especially the Tabrizi community of Abbasabad, were contemptuous of the residents of the old

Isfahan and perceived it in pejorative terms. For instance, a late seventeenth-century author notes that before the reign of Shah Abbas I, "The vestibules [*dihlīz*] of the houses were very low out of fear for the incursion of strangers [*khawf-i nuzūl*]. And pathways were narrow and dark, and alleys were serpentine, like the intestine, so that one entered [houses] stooped and with difficulty. Until the aforementioned king abolished the custom of *nuzūl* and released people from that fear. And numerous old houses in that shape remain." The author then quotes Muhammad Ali Saʾib, who was the most acclaimed poet of Isfahan and resided in Abbasabad, as having described the crooked alleyways of old Isfahan as the "lowest level of hell" (*darak-i asfal*).[70] Such derogatory statements imply that the architecture and urban form of the new neighborhoods signified wealth, status, and higher standards of living vis-à-vis those of the old town. It was in opposition to the old city, in other words, that the newness and contemporaneity of the new Isfahan was perceived; dichotomies of wealth and status had found a conspicuous spatial manifestation. Seen in this light, the disparity between the narrow, sinuous pathways of medieval Isfahan and the geometricized layout of the seventeenth-century neighborhoods signals two different social realities rather than cultural unity or harmonious urban growth, as some earlier studies have suggested.

In a sense, then, the new settlers of Isfahan can be seen as migrants conscious of their privileged standing; it seems that over time, as the displaced settlers of the early 1600s yielded to a new generation, a more complex civic identity emerged among the new Isfahan's residents. And the gridded, rectilinear plan of the extramural quarters was central to the formation of this collective *habitus*. Obviously, this sense of civic superiority was more an attribute of the Muslim Tabrizi residents of Abbasabad than of the Christian inhabitants of New Julfa, whose non-Muslim status imposed certain limitations on their urban experiences. Still, it would be inaccurate to see these differences solely through the lens of confessional divides. From a social perspective, the urban experience of affluent Armenian merchants was more akin to that of the upper-class inhabitants of Abbasabad than that of their laboring coreligionists. True, the former could be stripped of their privileges by the absolutist monarchical system, but so could their Muslim counterparts. The forced migration of Armenians does not mean that they remained passive subjects in an enslaved position; rather, they actively participated in the making of the Safavid society. Perhaps, as Landau and Van Lint note, the term that best describes the Armenians' status is Georg Simmel's notion of the "stranger": the stranger is "a member of the group in which he lives and participates and yet [someone who] remains distant from other— 'native'—members of the group on the basis of [their] 'external' origin."[71] Like the hybrid architecture of their churches, as with their interconnected yet self-contained quarter, the urban experiences of the well-to-do Armenians fell somewhere in between.

An intertwined reading of Isfahan's urban plan and social structure, then, reveals a far more complex urban phenomenon than what the Orientalist conception of the so-called Islamic city postulated. According to this essentialist conception, which has been persuasively discredited in recent decades, a set of principles drawn from Islamic law and customs bestowed a particular character on Islamic urbanism across a vast geography.[72] In the Orientalist view, crooked alleyways were the quintessential characteristic of the Islamic city, presumably evidenced by the fabric of the towns themselves.

It was precisely this notion that led the planners of F. H. Kocks to ascribe the rectilinear urban pattern of the quarter of Abbasabad to a German engineer; the labyrinthine fabric of the old Isfahan fitted more squarely into this deep-seated model than the orthogonal blueprint of the Safavid quarters. Setting aside this lens, we can discern not only that the orthogonal grid pattern was part of the Safavid planning apparatus but also how this early modern form of urbanism was tied to the city's social dynamism. Though physically juxtaposed, the old and the new Isfahan were conceived and perceived as temporally distant; past and present had taken on a spatial form in the city's dual structure.

PART 3

LYRICS AND SUBJECTIVITIES

The City Lyricized

ARCHITECTURE AND LITERATURE IN SAFAVID ISFAHAN

On the morning of January 19, 1629, Shah Abbas died in Ashraf, the palace-city on the Caspian Sea shore, where he spent his final years. The news of the king's death was kept secret until his grandson, Shah Safi (r. 1629–42), was installed on the throne in Isfahan. The young monarch's coronation was staged, with ceremonial pageantry, in the grand urban ensemble that his forebear had created in the Maydan-i Naqsh-i Jahan: girded with the sword of the Safavid dynasty founder Shah Ismaʿil, the new king ascended the throne at the Ali Qapu while the sound of drums and trumpets emanating from the naqqara-khana reverberated in the square. On the following Friday, at the Shah Mosque, Isfahan's chief cleric Mir Damad delivered the sermon (*khuṭba*) in the name of the recently enthroned ruler.[1] All the rites and rituals of the enthronement ceremony—religious or profane—were enacted in an urban ensemble whose uniform design enabled this elaborate form of imperial self-representation.

The accession of Shah Safi ushered in an era of relative peace and political stability in Safavid territories and one of prolific architectural activity in the capital. The middle decades of the seventeenth century—especially the reign of Shah Safi's son and successor Shah Abbas II (r. 1642–66)—also witnessed the rise of new practices and aesthetics in Isfahan's urban design and architecture: the regularized, monolithic civic projects of the age of Shah Abbas I yielded to urban schemes of greater formal delicacy and visual sophistication; royal gardens and pavilions assumed an exuberant character; and urban festivities became increasingly more affective and resplendent. With its wooden porch held aloft by slender mirror-clad pillars, the Ayina-khana (Hall of Mirrors) epitomized these emerging trends (fig. 86). Displaying a fascination with reflective surfaces and framing a silhouette of the city (fig. 89), the airy pavilion was placed in the urban landscape to be seen together with its glittering reflection in the river. Yet the Ayina-khana was not exceptional in engaging the urban prospects; as the city laid out in the early 1600s was completed—as the turquoise dome of the Shah Mosque rose on the skyline and the chinar trees of the Chaharbagh grew to form a green vault over the promenade—urban vistas came to be celebrated through the construction of belvederes and view-commanding edifices.

The rise of these trends in Isfahan's architecture and urban design paralleled the advent of a poetic discourse that was equally sensual and intricate in representing the city, its natural landscapes, and its monuments. Some poems drew inspiration from the sensuous features of the new edifices and gardens: a mirror-faced edifice such as the Ayina-khana lent itself to vivid poetic imagery; the Tavuskhana, a "house for peacocks," could certainly elicit a lyrical

FIGURE 86
Ayina-khana, Isfahan, ca. 1659–60, photo ca. 1880s. Stephen Arpee Collection of Sevruguin Photographs, FSA.A2011.03 A.26a. Freer Gallery of Art and Arthur M. Sackler Gallery Archives. Purchase, 2011. Photo: Antoin Sevruguin.

description. Other works turned to the markets, gardens, and coffeehouses of Isfahan, melding human emotions, desires, and metaphors of love with physical elements, vistas, and sensory perceptions of the urban landscape. Unlike the age of Shah Abbas I, when poetic praise for building works was scarce, now architectural creations were celebrated by ample poetry, and the songs of the poets played a key role in linking the state, the city, and urban dwellers. Isfahan supplied the setting for new modes of literary production, just as literary descriptions propelled new perceptions of the city.

These two cultural trends—the lyricization of architecture and the efflorescence of literary city description—were not only concurrent but also intimately intertwined. If architectural additions inserted theatrical, affective elements into the city, literary works lyricized the experience of the urban environment. Seen in this light, architecture and literature operated in a similar fashion; they enabled new forms of encounter with the city and affected its image and perception. For all their novelty, though, these midcentury architectural additions and literary pieces did not occasion a radical transformation in the overall meaning and perception of Isfahan's cityscape but rather embodied and articulated its quintessential urban character: they were lyrical expressions—in material and verbal forms—of the new Isfahan's conception as a locus of urban sociality and civic sensuality.

Delving into the sociospatial imaginaries of urban topographical literature, part 3, the final part of my book, probes the urban image and perceptual qualities of Safavid Isfahan. As a prelude to these discussions, this chapter charts the midcentury urban-literary world of Isfahan, considering the period's major forms of urban development and architectural design alongside the literary trends and discursive frameworks that undergirded the emergent modes of poetic engagement with the city and its social landscapes. The "Guide for Strolling" and other descriptions of Safavid Isfahan in verse and prose, discussed in the final two chapters, were informed by this confluence of literary and urban trends.

PATTERNS AND AESTHETICS OF URBAN DEVELOPMENT

Building work in mid-seventeenth-century Isfahan encompassed a broad range of forms and functions: new gardens, promenades, and residential quarters sprang up in the city's environs, while scores of religious and commercial foundations filled the vacant lands within the city walls.[2] The extent of the construction activities is reflected in the prodigious number of the city's public buildings: 162 mosques, 48 madrasas, 1,802 caravanserais, and 273 public baths. Chardin, who recorded these numbers in the 1670s, estimated that Isfahan was home to more than six hundred thousand souls, making it "the greatest and most beautiful town in the whole Orient."[3] Other accounts confirm this substantial physical and demographic expansion. According to Raphaël du Mans, the longtime prior of the French Capuchin convent in the Safavid capital, Isfahan grew "by a fifth or even a quarter in the two decades between 1645 and 1665."[4] In 1684–85 Kaempfer noted that the capital was still expanding in size and population.[5]

The dynamic urban expansion of the Safavid capital epitomized an era of political stability and commercial florescence that ensued after the demise of Shah Abbas I. Throughout this period the court was almost entirely stationary (princes were raised in Isfahan instead of the provinces); the state bureaucracy became increasingly elaborate and centralized (additional provinces were converted into Crown lands); and military conflict with the neighboring empires was scarce (the 1639 Treaty of Zuhab deprived the Safavids of their holdings in Iraq but led to an enduring peace with the Ottomans; the skirmish with the Mughals over the city of Qandahar was exceptional).[6] As Isfahan grew further enmeshed in global trade networks, long-distance commerce flourished, and the merchant class became increasingly independent of the state.[7] This period also witnessed a broadening of the bases of architectural patronage. Now a wider spectrum of the ruling elite—royal ladies, viziers, and eunuchs—sponsored civic and religious foundations.[8]

One of the earliest manifestations of the emerging trends can be seen in Isfahan's civic core: the Maydan-i Naqsh-i Jahan. In the 1640s, shortly after the accession of Shah Abbas II, a monumental pillared hall, or talar, was raised atop a masonry base before the Ali Qapu (fig. 44), and it appears that the now-lost clock pavilion with automata (fig. 43) was built on the opposite side of the square around the same time.[9] Jutting out of the maydan's surrounding arcades, these twin edifices altered the appearance and experience of the square: the latter with the hourly movement of sound-producing puppets, the former by furnishing a stage for ostentatious royal banquets. The shift from the primarily functional mechanical clock of the qaysariyya to a theatrical clock pavilion hints at the jubilant spirit that emerged in Isfahan's architectural culture.

FIGURE 87
Mural paintings on the qaysariyya
portal, Maydan-i Naqsh-i Jahan,
ca. mid-1600s. Photo: author.

The primary locus of construction, however, lay in the southeast of the city, on the banks of the Zayanda River. The centerpiece of the developments was the Saʿadatabad (Abode of Felicity) Garden. Completed in 1659–60, the garden was accessed through Khiyaban-i Khvaju, a tree-lined avenue that started off at the Hasanabad Gate and straddled the river via the Hasanabad (Khvaju) Bridge.[10] The royal garden and its adjoining estates and promenades established a framework for the development of urban infrastructure and the building of new residential quarters. The Khvaju quarter—a bustling neighborhood of more than one thousand houses that flanked the new khiyaban—was also developed in tandem with the Saʿadatabad project.[11] Moreover, a new "city" (*shahr*) was constructed to the west of the Saʿadatabad Garden, in the neighborhood of Zoroastrians (Gabrabad), who were relocated to the southern rim of New Julfa.[12] The construction of the Saʿadatabad complex, then, was part of a citywide program for expanding residential quarters and restructuring the capital's ethno-religious configuration; all Christian residents of Isfahan were forcibly moved to New Julfa around the same time. Antiminority sentiments in clerical circles appear to have contributed to this action, though it could also be seen as an ungracious response to the pressure of population growth.

Constructed ca. 1657–59 and modeled after the Allahverdi Khan Bridge, the Hasanabad Bridge (fig. 88) was the pivotal monument of these new urban developments.[13] Smaller in size yet far more elegant than its predecessor, the new bridge presents an innovative formal configuration: it features a split octagonal pavilion at the center, echoed by a half pavilion at either end. Due to its "perfect harmony" (*kamāl-i mawzūniyyat*), the bridge's "arched openings appeared like the intervals of hemistiches in

The sensuous murals that adorn the qaysariyya portal—including the scene depicting a European feast—were also likely part of the same campaign for upgrading the maydan with new architectural and visual interventions (fig. 87).

FIGURE 88
Pascal Coste, Hasanabad (Khvaju) Bridge. Bibliothèque de l'Alcazar, Marseille, MS 1132, 55.

poetry," Qazvini notes.[14] Even more than its prototype, the Hasanabad Bridge was a locus of socializing, causing "the dust of dullness [*gard-i kasādī*]" to settle on "the forehead of the old bridge."[15]

The Saʿadatabad Garden, which came to be known as the "New Hizar Jarib Garden," also referenced its namesake antecedent but furnished a distinct garden experience; if the old Hizar Jarib was planted with fruit trees, the new one was known primarily for its flowers and herbs.[16] Emulating the model set forth by the Chaharbagh, its central bridge, and the Hizar Jarib Garden, the Saʿadatabad complex was clearly conceived as a *naẓīra*, a counterpart or response, to a precedent, executed on a massive urban scale. Like a literary *imitatio*—a new work composed as a conscious response to a classical

piece—the new project adopted the general form and structure of its precedent to create a mannerist interpretation that surpassed its model.

With sluice gates placed in its foundation, the Hasanabad Bridge also served as a dam that created a lake (*daryācha*) in front of the Saʿadatabad Garden.[17] This tranquil body of water was suited for boat excursions and fireworks spectacles while also creating a cascade (*ābshār*) downstream; the bridge-dam fashioned an aquatic display out of Isfahan's shallow, slow-moving river. But the benefits of this artificial lake fell beyond recreational purposes; Qazvini notes that it enhanced agricultural productivity and increased the volume of water in the springs and water storages of nearby quarters.[18] Isfahan now had a permanent lake—a "new *naqsh-i jahān* [image of the world] fashioned on

FIGURE 89

Pascal Coste, the pillared hall of the Ayina-khana. Engraving based on an 1840 drawing. From Pascal Coste, *Monuments modernes de la Perse* (Paris: A. Morel, 1867), plate XXXV.

water," in the words of the poet Iʿjaz Herati— that did not ebb with the turn of seasons.[19]

Overlooking this (artificial) body of water, the Ayina-khana tapped into the illusionistic qualities of reflective surfaces—mirror and river—to engender a prismatic effect (fig. 86). The creation of scenic urban views was indeed central to the configuration of the Saʿadatabad Garden and its adjacent estates: the placement and materiality of the Ayina-khana rendered it a visible urban landmark, while the edifice, in turn, framed a view of the city. Indeed, the pavilion seems to have been placed deliberately off-center in the garden so that the vista of the domes and minarets of the Shah Mosque

appear on its axis, as Coste's engraving illustrates (fig. 89). The play on views also extended to the Bagh-i Nazar (Viewing Garden) across the river, which was connected to the Saʿadatabad via another bridge (Pul-i Juʾi, or Chubi) and featured a belvedere (*manẓar*) built atop a channel.[20] A viewing tower (*burj*) also stood at the center of the Bagh-i Burj (Tower Garden), laid out in 1685–86 across the Khiyaban-i Khvaju from the Bagh-i Nazar (fig. 95).[21] With the creation of these and other gardens, the row of estates that bordered Abbasabad and New Julfa extended eastward, generating a contiguous riverfront landscape dotted with view-commanding edifices.

Soon after their completion, the Saʿadatabad Garden and its surrounding landscape inspired vivid poetic descriptions. The Hasanabad Bridge, in particular, was the subject of abundant verses. Most of these lyrics were composed on the occasion of a monthlong inaugural celebration—comprising the feast of roses (*gulrīzān*) and the feast of lights (*chirāghān*)—held in the spring of 1659, during the river's annual flooding after Nawruz. In his phenomenological reading of the design, ceremony, and poetry of the Hasanabad Bridge, Losensky has shown how the structure spanned "the worlds of architecture and poetry," gathering the surrounding landscape.[22] The poems convey a range of meanings related to the royal and communal functions of the bridge. Those composed by court poets and chroniclers are predominantly encomiastic; filled with paradisal and cosmic imagery, they turn the edifice into the "emblematic portrait" of its royal patron.[23] Overall, however, it is the participants in the ceremony—the urban community—that take center stage in poetic descriptions. "Even when literary production was initiated by the court, as it was the case of these poems," Losensky concludes, "the play of signification could easily trespass ideological boundaries." When Shah Abbas II "commissioned the Hasanabad Bridge, it was designed to enhance his prestige and to serve as a stage for the display of his political authority. As a public work, however, it quickly entered into the life of the larger community."[24]

Among the poets who participated in the inaugural ceremony was Rukn al-Din Muhammad, who incorporated his own verses on the Hasanabad Bridge in his letter to Mansur Semnani. In the poem, Rukn al-Din likens the bridge to the Milky Way, stretching across the heavenly Zayanda River, and alludes to the moonlike, comely youths who occupied its arches during the celebrations. The poem's imagery and figures appear in other poetic treatments of the bridge; all these songs should have been recited there during the monthlong festivities. Rukn al-Din's lines convey a subjective take on the experience of a communal ceremony, a young man desiring the presence of his departed friend amid a dazzling celebration.

THE LITERATURE: MODES AND FORMS OF CITY DESCRIPTION

The poems composed on the Hasanabad Bridge belong to a large corpus of literary works in prose and verse that engaged with the monuments, gardens, and civic spaces of seventeenth-century Isfahan. These works were created in the context of momentous shifts in the forms and modes of literary production. Known as the "Indian style" (*sabk-i hindī*) in twentieth-century literary discourse, the Persian literature of the early modern period is characterized by two seemingly divergent yet socially linked trends. On the one hand, the short lyrical poem, or *ghazal*—the most cherished verse form of classical Persian poetry—took on a mannerist quality, deploying increasingly intricate imagery and rhetorical figures. In this poetic idiom, established metaphors became "twisted, broken, and reordered in unexpected ways so that mannerist effects [could] be observed."[25] This novel literary taste, termed "fresh style" (*shīva-yi tāza*) or "speaking the new" (*tāza-gūʾī*) by period commentators, granted a high level of sophistication to the aesthetics of ambiguity that characterized lyric poetry. On the other hand, colloquial expressions, aspects of quotidian existence, and realistic descriptions of places entered the poetic language. The proliferation of centers of cultural production across the Persianate world—a vast geography stretching from the Balkans to the Deccan, where Persian language and culture

held sway in elite and courtly circles—contributed to these trends, as did the broadening of the social context of poetry and its bases of patronage. These formal and social transformations accompanied a greater penchant for intertextuality. In both the high and low spheres, literature was in conscious dialogue with its heritage, displaying "an active and ongoing process of interpreting, revising, and recreating the poetic past in a new voice for a new age."[26]

The latter half of the seventeenth century, when the poetic descriptions of Isfahan proliferated, marked the apogee of these incipient literary trends. It was in this period, for instance, that the masters of the mannerist *ghazal*—Muhammad Ali Sa'ib of Isfahan (d. 1676) and Abd al-Qadir Bedil of Dehli (d. 1720)—composed their most intricate verses. Though adhering to established formal conventions, these poems exude a peculiar sense of modernity in their imagery and motives.[27] The poetry of Sa'ib also contains allusions to the urban landscape and material culture of Isfahan.

Catering to a primarily elite audience, however, the refined lyrics of these acclaimed masters represent only one facet of the early modern literary universe. Across the Persianate world, a host of other poets also created innovative works in different forms for diverse audiences. It was in this spirit that several literary figures active in the Safavid realm—Mansur Semnani, I'jaz Herati, Vahid Qazvini, Nawras Damavandi, and Mir Nijat—expanded on the established themes and genres of classical literature to convey their experiences and imaginings of Isfahan. These works are also analogous in terms of their contexts of production, intended audiences, and modes of representing the built environment. While a few contain allusions to royalty, they were primarily composed and consumed in non-courtly social settings.

The creation of these urban literary works was intimately intertwined with the emergence and expansion of a public sphere in Safavid Isfahan. With the growth of literacy and the participation of increasingly diverse groups in poetic production and consumption, it became more usual for "commoners" to compose poetry and collect literary and artistic works in anthologies and albums. The compendium of poets completed in 1680 by Muhammad Tahir Nasrabadi (d. after 1688) comprises notices on individuals from all walks of life—especially from the ranks of craftsmen—who were active in poetic composition. The "democratization" of literary production followed, in particular, the advent of new performative loci for literature. Whether recited orally or copied in anthologies, an expanding corpus of literary works was written for audiences in coffeehouses rather than exclusive elite circles. The works themselves contain allusions to coffeehouses, urban spaces, and suburban gardens, which hint at their contexts of creation, recitation, and reception.

For their contemporary audiences, the rarefied literary output of a poet such as Sa'ib and the urban songs of the (now) lesser-known poets mentioned above were part of a shared literary terrain marked by a penchant for freshness. This is revealed, for instance, by an eighteenth-century note on Mir Nijat, a poet active in late Safavid Isfahan (whose poetic city description is discussed in the following chapter). This biographical notice describes Mir Nijat as a poet "who has invented a fresh style [*ṭarz-i tāza*] appreciated by commoners [*ʿavām*]. This means that he has followed the lewd [*ajāmir*], the riffraff [*awbāsh*], and the marketmen (*bāzārīyān*), basing his poetry on their expressions."[28] Both modes of the "fresh style"—mannerist and mundane—were products of an age that valued novelty and innovation. They were also socially linked; as a

broader social spectrum participated in poetic production, the learned class embraced sophisticated rhetorical figures to differentiate themselves from the rest. The dual hallmarks of early modern Persian literature—taking pleasure in literary artifice and engaging with ordinary urban life—were facets of the same lifeworld.

The shahrashub—a genre of poems or verses on youthful artisans and social characters—was the major medium for producing "urban topographical" literature in seventeenth-century Isfahan.[29] Like other aspects of the early modern literary universe, shahrashub had deep-seated roots; the earliest known examples appear to be a set of occasional poems by Mas'ud Sa'd Salman (d. 1121).[30] The following poem by Sa'd Salman, dedicated to the "blacksmith beloved" (*dilbar-i āhangar*), encapsulates the poetic conventions of the shahrashub.

> If smithcraft is your art,
> Consent with me O you heart-alluring one!
> From your own heart and my heart,
> Build, for your work, iron and kiln;
> As there is no iron as hard as your heart,
> And there is no kiln as warm as mine.[31]

As these lines illustrate, the poet's art is to invent images of love—describing the allure of the beloved or expressing the passionate yet rarely requited yearning of the lover—using similes and metaphors drawn from the tools and working methods of the artisan. Sa'd Salman's verses suggest that the typical appearance and trappings of a social personage, such as a jurist (*faqīh*) or an antinomian dervish (*qalandar*), could also be the focus of shahrashub poems. As a literary theme, then, shahrashub offers infinite potential for fashioning new lyric imagery to describe or address the beloved. Nevertheless, unlike early modern examples, Sa'd Salman's

poems are highly generic—no specific locale or individual is mentioned.

Based on these medieval precedents, shahrashub evolved into a popular vehicle of city description across the culturally interconnected realms of the Ottomans, Safavids, Uzbeks, Mughals, and the Deccan sultanates of South Asia. The expansion of this genre was thus largely an early modern transregional phenomenon, formed in tandem with the literary sensibilities that emanated from the emerging patterns of urbanization in West and South Asia. As in the broader Persianate world, the distinctive feature of the shahrashub poetry composed about Isfahan consisted of a shift from a metaphoric mode of description to realism, a feature that can be seen across languages and regions.

This "realistic" ethos does not mean, however, that all the amorous themes in the works of Qazvini or Semnani reflect actual affective experiences. Gazing at the beautiful face of a male adolescent—as embodiment of ideal human form and hence a *shāhid*, or "testimony," to divine beauty—was an established Sufi practice.[32] The homoerotic appreciation of pleasant-looking boys—who were employed as cupbearers and pages—was also a common, culturally sanctioned practice at royal courts and in the elite male circles throughout the medieval and early modern periods. In Safavid Isfahan, the practice had spread to coffeehouses, and there are several references to poets who experienced passionate love (*'ishq*) for certain coffee servers.[33] Still, it is implausible to assume that Semnani in the seventeenth century had fallen in love with all the artisans and vendors of Isfahan, just as it is implausible to make this assumption regarding Sa'd Salman in the twelfth century. In other words, the homoerotic veneration of youthful beauty was both a literary convention and a social practice—at once a pursuit of the mind

and of the flesh. Hence, the social contexts of shahrashub poems need to be examined along-side their literary conventions. Indeed, realism was another current of early modern Persian literature: the so-called Realist School, or School of the Incident (*maktab-i vuqūʿ*), which favored works that derive (or claim to derive) from real-life events and experiences.[34]

In terms of literary form, the "urban topographical" works that deal with Isfahan can be divided into two major categories: narratives in the form of rhyming couplets (*masnavī*) and prose compositions interspersed with poems (*inshāʾ*). A poem of interminable length, the masnavi was suited to creating narratives flowing across time and space. Some of the poems in this category describe the city in the course of personal travels through various cities in Safavid lands and beyond, while others recount excursions in specific gardens and urban spaces or describe the city's artisans in the shahrashub mode. Yet the most innovative mode of city description that flourished in Isfahan specifically was inshaʾ. An embellished piece of rhymed prose interspersed with poems of various lengths and forms, inshaʾ had long been used to compose texts ranging from administrative decrees (*farmān*) and diplomatic correspondence (*rasāʾil*) to friendly letters (*ikhvāniyyāt*) and prefaces (*dībācha*) to literary collections or albums of paintings/calligraphy.[35] Verbal virtuosity is a key characteristic of the inshaʾ, manifested in rhyming phrases (*sajʿ*) and elaborate figurative speech.

As is evident in the works by Semnani, Iʿjaz Herati, and Nawras Damavandi (discussed in chapters 8 and 9), several aspects of the inshaʾ rendered it a capacious medium for city description. No less than in the versified masnavi form, it was possible to create a fluid narrative in prose, which was free of the structural limitations of meter, rhyme, and length that govern verse forms. Hence, in relatively pliable forms such as masnavi and inshaʾ, a parallel could be established between the temporal flow of text and that of urban experience. Moreover, due to the absence of a uniform metrical structure, prose could incorporate a larger number of toponyms than metered poetry. It also appears that the rhetorical density of the ornate epistolary style provided a suitable vehicle for representing Isfahan's hustle and bustle.

The urban topographical descriptions of Isfahan, then, were composed in various forms that displayed thematic and formal innovation in dialogue with the heritage of classical Persian literature. Citing and mixing a multitude of literary models were viable devices for representing the complex urban realities of early modern cities. Yet despite the diversity of these works in their literary forms and approaches and the social backgrounds of their authors, the multiple manuscript copies and the interconnections between them reveal that they were not sporadic efforts but rather constituted a discourse on the city. In other words, there were communities of writers, readers, and listeners—centered on Isfahan—who took an interest in literary representations of the urban environment. Besides providing a source of inspiration for poets, Isfahan was also an ideal locus for the oral and written dissemination of literary works; if coffeehouses nurtured a public eager for new forms of literature, the city's papermaking workshops furnished the material support for their textual diffusion in reading communities across Iran and beyond.

CIVIC LYRICISM AND ISFAHAN'S URBAN IMAGE

The bulk of the corpus of topographical literature on Isfahan dates from the mid-1600s, and

specifically the period between 1650 and 1675, which spans the reigns of Shah Abbas II and Shah Sulayman (r. 1666–94). Chronicles of the Shah Abbas I period abound in short poems containing chronograms commemorating the design or completion of buildings, but, to my knowledge, no versified work was produced on architectural or urban projects.[36] Despite the far greater scale of the constructions instigated by Shah Abbas I, no poem comparable in scope to Abdi Beg's *Jannāt-i ʿAdn* (a poem of more than four thousand verses commissioned by Shah Tahmasp in celebration of his new capital, Qazvin) appears to have been composed to describe Isfahan as it was built in the early 1600s.

Various reasons can be suggested to explain why the mightiest sovereign and greatest builder of all Safavid dynasts did not deem it worthwhile to memorialize his grand architectural achievements through the medium of verse. The presumed disregard of Safavid rulers for the poetic arts—traditionally cited as the major cause of the "decline" of poetry in Safavid times—is unconvincing, since the reigns of both Shah Tahmasp and Shah Abbas II saw extensive patronage of court poetry. Rather, the most plausible reason for this want of commemorative poetry is that the ultimate intent of courtly panegyric verse was not suited to the urbanistic projects of the age of Shah Abbas I. Since the early Abbasid period, and based on a pre-Islamic tradition, Arabic and Persian poetry about palaces had developed a repertoire of themes and images that aimed to turn the royal edifice into an emblem of the ruler. "Set up as a mirror of the king," the palace was "both a physical and mental construct," as Irene Winter remarks about ancient Mesopotamia. "The rhetorical function of the palace, as exemplified through its affect," Winter argues, was "as essential as its residential, administrative, productive, and ceremonial functions."[37] Regarding the earliest examples of Persian poetry on palaces, Julie Meisami notes that such poems should be understood in light of this "rhetorical affect."[38]

The central quality of the urban plan of Isfahan that needed to be highlighted was certainly not, I argue, this particular kingly "rhetorical function." That no panegyric poem was commissioned on the grand monuments and urban plans of the Safavid capital during the reign of Shah Abbas I thus speaks to the distinct civic character of seventeenth-century Isfahan, revealing that it was conceived and perceived as more than a mere rhetorical manifestation of traditional kingship. Like any grandiose urban complex, early modern Isfahan was both a physical and a mental construct; the poetic articulation of its ethos, however, required a different modality of verbal expression. Only through some years of urban encounters and human dwelling, it seems, could the essence of the city's experience be conveyed in verse and prose; Isfahan had to be lived and experienced, felt and dwelled in, before it could be poetically expressed. The following chapters explore how the urban songs of midcentury poets articulated Isfahan's civic character by engaging with the city's humans and experiences, affects and vistas, senses and pleasures.

Urban Sights and Discursive Images

MODES OF VISUAL AND VERBAL ENGAGEMENT

Junabadi's narrative of the construction of Isfahan, penned in 1617 and incorporated as a self-contained essay into his chronicle, is probably the most coherent literary description composed about the development of the Safavid capital. In contrast to other chroniclers, who recount building activities in discrete episodes, Junabadi integrates the consecutive stages of Isfahan's development into a unified narrative with a beginning, middle, and end.[1] The text opens with a preamble describing how each era witnesses the rise of a just king under whose reign people engage in developing the world. An example of such circumstances is the accession of Shah Abbas, who assumed the throne amid a tumultuous period. Rising like a sun on "the lofty horizon of the Safavid dynasty," the rays of the shah's justice "illuminated all the corners of the world, and out of the spring of his paradisiacal character, the planning and adornment of gardens, markets, and maydans embellished cities with novel designs and wondrous images." And the construction of markets, gardens, squares, and residences in Isfahan "testify to this claim."[2] In Junabadi's tale of Isfahan's development—which is informed by the time-honored notion of construction as an index of kingship—the protagonist is Shah Abbas, who embarks on revamping the Maydan-i Harun-i Vilayat and its adjoining markets but, faced with the distrust of local notables, turns his attention to the construction of the Maydan-i Naqsh-i Jahan, the Chaharbagh, and extramural quarters. Ultimately, through these projects, a "new city" is created.

Junabadi's narrative is also distinct in its coherent treatment of Isfahan's urban components, as is evident in the description of the Chaharbagh:

> Then a fifty-cubit-wide khiyaban was planned between the Abbasabad [Garden] and the Dawlat Gate, which lay at a distance of one *farsakh* [two and a half miles]. According to the world-obeying order, the great khans and generals together with the noble viziers and religious and bureaucratic officials, whether residing in the capital or stationed in the provinces, laid out pleasant gardens opposite one another along both sides of the khiyaban, each to his own tastes and temperament. At the entrance of each garden, they built lofty edifices made of brick, stucco, and marble. The walls and roofs were faced with colored tiles, and some were adorned with pleasant paintings and wondrous ornaments. In the space of the khiyaban, enormous pools of various shapes were built in front of each edifice.[3]

By referring to shapes, measurements, and configurations, the text conveys a concrete picture of the Chaharbagh's overall configuration.

Indeed, even if nothing else were known about the Chaharbagh, it would still be possible to draw—based on Junabadi's description alone—a scaled schematic plan of the entire ensemble, with its accurate width and length, beginning and end points, and rows of paired edifices flanking pools of various shapes.

This kind of verbal exposition is essentially different from the mode of spatial representation that underlies nonroyal urban topographical descriptions of Isfahan. Junabadi portrays urban spaces in broad brushstrokes, evoking a planimetric view of the Chaharbagh as seen from an elevated locus—a stance befitting the intended royal audience of a chronicle. Non-courtly works, by contrast, encompass a broader range of viewpoints, representing the city through a panoply of vignettes, metaphors, and sensory impressions as experienced by a kinetic beholder. What binds the city elements together in the latter works is not the geometric construction of space, as in Junabadi's account, but the holistic, interconnected character of the urban environment as experienced by sensing bodies and as reflected in memory and imagination.

To some extent, these two types of spatial narration represent successive episodes in the history of Isfahan: the moment of its creation as a cluster of monumental urban ensembles and that of its saturation with sensations and subjectivities half a century later. Even so, these two modes of urban representation are not mutually exclusive; they mark the ends of a broad spectrum of spatial and visual experiences. Though primarily centered on planimetric aspects, Junabadi's description is not devoid of sensory glimpses—it refers to the breezes that waft into the Allahverdi Khan Bridge—just as the literary works that catered to an urban audience contain passages that evoke an overarching image of the city.

Reading the urban spaces and vistas of Isfahan in light of literary representations of the urban environment, this chapter interrogates the diverse manners of seeing, perceiving, and imagining the city that early modern Isfahan propelled and harbored. To reveal the link between spatial images of Isfahan and its poetic descriptions, I first explore the principal modes of urban spectatorship before turning to literary representations of the cityscape. Theories of visual perception and urban image afford an array of critical concepts for comprehending the cognitive modes of engagement with the urban environment. My objective, though, is not to chart the modalities of urban perception through these interpretive prisms. Rather, I primarily aim to reveal the social import of embodied sensory encounters with the city by examining how urban experiences nurtured distinct conceptions and expressions of urban subjectivity. Whether perceived by its underlying geometric designs or its panoramic views, whether imagined through discursive metaphors or kinetic encounters, Safavid Isfahan established a dynamic arena for fashioning new civic selves.

THE CITY AS DESIGN

Safavid sources abound with references to designs (*ṭarḥ*) in a manner that is suggestive of drawn blueprints. Yazdi, for instance, refers to the commercial spaces of the Maydan-i Naqsh-i Jahan as having fine designs (*khvush-ṭarḥ*) and extols its architect for his innovative schemes (*nuqūsh-i badāyiʿ-nigār*).[4] Other chronicles, too, frequently describe the designs of the monuments and urban spaces of Isfahan with adjectives such as "pleasing" (*dil-nishīn*). Similarly, Qazvini, in his versified description of the neighborhood of Abbasabad, likens the arrangement of its houses to a chessboard, a simile

that conjures up the modular grid plan of the quarter.[5] Building projects, in other words, were widely appreciated for the geometric designs that underlay their construction—the design itself was a criterion of aesthetic quality and a source of visual pleasure.

To a large extent, this appreciation of architecture and urbanism in terms of "design" stemmed from the intermediary role of drawings on paper in conceiving a building project, a practice that is traceable back to the early medieval period and flourished particularly from the thirteenth century onward. Although no architectural drawing associated with Isfahan's construction seems to have survived, the sources refer to the preparation of architectural drawings, hinting that the practices documented in the extant scrolls were common in Safavid Isfahan.[6] One intriguing reference appears in a 1614 decree issued by Shah Abbas regarding the construction of a church in New Julfa. The decree orders the "royal architects" (*miʿmārān-i khāṣṣa-yi sharīfa*)

> to design an exquisite church on the allocated land . . . and draw its design [*ṭarḥ*] on paper and board [*kāghaz va takhta*], and send it to the noble one so that We might inspect it. After inspection, We will order the masters [*ustādān*] to begin the work.[7]

Another reference, a passage in a mid-seventeenth-century chronicle, relates that in 1610 Shah Abbas ordered three individuals—the calligrapher and head of the royal atelier Ali Riza [Abbasi], the astronomer Yazdi, and the theologian and polymath Shaykh Bahaʾi—"to travel to Maragha [a city in the Azerbaijan province], observe the building of the Maragha observatory, draw its plan [*ṭarḥ*], and bring it to the noble attention."[8]

These two cases indicate that an edifice—commissioned or standing—could be (and often was) represented through the medium of drawing on paper. They further imply that such drawings were reviewed by the shah as well as a courtly circle. The architectural and urban components of Isfahan were likely created in a collaborative process similar to the ones noted above. It is not surprising, then, that evocations of the city and its components in terms of "design" appear primarily in chronicles; the courtiers' access to drawings would have facilitated this mode of verbal representation.

What is unique to Isfahan is that the modes of design previously used in the development of individual gardens and edifices were deployed on a grand urban scale; geometric clarity and visual intricacy—an aesthetic trend that had reached its apogee in Timurid architecture—was now appreciated as a key quality of urbanism. Nevertheless, while the intermediation of architectural drawings was instrumental in the emergence of this mode of description, these drawings were not the only factor that encouraged the perception of the city from an all-encompassing viewpoint. As already noted, one could apprehend the city's layout from southern hillsides or deduce a mental map through an accumulation of experiences over time. In any event, the textual references to an abstract language of design—geometric shapes, checkerboard patterns, and symmetrical arrangements—indicate a consciousness of space as a homogeneous entity, one that could be created through a modular, geometric disposition of physical and natural elements on two coordinates and could be imagined as such.

THE CITY AS VIEW

On arriving in Isfahan in December 1703, the first thing the Dutch painter and author

Cornelis de Bruyn did was to ascend the sloping foothill of Suffa Mountain. There he made a panorama of the city that later appeared as a foldout engraving in his travel narrative first published in Amsterdam in 1711 (fig. 90). Depicting the city in its natural setting, this sweeping vista illustrates the major physical and topographical features of Isfahan: the Hizar Jarib Garden and its pigeon towers are depicted in the foreground, while a number of urban landmarks—minarets, gardens, churches—are rendered across the picture plane.

In its pictorial conception, this panorama was informed by a mode of topographical representation that first emerged in early modern Europe. And yet, the view itself was not De Bruyn's invention; rather, the Dutch painter drew this scene from an elevated vantage point on Suffa Mountain that had already been established as a locus for gazing out over the cityscape. Known as Takht-i Sulayman (Solomon's Throne)—a reference to the flying throne of prophet-king Sulayman—the lookout was created at a promontory featuring a spring that gushed in a grotto (fig. 91). Visiting Isfahan in 1628, Herbert described the vista from this point, suggesting that it had served as a viewing site since the outset of Isfahan's development.[9] It was under the eponymous Shah Sulayman (r. 1666–94), however, that the lookout was fashioned into a terraced platform with belvederes perched atop it. Chardin notes that Shah Sulayman ordered the site's construction because he wanted "to show the city to his mother from there," and Kaempfer relates that the king frequently visited the viewpoint with his harem after proceeding through the Chaharbagh.[10] Kaempfer further notes that Takht-i Sulayman comprised four terraces, and his drawing (fig. 92) displays two cylindrical towers (s. *burj*), one featuring an open-air roof terrace, the

other covered with what seems to be a conical wooden canopy. "Apart from a panoramic view that allows one a circular view," Kaempfer "did not find anything notable, nothing worthy of the founder."[11] It was clearly the view—framed as a continuous vista by the ribbon aperture of the cylindrical tower—that made the site worthy of visitation by the women and men of the royal household.

Situated south of the Hizar Jarib Garden, Takht-i Sulayman was experienced as part of the axis of the Chaharbagh. Indeed, the implied itinerary of Qazvini's "Sāqī-nāma" (discussed in chapter 5) does not halt at the southern pavilion of the Hizar Jarib Garden but rather proceeds further uphill to this lookout: "When you exit the area of the garden," the poet notes, "like [the legendary stone carver] Farhad, you become enamored with a mountain."[12] Qazvini likens the mountain to a seated figure exploring the world and alludes to the vista of the Chaharbagh's "rows [*ṣufūf*] of chinars" that unfolds in front of the viewer. Further on, he characterizes Takht-i Sulayman as the "qibla of Isfahan," toward which the world has turned its face.[13] By evoking both the sight of the mountain and the vista that it affords, these verses cast Suffa Mountain as a constituent part of urban scenery.

The Takht-i Sulayman and its belvederes, then, generated the principal panoramic view of Isfahan. Revealing the city and its hinterland as a singular vista, this viewing stage enabled observers to perceive the city in its entirety and hence as an object of contemplation. As Roland Barthes notes, the bird's-eye view embodies a distinct sensibility of vision, one that "gives us the world to *read* and not only to perceive." As such, the panoramic view transforms the city into an "intelligible object," a structured entity whose essence could be comprehended and savored.[14] Indeed, the labeling of Isfahan's

FIGURE 90
Cornelis de Bruyn, panoramic view of Isfahan from the Takht-i Sulayman on Suffa Mountain, detail. From Cornelis de Bruyn, *Reizen over Moskovie: Door Persie en Indie* (Amsterdam: Rudolph en Gerard Wetstein et al., 1714), fig. 74. Utrecht University Library.

landmarks in De Bruyn's engraving probably reflects the practice of period viewers, who were surely capable of identifying the city's constituent elements from this vantage point. It is no coincidence, then, that the two major panoramic views of Isfahan made by European travelers (Grélot and De Bruyn, figs. 83 and 90) were drawn from Takht-i Sulayman; without it, such city views would not have existed.

Even so, the panoramic view of the city did not convey a uniform message to all beholders. For the royal patron of the Takht-i Sulayman, the prospect of the orderly design of the cityscape,

nestled in the cultivated valley of the Zayanda River, signaled natural bounty and material prosperity; the belvedere was a metonym for the royal gaze, even in the absence of the king, projecting a fresh sense of sovereignty over a settlement that had expanded significantly since 1600. But the viewing terrace of Isfahan was not an exclusively royal retreat; it was accessible to the public, could accommodate scores of viewers, and was experienced as an extension of the city's public promenade. This accessibility is emblematic of the dynamic social environment in which the gaze was enacted in Safavid Isfahan. All

could take in the city as a view and establish a subjective relationship with the urban environment as a panoramic spectacle.

URBAN PROSPECTS

The panoramic view was one among many modes of visual apprehension, both old and new, through which Isfahan was perceived and represented. One such visual mode was the silhouette. In Persian literary tradition, the term for silhouette, *savād*, has several connotations related to the core meaning of "darkness" or "blackness": smoke, manuscript copy, the environs of a settlement, and the "pupil of the eye."[15] The city and vision are thus intimately combined in the semantic field of the word itself. In Qazvini's *ʿAshiq va maʿshūq* (Lover and Beloved), when two lovers reaching Isfahan from India first see the city's silhouette (*savād-i shahr*), it appears to them like "the pupil of the eye filled with light."[16] The references to *savād* also take on various metaphorical associations. Mir Nijat, for instance, likens the *savād* of Isfahan to a "curled hair on the face of the world."[17] Descriptions of the silhouette often allude to its salient visual elements, such as the city walls and minarets.

FIGURE 91
Cornelis de Bruyn, view of Takht-i
Sulayman. From Cornelis de Bruyn,
*Travels into Muscovy, Persia, and Part of
East-Indies* (London: A. Bettesworth
et al., 1737).

The *savād* of Safavid Isfahan was understood as an entity in its own right.

Yet Isfahan also witnessed the rise of unprecedented modalities of vision. For example, one can find several allusions to perspectival vistas formed by the city's tree-lined avenues; when Qazvini describes the Chaharbagh with the phrase "behold the chinars arrayed on both sides," he clearly invokes a perspectival prospect.[18] It is no surprise, then, that when one-point perspective first appeared in Safavid painting, in the work of Muhammad Zaman (fl. ca. 1670–1700)—Shah Sulayman's chief court painter, who practiced in the Europeanizing (*farangī-sāzī*) idiom—it was almost invariably in the form of a vignette of a tree-lined walkway leading to a gatehouse (fig. 93).[19] Such vistas were ubiquitous in the new Isfahan's urban spaces and gardens, providing the closest analogue to the mode of picturing space

from a fixed point that single-point perspective encapsulates. It is also remarkable that these linear perspectives typically terminate in a pavilion with an upper-floor porch containing a talar or iwan; if for Muhammad Zaman and his contemporary Isfahani viewers the receding rows of trees resonated with the converging lines of a linear perspective, the pavilion seems to have embodied and confirmed the existence of a vanishing point and a viewing subject. As Marvin Trachtenberg notes regarding the urban design of fourteenth-century Florence: "Perspective is the one level of planning that explicitly—by design—incorporates the viewer into its paradigm. As in essentially all perspectivally constructed images, whether purely pictorial or architectural, trecentesque or Albertian, the viewer is made the fulcrum of the entire spatial composition."[20] For Safavid-era viewers, single-point perspective, embedded in Isfahan's urbanism and garden design, constituted one way of seeing the city, alongside other modalities of vision, through which subjectivity was constructed.

This overview of the intertwined modalities of visual perception—planimetric, panoramic, and perspectival—reveals the complex, layered visuality of early modern Isfahan. In seventeenth-century Isfahan, gazing at the city as a panorama was as integral to one's viewing experience as observing the city from a fixed standpoint. The spatial form of the city was instrumental to the rise of these new scopic modes, as was familiarity with the emerging conceptions of visual representation that were introduced through global interactions. Enabling and representing perspectival and panoramic modes of viewing, the new Isfahan enabled its residents to perceive and imagine their city—and the world—anew.

FIGURE 92
Engelbert Kaempfer, Takht-i Sulayman on Suffa Mountain. British Library, MS Sloane 5232, fol. 44r. © The British Library Board.

THE PERIPATETIC EYE OF THE TRAVELER

Beyond optical perception, the literary descriptions of Isfahan reveal a broad range of urban sensitivities, offering glimpses into the ways urban experiences were interpreted by individuals and communities. As verbal representations of the urban environment, these works enable us to read the city like "a poem which unfolds the signifier," and "it is this unfolding that ultimately the semiology of the city should try to grasp and make sing," as Barthes notes.[21] But literary urban descriptions were more than mere linguistic translations of the city; at the core, they were informed by kinesthetic sensations and phenomenological encounters, revealing an array of subjective yet interrelated lifeworlds that were inextricably bound up with the city environment. In this way, these descriptions

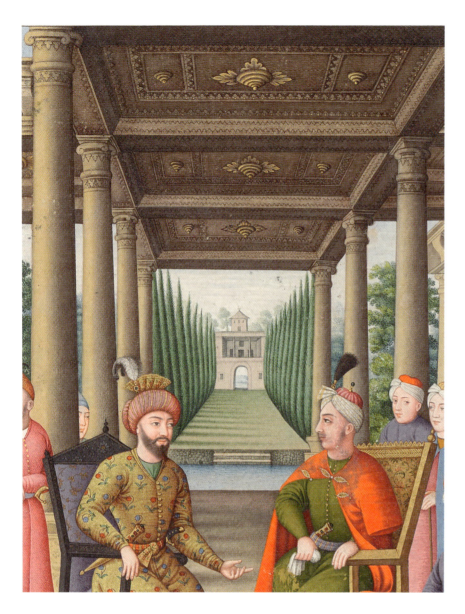

Nūr al-mashriqayn (Light of the Two Easts, 1657), *Muḥīṭ-i kawnayn* (Surrounding of the Two Worlds, 1672–73), and *Masīr al-sālikīn* (Pathway of Wayfarers, 1674–75).[22] Unlike the primarily metaphoric masnavi poems of the medieval period, these early modern travelogues are marked by spatial realism. The urge to verbalize a personal journey for the self and for transregional publics and audiences contributed to the heightened spatial specificity. Encountering unknown foreign lands—particularly the cities, landscapes, and peoples of the Indian subcontinent—prompted concrete descriptions of physical and natural environments, which in turn shifted topographical poetry about individual cities like Isfahan toward a higher degree of realism.

While these travelogues are structured around the authors' movements from city to city across a vast geography, each locus is represented in a fairly static manner, with a set of discrete descriptions focused on specific locales and monuments. The inclusion of city descriptions in a broader spatial narrative determines the overall descriptive pattern of these works. For instance, it is primarily in these travelogues that Isfahan's fortifications and bastions (*ḥiṣār, bārū, kungur*)—the first sight of the cityscape that an approaching traveler would behold—are described. Overall, one can discern a fairly hierarchical progression from the city's silhouette (*savād*), as it is viewed from afar, to its major urban spaces, its monuments, and occasionally its prominent notables. In this continuous narrative of a journey, the city description is framed between moments and visual impressions of arrival and departure.

In keeping with established tradition, architectural monuments are typically described in hyperbolic terms. But rhetorical exaggeration does not mean that specific or concrete features

point to the dual nature of sensory perception—a process conditioned both by culture and by phenomenological encounters with material spaces.

Some of Isfahan's perceptual qualities are articulated in verse travelogues that describe the city through the eye of a peripatetic traveler. At least three such topographical narratives contain substantive descriptions of Isfahan:

are absent. The choice of sites and features worthy of exaltation in each city reflects the period understandings of a settlement and the tropes associated with it. In descriptions of Isfahan, for instance, the enormous size of the Safavid capital is often underscored: Isfahan is the "essence of the world" (*khulāṣa-yi jahān*), filled with "people of both worlds" (*khalq-i du jahān*).[23] Some city elements are extolled for their size and perceived significance in the urban landscape. The monuments surrounding the Maydan-i Naqsh-i Jahan—the Shah Mosque, the palace quarter, the qaysariyya, and the mint (*żarrābkhāna*)—are expansively described. Indeed, both Bihishti and Salik describe the maydan's components in the order mentioned above, which corresponds to the ranking of their size and perceived significance.

Aspects of everyday life and less monumental structures such as the Royal Bathhouse (Hammam-i Shah) figure in these poetic travelogues as well. Tucked behind the market lanes on the north side of the Maydan-i Naqsh-i Jahan, the Royal Bathhouse was not a conspicuous landmark, but it was an attractive site and an integral part of the city experience, and hence worthy of description. Not surprisingly, coffeehouses and their youthful servers are highlighted in these versified travelogues. "Natives [*yārān-i vaṭan*] and strangers [*kasān-i ghurbat*]" gather in coffeehouses.[24] At each may be found "an assembly of elegant people [*żarīfān*]" with "rows of companions [*ḥarīfān*] on every side; some are engaged in poetic recitation [*bayān-i shi'r*], others rejoice in song and music [*surūd u sāz*]."[25] The presence of the coffeehouse as the principal venue of social life and urban leisure is the primary feature that sets Isfahan apart from other cities in these travel accounts.

In all these works, the description of the Maydan-i Naqsh-i Jahan is followed by a section

on the Chaharbagh and the Zayanda River, connecting the city to its natural environs and extramural gardens. On the whole, these literary travel narratives portray Isfahan as a city with cosmopolitan markets, teeming public spaces, and ethnically diverse denizens. The overall image is not of a city of erudite notables, but rather of a bustling metropolis embedded in a transregional web of settlements. The latest work in this genre, *Masīr al-sālikīn*, by Mir Nijat (discussed below), is remarkable for the way it evokes a physical itinerary through monuments and city spaces.

DISCURSIVE IMAGES AND URBAN ALLEGORIES

The most innovative mode of city description that flourished specifically in Isfahan was created in the form of ornate prose, or insha'. In rhetorical texture, these works consist of wordplay and metaphors derived from the names of the gardens, markets, monuments, quarters, and suburbs of Isfahan. Combining the literary devices of the epistolary arts with shahrashub elements and ekphrasis, these prose compositions form a distinctive genre, crafted to convey the experiences and impressions of Isfahan for the publics and audiences of later Safavid times. An analysis of three of these works, composed by the literati of various backgrounds—Nasira Hamadani, I'jaz Herati, and Nawras Damavandi—not only offers unique insights into the urban image of Isfahan but also reveals the manifold ways in which the city was imagined by individuals.

The earliest known prose description of Isfahan, datable to the 1610s, is a fairly short work titled "Preface on the Description of the Status of the Self, and Description of Isfahan and Separation from the Shah," penned by Nasira Hamadani (d. 1620–21), a bureaucrat employed

at the royal chancellery during the reign of Shah Abbas I and acclaimed for his eloquent compositions.[26] Following a densely ornate preamble (*dībācha*) on "the status of the self"—a complaint about the vagaries of the age and the ignorance of the author's contemporaries—the text turns to a description (*vaṣf*) of Isfahan. The figures of speech emerge from one central allegory: Isfahan as a new bride (*ʿarūs*). Adorned with flowers, the bride anxiously awaits the groom's arrival in "the bridal chamber [*ḥijla*] of [the neighborhood or garden of] Abbasabad."[27] Yet the new bride is "sick from the agony of separation from the royal retinue [*mawkab-i humāyūn*]." Isfahan itself is in the chamber of malady (*nātavānī*). It is as if the Zayanda River is weeping through the eyes of the bridges. What further augments the city's pain—which Isfahan itself utters in the first-person voice, or *zabān-i ḥāl*—is its envy (*rashk*) of the city of Farahabad. Only the shah's visit could heal the malady of Isfahan.[28]

A geographical shift in the focus of royal patronage underlay this eloquent plea for the shah's return; from the 1610s onward, Shah Abbas I spent little time in Isfahan, instead turning his attention to the development of the cities of Farahabad and Ashraf in the Caspian Sea littoral. Nasira's composition thus heralds a key characteristic of Isfahan's literary descriptions: the absence of the monarch, rather than a royal mandate, propels individuals to write about the city. From the moment of its creation, the letter to the shah is a public text that engages an urban audience.

As an encomium, Nasira's composition is remarkable for the manner in which it links the city to the patron by portraying the former as a woman desiring the presence of the male patriarch. In this allegory, Isfahan is a sensual feminine figure created by the king and left with no one to care for her. Analogizing a palace to a bride was an established literary theme in classical Arabic and Persian poetry. Here, though, what is allegorized as an object of imperial affection is not a stand-alone edifice or garden but the entire city, with its districts, bridges, and natural environment. The personification of the city is achieved by deploying the trope of prosopopoeia (*zabān-i ḥāl*), a time-honored figure of speech, whereby inanimate material artifacts—objects, buildings, cities—are endowed with the power of speech.[29] By juxtaposing a description of his "individual state" (*ḥāl-i khud*) with that of a personified Isfahan, Nasira draws a parallel between his own subjectivity and that of the city. Speaking in the first person, Isfahan acquires the character of a living entity mediating between the ruler and the subject.

Another interesting example of this mode of city description is "Taʿrīf-i Iṣfahān" (Description of Isfahan) by Iʿjaz Herati (d. before 1680). In his biographical notice on Iʿjaz Herati, Muhammad Tahir Nasrabadi says that the Herati poet—who moved back and forth between Isfahan and his hometown, Herat—composed both verse and prose and considered himself to be *mutafarrid* (literally, "unique"). More interestingly, Nasrabadi relates that on arriving in Isfahan, Iʿjaz "wrote satires about Isfahan in the guise of encomiums [*dar libās-i madḥ*]," which in turn aroused Nasrabadi's "villager's bias" (*taʿṣṣub-i rūstāʿī-garī*), spurring him to write a number of responses (*javāb*) in prose.[30] This statement suggests that the medieval notion of interurban rivalry—and the double meaning of shahrashub as satire and encomium—remained a driving force of city description in seventeenth-century Isfahan. The anecdote further implies that the surge in the production of urban topographical literature in the mid-1600s was not the result of

isolated attempts but was rather part of a public discourse involving provincial visitors (Iʿjaz Herati) and natives of Isfahan (Nasrabadi).

Nasrabadi's passage also reveals something about the perception of Isfahan by provincial literati. Aspiring poets came to the Safavid capital not merely as a stop along their journeys but also in search of the joys of the metropolis or in hopes of financial gain from patrons among the court and elites. The city offered some opportunities for professional men of letters, but obviously not everyone could ascend the social ladder. One can discern an aspirational subtext in the production of works such as Iʿjaz's description of Isfahan—a mix of desire, envy, and disdain for the capital's resources of pleasure and the luxury lifestyle of its privileged denizens. Poets who failed to secure a career at the Safavid court could take up a bureaucratic position or engage in a craft while participating in the informal literary circles hosted in coffeehouses, gardens, and private literary assemblies of the capital.

The composition titled "Taʿrīf-i Isfahān" is likely that which Nasrabadi characterized as "satire disguised as encomium." In the preamble, Iʿjaz describes himself as a stranger (gharīb) from the city of Herat who arrived in Isfahan on his way to the Hijaz (the region in western Arabia where Mecca is located; i.e., he was on his way to perform the hajj), relating how he was cured at the city's hospital (dār al-shifāʾ).[31] Alternating between ornate prose and verse, the text then offers a kaleidoscopic view of the city, alluding to urban sites and scenes as diverse as the lake of the New Hizar Jarib Garden, the comely youths of coffeehouses, the troupe of dancing courtesans parading through the markets, and the nocturnal scene of the light festival (chirāghān). The composition also includes

descriptions of craftsmen in the shahrashub mode, but these are, distinctively, embedded in a narrative packed with toponyms. Unlike a classical shahrashub, here the city is not idealized as an abode of generic beloveds. The overall picture that emerges from this description is that of a bustling city—with its peculiar sounds, tastes, and sights—and a lavish culture of public leisure.[32]

The core message of Iʿjaz's composition is made plain in the concluding passage (māḥaṣal-i kalām), where he proclaims, in a humorous vein, the truth (ḥaqīqat) of "this utterly metaphorical story" (dāstān-i sarāpā majāz) as "expressing gratitude for the security of the world of appearance [ṣūrat] and meaning [maʿnī] for the inhabitants of the heart-rejoicing domain of Iran."[33] Such statements reveal that in later Safavid times the sense of belonging to a territorial entity had trickled down from the ruling elites to the broader urban society. More interestingly, here the well-being of the residents of Isfahan is taken as a metonym for the prosperity of the entire populace of Iran. The rise of Isfahan as a metropolis—the agglomeration of people of diverse origins in a massive built environment associated with a centralized bureaucratic empire—helped create a sense of territorial integrity and what in hindsight can be described as a kind of protonationalist subjectivity.

A very different picture of Isfahan is conveyed in "Shahrāshūb-i khīyāl" (City Disturber of Imagination), a short composition penned by the calligrapher-poet Nawras Damavandi (d. after 1693).[34] While written in the format of inshaʾ, Nawras's dreamlike piece has a more coherent textual fabric and is devoid of the variegated details and peculiar tone that grants Iʿjaz's work a satirical edge. The text opens with a prose passage, in which the author offers a

narrative of himself as a lifelong lover wandering in the markets of Isfahan, followed by a poem:

> I saw Isfahan to be the silhouette of beauty
> [*savād-i ḥusn*],
> I drew its picture [*taṣvīr*] through
> shahrashub.
> I painted a picture from fresh imagination
> [*khiyāl-i tāza*]
> I arranged a spread for the mirth of speech.[35]

In these lines, Nawras links visual and verbal expressions but also underscores the centrality of his imaginative, subjective view in the formation of the description. Here the notion of shahrashub is consciously recast as a mode for producing an imaginary urban image (*taṣvīr*). Unlike a traditional shahrashub, the text lacks any description of artisans. Instead, the city's components have been turned into objects of love; it is the city itself that arouses the senses. Epistolary rhetorical devices mingle with metaphors of love and desire to fashion a textual representation of the city—a lyrical portrait that is entirely encomiastic.

A narrative depicting a wandering self undergirds the ensuing urban description: the core of the composition consists of a succession of short phrases in prose beginning with the term *gāh* (sometimes): "Sometimes in the convents [*takāyā*] of dispersed curls; sometimes in the church [*kilīsīyā*] of eyes with fine eyelashes; sometimes in the fire temple [*ātashgāh*] of reddish-yellow flame [*rang-i āl*]."[36] The references to convents, churches, and the fire temple convey a sense of the confessional and devotional diversity of Isfahan's cultural landscape—the Sufi convents scattered across the city, the churches of New Julfa, and the Zoroastrian fire temple outside the city walls—while evoking a long-established Sufi trope: the irrelevance of

religious affiliation to the pursuit of the mystical path. Likewise, the names of urban establishments such as wine taverns (*kharābāt*) and brothels (*bayt al-lutf*) evoke the urban reality of seventeenth-century Isfahan while referring to recurrent tropes in medieval mystical poetry.[37]

Aside from these generic, mystically laden allusions, the bulk of the work consists of references to a wide range of real sites—fifty-three toponyms are mentioned. Through these verbal indexes of space, the text takes the reader on an imaginary tour of Isfahan. Beginning in the Maydan-i Naqsh-i Jahan, it proceeds through the tree-lined avenues to gardens and neighborhoods, hovering above the towers of Takht-i Sulayman and glancing over the gardens, neighborhoods, gates, shrines, and avenues of Isfahan. The named sites are scattered in the new Safavid developments as well as in the old city and the hinterland. An interesting component of the old city referenced in the text is *kūcha-yi yāzdah pīch* (alley of eleven twists); here an established trope of Persian poetry, the serpentine curls of the beloved, is matched to the physical form of an urban pathway. The mapping of the toponyms suggests that the connections between the city parts are semantic and spatial: Tavuskhana is adjacent to the Allahverdi Khan Bridge; Dry Avenue leads to the neighborhood of Bidabad.

Through this mode of description, Nawras envisages the mental geography of Isfahan, one that can be construed as a cognitive "city image." Indeed, the majority of the fifty-three toponyms mentioned by Nawras can be classified within perceptual categories (paths, edges, districts, nodes, and landmarks) that, according to the theory of urban image proposed by Kevin Lynch, constitute one's mental image of the urban environment.[38] The most interesting and novel components of Isfahan in this regard

are the city's avenues—Khiyaban-i Khushk̇ (Dry Avenue), Khiyaban-i Taqnama (Avenue of Blind Arches), Khiyaban-i Abbasabad (Abbasabad Avenue), and Khiyaban-i Khvaju (Khvaju Avenue). These names reveal that the khiyabans of Isfahan were perceived as discrete elements of the urban environment (see fig. 82).

As a city description, then, the novelty of Nawras's composition lies in the way it incorporates Isfahan's urban components into a perceptual image. The successive references to various urban sites enabled audiences to conceive the city in its totality and to wander imaginatively within—and above—Isfahan. The fragments create a lyrical picture of the whole city, intertwined with imagery derived from the body parts and facial features of an ideal beloved. Through this exposition, Nawras paints a bird's-eye view of Isfahan, a discursive picture (*taṣvīr* or *naqsh*) akin to the one De Bruyn drew from the lookout on Suffa Mountain.

MOBILE BODIES AND SPATIAL ITINERARIES

Literary sources hint at concrete immersive modes of experiencing the city that occur when the self becomes closely entangled with the city's spatial structure. In these works, the verbal flow of the text comes close to the actual experience of moving through space. One example is "Ramz al-rayāḥīn" (Secret of Fragrant Herbs), by Ramzi Kashani.[39] The poem opens with a description of a friendly gathering, during which a companion makes mention of a garden in the vicinity of the city. The garden, he proclaims, "is a paradise near Isfahan," filled with pomegranate blossoms that resemble the color of dawn. Lured by this desire-provoking description (*taʿrīf*), the group sets off on an excursion. They traipse along a pathway lined with saplings—a reference to the newly laid-out Khiyaban-i Khvaju—until the luminous verdant silhouette of the Saʿadatabad Garden appears against the backdrop of the Zayanda River. Passing over the bridge, the companions then enter the garden through an ornate gate and stroll down a tree-lined walkway before settling near a pavilion encircled by a watercourse and fronted by pools on all sides.

Ramzi's poem dwells primarily on the evanescent sensory experience of the garden, focusing on the various flowers that one would encounter there. Yet it is also remarkable for its spatial trajectory; the garden is not an isolated suburban site but is connected to the city by a tree-lined avenue. Moreover, even if there is an element of panegyric (*madḥ*), it is clear that an informal friendly assembly, rather than courtly society, was the poem's primary source of inspiration. What Losensky has argued about the Hasanabad Bridge is equally true of the entire Saʿadatabad complex; from the moment of its inception, the royal estate became a setting of communal urban leisure.

The "Gulzār-i saʿādat" (Rose Garden of Felicity), composed by Muhsin Taʾsir Tabrizi, also describes the Saʿadatabad Garden, as well as a number of other riverfront gardens.[40] The poem begins with a description of the garden's trees, herbs, and flowers before turning to its edifices and designed landscape. As in the "Ramz al-rayāḥīn," the sequence of descriptions evokes a spatial trajectory within the Saʿadatabad Garden and along the river. Entering the garden through its southern gate, the poem proceeds northward along the axial walkway of the estate. There one reaches a raised basin (*mahtābī-yi dawrī*) before arriving at an octagonal building (*ʿimārat-i muṣamman*) surrounded by a timber peristyle, which the poet calls a talar. The poem then extols the garden's stone-paved walkways and its water channels with fountains (*jadval-i favvāra*), which run from edifice to edifice, leading to the

Ayina-khana, by the lake. It is a matchless palace, the poet proclaims, and if there existed a counterpart (*naẓīr*) for it, that could only be the palace's reflection (*ʿaks*) in the water (fig. 86). Reaching the lake in the midst of the Zayanda River, the poem then turns to the two bridges that bracket the body of water like "two eyebrows." Then ensues a description of the Bagh-i Nazar (Viewing Garden) and its belvedere (*manẓar*). Finally, the poem lingers over the Bagh-i Burj (Tower Garden) and the Tavuskhana, evoking a stroll along the northern bank of the Zayanda River.

These poems read as vivid descriptions of the riverfront gardens of seventeenth-century Isfahan. That the verbal description flows from one garden to another reflects the extent to which these estates created a unified riverscape. Although both Ramzi and Taʾsir praise Safavid monarchs, it is the narrative of an excursion—the physical itinerary of a journey through the urban landscape—that lies at the heart of their poems. Animating the literary description, the kinetic experience threads the city and poetic elements into a continuous whole.

An uninterrupted urban itinerary is also offered in Mir Nijat's *Masīr al-sālikīn*, a poem of twelve hundred verses (composed in 1674–75) that combines an autobiographical account (*sharḥ-i ḥāl*) with a description of Isfahan.[41] The verses reveal that the work was penned for an urban audience; after describing forty-two of his companions, the poet relates how they would spend their days, from dawn to dusk, in good company (*ṣuḥbat*) and enjoyment (*ʿishrat*)—in the "maydan, mosque, or monastery [*dayr*]"—visiting one coffeehouse after another, seeking a youthful beauty or listening to a recitation of Firdawsi's *Shāhnāma* (Book of Kings).[42] Mir Nijat's poem is composed in the masnavi form but, unlike the versified travelogues discussed above, is not divided into short subsections

offering discrete descriptions of urban elements. It instead reads in a fluid manner, conjuring up a specific itinerary.

Mir Nijat's portrayal of Isfahan begins at the city's most iconic religious monument: the new congregational mosque, the Shah Mosque. After praising the city's vastness, ramparts, and bastions, the poet exalts Isfahan's lofty edifices, shrines, and mosques, among which he singles out the congregational mosque, an edifice "whose like the ages have not seen in the kingdom of Iran."

> With a sigh at its prayer niche [*miḥrāb*],
> The heart's plea is attained, like a candle's drop.
> Its lamps illuminate the sanctuary [*shabistān*],
> Like the hearts in the chests of worshippers.
> The pious pray on every side,
> Settling there like felicity.
> The servants are sincere in service,
> Assistants of the faithful.
> The insightful receive the grace of the two worlds,
> From the vault of the iwan before the dome chamber [*ṣuffa-yi maqṣūra*] . . .
> Behold that fine pool [*ḥawż*] inside the mosque!
> Behold the wave of honor in the sea of grace . . .
> Around it is a colored stone pavement [*farsh-i sang*],
> Elegant and solid, like a preacher's sermon.
> The clay prayer disks [*muhr*] and rosary beads [*tasbīḥ*] in the corridor [*dālān*],
> Are far finer than the moles and curls of beauties.
> Its glory has taken the claim of height from the moon,
> What an iwan! What a gateway [*dargāh*]! Exalted Lord![43]

The poem's description is structured around distinct components of the mosque: the prayer niche (*miḥrāb*), the sanctuary (*shabistān*), the main iwan (*ṣuffa-yi maqṣūra*), the pool (*hawż*), the stone pavement (*farsh-i sang*), the corridor (*dālān*), and the portal (*dargāh*). In describing each element, the verses oscillate between symbolic associations and physical attributes. But the poem offers more than a mere laudatory description of random architectural elements; mapping the sequence of the described physical features onto the mosque's floor plan reveals a clear spatial trajectory: starting off at the *miḥrāb*, the poem leads the reader to the courtyard through the main iwan; proceeding through the corridor, the verses end at the mosque's monumental portal on the maydan (fig. 94).

A similar sense of spatial continuity, punctuated by vignettes, informs the rest of the poem. From the mosque, the poet takes the reader to the plaza through a picture as seen from the mosque's entrance: "The maydan appears [*namāyān*] from the mosque's door in one hundred beehives / Like a tear on the garment of lovers." To convey its vastness, Mir Nijat likens the square to a boundless sea, "a desert within a desert." "Like the sound of a nightingale, it has one hundred songs and instruments. It is at once disturbed and ordered, like a flower growing in water." The poem then dwells on the social ambience of the maydan and the makeshift stands set up all around. Next, Mir Najat turns from the open-air space of the maydan to its coffeehouses: "Coffeehouses appear in front / like the arched brows of the beloved." In these lines, the term "appearing"/"to appear" (*namāyān*) is used to shift the reader's focus, first from the mosque to the maydan and then to the coffeehouses; the movement through the city is punctuated by vistas of the urban landscape as seen by an individual observer. Mir Nijat ends

the verses on the maydan with a description of the qaysariyya and the hospital (*dār al-shifā*). The poem thus follows a longitudinal axis stretching from the mihrab of the Shah Mosque to the northern end of the qaysariyya market, on the north side of the maydan (fig. 95).

A kinetic experience is also evident in the concluding section of Mir Nijat's poem, which turns to the Chaharbagh. The verses begin with praise for the promenade's length, rows of plane trees (*chinār*), walkway (*khīyābān*), and stream (*nahr*), as well as the convents (*takāyā*) and the pool (*hawż*) that lies in front of them. Because of the "uproar of the nightingales and the fragrance of flowers," one would stroll up to the Allahverdi Khan Bridge unconscious (*bīhūsh*). From the bridge, the verses proceed to the Lunban Mosque (presumably along the riverbank) to meet the poet Nasrabadi. There, adjacent to the long-standing mosque, Nasrabadi had built a coffeehouse, where he spent most of his days.[44] In concluding his city encomium with praise for a renowned literary figure, Mir Nijat's poem recalls the conventional ending of the classical panegyric ode (*qaṣīda*). Here, though, the subject of praise is not the patron; it is a poet who resides in a coffeehouse. The city and the self are now interrelated in a new configuration.

As this spatial analysis demonstrates, what might initially read as a hyperbolic poetic description is marked by a novel mode of engagement with the built environment. The combination of a physical itinerary, a subjective angle, and urban vistas as building blocks of city description is rarely encountered in classical literature. The poem lyricizes the city, even its religious monuments; the inscription that frames the portal to the Shah Mosque is likened to the *khaṭṭ-i yār* (the down on the cheek of a youth), a sensual feature of the ideal beloved. The amorous gaze of the poet unifies discrete urban

the imperial rhetoric of Junabadi's description—yields to a kinetic city unified by the movement of bodies and by the imagination of individual subjects.

CITY EXPERIENCE AND URBAN SUBJECTIVITY

As the works discussed above demonstrate, a visceral feeling of the urban environment underlies literary representations of Isfahan. Despite the predominantly nonmimetic character of poetry—concrete visual features of monuments and urban spaces are rarely described in exhaustive detail—kinetic experience punctuated by vignettes was a salient trait of Safavid urban topographical literature. Taken together, these poems and prose pieces indicate the formation of new manners of experiencing and perceiving the city that were peculiar to the early modern period. The primacy of a subjective view is evident not only in certain rhetorical features, such as the extensive use of the first-person voice and the blending of an autobiographical account (*sharḥ-i ḥāl*) with city description, but also in the tone and structure of the works—in the unprecedented centrality of embodied individual experience in the formation of literary texts.

These works are also remarkable for the diversity of the urban trajectories they invoke and for the range of messages they convey through a verbal portrayal of Isfahan's physical and social environment. Mir Nijat begins at the sacred heart of the city's new congressional mosque, proceeds to the maydan and the markets, and concludes with a visit to Nasrabadi's coffeehouse. Semnani's "Guide for Strolling" (discussed in the following chapter) starts off in the market and coffeehouses and ends in the brothel district of Isfahan. Each work engages with different urban elements and imagines a

FIGURE 94
Plan of the Shah Mosque, Isfahan, showing the itinerary suggested by Mir Nijat's poem: (1) prayer niche (*miḥrāb*); (2) sanctuary (*shabistān*); (3) iwan preceding the dome chamber (*ṣuffa-yi maqṣūra*); (4) pool (*ḥawż*) surrounded by stone pavement (*farsh-i sang*); (5) corridor (*dālān*); (6) entrance portal (*dargāh*); (7) Maydan-i Naqsh-i Jahan. Plan by author.

elements and strings them together to fashion a kinetic image of the urban environment.

These poems, then, can be interpreted as verbal traces of the movements of sensing human bodies through the city. Indeed, the implied excursions of all three poems discussed above can be traced on a map of Isfahan (fig. 95). As spatial stories, to use de Certeau's terms, these works simultaneously follow and disrupt "the clear text of the planned and readable city."[45] The seemingly static picture of the built environment—Isfahan's overarching plan as conveyed by

FIGURE 95
Plan of Isfahan showing the trajec-
tories of poems by Mir Nijat (1a–1b),
Ramzi Kashani (2), and Taʾsir
Tabrizi (3). Plan by author.

Dar al-Shifa

Qaysariyya

1b

Shah
Mosque 1a

convents
(takāyā)

Tavuskhana

To Lunban
Mosque

Allahverdi Khan
Bridge

Zayanda River

Khiyaban-i Khvaju

Bagh-i Burj

Bagh-i Nazar

Juʾi/Chubi
Bridge

Hasanabad
Bridge

Ayina-khana

Namakdan

Saʾadatabad
Garden

3

distinctive route through the urban landscape; a new consciousness of space informs city description.

And yet these urban routes are not random trajectories. Lurking beneath each spatial narrative or discursive image is a unique human being. Consider the lyrical cityscape pictured in Nawras's composition, the satirical social subtext of Iʿjaz's work, and Mir Nijat's continuous spatial journey through the Shah Mosque and the Maydan-i Naqsh-i Jahan. Although the topical urban referent is the same, the approaches and messages vary, as do the individual identities that each work strives to forge and represent. Each poem or prose piece represents a distinct manner of seeing, experiencing, and imagining the city. Human sensations and emotions, desires and metaphors of love, are threaded along an itinerary at whose core lies an embodied subjective experience. Ultimately, these civic lyrics and imaginaries reveal how early modern Isfahan formed a setting where a new kind of self could be fashioned.

Solitary Wandering and Civic Pleasures

A DAYLONG JOURNEY IN ISFAHAN

In the corpus of literary works composed about Safavid Isfahan, the representation of a kinetic experience through the city finds its most elaborate expression in Semnani's "Guide for Strolling in Isfahan." In this work, spatial description attains a higher level of clarity, real individuals appear alongside idealized characters, and the imagined city wanderer emerges as a palpable human subject. In its overall literary framework, the composition conforms to the generic conventions of "friendly letters" (*ikhvāniyyāt*): it begins with a lament about separation from friends and closes with a prayer (*duʿā*) for the well-being of the recipient. Such epistles were penned not merely as private correspondence but also as veritable literary expressions intended for a relatively broad audience. The sheer number of fraternal letters compiled in Safavid compendia attests to the ascending popularity and sociocultural import of the medium at the time. Most of the manuscript copies of the guide are indeed transcribed in oblong-format anthologies known as *safīna*, which were commonly used for personal collections of belletrist literature (fig. 96).[1]

The epistolary character of Semnani's composition is doubly manifest in that it was penned in response to a letter written by Rukn al-Din; both pieces are included in at least one of the manuscripts, suggesting that the pair were likely read together. Rukn al-Din's terse missive,

however, is comparatively conventional in tone and imagery. Yearning for the return of his former companion, Rukn al-Din calls Semnani a "brother in soul" and a "truthful friend" and proceeds to express his feelings of affection, agony, and solitude in a plaintive lyrical tone. Pining for a departed friend was a long-established trope of fraternal letters and lyrical poetry. Still, Rukn al-Din's composition too conveys a sense of attachment to Isfahan as the locus of their friendship: it is sitting in the coffeehouse and "inhaling the ambergris-scented smell of coffee" that fills him with memories of his former companion, and he particularly highlights the Hasanabad Bridge to prompt his friend to return. The allusions to their joint forays in Isfahan—roaming the alleyways (*kūcha gardī*), taking excursions in the city and markets (*sayr-i shahr va bāzār*)—offer intriguing glimpses into their urban experiences.[2]

Yet although Rukn al-Din's letter likely spurred the writing of the "Guide for Strolling," the latter's novel format and content set it apart as a singular work whose appeal falls beyond that of a refined epistle. For one, the composition of a manual, or *dastūr al-ʿamal* (literally, "exemplar of action"), for urban excursion appears to have been unprecedented.[3] The multiple extant copies of the text—it survives in at least six manuscripts—further attest to its fame and widespread diffusion.[4] Still, concrete

of Ashiq ("in love," "lovelorn"). None of the copies are dated, but internal clues—references to historical individuals and monuments—indicate that it was penned around 1659–60, based on the author's experiences in Isfahan in the mid-1650s, during the reign of Shah Abbas II.[5]

At the most basic level, the guide can be analyzed as a kaleidoscopic representation of the topography of urban leisure in seventeenth-century Isfahan. The variegated modes and sites of pleasure invoked by the text disclose a vivid picture of social venues and everyday practices in the Safavid capital, especially in the elite circles wherein the work circulated. The main subject of the guide, then, is Isfahan itself, portrayed from the viewpoint of a desiring male subject. Devoid of any evocation of royalty, the composition offers unique insights into the loci and patterns of civic pleasure in Safavid Isfahan.

To examine the text for social information alone, though, would fail to account for its originality, obscuring the unprecedented effect it had in its contemporary context. Rather, as I expound in the ensuing pages, the composition derives its poignancy primarily from the manner it functions simultaneously as a literary artifact *and* as a spatial representation. There can be no doubt that period audiences first and foremost appreciated the work as a piece of belles lettres. Partaking of the long-standing imagery and rhetorical procedures of Persian letters in its intertwined lyrical and mystical strands, it engaged its publics in an intertextual discursive realm—an inherited repertoire of similes, metaphors, and verbal rhythms to which Semnani added his own idiosyncratic twists and flourishes to display his mastery of the literary canon and charm his audiences. Yet at the same time, and in a strikingly novel manner, the text represents the material environment of Isfahan by referencing a sequence of concrete locales

FIGURE 96
Folio from an anthology in the oblong format (*safina*), completed in 1100 H (1688), showing the beginning of the "Guide for Strolling in Isfahan." Malek Library, Tehran, MS 5403, fol. 106r.

biographical information about the guide's author, Mir Muhammad Mansur Semnani, or Aqa Mansur (as the author is commonly called in the manuscripts), is scarce. Safavid sources describe him as a poet native to Semnan (a town to the northeast of Isfahan, in the province of Khurasan), who went by the pen name (*takhalluṣ*)

and landmarks; to anyone familiar with the city, the names of these sites would have conjured up the urban topography as experienced by a mobile individual and imprinted in memory. An in-depth perusal of the text at these two entangled registers—discursive and spatial—not only illuminates its intricacies as a distinct form of urban topographical representation but also reveals the new kind of civic subjectivity that it embodied and fashioned. Ultimately, through this literary-spatial analysis, the "Guide for Strolling" emerges as a new form of subjective engagement with the city at whose core, I argue, stands a novel urban character: the solitary city wanderer, an early modern persona that prefigures the nineteenth-century flaneur.

FROM DAWN TO MIDNIGHT: A DAYLONG JOURNEY IN ISFAHAN

The tour of Isfahan begins at the crack of dawn, when one is to "don the pilgrimage robe" in the chamber and set off. It appears that the visitor is imagined residing in a cell (*hujra*) at a caravanserai in the market, and the expression *iḥrām bastan* (the donning of a two-piece robe to initiate the hajj pilgrimage) grants a ritualistic aura to the itinerary from the onset. The first stop is the *bāzārcha* (small market) of an unspecified *tīmcha* (covered commercial establishment), where "one should have a morning wine [*ṣabūḥī*] effected by the exhilarating sight of the wanton tobacco vendor and alleviate the headache caused by the hangover of separation." It seems that the imagined visitor has woken up from a night of imbibing and reveling. He is then instructed to pass by the shops of Armenian "infidel boys." Here the text assumes a didactic tone, offering advice on the primacy of love over matters of religion: "one who has stepped into the circle of love should stay away from [caring about matters of] Islam and disbelief."

The irrelevance of confessional affiliation to the pursuit of mystical love is a theme with Sufi metaphorical associations; the Zoroastrian or Christian wine server (*sāqī*) had long been an object of affective veneration in mystical Persian poetry.[6] What is distinctive here is how these established metaphors are adapted to the urban realities of Safavid Isfahan: Armenian vendors embody the venerated "infidels" of Sufism, and it is tobacco—a novel substance introduced from the Americas—that alleviates a hangover. Rather than evoke a transcendental Sufi theme, these references seem to provide a pretext for a carefree life of carnal love and desire, one that is more akin to the debauchery of antinomian dervishes yet assumes a new quality in the metropolitan context of early modern Isfahan. That the tour culminates in a tryst with a courtesan negates a strictly metaphorical reading of these mystical expressions.

The multiple tobacco shops mentioned in seventeenth-century sources suggest that these stores were a common sight in Isfahan. For instance, a newly constructed tobacco shop (*dukkān-i tanbākū-furūshī*) was among the endowed properties of the Jadda-yi Buzurg Madrasa, built in 1648–49 to the northeast of the Maydan-i Naqsh-i Jahan.[7] The tobacco store and the shops run by Armenians were likely situated along the southern segment of the Grand Bazaar, which leads to the northeastern corner of the maydan. That these shops were in this area is confirmed by the subsequent path that the visitor is told to take:

One should then head toward the qaysariyya via the paths running through the coffeehouses and in the rear of the coffeehouses. It is permissible to linger to smoke a water pipe at the stall of Salih-i Khavas-Khvan, and if [one's] temperament is inclined toward

FIGURE 97

Plan of the northeast corner of the Maydan-i Naqsh-i Jahan, showing the itinerary of the initial part of the "Guide for Strolling in Isfahan." Passing by the tobacco-vending stall and the shop run by young Armenians in the bazaar (1), the visitor proceeds along the path in "the rear of the coffeehouses" (2), pausing at the hookah stall of Salih-i Khavas-Khan (3) and the Khvaja Ali Coffeehouse (4), indicated hypothetically here. Strolling "through the coffeehouses," the visitor then reaches the qaysariyya portal (5) and takes a cup of salep at the "salep-making and syrup-selling stall" in one of the flanking shops (6). Moving inside the qaysariyya, the visitor strides through the textile market, visits the mint (7), and circles back to the market of the Mulla Abdallah [Madrasa] in the bazaar via the path of the Yazdi and Kashi caravanserais (8). Drawing by author.

coffee, one can get a cup from the hand of Mirza Ashraf at the Khvaja Ali Coffeehouse.

The hookah stall owned by Salih (who was a *khavāṣ-khvān*, or an expert in the "properties" of *adviyya*, or drugs) and the coffeehouse run by Khvaja Ali were most likely part of the complex of drinking establishments that lay in the northeastern arcades of the maydan. The reference to two paths running through and in the rear of the coffeehouses matches the peculiar configuration of the coffeehouses, which consisted of six domed octagonal halls interlinked by alcoves that served as seating places for the clients (fig. 97). Accessed from multiple entrances, the coffeehouses were porous structures linked to both the bazaar and the maydan, and Semnani's guide echoes the flowing experience of urban spaces and social establishments. Literary sources suggest that each of the maydan's coffeehouses was named after the person who ran the venue or after a particularly attractive coffee

server; here Semnani mentions two of his favorites: Mirza Ashraf and Khvaja Ali.[8] By drinking a morning coffee in a public coffeehouse, the visitor would participate in the novel daily routines of Isfahan.

After taking a cup of coffee at the Khvaja Ali Coffeehouse, one should proceed toward the entrance to the qaysariyya through the interconnected coffeehouses while beholding the surroundings. At the portal, the primary attraction is the "jewel-vendor idol"; the text employs the imagery of precious stones to offer metaphors of love. One is then advised to rest in front of the platform (*takht*) of the "salep-making and syrup-selling stall" to drink a cup or two of musk- and ambergris-scented salep. This "stall" most likely refers to the "shops for beverages" or "sherbet houses" that, according to Kaempfer, flanked the qaysariyya portal.[9] A hot starchy beverage made of orchid tubers and particularly known for its aphrodisiac power, salep (*saʿlab*) was likely recommended here to counter the presumed antierotic effect of coffee, which was believed to curb sex drive (*qāṭiʿ-i shahvat*).[10] In any event, lounging at the qaysariyya portal is not advisable just for the sake of the drink alone, for directly in front of that shop would be "the moonlike jewel-vendor idol." The visitor should first take a direct glance, then stealthily gaze, at the beloved from a distance while relishing the aromatic beverage. In an innovative take on the shahrashub themes, the two sensory pleasures available at the qaysariyya portal are merged by synesthesia: the sight of jewelry mingles with the taste and smell of a cup of hot scented salep.

One is then to explore the market's interior. The author compares the qaysariyya to Egypt (*miṣr*), where one would go to purchase the beauty of Yusuf (the biblical Joseph, deemed the paragon of male beauty). In a cascade of commercial and sartorial expressions, the text then conjures a vivid picture of the myriad fabrics traded in the qaysariyya. The tempo of the prose—the flurry of fabric-related imagery in a seamless extended sentence—conveys a sense of the space, visualizing the variegated textiles displayed at the royal cloth market. The use of dense, ornate prose—a sequence of rhyming phrases—in lieu of versified couplets captures the mood of the qaysariyya market and its abundant materials. Further on, a similar metaphorical description evokes the nearby royal mint (*żarrāb-khāna*) and the striking of coins that took place there.

With its coffeehouses, syrup stores, hookah stalls, and confectioneries, the north side of the Maydan-i Naqsh-i Jahan was one of the foremost hubs of social leisure and sensual pleasure in Safavid Isfahan. The qaysariyya itself was a major urban attraction, figuring in every literary description of the city. Its appeal was not unlike the lure of nineteenth-century shopping arcades or twentieth-century malls: it was not only the city's largest covered market but also a cosmopolitan locus of trade, where luxurious fabrics and rare commodities were displayed and sold and where people of different ethnicities could be met. In the seventeenth century, one would visit the qaysariyya not merely to engage in trade but also to view or purchase the printed pictures that the Venetian merchant Alessandro Studendoli offered for sale there. As is true of its modern progeny, the shopping mall, the lure of the qaysariyya lay as much in its rich array of merchandise as in its variegated human scene. Not everyone had the means to afford the lavish textiles and substances, but all could take delight in being around them, seeking pleasure in the same articles of trade whose circulation enabled such an urban existence.

After exploring the qaysariyya, the tour continues in the marketplace. Passing through

the Yazdi and Kashi caravanserais, one should enter the small market (*bāzārcha*) of the Mulla Abdallah [Madrasa] to reach the store of the "sweet-essenced . . . confectioner." As their names suggest, these two caravanserais were associated with merchants from the cities of Yazd and Kashan; according to a seventeenth-century description of Isfahan's caravanserais, these two establishments were situated in the qaysariyya and offered for sale luxury textiles of their respective cities.[11] Located in the northeast corner of the Maydan-i Naqsh-i Jahan, the still-standing Mulla Abdallah Madrasa is accessed via a domed crossing (*chahārsū*) at the northeast junction of two market lanes that border the maydan. Confectioneries were in the lane behind the coffeehouses and around the *chahārsū*. It appears that the visitor is supposed to exit the qaysariyya from a rear gate and pass through the caravanserais, making a clockwise turn to get back to the northeast corner of the plaza.

Leaving the confectioner's shop, one was to go to "the stall of the hard-hearted one who ties [tubes] to the glass bases of hookahs." A novel material artifact, hookah bases were produced in elaborate forms in Safavid Isfahan and embodied a distinct pleasure of the city. Overall, it seems that Semnani's recommended tour begins with a swirl in the most bustling segment of Isfahan's market, where the city's unique artifacts and senses merge with metaphors of love to forge a lyrical urban portrait.

Then hunger prevails: "From there one should return to the chamber [*hujra*]. Although on such a day there should be no concern for eating and sleeping, but since nature is accustomed to food, and the carnal soul is wont to eat and drink, one is to stop for an hour to have an early lunch [*chāsht*], and one should be content with a rapidly prepared snack [*māḥażar*]." For the light

meal, Semnani recommends two specific kinds of bread: *sangak* (a thick bread made in a pebble-covered oven, first invented or popularized in seventeenth-century Isfahan) baked by a certain Parviz Beg, and *lavāsh* (a type of thin bread) by Master Taymur, along with specific types of cheese, yogurt, and fruit—grapes, peaches, and watermelons, among others. The visitor is apparently expected to buy these items at different venues and eat them at his lodging—the *hujra*—not in a public setting. Literary sources, however, suggest that options for eating in public were available in Isfahan, though they seem to have been frequented primarily for supper (the primary meal for Persians, Chardin notes).[12] The choice of a solitary light meal over a substantial lunch in public, then, reflects the nature of the midday meal at the time rather than available dining options, while also allowing the text's readers/listeners to imagine savoring a broader range of Isfahan's gustatory delights. A light meal, after all, would be fitting for a day full of intense strolling and heavy consumption of stimulants such as coffee and tobacco.

After the meal, the tour takes a new turn. Now, "to delight the mind and open the temperament," one is to visit Qahva-yi Saz ("the coffeehouse of the musical instrument"; both *qahva* and *qahvakhāna* were used in Safavid times to refer to a coffeehouse), which appears to have been located inside or adjacent to the qaysariyya market. Combining the functions of a coffeehouse and tavern, this establishment's ambiance was distinct from that of the coffeehouses in the arcades of the maydan, such as the Khvaja Ali Coffeehouse, where one could make a quick stop for a sip of coffee or a puff of hookah, during a respite from labor, without lingering. As its name suggests, music was a salient feature of this establishment; Semnani paints an animated picture of a jubilant, clamorous assembly

of drunken revelers enlivened by singing and dancing. The coffeehouse is the largest agglomeration of beloveds (*dilbarān*) and idols (*butān*), a "garden of beholding" (*bāgh-i tamāshā*) teeming with the narcissus, tulip, and jasmine of comely faces.

A painting of two dancing men in Kaempfer's album represents the typical performers who entertained the clients in Isfahan's coffeehouses (fig. 98).[13] Wearing conical hats with tilted brims (*kaj-kulāh*), the dancers have rolled up their garments, raising their legs in tandem. The one who sports a mustache strums a stringed instrument (*ṭanbūr*), while the other pulls a yellow scarf back and forth around his neck to the beat of the tune played by his peer. The sound of small bells, strung in bands tied around the dancers' arms and legs, would have enlivened the assembly with the rhythmic movement of their hands and legs. Around the basins of coffeehouses "boys dance with Indian bells," Kotov notes, "while others play on drums and pipes and flutes."[14]

The servers of Qahva-yi Saz, though, were of a particular appearance: they all had "bewitching European gazes" (*jādū-nigāhān-i farangī*). Likely this is a reference to the ethnic origin of the exploited servants of Isfahan's coffeehouses, who were mostly Georgian boys with bright-colored eyes.[15] The use of the descriptor "European" (*farangī*) in this context points to an

Riza Abbasi, *Kneeling Youth Offering Coffee*, 1630. Gulistan Palace Library, Tehran, MS 1668 (Muraqqaʿ-i Gulistan or Gulshan), fol. 37.

expanded racialized discourse that had come to characterize the perception of the self and other in later Safavid times. Among the servers of the Qahva-yi Saz, the most attractive for Semnani is Piyala (literally, "cup"), who is lauded first in rhyming prose and then in verse. The rhythmic meter and rapid tempo of the poem renders it akin to a song lyric set to a musical scale (*tasnīf*), evoking the aural jubilance of the bustling

establishment. In the lines dedicated to Piyala, Semnani deploys metaphors drawn from the properties of coffee: "like coffee he boils warm with everyone" and "because of the intoxicating effect of his gaze / The coffee cup resembles a goblet of red wine." Several seventeenth-century paintings depict such servers of Isfahan's coffeehouses. Like Semnani's verses on Piyala, these paintings convey a peculiar sense of an individual person rendered as an idealized object of desire (fig. 99).

Departing from the musical drinking house, the visitor is to return to the arcades around the Maydan-i Naqsh-i Jahan. The references to recognizable parts of the market make it possible to map the rest of the itinerary with precision (fig. 102): passing through the Shoemakers' Market (*bāzār-i kaffāshān*), one would proceed by way of the market on the western side of the square to reach the Ali Qapu, the main gateway of the palace complex. Here, "if there is sufficient time, one is to visit the Talar-i Tavila [Hall of Stables]" to behold "European images" (*tasāvīr-i farang*) or "Christians of the European monastery" (*tarsāyān-i dayr-i farang*).[16] Yet one should be cautious not to be "beguiled by the made-up beauty [*ḥusn-i sākhta*]" of those with "bewitching gazes" (*jādū-nigāhān*) and not to become "enamored of the images on the walls."

A now-vanished palace with a pillared semi-open hall, the Talar-i Tavila was located behind the Ali Qapu, within the palace grounds; since its erection in the 1630s, it had functioned as the principal venue of royal ceremonies and receptions.[17] Adam Olearius, who in 1637 attended a festive audience at the Talar-i Tavila, observed "three large European paintings of historical scenes" hung on a wall.[18] In an engraving published in Olearius's travel narrative, two framed paintings are depicted on a sidewall (fig. 100). It is likely that these paintings were what the

View of the Talar-i Tavila, showing a 1637 royal reception attended by the embassy of the Duke of Holstein-Gottorp. From Adam Olearius, *Vermehrte Newe Beschreibung Der Muscowitischen und Persischen Reyse* (Schleswig: J. Holwein, 1656).

text refers to as European images. More striking, though, is that no reference is made to the royal presence; it seems that the Talar-i Tavila was an integral part of the city and the Maydan-i Naqsh-i Jahan and was perceived as a kind of public museum. European accounts suggest that the Safavid royal palaces and gardens were generally open to the public. Chardin and Kaempfer were both able to visit the inner precincts of the palace complex in the absence of the shah. Semnani's guide provides evidence that such visits were also common among the local elites, or at least that these places were perceived to be accessible. From the churches of New Julfa to the Sufi convents of the Chaharbagh to the royal palaces, Isfahan offered a range of sites for public viewing of "European images."

Following this detour from the market, the visitor is instructed to stroll on through the "lane of lapidaries" (*rāsta-yi ḥakkākān*) and step into the "Market of Vendors of Small Wares [*bāzār-i khurda-furūshān*], famed as the 'abode of mirrors' [*āyīna-khāna*]." Here Semnani highlights yet another new material artifact of Isfahan: glass mirrors. Traditionally, mirrors were made from metals, but beginning in the early seventeenth century, Venetian looking glasses were imported, and glass mirrors were locally manufactured.[19] In the world of Semnani's guide, this is the most intriguing part of the market,

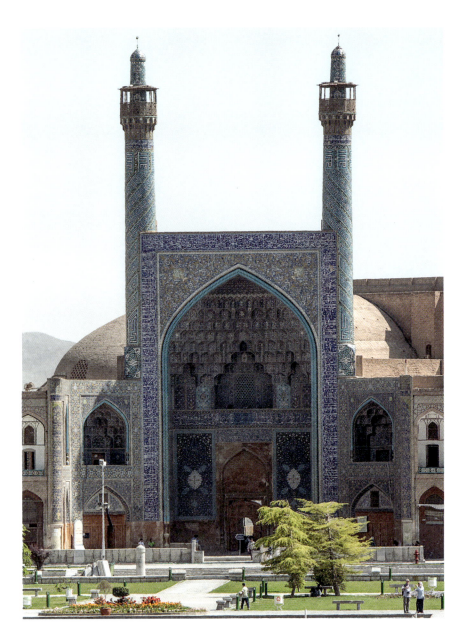

FIGURE 101
Shah Mosque, portal on the
Maydan-i Naqsh-i Jahan. Photo
courtesy of Daniel C. Waugh.

Here there is an alluring perfumer/druggist ('aṭṭār) in the stall facing that of Haji Tahir, where one could seek a cure for the "incendiary fever of separation and the lethal malady of desire." The shops selling medicinal herbs and perfumes ('aṭṭārī) at the portal of the Shah Mosque are also mentioned by Chardin, who relates that on the second floor were found the boutiques of pharmacists and physicians.[20] In the seventeenth century, the forecourt of the Shah Mosque would have been redolent of the scents emanating from the apothecary shops, activating the olfactory sense of worshippers as they stepped into the dazzling sanctuary of Safavid Isfahan.

Then, in a theatrical coincidence, just as the visitor is contemplating the apothecary shops, comes the time for the noon worship, and "the melodious muezzins, with the exhilarating sound of 'Hurry to prayer!' stir uproar in the turquoise dome of heaven." Here the call to prayer not only functions as an aural signal but also indexes the passage of time; half a day has passed since the tour commenced at daybreak. Semnani first dwells on the mosque's door, which he likens to that of the Ka'ba, leading toward paradise. Moving inside, he then describes the "rows of worshippers and ascetics" attending the Friday noon prayer and proceeds to the domed sanctuary; a poem alludes to Mulla Muhsin (Fayz Kashani, d. 1680), the cleric who served as the mosque's official preacher, delivering the sermon at the pulpit (minbar) like "Moses on Mount Sinai." One is also invited to perform the religious duties (farā'iż). Yet, within the broader context of the city tour, the mosque is treated as if it were a secular monument; the sanctuary's appeal lies in its visual *and* spiritual character (one is to take delight in *seeing* the assembly of worshippers). The mosque is lyricized as a locus of aesthetic spirituality, just as

described in the longest segment of the composition. In prose and verse, Semnani draws on mirror-related imagery to offer amorous metaphors.

On passing through that market, one would reach the portal of the "congregational mosque" (*masjid-i jāmi'*), or the Shah Mosque (fig. 101).

the call to prayer functions as a vocal ornament as well as a functional signal for prayer.

The visit to the Shah Mosque marks a spatiotemporal watershed in the excursion, for after this point a journey to the old city is recommended: upon leaving the Shah Mosque, "if supposedly it is a Friday and time is ample, one is to don the robe of pilgrimage and set off, with no hesitation, to visit the Old Mosque." The Old Maydan was linked to the Maydan-i Naqsh-i Jahan by way of the city's covered market (the Grand Bazaar), lined with scores of caravanserais, mosques, madrasas, and bathhouses (fig. 102). Along the way, one should "behold like the morning breeze in a field of flowers." Yet while relishing the beauties in passing, "one should not pause along the way before reaching Takhtgah," the site of multiple coffeehouses on the periphery of the Old Maydan (see figs. 10–11).

> You will see one hundred royal thrones,
> Each like a picture gallery filled with idols:
> Moon-faced, beloved boys,
> Flower-faced, cypress-statured idols,
> Standing at your service, left and right,
> Bringing you whatever you want.
> The moon-shaped with bodies like wild roses
> Prepare the hookah and bring you coffee.

Adjoining the shrine of Harun-i Vilayat, Takhtgah was one of the most famous venues of public leisure in seventeenth-century Isfahan. Here "one hundred coffeehouses [were] located side by side," and one could find large crowds gathering to drink coffee and smoke tobacco.[21] At Takhtgah—the first stop in the tour of the old city—one can linger for a while to smoke a water pipe, drink a cup of coffee, and gaze at comely servers. This is the second opportunity for the visitor to take coffee and tobacco.

Having trekked about two kilometers through the bazaar, the visitor deserves the chance to rest, restimulate the senses with caffeine and nicotine, and muster the energy to tour the old Isfahan.

After this midday rest or nap (taqayyul), one should visit the Harun-i Vilayat shrine before heading toward the Old Mosque. Extolled as the "manifestation of grace [fayż]" and the "envy of the heavenly house" (the prototype of the shrine at Mecca [bayt al-maʿmūr]), the Old Mosque is portrayed as a house of worship on a par with the new Safavid congregational mosque, if not superior to it: heaven is envious of the mosque's vast space; its masses of pigeons resemble angels. But when the visitor reaches the Old Mosque, the time of the prayer has passed," and hence the visitor will miss "the bliss of following Muhammad Taqi [Majlisi] in congregational prayer." Still, it may be possible to listen to the preaching (mawʿiża) of Majlisi, who served as the official leader of the Friday prayer (imām jumʿa) at the Old Mosque.[22] This is an interesting attempt to create a sense of temporal realism; at the time of the noon prayer, the visitor would have been in the Maydan-i Naqsh-i Jahan, so it would not have been possible to make it to the prayer service at the Old Mosque.

After visiting the Old Mosque, one could make a stop at the convent (khānqāh) of Sufi Nasir and enter the circle of dervishes. Here the visitor could seek grace and relish the performance of the zikr, or the Sufi audition. But then, rather abruptly, one should follow "the dictum 'returning is better' [al-ʿūd aḥmad]" and return to the Maydan-i Naqsh-i Jahan.

Within the overall itinerary of the guide, the visit to the Old Maydan and its attractions appears to be a journey within a journey: one is to tread like a breeze and return in due time. This nested urban journey reflects the

FIGURE 102

Plan of the urban core of Isfahan,
showing the itinerary of the "Guide
for Strolling in Isfahan." Drawing
by author.

Old
Mosque

Old
Maydan

Harun-i Vilayat
Shrine

Takhtgah
(Coffeehouses)

Bazaar

Bazaar

Shoemakers'
Market

Kucha-yi Naw?
(Quarter of Courtesans)

Ali Qapu

Lapidaries

Talar-i
Tavila

Mirror
Market

Shah
Mosque

0 100 200m

N

perception and meaning of the old core of Isfahan in relation to Safavid developments. Distant yet accessible, the old square remained a bustling urban hub but was subordinated to the new royal square. Moreover, unlike the new maydan, where profane pleasures figured prominently, the primary attractions of the old Isfahan were religious institutions: a shrine, a mosque, and a convent. Hence, the visitor is to "don the robe of pilgrimage" for a second time before setting off to see the Old Maydan.

The return to the Maydan-i Naqsh-i Jahan marks the final episode of the tour. But now an entirely new scene awaits the visitor: as dusk begins to fall over Isfahan, the focus of the activities shifts from the shaded markets that encircle the maydan to the open-air space of the plaza, and the presence of the crowds propels a wholly different urban experience. One is first to take a stroll: "Reaching the vast Maydan-i Naqsh-i Jahan, one should rove in space and behold the uproar and frenzy throughout. From the crowding of people, the page of the maydan is adorned like the sky with planets and stars, resembling the queue and crowds on the day of resurrection; it is hard to come and go, and it is difficult to move." In just a few words, Semnani paints a vivid picture of the maydan at sunset; brimming with crowds and reverberating with the sound of music—a beating on drums and blowing of trumpets—emanating from the naqqara-khana, it is reminiscent of the end of time. By nightfall several tented stands and makeshift stages for performances (maʿraka) have been set up throughout the square. Scores of jugglers, vendors, and acrobats fill the space, turning the plaza into a massive urban spectacle. Extensive illumination augments the appeal of the maydan after dark; hundreds of lamps, lit on poles installed on the surrounding arcades, illuminate the square as well as the nearby

coffeehouses, where storytellers are busy entertaining the customers. All of this is too exciting to be missed, so one is instructed to hasten back to the Maydan-i Naqsh-i Jahan after visiting the Old Maydan.

Among the urban shows, Semnani recommends the performance of the "long-bearded" (rīsh-dirāz) Baba Qasim. But to ensure an apt viewing position, one needs to find a spot "before the rushing of spectators [tamāshāʾiyān] and the crowding of beholders [naẓẓāragīyān]." Then comes the highlight of the show, Aqa Hasan Ali, an acrobat and jester who stirs tumult with his "feverish face and long tresses." The Safavid painter Shaykh Abbasi (fl. 1650–1684) illustrated one such acrobat performing alongside a peer playing the tambourine (fig. 103). Semnani also recommends watching the wrestling of a certain Muhammad Khuljani. Another painting in Kaempfer's album (fig. 104) depicts two wrestlers supervised by a master (kuhna-savār). The treatment of the entangled wrestlers in this painting was clearly inspired by the aesthetics of shahrashub.

FIGURE 103
Shaykh Abbasi, *Musician and Acrobat*, 1653–54. Pigment, ink, and gold on paper. Dublin, Chester Beatty, In 47.14. Photo © The Trustees of the Chester Beatty Library, Dublin.

FIGURE 104

Jani (attr.), *The Manner of Iranian Wrestlers*, 1684–85. The British Museum, "Album of Persian Costumes and Animals with Some Drawings by Kaempfer," 1971,0617,0.1.19. Photo © The Trustees of the British Museum.

Then come the darker hours of the night, and after a day of furtive gazing and concealed yearning, it is finally time to fulfill one's desires through real bodily experience: "And if you long for the company and pleasure of the silver-faced, and [if you are] desirous of union and seek closeness to the fairy-bodied, in the Mahalla-yi Ard-Furushan . . . deceitful and devilish brown-faced people look out to sell the coyness of those whose company is available for 1 dinar." The first suggestion is the Mahalla-yi Ard-Furshan ("flour-sellers quarter," located in Jubara, in the northeast of the walled town). Here sex workers

are available for the low price of 1 dinar, and deceitful brown-faced (*gandumgūn*) pimps are at the service of customers. Yet while seeking the prostitutes of old Isfahan may be more affordable, it would not be ideal; for a true lover, one needs to visit the district of courtesans:

> But if you desire a lover of whose courtship you can speak and from whose company you can gain full grace, you must inquire about Kucha-yi Naw. . . . Although, due to the improper behavior of a group among this class, the "flower of notoriety" [venereal

disease] has blossomed and has concealed the name of the good ones . . . there are still numerous graceful, witty mistresses in this clan who are hidden from the eyes and not well known.[23]

Kucha-yi Naw ("new alley") was the district of Isfahani courtesans.[24] According to Chardin, it consisted of three streets and seven caravanserais that lay to the northeast of the Maydan-i Naqsh-i Jahan, behind the Shaykh Lutfallah Mosque;[25] hence, its residents were also known as the "ladies of the dome's neighborhood" (*khavātīn-i maḥalla-yi gunbad*).[26] The district of courtesans was likely formed under Shah Abbas I as part of the original plan for the city. At times, the upper-story chambers around the maydan were rented out to courtesans, who plied their trade in the plaza's arcades and caravanserais after dusk.[27] And other sources confirm that syphilis (known as *ātash-i farangī*, or "European fire") was indeed rampant among the men who frequented Isfahan's brothels.[28]

By referencing courtesans, Semnani underscores a ubiquitous social phenomenon of Safavid times. As Matthee has shown, "far from living marginal lives, [courtesans] were highly visible in society, enjoyed a measure of respect, and were their own agents, with the wealthiest ones maintaining independent homes."[29] Letters addressed to famed courtesans by literary figures further attest to their public visibility and intimate ties to elite men.[30] Chardin notes that the clientele of high-end courtesans was limited to "men of the sword and the young nobility that operated in the court's orbit."[31] The fact that Semnani and his fellows could frequent both the low- and the high-class women of leisure is suggestive of their liminal social standing: they could aspire to elite pleasures, although other options were available to them.

Having explained the urban topography and circumstances of prostitution in Isfahan, Semnani proceeds to describe the courtesan he cherished the most, without stating her name. He first extols her in a tour de force of breathless prose—fifty-three rhyming adjectives dealing with the physical attributes and demeanor of the subject—and then in a lengthy poem that thoroughly describes her body. Beginning with tresses, lips, eyes, nose, and mouth, the verses go on to extol her neck, chest, and waist.[32] Yet he declines to venture further, as it would be beyond decency "to lift the curtain from the hidden secret." Skipping the middle zone of the body, between waist and legs—and obliquely drawing attention to it—the poem advances toward her crystal legs, concluding by describing the soles of her feet, which are "adorned with rosebuds" of henna.

From head to toe, these lines evoke a visual journey over the body of the courtesan. If the comely faces of youthful males are the primary focus of affection during the day, it is the sensuous body of the courtesan that acts as the locus of desire at night. This mode of describing a charming female has a long pedigree in Persian verse romances; the most well-known is the poet Nizami's treatment of the Armenian princess Shirin.[33] But it was only in Safavid literary works that the head-to-toe description of the female body became exceedingly detailed and erotic. For instance, in *Farhad and Shirin*, Vahshi Bafqi's sixteenth-century response to Nizami's romance, a far more exhaustive description of Shirin's body is offered.

Incorporated into a spatial narrative, Semnani's description assumes further significance: it establishes a parallel between the gaze rolling over the female body and the voyeuristic voyage through the city. It is as if, at the close of the urban excursion, the city melts into the

FIGURE 105
Mir Afzal Tuni, *Reclining Lady with a Dog*, ca. 1640. The British Museum, OA 1930,0412,0.2. Photo © The Trustees of the British Museum.

courtesan's body—all, it seems, was in anticipation of this final gratification of desires. In a literary work composed in the spirit of shahrashub—which predominantly focused on youthful male beauty—the appearance of a female object of desire in the entirety of her bodily glory is striking; the daylong voyeurism has served as a prelude to a nocturnal encounter with a woman of pleasure. This finale reveals that for the imagined wanderer of Semnani's guide, Isfahan was an unabashedly erotic place, one that aroused and fulfilled male sexual desires. Over the course of the day, the visitor's amatory adventures soar in intensity from furtive looks to full gazing to sexual intercourse.

In Semnani's portrayal of Isfahan, the male and female objects of desire were complementary elements of the daily rounds of pleasure that were associated with a series of dichotomies: day and night, visibility and concealment, facial and bodily beauty, scopic and fleshly pleasure.

The literary representation of a courtesan as an object of the male gaze and desire finds a counterpart in a ubiquitous subject of Safavid painting: a recumbent female figure portrayed with an erotic gaze or gesture, often scantily clad and occasionally entirely naked. One elaborate example, dating from the 1640s, is a painting by Mir Afzal Tuni (Husayni) (fig. 105).[34] Reclining on cushions, the woman has rolled up her

dress to reveal her ornate pants and naked belly, while staring at a lapdog who seems to be sipping from a blue-and-white bowl. As Sheila Canby has shown, the subject's overall posture derives from Marcantonio Raimondi's engraving of Cleopatra, itself based on a painting by Raphael; this figural model first entered Safavid visual culture in the works of Riza Abbasi in the 1590s.[35] Seeing Afzal's painting in light of Semnani's poem, one can discern how this European image was lyricized with established tropes of love, desire, and beauty. Consider, for instance, her serpentine locks of hair (*pīch-i zulf*), a time-honored metaphor for the seductive beloved and the dishevelled state of the lover, or her curved waist, an object of admiration in Semnani's poem. Afzal's painting and Semnani's poem were products of the same cultural milieu, reflecting a new erotic appreciation of the female body that emerged in the male-dominated cityscape, literature, and visual culture of later Safavid times.

The nocturnal dalliance with the courtesan constitutes the concluding episode of the whirlwind urban excursion. Yet it does not mark the end of the composition. In accord with the conventional ending of epistolary communication—a prayer (*duʿā*) for the well-being of the letter's recipient—Semnani closes the text with an ode (*qaṣīda*) addressed to his friend. In a logical yet surprising conclusion to this dramatic representation of Isfahan's pleasures, Semnani advises Rukn al-Din to take a wife from the beauties of Isfahan and enjoy life.

With this eloquent coda, the composition circles back to the personal tone of its opening passage, (re)establishing itself as a friendly epistle. But here this conventional ending also serves to underscore the artificiality of the text. For the reader or auditor absorbed in Semnani's sensual portrayal of Isfahan, the whole realistic guide to strolling in the city is suddenly exposed as a mere theatrical depiction. In a deliberate rhetorical move that evokes twentieth-century postmodernist literature, the text's "discourse of the real" is reaffirmed as a mere representation in the poetic sphere.

THE AUTHOR AND HIS AUDIENCES

On his return journey from Isfahan to Bukhara in 1682–83, the man of letters Maliha of Samarqand sojourned for a few days in the city of Semnan. In the biographical compendium of poets that he compiled after his three-year voyage to Safavid Iran, Maliha recounts that during his stay in Semnan, he met Aqa Mansur Semnani in the coffeehouse the poet himself had set up in his own neighborhood (*maḥalla*). Known as Aqa Mansur's Coffeehouse (*qahvakhāna-yi Aqā Manṣūr*), the establishment was the primary haunt of the city's literati. Likely it was Semnani's encounter with Isfahan's coffeehouses that had propelled him to build a similar social establishment in his hometown. In the substantial notice that he dedicates to Semnani, Maliha relates that while in Semnan, he befriended the poet and conversed with him every day. Their most memorable encounter, though, occurred when Maliha spent an entire day with Semnani and his companions in Aqa Mansur's Coffeehouse. During that day, a poem by Semnani's father, Mir Fuzuni, was recited several times, and afterward they all visited the sites where the affair recounted in the poem had taken place.[36]

Maliha's narrative is particularly remarkable for the insight it provides into the social milieu in which the "Guide for Strolling" was created. Semnani likely committed the piece to writing in his own coffeehouse and later sent it as a missive to his friend in Isfahan. The account of the repeated reading of a poem also hints at the performative manner in which such literary works

were enacted. Like the poem that was read several times during Maliha's visit, the narrative of strolling in Isfahan was probably recited, over and over again, in the coffeehouse in Semnan, where the aural reenactment of Isfahan's pleasures mingled with the taste of coffee and the scent of tobacco, materials that must have been particularly reminiscent of the Safavid capital. One can imagine the text's being read during the day, at a slow and leisurely pace, so that the duration of the verbal performance matched the temporal length of the city experience.

Other than Maliha's account, documentation of Semnani's life and literary output is scanty. The earliest biographical reference to him appears in Vali Quli Shamlu's chronicle (completed ca. 1667–68), where Semnani is briefly noted among the "poets" of the age of Shah Abbas II; raised in Semnan, Shamlu notes, he was, at the time of writing, "more than thirty years old," and "his collected poems amount[ed] to seven thousand couplets."[37] Likewise, a 1672–73 miscellany collection—which contains the composition Semnani penned on the Tavuskhana (the "peacock-house" built under Shah Abbas II in 1657–58)—refers to him as "Aqa Mansur, son of Mir Fuzuni Semnani, whose pen name is Ashiq."[38] An early nineteenth-century compendium describes him as a notable (*nujabā'*, s. *najīb*) from Semnan who was "conversant in the occult sciences [ʿ*ulūm-i gharība*] and [had] written a treatise on the science of numbers [ʿ*ilm-i aʿdād*]. He resided in Isfahan for a while, and after returning to his hometown [*vaṭan*], wrote some letters to the people of Isfahan using the lingo of Isfahan's libertines [*alvāṭ*], letters that are not devoid of sweetness."[39] Another nineteenth-century compendium offers a similar account—"In Isfahan for some time, at the request of libertines, he wrote satire [*hajv*] in verse and prose"—adding that he died

in 1732–33.[40] This date of death, together with Shamlu's reference to Semnani's age in 1667–68, suggest that he must have been a young man, in his early twenties, when he composed his guide to the pleasures of Isfahan.

Semnani's other epistolary compositions offer further glimpses into his social network and audiences. In one letter, for instance, he complains about the mediocre quality of the rosary (*taṣbīḥ*) he had received from a friend. Other messages include a request for tulips for his garden and a complaint to a friend about the latter's delay in sending tobacco. A number of Semnani's missives were exchanged with a certain Muzaffar Ali, another friend based in Isfahan. In one letter, Muzaffar Ali asks Semnani to send him a partridge (*kabk*) from Semnan, where the animal is commonly found.[41] Though physically absent, Semnani remained connected to the capital's literary circles through his correspondence. This corpus of insha' works—which includes friendly letters as well as prefaces for literary anthologies and albums of artworks (*muraqqa'*)—corroborates later biographies, suggesting that Semnani was well regarded as a master of prose. The work that earned the esteem of contemporaries was no doubt the "Guide for Strolling." In some manuscripts, though, the composition is wrongly attributed to other authors.[42] The fame of the text surpassed that of its author.

Based on these fragments of evidence, a profile of Semnani's life and social background can be sketched out. The son of a poet, Mir Muhammad Mansur came from a notable family of sayyids (descendants of the Prophet) and was raised in his provincial hometown.[43] The poet's pen name (Ashiq) may signify his liking for music and popular culture; in Safavid times the appellation particularly designated a "bard, balladeer, or troubadour, who accompanied his

song . . . with a long-necked lute."[44] Semnani's first extended stay in Isfahan likely occurred in the 1650s, when he seems to have sojourned in the city together with Rukn al-Din, a friend from Semnan.[45] The composition he penned in praise of the Tavuskhana indicates that he was present in Isfahan at the time of the inauguration of the complex in 1657–58 and had sought royal patronage or had links to courtly circles. By the spring of 1659 (before the inauguration of the Hasanabad Bridge), however, Semnani must have returned to his native Semnan, while Rukn al-Din stayed on. In his biographical notice, Shamlu notes that Semnani, at the time of writing, had been "appointed to the post of *shaykh al-Islāmī* [chief clerical authority] of [Semnan]."[46] Whether this meant an official tenure or an honorary position is unclear. As a learned man, Semnani should have been educated in official religious sciences, and his varied career may have included a stint in some clerical or legal capacity. Indeed, the pursuit of diverse vocations and interests was not uncommon among the period elites; like many of his contemporaries, Semnani appears to have cultivated an idiosyncratic self, one that cannot be subsumed under the generic rubrics of medieval social collectives. In any event, when Maliha met him in his coffeehouse in 1682–83, Semnani seems to have led a jubilant, carefree existence in his watering hole—a life perfectly attuned to the guide that he had composed some twenty years earlier. Like later biographers, Maliha extols Semnani's oeuvre in verse and prose, describing him as the central figure of a convivial literary circle formed in his coffeehouse, where local poets "come to seek grace from his companionship every day."[47]

This biographical profile has several implications for understanding Semnani's text and the sociocultural circumstances of its creation and reception. The "Guide for Strolling" was composed by a young cultivated man of noble provincial background and was presented as an epistle addressed to a friend with whom he appears to have journeyed to Isfahan from his hometown. Semnani and Rukn al-Din were thus among the scores of young men of letters attracted to the Safavid capital in search of work, learning, fame, and pleasure. The emergence of Isfahan as a massive metropolis had clearly led to a sharper dichotomy between "the metropolis" and "the province" in Safavid territories; visiting the capital offered a host of new experiences—coffeehouses, crowds, brothels—that were rarely encountered in the provinces. The sources indeed refer to individuals from country towns who periodically traveled to the capital solely for pleasure: a certain Muzaffar Husayn, who resided in Kashan, had a chamber (*hujra*) in Isfahan and came to that city every year "for the sake of pleasure" (*jahat-i taḥṣīl-i ʿaysh*).[48]

On these grounds, the "Guide for Strolling" would have enticed both metropolitan and provincial audiences. Those who listened to its recital in the coffeehouse in Semnan—young country men who wished to embark on similar adventures and insinuate themselves into urban pleasures—received the text as a dramatic representation of Isfahan; for them, this voyeuristic verbal journey must have made the lure of the Safavid capital irresistible. By composing this guide, Semnani not only crafted a lyrical literary image of Isfahan but also flaunted his cultural sophistication as a connoisseur of urban pleasures; the founding of the coffeehouse and the writing of the guide were two facets of an attempt at self-fashioning, cultivating a public persona in a social matrix straddling the capital and provinces. At the same time, the text appealed to the emerging sensibilities of Isfahan's elite, who must have relished this daring,

vivid representation of the sites and moments of their leisurely everyday existence.

REPRESENTING SPACE AND TIME

What notion of the city undergirded the "Guide for Strolling"? What key traits distinguish this mode of urban representation from its literary precedents? Associating the city (*shahr*) with idol-like beauties (*nigār, but, shūkh*) was a ubiquitous trope in medieval Persian poetry. As noted previously, a distinct literary genre that dealt with youthful artisans in urban settings appears to have developed beginning in the twelfth century, and poems in the shahrashub mode focused on specific cities from the late fifteenth century onward. Yet in these works the imagery of guilds and professions was predominant; it was primarily the artisanal tools and trades, rather than specific individuals or locales, that provided the material for poetic expression.

A key trait that distinguishes the "Guide for Strolling" from its antecedents and cognates is its pronounced sense of verisimilitude and its integration of material spaces into a narrative framework representing time and space in a continuum. Unlike the primarily metaphoric shahrashub poems of the medieval period, here a host of real individuals (the cleric Majlisi, Sufi Nasir, the wrestler Muhammad Khuljani, etc.) and concrete loci (various coffeehouses, the old and new maydans, a palace, the mosques, a shrine, and a convent) are represented alongside anonymous youthful artisans and vendors. The text is indeed marked by an unprecedented degree of spatial specificity; nearly all the attractions are located in space, and even generic descriptions of specific segments of the market or unnamed vendors are pinned to particular points in space. In Semnani's composition, the city does not merely provide a context for an idealized portrayal of artisans; rather, these figures are integrated into the fabric of a spatial narrative. The names of Mulla Muhsin Fayz and Muhammad Taqi Majlisi are mentioned not just as clerics who reside in the city but as officiants whom one could meet at the Shah Mosque and the Old Mosque, respectively. Even the jester Aqa Hasan Ali is to be found at the same spot in the maydan where the "long-bearded" Baba Qasim sets up his performance every evening. Each element of the narrative—animate or inanimate, social or architectural—assumes a new significance by virtue of its place in a choreographed sequence of movements through space.

The effect of spatial specificity is further accentuated by temporal realism; the guide offers not only a precise itinerary but also a precise schedule. Unfolding in just one day, the schedule is particularly notable for its relatively short duration—a time frame that captures the temporal intensity of urban experience and dramatizes the diverse sensorial pleasures of Isfahan. The rapid tempo of daily life in an early modern metropolis was certainly a key characteristic that gave rise to this emerging temporal consciousness. Fleeting moments of pleasure attain new meanings through incorporation into a coherent spatiotemporal narrative, informed by a theatrical unity in both time and space. In what seems to be unprecedented in Persian-language verbal arts, the dual temporalities of the narrative—the time of actions (story) and the time of narration (discourse)—came to correspond to each other.[49]

Semnani's composition effects this novel sense of spatial and temporal verisimilitude through a specific rhetorical strategy: the integration of unadorned direct prose into the dual prosimetrical fabric of the inshaʾ, which consists of a rhythmic alternation between rhymed prose and verse. Conveying the instructions of the

itinerary, these direct prose passages (written mostly in the third person plural form of Persian subjunctive verbs) create a narrative framework that alters the effect of both the rhymed prose and verse.[50] For the most part, unrhymed prose evokes a kinetic experience through the city, while the verses and rhyming passages typically conjure a contemplative hiatus: an extended time of gazing at a beauty, watching a social scene, or regarding an architectural monument. Prescribing spatial movement, the direct prose also serves to convey the passage of time by breaking the narrative into discrete segments. Variations in the length, meter, and format of the verses—almost all the major forms of Persian verse are harnessed—also communicate the moods of particular spaces (for example, the long passage on the qaysariyya or the beat of the poem dealing with the author's favorite coffee server).

At the same time, the composition was written as a work of belles lettres, drawing on the conventional tropes and stock images of Persian lyric poetry. These tropes link the piece to an established canon of works, while the spatial framework of the narrative and the references to aspects of everyday life turn it into a novel literary expression, one that combines the specific with the generic to achieve a peculiar effect. Even so, the length of individual parts does not necessarily reflect their significance in the city or to the author. The extensive treatment of the mirror market, for instance, seems to have more to do with the potential of the mirror to generate poetic imagery than with the real attraction of the market. Still, even in such seemingly generic sections, the text is not devoid of realistic evocations of space and individuals. For instance, in the description of the "Market of Vendors of Small Wares" (*bāzār-i khurda-furūshān*), the author warns the reader to avoid "the first shop on the right-hand side" and thus being haunted by a particularly alluring vendor. The use of such details heightens the sense of verisimilitude regardless of the details' veracity.[51] These literary devices are as fundamental to creating a sense of reality as are the references to recognizable locales and individuals.

THE SOLITARY WANDERER

The "Guide for Strolling in Isfahan" conveys a peculiar sense of aloofness from the city. Except for the memory of his absent friend, the imagined visitor does not need company. Nor does he engage in conversation with the myriad persons he encounters or beholds with love and admiration. He eats his meal alone. He does not have a particular haunt, nor is he invited to join a friendly circle in a coffeehouse. He roves through the markets and amid the crowds, sneaks into mosques, and watches urban shows, but throughout it all preserves a kind of mental autonomy vis-à-vis the urban landscape. A solitary wanderer, it seems, lies at the heart of the composition.

At the most basic level, one might seek the roots of this sense of solitude in the author's biography or in the framing of the composition as a piece of friendly correspondence. From this perspective, the guide can be read as a memorial to an intimate friendship, a homosocial bond forged between two young men during their joint forays in Isfahan's markets, alleyways, coffeehouses, and brothels. In keeping with the ethos of friendly letters, here "the attitude towards a friend is like the attitude towards oneself, the friend being an alternative self."[52] Each letter, though, hints at a unique personality: one yearns for reunion and intimacy, the other crafts a narrative celebrating urban joys and pleasures.

Rather than depart for Isfahan, Semnani creates a text that reenacts his bodily presence, evoking the vivid images, tastes, and sights of Isfahan that lingered in his mind.

And yet the "Guide for Strolling" is not a personal memoir; it is a literary representation that strives to embody and fashion an ideal character. Throughout the text, Semnani only refers to himself by his pen name, Ashiq, and this mode of self-referencing indicates that the epistle is written in the voice of a literary self. More than evoke an actual person or an alter ego, then, the "Guide for Strolling" represents an ideal urban type—an anonymous observer meandering through the city for pleasure. The act of urban wandering is ritualized and commemorated; it can now be reenacted by any person. It was the massive metropolitan context of Isfahan that enabled a (male) subject to disappear in the city and engage in such incognito voyeurism. Semnani's composition not only gives voice to this emerging social practice, it also bestows a cultural meaning on this nascent mode of encountering the urban environment. Once it was committed to writing and performed in coffeehouses, it no longer reflected an idiosyncratic mind; it embodied a shared subjective urban experience.

This kind of solitary urban experience in a metropolis recalls the famous figure of the flaneur, an idle man who ambled alone in the boulevards and arcades of nineteenth-century Paris.[53] Like his nineteenth-century counterpart, the Isfahani personage is a solitary wanderer who saunters through the city as a subjectively detached beholder. He, too, is a privileged young man with the time and money to indulge in urban leisure. The liminal social and spatial position of the flaneur—he "is still on the threshold, of the city as of the bourgeois class," Benjamin notes—is somewhat true of the Isfahani figure as well.[54] Both characters remain anonymous in the crowds of the metropolis; they immerse themselves in the city but preserve a pronounced sense of a unique self. And like the Parisian flaneur, Semnani styles himself as an aesthete and a connoisseur of urban pleasures; he knows the city's best coffeehouses, the finest bakeries, the most alluring youths, and the most seductive of all the city's courtesans.

There are also significant differences between the Parisian flaneur and his Isfahani counterpart. Unlike Baudelaire's artist-flaneur, for instance, the urban wanderer of early modern Isfahan does not seek an epiphany or a radical transformation of the self. The swiftly expanding nineteenth-century cities were in constant technological, political, and social turmoil, a condition that propelled a distinct appreciation of transitory urban pleasures, as expressed in the fleeting vignettes of urban life in Baudelaire's poems. And the Isfahani proto-flaneur is not truly an aimless ambler; he follows a "guide" that exerts a measure of control over urban experience. In the world of Semnani's guide, there seems to be no ambivalence or ambiguity in the relationship between the self and the city: all the urban elements are in perfect harmony, experienced with a degree of self-control and under the sway of an ostensibly strict itinerary.[55]

The Isfahani figure is also distinct in its integration of all the sense modalities into the act of walking. To be sure, the imagined wanderer is a full-fledged observer; beholding (*naẓar*) and spectating (*tamāshā*)—the beloveds, crowds, performances, worshippers, dervishes, and paintings—are central to his urban experience, just as "the joy of watching is triumphant" for the flaneur.[56] The intertwinement of the acts of walking and seeing is echoed in the etymology of the word *tamāshā*, which is frequently used in the text; the term derives from the Arabic root

m-sh-y (literally, "walking") but in Persian primarily connoted viewing a scenery or spectacle. The urbanization and semantic expansion of the concepts of *naẓar* and *tamāshā* in the "Guide for Strolling" is emblematic of the rise of a metropolitan vision in early modern Isfahan.

Yet in Semnani's guide, the sense of sight constantly mingles—in the body of the wanderer and in urban spaces alike—with other sensory perceptions. As such, the guide reflects a conception of walking the city in which the whole sensorium is activated and ocular engagement does not overshadow nonvisual sensory perceptions. Indeed, one could argue that in this representation, urban experience is primarily synesthetic, capturing the phenomenological perception of space by sentient human bodies. Urban spaces are defined, first and foremost, by the bodily, sensual presence of human subjects; the body—that of the wanderer and those of the beloveds and crowds—mediates between the subject and the city. The quintessentially multisensorial and corporeal nature of urban experience is another key feature that sets Semnani's portrayal of Isfahan apart from the traditional conception of flânerie.[57]

It is also important to consider the medieval roots of the guide. Certainly, turning the bustle of the marketplace into the idealized object of the poet's amorous gaze was the essential act of the shahrashub, and in both its overall conception and its rhetorical texture, Semnani's work drew upon this established genre. Arguably, the medieval shahrashub, too, was the product of a subversive culture, one that deliberately strove to undermine mainstream social mores and religious customs. And yet never before had shahrashub-inspired urban descriptions evinced the sense of a feeling human subject as does Semnani's work, which celebrates the intensity and immensity of all

urban pleasures and, above all, the possibility of anonymity in an immense metropolis. Unlike the poetic personae of classical lyric verse, the imagined subject of the "Guide for Strolling" is not solely enthralled by youthful male beauties; he is also dragged around the city by the appeal of substances, coffeehouses, and monuments; he is equally captivated by spaces and crowds. He seeks the full city experience—the entire gamut of sensorial delights and pleasurable emotions—as an embodied human subject.

In a sense, this roving, pleasure-seeking persona was the ultimate product of the new Isfahan—a city of flowing pedestrian movement by design. Isfahan's expansive arcades, leisure amenities, and paved thoroughfares lent themselves to prolonged ambles filled with sensory pleasures. That Semnani imagines his tour to occur on a Friday (the weekly day of respite) suggests that it might have been inspired by a common leisurely routine of drifting from one coffeehouse to another, from one market to the next. Undoubtedly, the full-fledged mode of such urban experience was accessible only to the leisured men of Safavid times. Still, as I have hinted in the preceding chapters, marginalized groups like women and minorities, too, could partly draw on such urban experiences to define new urban selves. A more thorough scrutiny of the sources will surely yield a more complete picture of subaltern urban experiences.

The affinities between Semnani's guide and other forms of walking the metropolis, then, do not represent uncanny similarities between temporally or geographically distant cultures; rather, they are indicative of the early modernity of Isfahan's urban culture. Meager as they may be, the unprecedented features of the text—condensed temporal structure, representation of concrete urban spaces, primacy of subjective feelings in urban experience—reflect the new

perceptions of the city, the world, and the self that emerged in early modern Isfahan. These new perceptions were rooted in the potential of the city—its material realities, spatial forms, and patterns of urban existence—but they were activated through subjective encounters that involved the bodies and minds of individuals. Moving through the urban environment, the individual had a remarkable degree of agency in appropriating the city and in defining a unique self. Ultimately, what renders the "Guide for Strolling in Isfahan" a novel literary work—and an intriguing cultural artifact of Safavid times—is the evocation of a human subject. Urban experience was essential to the genesis of this new form of subjectivity in early modern Iran.

Conclusion

ISFAHAN AS AN EARLY MODERN CITY

What a pity, Isfahan! It is like a dry sea, and fish and animals are all dead. The one who has remained dies and comes alive in every blink of the eye.

—AHMAD, SAFAVID ROYAL LIBRARIAN, 1726

[Isfahan] resembles a corpse, which was but lately a living and breathing man.

—ROBERT B. M. BINNING, ENGLISH COLONIAL AGENT, 1851

Penned in the mid-seventeenth century, the "Guide for Strolling in Isfahan" portrays the Safavid capital at the pinnacle of its glitter and prosperity. The teeming markets and the variegated textiles traded in them signal commercial vibrancy; the abundance of fruits and bread hints at burgeoning agrarian production; and the bustling leisure venues echo the luxurious lives of the privileged urbanites. The city—its elite and ordinary residents, old and new quarters, monuments and gardens—all seem to pulsate in an everlasting harmony. Seen in this light, the "Guide for Strolling" appears as a metonym for the well-being of the denizens of Isfahan—and, by extension, Safavid Iran.

The contrast between this euphoric moment and the city's sudden collapse a few decades later renders the tale of the rise and fall of Isfahan a quintessentially dramatic narrative. After reaching the Safavid capital in the spring of 1722, the Qandahar-based confederation of Ghalzay Afghan tribes laid siege to the city for more than

seven months. Unable to hold out any longer, Shah Sultan Husayn (r. 1694–1722), the last effective ruler of the dynasty, surrendered the city and his crown. Isfahan was then plundered, its inhabitants dispersed, and its urban quarters devastated in the ensuing decades, which witnessed civil wars and the shift of the political center to Shiraz under the Zands (1751–94) and eventually to Tehran under the Qajars (1794–1925). From then on, Safavid monuments attested to Isfahan's former luster, but the city was bereft of the variegated people, quarters, and experiences that gave it a cosmopolitan character.

For the Isfahani poet Hazin Lahiji (d. 1766), whose family members perished in the aftermath of the siege and sack of Isfahan, this dramatic fall was caused by the long period of peace and prosperity that preceded it: "Since prosperity, tranquility, and earthly pleasures had for centuries reached utmost perfection in the paradisal domains of Iran, [the country] was prone

to perfect calamity. The king, ignorant generals, and an unperturbed army whose swords had not been drawn for nearly one hundred years did not concern themselves with dealing with the insurrection."[1] Whatever its immediate causes may have been, the Ghalzay Afghan insurrection precipitated the demise of the Safavid dynasty and the entire sociopolitical system that had come into being with its formation. In the blink of an eye, the long-lasting imperial structure dissipated.

The horrors of the siege and sack of Isfahan were recorded in graphic detail by several contemporary observers. According to the oft-quoted narrative of the Polish Jesuit Judas Thaddeus Krusinski, the city's starving inhabitants were forced to feed on dogs and cats.[2] The writings of Ahmad, a *ghulām* who worked at the imperial library during the final decades of Safavid rule, offer a more intimate glimpse into the dire conditions that befell Isfahan in those years. During and immediately after the siege of Isfahan, Ahmad was engaged in transcribing a literary anthology (*jung*), which he interpolated with personal notes such as the melancholic passage quoted in the epigraph.[3] This gloomy portrait appeared at the end of a letter penned by one person to his friends in Isfahan. The composition arose from the same literary world that gave rise to the "Guide for Strolling" and other poetic descriptions of Isfahan. That world, though, had vanished. The city was like a sea that had dried up, and fish and animals were dead.

Littered with deserted mansions, the derelict quarters of post-Safavid Isfahan assumed a gloomy aura in the writings of nineteenth-century European travelers as well. "A person may ride for miles amidst the ruins of this immense capital," wrote the Englishman John Macdonald Kinneir in 1809.[4] In the mid-1800s, the English traveler Robert B. M. Binning observed "miles upon miles of roofless and shattered walls, and shapeless masses of rubbish, arranged in the semblance of streets and quarters."[5] Having read seventeenth-century travelogues, Binning was keenly aware of the city's former splendor, and hence compared Isfahan to "a corpse, which was but lately a living and breathing man." For him, though, the sight of the ruins did not cater to a romantic sensibility alone; it also served to justify British imperial ambitions: the ravaged city heralded an imminent era when "the civilizing enlightenment of the Christian faith shall rise upon the extinct ashes of Islâm."[6] If for Ahmad the horror of the present moment invoked a wistful sense of nostalgia for a bygone age of glory, Binning and his peers saw in the crumbling Safavid capital a declining civilization—and a call for European dominance.

These sentiments are expressed even more bluntly by George Curzon, the English statesman and the future viceroy of the British colonial government in South Asia, who journeyed to Iran in 1889–90. After quoting from the descriptions of the Chaharbagh in travel narratives, Curzon describes the promenade's derelict condition, contrasting its fate with that of its European counterparts: "Two centuries of decay could never make the Champs Élysées in Paris, the Unter [den] Linden in Berlin, or Rotten Row in London, look one half as miserable as does the ruined avenue of Shah Abbas. It is in itself an epitome of modern Iran."[7] Whether underscoring "civilizing enlightenment" or expressing a plea for imperial hegemony, these commentators cast the history of Isfahan in civilizational terms. Informed by the discourses of Oriental decadence and racial superiority, they construe the story of the rise and fall of the Safavid city in temporal terms vis-à-vis European progress. The ruins of Isfahan thus became a metaphor

for a typical non-Western country inherently incapable of modernity—a land mired in "two centuries of decay" and in desperate need of a "civilizing mission."

I do not conclude this book with the narrative of the fall of Isfahan and the perceptions of the city's demise to offer a critique of the decline paradigm and Orientalist views. These assumptions have been discredited in recent scholarship, although Safavid study still has some way to go to rid itself utterly of the prejudiced views inherited from nineteenth-century Orientalism. Nor do I invoke the fall of Isfahan to justify the rupture in Safavid history due to internal conflicts. The nationalist framework—the implicit or explicit tendency to narrate the story of Isfahan as a diachronic evolution in a hermetic locality—has equally obscured the city's significance in the broader global context.

I invoke the fall of Isfahan to underscore how the rise-and-fall, teleological accounts have distorted the character of the city as an early modern metropolis. The teleological narrative imagines Safavid Isfahan as a pendant to a long-lasting tradition, one that is entirely distinct from the form of modernity that began to hold sway in the 1800s, at the height of European colonialism. According to this view, the Safavid experience dies out, along with the novel experiences of life, time, and space that historians now call early modernity, and then there emerges a supposedly nonindigenous form of modernity that takes its inspiration—in politics, culture, and architecture—from the West. Yet the fact that the Safavid experience of early modernity did not follow the European trajectory toward modernity does not make it any less early modern. That the qaysariyya's mechanical clock stopped working, that the city's cosmopolitan inhabitants disappeared, that the silk fashioned in the Caspian Sea region was no longer

a sought-after global commodity, that the coffeehouses ceased to function as constituents of a public sphere—none of this renders less significant the moment when all of these were critical components of a dynamic metropolis interconnected with global networks of exchange. As several recent studies have shown, the disappearance of these elements had more to do with the shifts in the patterns of trade, and perhaps global climatic upheavals, than internal political turmoil, perennial geographic conditions, or local cultural practices.

To fully comprehend the early modernity of Safavid Isfahan, then, requires a double shift in scholarly gaze: from the court-centered ethos to urban experiences and from a local, diachronic perspective to a view that sees each locality as an intersection of flowing movements and global interactions. Setting aside locality and royalty as linchpins of historic interpretation—and engaging in transdisciplinary modes of inquiry—opens up a vast interpretive horizon that has just begun to be investigated by scholars. This paradigm shift promises to reveal a new understanding of Isfahan and Safavid art and architecture in general, one that would enable the field to find its place in the studies of global early modernity.

In this book, my primary objective has been to move the center of inquiry from the production and royal significance of urban spaces to perception and experiences of the cityscape. Yet this phenomenological turn—the foregrounding of senses, feelings, and experiences in the scrutiny of the urban environment—does not merely add an interpretative layer to our understanding of the city. Rather, by exposing the modes of human "dwelling" in a place that bestowed a distinct character on the urban environment, it reveals the quintessential ethos that underlay the creation of Safavid Isfahan. The city was not

a representation; it "opened up a world," to use Heidegger's words. To conceptualize Isfahan as a mirror or reflection is to see its architecture and urban design as a mere overlay on political, social, and economic trends rather than as active agents in the shaping of those trends.

At the same time, a ground-up narrative of Safavid Isfahan sheds new light on the city's intimate links to the conditions and material realities of the early modern world. Seen in this light, it was not just Isfahan's majestic urbanism that rendered it an early modern metropolis; it could be felt in the city's sounds, smells, and tastes—in the rhythms of life, modes of self-fashioning, and social associations that the spatial design and material world of the city enabled and fostered. Multisensory experiences, spatial configurations, and public institutions operated in concert to engender a form of urbanity that was not only more cosmopolitan and complex but also more ambiguous, individualized, and fragmented than what existed before. What is stunning about Isfahan is perhaps how these new forms of life—the modes of sociability, communal rituals, and sensuous manners of urban pleasure—were seamlessly inscribed into the city's spaces, walls, and landscapes. Space and matter, senses and vistas, nature and artifice acted in unison to form a social ideal that was enacted through embodied engagement of the city's inhabitants.

From a global perspective, then, Safavid Isfahan stands out as an example of how the materials and sensibilities of the early modern times can constitute the urban environment. The social behaviors, aesthetics, fashions, and desires that came with new materials and commodities—fused with those that were inherited from the past—were framed and shaped by the built environment: the promenades, pleasure gardens, coffeehouses, and trading spaces. Transient though it may have been, Isfahan participated in the gestation of urban experiences that came to define the early modern world. All of these flourished in a context of heightened flow of people and materials across the globe, creating a living environment where new ways of being a human subject were experienced.

APPENDIX: *Mir Muhammad Mansur Semnani (Ashiq), "Guide for Strolling in Isfahan"*

Translated from the Persian by Farshid Emami

This is an almost full translation of the text. Due to limitations of space, some passages and poems have been omitted. Transliterations are given in parentheses, with my own interpolations in square brackets.

Incarcerated in the wistful abode of separation, the longing Ashiq does not know with what words to express the blows of departure and under what rubric to describe the grief of leaving one's friends. If the scribe of the mind turned the trees of the Chaharbagh into pens (*qalam*), and made the Zayanda River (*zinda rūd*) ink (*midād*), and then set out to record the days of separation with the prolonged hand of desire on the page (*ṣafḥa*) of the Maydan-i Naqsh-i Jahan, even a little could not be written in infinite years. Hence, how much could the wooden-legged steed of the pen roam upon the letter's field, and how far could it stride on the route of discourse?

> How could the pen describe the toil of
> separation?
> How could the wooden steed roam in this
> field?
> I am incapable of counting [my] wearing
> pains,
> How could one reckon the drops of rain?
> How could I conceal my love from strangers?
> How could a tulip hide its burn mark (*dāgh*)?
> The Zayanda River's water flows from my
> eyes

Whenever my weary mind reminisces on
 Isfahan.
Being distant from friends and deprived of
 strolling (*sayr*) on the Chaharbagh
Is extremely hard, may God ease it for Ashiq.

After complaining of separation and expressing a penchant [for meeting], a guide (*dastūr al-ʿamal*) on the subject of strolling the markets, roving flower gardens, and beholding visages is written by the pen of expression. One is by no means permitted to stray or to deviate from this itinerary (*ṭarīq*).

One must follow this guide (*dastūr*).

It was my mind's will to write an extensive guide with a restorative description on each subject, but since there was not sufficient time, [the mind] contented itself with a sampling. If [one's] temperament is sharp-witted, this is sufficient.

My dear, in the morning, when the swift-handed master of fate lifts the shutter of morning from the front of the eastern shop, the mirror-seller sun heats the market of the age, and the poor speck arrays the spread (*bisāṭ*) of small wares, seeking trade with fairy-faced coquettes and intent on purchasing the commodity of pleasure and coyness, one is to don the pilgrimage robe in the chamber (*ḥujra*) and set off.

First, at the *bāzārcha* [small market] of the *tīmcha* [covered commercial establishment], one should have a morning wine (*ṣabūḥī*) effected by the exhilarating sight of the wanton tobacco

vendor (*tanbākū-furūsh*) and alleviate the headache (*ṣudā'*) caused by the hangover (*khumār*) of separation.

> If you desire union with the good-looking,
> Pass once by the stall of that fairy-faced one.
> Alleviate the separation's hangover by
> [beholding] that countenance,
> Imbibe a morning drink from that wine.

From there, one should then pass by the shops of Armenian infidel boys (*kāfar-bachchagān-i Arāmana*) and in the custom of the Christian faith wear their non-Muslim girdle (*zunnār*) in submission to the cross-shaped tresses of those devastating flower-faced ones.

> Their magical looks annihilate the heart,
> [Seeking] their affection harms the soul (*jān*).
> An idol turned dust into mud with my blood,
> and said:
> "This is the color of the Armenian bole (*gil-i Armanī*)."[1]

The first advice is that the one who has stepped into the circle of love (*dā'ira-yi muḥabbat*) should stay away from [caring about matters of] Islam and disbelief (*kufr*).

> When you enter the realm of love,
> Like a mirror, be sincere with everyone.
> Be familiar with the seventy-two religions,
> Sometimes be a Christian (*tarsā*), sometimes
> pious (*pārsā*).
> Sometimes engage in prayers with Sufis,
> Sometimes imbibe wine with libertines
> (*rindān*) in taverns (*kharābāt*).
> Sometimes read the scripture (*muṣḥaf*) from
> a countenance,
> Sometimes wear the non-Muslim girdle
> (*zunnār*) made of idols' tresses.

> Of all creeds, choose the religion of love,
> Salvation is through the auspices of love.

One should then head toward the qaysariyya via the paths running through the coffeehouses and in the rear of the coffeehouses. It is permissible to linger to smoke a water pipe at the stall (*dukkān*) of Salih-i Khavas-Khvan, and if [one's] temperament (*ṭabī'at*) is inclined toward coffee, one can get a cup (*finjān*) from the hand of Mirza Ashraf at the Khvaja Ali Coffeehouse.

From there, one should stroll toward the qaysariyya portal, which is the auspicious zodiac house (*burj-i sharaf*) of the star of felicity (*akhtar-i sa'ādat*) and the jewel casket (*durj-i gawhar*) of beauty and comeliness (*ḥusn u ṣabāḥat*), and one should reside there and purchase, at that gate of delight (*bāb al-ṣafā*), the ruby of lips and temples from the moonlike jewel-vendor idol (*nigār-i jawhar-furūsh*).

> The jeweler's moonlike face is the flower of
> hope,
> From head to toe, he is the sun's essence.
> His eyes, lips, cheeks, and teeth,
> Are black-and-white shells (*jaz'*), red gems,
> rubies, and pearls.

From the worthy-of-life jewel of the vision (*khiyāl*) of his beauty, one should adorn the stringed veins of the soul with jewels and fill up the heart's casket with rubies. Yet since the fear of the amorous glance does not allow one to purchase the closeness of union, one should rest in front of the platform (*takht*) of the salep-making and syrup-selling stall (*dukkāncha-yi sa'lab-pazī va shīra-furūshī*) that lies opposite the place of that moonlike beloved, and drink a cup or two of salep—which is sweeter than sugar juice (*shīra-yi nabāt*), scented with musk and ambergris, and due to the grace (*fayż*) of sight has the effect of

exhilarating [opiate] drugs (*nūshdārū-yi luʾluʾī va mufarriḥ-i yāqūtī*)—as much as capacity allows, and with that excuse [one is to] sweeten the soul with the sherbet of [his] countenance (*dīdār*).

> Stealthily, imbibe the wine of union with the
> beloved,
> Stealthily, imbibe brimful cups.
> Every moment, take a sip of salep.
> Mingled with the sherbet of [his] countenance.

Then, intent on purchasing the beauty of Joseph, one should enter the Egypt-like qaysariyya and observe all sides and corners: Potiphar has spun the satin of the face, warp and weft are interwoven from light, and superb textiles are in the stalls; I suspect that with a burnt needle the heart is sewn to eyelashes and they trade in the market's dullness. Offer the shawl of patience and intelligence as earnest money (*bayʿāna*), and if this is not a good bid, put the turban (*dastārcha*) of your soul on your head, for there would be no loss in trading the heart's linen (*katān*) for a brocade (*māhtāb*).

> Do not divulge your heart's secret there,
> Your heart will be injured, stay away from
> there.
> Behold the shops of the qaysariyya,
> As there is beauty of a fine type there.
> The good ones steal your heart from you,
> I wish my heart were with you there.

Then take the adulterated (*nāsara*) coin of your gilt-with-lust heart to the mint (*żarrāb-khāna*) of affection, and make it standard with the perfect coin of love, so that from the amorous elixir of the two flower-faced, silver-bodied, cypress-statured [coiners] it will become prevalent, like a double-faced gold coin (*ashrafī-yi dubutī*), in the market lane of love.

> Without the love of the two coiner idols who
> are fine throughout,
> Every heart is impure, like a small piece of
> money (*pashīz*).
> From the coin of their love in the market of
> loyalty,
> My heart became honored like a double-
> faced gold coin.

From there one should go to the Yazdi and Kashi caravanserais [commercial establishments associated with merchants from Yazd and Kashan], enter the small bazaar (*bāzārcha*) of the Mulla Abdallah [Madrasa] from there, and seek a cure for the bitterness of separation at the stall of the sweet-essenced beloved confectioner (*dilbar-i shīrīn-nahād-i qannād*)

> The mind is checkmated by the confection-
> er's bewildering countenance,
> The foundation of patience is shaken by that
> face.
> I want such a kiss from his sack of sugar
> (*tang-i shikar*),
> So that the heart in my chest becomes a
> glass-container of sweets (*shīsha-yi nabāt*).

If the parrot of the tongue describes that sugar-lipped, sweet-mannered one, surely the pen turns into sugarcane (*nayshikar*) and the page becomes halva's wrapping paper (*kāghaz-i ḥalvā*). . . .

With a sorrowful heart, one should pass that place and proceed to the stall of the hard-hearted one who ties [tubes] to the glass bases of hookahs (*shīsha-yi qalyān*) and hand him the broken glass of the heart so that he pricks it with [his] eyebrow's diamond and ties it to the twisting strands of [his] hair (*maftūl-i marghūl-i kākul*).

> That wanton boy (*shūkh*) who ties the hearts'
> glasses

And alights with stars, each night, the
 circling [censer of] wild rues (*charkh-i
 sipand*),
He tied countless glass bases of hookah
And did not tie a broken heart once.

From there one should return to the chamber
(*hujra*). Although on such a day there should be
no concern for eating and sleeping, but since
nature is accustomed to food, and the carnal
soul (*nafs-i bahīmī*) is wont to eat and drink,
one is to stop for an hour to have an early lunch
(*chāsht*), and one should be content with a rapidly
prepared snack (*māḥażar*). One is to eat: some
sangak [a kind of bread made in a pebble-covered
oven] by [the bakery of] Parviz Beg, *lavāsh* [a thin
type of bread] by Master (*ustād*) Taymur, cold
cheese (*panīr-i yakhchālī*), Javali yogurt (*māst-i
javālī*), grapes (*angūr-i kishmish va rīsh-bābā*),
peaches with sweet seeds (*hulū-yi dāna-shīrīn*),
green plums (*shaftālū-yi sabz*), dried pear mixed
with walnut (*amrūd-i jawqand*), watermelon of
the Kashan stock (*hinduwāna-yi tukhm-i Kāshān*),
and watermelon (*kharbuza-yi qurqī*). . . .

Then, to delight the mind and open the
temperament, one is to visit the idol house
(*butkhāna*) of Taraz, namely Qahva-yi Saz ["cof-
feehouse of the musical instrument"]—which is
the abode of libertines (*rindān*) and the assembly
of candle-faced sweet-lipped ones—and for a
while behold that picture gallery (*nigāristān*) and
become enamored with that springtime garden
(*bahāristān*). It is in fact a pleasant convention
and a marvelous assembly. Heart-ravishing
beloveds (*dilbarān*), with colorful coquettes,
and the minstrels (*muṭribān*), with sweet songs,
adorn the assembly and augment joy. Each part
is like the spring, with the narcissus of the eye,
the tulip of the face, statures resembling box
trees, rose-like cheeks, jasmine-hued foreheads,
and temples like wild roses; they delight the

garden of beholding and bestow pleasure on
desire. On every side, yearning for a beloved,
one hundred embracing arms are open like
combs, and in every corner, desiring a candle-
like face, one hundred smoldering hearts lie
on the ground. With the "mulla's dance" (*raqṣ-i
mullā*), the moon-statured ones take reason away
from the old and the young.[2]

Idols with faces of jasmine hue,
In coquetry each superior to the other.
Silver-legged, cypress-statured idols,
All suitable for the desire's embrace.
All have bewitching European gazes (*jādū-
 nigāhān-i farangī*),
Roman (*rūmī*) in face, African (*zangī*) in hair.
A throng of beloveds appears on each side,
All intoxicated, dancing and stamping their
 feet.
With graceful gait, they have fastened their
 belts tight,
With a pair of compasses, they have broken
 all hearts.
With the melody of the face, they strum the
 nightingale's tune (*rāh-i bulbul*),
With the circle/pollen (*gard*) of the rose, they
 disturb the hyacinth (*sunbul*).
The heart-ravishing tunes of the reed flute
 (*nāy*) and lute (*ṭanbūr*)
Stir uproar in the hearts of the young and
 old.
The cry of the organ (*arghanūn*) and the moan
 of the lyre (*chang*)
Rub rust from the heart with the Iraqi tune
 (*āhang-i ʿIrāq*).[3]

Among those fairy-statured, slim-waisted ones,
a beloved . . . named Piyala ["cup"] is the star of
the feast. His eyes afflict the minds of prudent
ones; his wanton smile and flowery laughter stir
tumult.

Piyala is the chief of all beloveds,
His countenance has the tulip's hue.
His curls and moles have cast snare and
 seeds,
For the bird of the heart's griefs.
With a warm breath, he is alluring like the
 water pipe,
Like rosebud in the veil of modesty (*sharm*).
Like coffee he boils warm with everyone,
Like a flame he mingles with rubbish . . .
The image of the countenance of that singu-
 lar moon
Has turned the coffeehouse into a picture
 gallery.
Because of the intoxicating effect of his gaze,
The coffee cup resembles a goblet of red wine
 (*ṣahbā*).
So sweet is his silvery chin
That lips become sweet by mentioning kiss-
 ing it.
His corrugated dress (*kamar-chīn*) has tight-
 ened my heart,
Since it embraces his waist tight.
I boil with yearning for his union so much,
That it seems I am embracing him.

From there one should set off for the mar-
ket and pass through the Shoemakers' Market
(*bāzār-i kaffāshān*). Reaching the portal of the
royal complex (*dar-i dawlatkhāna*), if there is
sufficient time, one is to visit the Talar-i Tavila
[Hall of Stables], the idol house of China and the
Arzhang [holy book] of [the prophet] Mani, to rub
off rust from the mind by beholding the Chris-
tians of the European monastery (*tarsāyān-i
dayr-i farang*). Beware not to be beguiled by the
made-up beauty (*ḥusn-i sākhta*) and the color
of the countenances (*rang-i ʿāriż*) of those cruel
ones with bewitching gazes (*jādū-nigāhān*), and
do not become enamored of the images on the
walls.

From there, one is to enter the market lane
of lapidaries (*rāsta-yi ḥakkākān*) and give the
Solomonic ring stone of the heart to the daring
lapidary to engrave, with the diamond pen of the
eyelash, his faithful name on it so that no other
idol would penetrate the finger of usurpation
into it.

The firmament is enamored of the lapidary,
May no harm afflict his eyelashes.
When he saw the carnelian (*ʿaqīq-i jigarī*),
 at once
He hewed it with his wink and engraved it
 with his eyelash's tip.

Passing from there, one should first leave
religion and the heart behind, and bid farewell
to patience and tolerance, and then step into
the Market of Vendors of Small Wares (*bāzār-i
khurda-furūshān*), famed as the "abode of mir-
rors" (*āyīna-khāna*). In that port (*bandar*), two
tulip-faced beloveds, resembling the moon and
sun, are engaged in mirror selling (*āyīna-dārī*)
and, like the rose and the wild rose, are engaged
in vending small wares. . . .

If you do not lose your life in that market
 lane (*rāsta*),
You will certainly lose your faith there.
O heart, whoever strides on that path,
Will burn like wild rue in the sun's fire.
In that painful field of the suns,
You lose yourself soon like a speck.
When the light of the sun falls on the mirror,
It burns the picture of anyone on whom it
 shines.
When you see the beloved's reflection in
 mirror,
You pluck the flower of fire from the garden
 of union.
I have a thorn in my heart,

From the eyelash that made my chest a broken mirror.
That fairy's reflection ruined me,
May the abode of mirrors be prosperous! . . .

My dear, avert your gaze from the first shop on the right-hand side, and listen to the words of this compassionate advisor and proceed to the stall of small wares at left. Like a mirror, gaze in bewilderment, and like a flower's crown, bear your life in your hand, and in the manner of quicksilver, become enamored with that market and purchase from that moon-faced beloved. . . .

Like the pupil of the eye, [he] has made an abode of mirrors, [and aided] by an exorcist (ʿazāʾim-khvān) has filled the glasses with the beauty of fairies. Reflecting his face, the mirrors have adorned the market with wineglasses and flower bouquets. . . .

The lantern of the stall of that arrogant candle
Set alight the hearts of countless moths. . . .
Merry the melody that remedies the heart
And sooths me with the tune of Isfahan.
I am crazed about that market side,
Selling wonder, mirror-wise.
Like a flower stalk, I have burn marks (dāgh)
 throughout,
O moon! Rise in my mirror field!
In that flower field, O you dear friend!
Swear to our amity, that you will reminisce
 on Ashiq.
Say: O you pain-stricken debauchee
 (lā-ubālī)!
In this garden palace, you are missed.

From that market, one is to pass with blood-scattering eyes and a wounded heart, glancing back with sighs. At the portal of the congregational mosque (masjid-i jāmiʿ), in the perfumer/druggist stall (dukkān-i ʿaṭṭārī) located opposite [the stall] of Haji Tahir, there is a druggist sweetheart with whom the city is enamored. From coquetry he has made concoctions and exhilarating drugs. Present your ailing heart to that druggist so that perhaps, with the jujube (ʿunnāb) sherbet of [his] lips and the apple wine of [his] chin, he could cure the incendiary fever of separation and the lethal malady of desire. . . .

When the time comes for the noon prayer (namāz-i ẓuhr), the melodious muezzins, with the exhilarating sound of "Hurry to prayer!" (ḥayya ʿalāʾl-ṣalāt), stir uproar in the turquoise dome of heaven. And through the gate of purity (bāb al-ṣafā), namely the golden door that is open to all like the gate of mercy and fulfills the wishes of the needy. . . , one should enter, as confirmed by the truth of the verse "whoever enters it [i.e., the sanctuary of Mecca] should be safe" [Quran 3:97], the protected graceful realm of God.

Ashiq! When you reach that Kaʿba of secrets,
Seek from that door whatever you need.
There the Kaʿba's door has opened in Isfahan,
From that door they take you to Paradise
 with grace.

In that locus of divine grace and repository of infinite mercy, you will see various people, from elites and commoners (khavāṣ va ʿavām) and reciters of the Quran (ḥuffāẓ-i kalām), in worship, and you will find rows of worshippers and ascetics (ṣufūf-i zuhhād va ʿubbād) praying with masses of angels.

The crowding of ascetics in that locus of light
Resembles the mass of angels in the heavenly
 house (bayt al-maʿmūr).
On the pulpit (minbar), which reaches the
 heavens,
Mulla Muhsin [Fayz] resembles Moses on
 Mount Sinai.

In that place of truth and purity, one should perform the religious duties (*farā'iż*), and after finishing, if supposedly it is a Friday and time is ample, one is to don the robe of pilgrimage and set off, with no hesitation, to visit the Old Mosque (*masjid-i kuhna*). Along the entire way, amid the markets, one should stroll and behold like the morning breeze in a field of flowers, . . . and one should not pause along the way before reaching Takhtgah.

> If [the prophet] Khizr's enthusiasm is your
> guide,[4]
> He will show you the way to Takhtgah.
> You will see one hundred royal thrones (*takht*),
> Each like a picture gallery (*nigār-khāna*) filled
> with idols·
> Moon-faced, beloved boys,
> Flower-faced, cypress-statured idols,
> Standing at your service, left and right,
> Bringing you whatever you want.
> The moon-shaped with bodies like wild roses
> (*nasrīn*)
> Prepare the hookah and bring you coffee.
> The hookahs are all inlaid (*tah-nishān*) and
> gilded (*zarkūb*),
> With silver trays and wooden bases.
> Each glass of coffee, mirth-exciting,
> Like a glass of wine, intoxicating.
> Coffee is mixed throughout,
> With the color of musk and smell of
> ambergris.
> Wood aloe juice is mixed with rose water,
> Like Khizr's [life's] spring in darkness.
> The hookah is charming like the stature of
> idols,
> Filled with purity, like lovers' chests. . . .

And at that venue, one should linger for some time to smoke hookah, drink coffee, and behold the fairy-faced idols. After this midday rest or nap (*taqayyul*), one should turn toward the heavenly threshold of the sultan of the realms of guidance, Harun-i Vilayat—the world-illuminating sun of the faith and the protector of Isfahan from disasters—and visit that holy shrine and engage in repentance and worship.

Then one must depart that graceful threshold, head toward the Old Friday Mosque (*masjid jāmi'-i qadīm*) and enter that Ka'ba-resembling mosque watched by angels; in space it is the envy of the sky, and in purity it is the grudge of Jerusalem (*bayt al-muqaddas*).

> The Old Mosque is the manifestation of grace
> (*fayż*),
> That ancient abode is the clearest manifesta-
> tion of grace.
> Envy of the heavenly house,
> Locus of grace and repository of light.
> In that garden of hope, all at once,
> You could pluck flowers of blessing from the
> air.
> Masses of angels, each morning and evening,
> Reside there like doves.

Since in fact the time of the [noon] prayer has passed, one will not find the bliss of following Muhammad Taqi [Majlisi] in congregational prayer. Still, if you could make it to that unique gnostic's preaching (*maw'iża*), you would receive blessings. And if you miss that, you should go to the convent (*khānqāh*) of the peerless Sufi Nasir and enter the circle of the Sufis, with sincere hearts, and the dervishes, with pure beliefs.

> You will see an assembly of masters of purity
> (*arbāb-i ṣafā*),
> Like the eternal light (*'aql-i kul*) detached
> from the material world.
> Feeble and emaciated, like the reed flute
> (*nay*),

Moaning, day and night, from the pain of
 love. . . .

One must relish the ecstasy of the loud and
quiet audition (*zikr*) and the spiritual state of that
tribe, and take delight in the wine of yearning.

From there, in accordance with the dictum
"returning is better" (*al-ʿūd aḥmad*), one should
return [to the Maydan-i Naqsh-i Jahan].

Reaching the vast Maydan-i Naqsh-i Jahan,
one should rove in space and behold the uproar
(*shūr*) and frenzy (*ghaughā*) throughout. From
the crowding of people, the page of the maydan
is adorned like the sky with planets and stars,
resembling the queue and crowds on the day of
resurrection (*maḥshar*); it is hard to come and go,
and it is difficult to move.

> The maydan, which is vaster than the realm
> of imagination,
> Every evening, the resurrection day can be
> seen in it.
> The sound of the trumpet is like the one
> blown on the judgment day (*nafkh-i ṣūr*),
> From the uproar of people, the maydan
> resembles the resurrection day.

Reaching the maydan, one should become
hooked (*pābast*) by the performance (*maʿraka*)
of the long-bearded (*rīsh-dirāz*) Baba Qasim
and become fettered by the chain-like tresses
of that wanton jester (*shuʿbada-bāz*). You must
pick a suitable position on the periphery of
the performance (*maʿraka*) before the rushing
of spectators (*tamāshāʾiyān*) and crowding of
beholders (*naẓẓāragīyān*). For when that leader of
all jesters (*ṭannāzan*) and the chief of all acrobats
(*mawzūnbāzān*) enters the maydan like a lion
with two chains, space becomes so tight that the
hearts would not have room for beating and the
eyes would not have field for viewing.

> When that ludicrous one enters the maydan,
> With feverish face and long tresses,
> It is as if [the day of] resurrection has
> arrived,
> Consciousness and patience evade all.
> His gait resembles that of the peacock,
> His strands of black hair are like two wings.
> His name is Aqa Hasan Ali,
> Affection is trapped in his snare.
> His eyelashes strike a dagger into the liver
> [*jigar*, the locus of emotions],
> The curve of his waist takes patience away.
> Like the gates of hope, his eyebrows
> Have drawn a blade (*tīgh*) on the sun.

From there, with the heart disturbed like
the beloved's tresses and the eyes weeping like
a spring cloud, one could pause for a second
at the wrestling scene of the young Muham-
mad Khuljani, since truly [the wrestling of] this
lovely, frisky wrestler and that fearless wanton is
pleasing. . . .

And if you long for the company and pleasure
of the silver-faced, and [if you are] desirous of
union and seek closeness to the fairy-bodied,
in the Mahalla-yi Ard-Furushan ["flour-sellers
quarter"], which is a quarter of [sellers of]
beauty (*ḥusn*), deceitful and devilish brown-faced
(*gandumgūn*) people look out to sell the coyness
of those whose company is available for 1 dinar,
and one could embrace them with the vigorous
arm of gold and the mighty forearm of silver.

But if you desire a lover (*dilbar*) of whose
courtship you can speak and from whose com-
pany you can gain full grace, you must inquire
about Kucha-yi Naw ["new alley"], the ancient
nest of inebriated peacocks (*ṭāvūsān-i mast*) and
the seat of faithful pheasants (*tazarvān-i vafā-
parast*). Although, due to the improper behavior
(*aṭvār-i nāmulāyim*) of a group among this class
(*ṭabaqa*), the "flower of notoriety" [*gul-i badnāmī*,

i.e., syphilis / venereal disease] has blos-
somed and has concealed the names of the good
ones—and has stained the fame of this pure tribe
with slander and has thrown them into the abyss
of dishonor—there are still numerous graceful,
witty mistresses (*nāzanīnān*) [or "descendants
of the prophet (*sayyida*), as well as pious (*zāhida*)
and virtuous (*ṣāliḥa*) ones"] in this clan who
are hidden from the eyes and not well known.[5]
Among them there is a beloved—coquettish,
[fifty-two more adjectives]—who is the monarch
of the realm of beauty (*ḥusn*) and the moon of the
sky of elegance (*malāḥat*).

The old sweetheart is in the Kucha-yi Naw,
Heart-stealing, moon-faced, and
 silver-chinned
Cypress-statured, silver-chested, and
 coquettish,
An intriguer, from head to toe, tender.
The heart's dominion is under her rule,
The old firmament's eye is amazed at her.
Her tresses are sweet-smelling,
When speaking, her lips are a blight for
 consciousness.
The heart is ruined by her black eyes,
The mind is crazed by her gaze.
Her complexion is a workshop of loveliness,
Her nose is known for its fineness.
Her mouth's chest is Khizr's spring [of life],
Hidden, of course, from the eyes.
Her neck is like a candle, but made of
 camphor,
Turning her garment's opening into a foun-
 tain of light.
From feet to head covered in the flower of
 delicacy,
Her chest is a mirror seller due to its purity.
Her shirt smells of the scent of roses,
Her tenderness (*nazākat*) vexes her body.
A dangling strand of hair has curved,

And that curve has been termed "waist."
Part by part, with the tip of my pen,
I was writing her description on a tulip sheet.
Yet it is not permissible by the rules of deco-
 rum (*adab*),
To lift the curtain from the hidden secret.
Her comely gait resembles a flowing stream,
Her legs are silvery fish in it,
Like two crystal columns,
Trembling in the manner of quicksilver
 (*sīmāb*).
The [henna-dyed] soles of her feet receive
 tribute from [the carnelian of] Yemen,
Her toes are adorned with rosebuds.
If her dress was made of brocade,
It would tear from her radiant heat.
I'm so struck by the sight of that silver-
 chested one,
That like one fairy-struck (*parī-dīda*), I'm not
 aware of myself.
She wouldn't leave my tear-filled eyes,
Water reflects a cypress.

O you the one with fine manners!
May your goblet incessantly brim with the
 wine of joy.
May your hand comb the beloved's locks,
May your arm be the necklace around her
 neck.
Listen to the words of this trustworthy
 advisor,
Keep in mind my advice:
Choose from the idols of Isfahan,
A sun-faced, pleasant-mannered sweetheart.
A slim-statured cypress with silvery legs,
A fairy-faced beloved, with a moonlike
 forehead.
A jasmine-smelling one, with breasts that
 resemble pomegranates,
A beloved whose wink wounds the heart.
If the zephyr wafts through her tresses,

It bestows the essence (*māya*) [of musk] to
 the Tartarian caravan.
Seek union with the desired moon,
A union with no separation.
Intoxicated with joy,
Nothing shall be awoken but your fortune.
Make the rose garden of union your home,
Embrace the free cypress.
Imbibe pure wine from her lips,
Pluck thornless roses from her face.
The sun's flower augments affection,
Red wine is pleasant.
As your weary heart seeks a kiss,
Do not let her lips utter a word.
Do not remain idle (*dast dar ḥanā*)
When you take the hand of an idol.
Sometimes one should untie the lock of hair,
Sometimes one should wear the non-
 Muslims' girdle.
Don't forget the company of sweethearts,
Don't forsake the beloved's curls.
O you the one from a selected root!
I have asked of God four things for you:
A desired lover and pure wine,
A joyous mind and ample gold.

Introduction

1. M. T. V. Qazvini (hereafter simply Qazvini), *Tārīkh-i jahān-ārā*, 633–35, 667–72; Shamlu, *Qiṣaṣ al-khāqānī*, 1:517–19. For poetic descriptions of the bridge, see Losensky, "'Equal of Heaven's Vault.'"

2. University of Tehran, MS 8235, fol. 169v; Danishpazhuh, "Iṣfahān va Ṭāvūskhāna-yi ān," 209.

3. See chapter 9 for an in-depth discussion of the text; see the appendix for an English translation.

4. On these reforms, see Savory, *Iran Under the Safavids*, 76–90. For an overview of the reign of Shah Abbas, see Quinn, *Shah ʿAbbas*. For general introductions to Safavid history, see Newman, *Safavid Iran*; Amanat, *Iran: A Modern History*, 31–125; and Roemer, "Safavid Period."

5. Babaie et al., *Slaves of the Shah*.

6. See Ardalan and Bakhtiar, *Sense of Unity*, and Stierlin, *Ispahan, image du paradis*, prefaced by Nasr and Corbin, respectively.

7. Major earlier studies of Safavid Isfahan include Godard, "Iṣfahān"; Beaudouin, "Ispahan"; Holod, *Studies on Isfahan*; Hillenbrand, "Safavid Architecture"; and Ahari, *Maktab-i Iṣfahān* (1380, 1385).

8. Hunarfar, *Ganjīna*; Rafiʿi Mihrabadi, *Āsār-i millī*.

9. Blake, *Half the World*.

10. McChesney, "Four Sources."

11. Necipoğlu, "Framing the Gaze."

12. See Babaie, *Isfahan*, and Babaie, "Sacred Sites of Kingship."

13. Iskandar Beg, *Tārīkh-i ʿālam-ārā*, 2:1110; Astarabadi, *Tārīkh-i sulṭānī*, 134; and Fazli, *Chronicle*, 1:90, 472.

14. See Emami, "Coffeehouses."

15. Blair, "Inscribing the Square."

16. De Certeau, *Practice of Everyday Life*, 91–130.

17. Within an expanding literature, see Hamadeh, *City's Pleasures*; Dadlani, *From Stone to Paper*; Khera, *Place of Many Moods*; Kafescioğlu, "Picturing the Square"; and Rizvi, *Affect, Emotion, and Subjectivity*. Recently, Babayan, *City as Anthology*, has also examined notions of urbanity and (homo)eroticism in Safavid Isfahan.

18. Seamon, "Way of Seeing," 157.

19. Merleau-Ponty, *Phenomenology of Perception*, 209.

20. Schmarsow, "Essence of Architectural Creation," 286. Phenomenology has inspired myriad interpretive approaches in the studies of environment and architecture. Within a vast literature, see Norberg-Schulz, *Genius Loci*, and Holl, Pallasmaa, and Pérez-Gómez, *Questions of Perception*.

21. Foundational studies of vision and visuality include Foucault, *Discipline and Punish*, 195–238, and Jay, "Scopic Regimes of Modernity." On vision and the gaze in Islamic art and architecture, see Necipoğlu, "Scrutinizing Gaze," and Ruggles, "Making Vision Manifest." Drawing on physical and literary evidence, this book explores the social meaning and urban practices of vision in Safavid Isfahan. A fuller contextualization of the gaze requires an investigation of philosophical, scientific, and cosmological sources, a task that falls beyond the scope of this study.

22. On nonvisual sensory perception in architecture, see Pallasmaa, *Eyes of the Skin*. Noteworthy literature in the interdisciplinary field of sensory studies includes Cowan and Steward, *City and the Senses*; Howes, *Varieties of Sensory Experience*; and Promey, *Sensational Religion*. See also the multivolume set *A Cultural History of the Senses* (Bloomsbury Academic), which offers a comprehensive history of the senses in the Western world.

23. Baxandall, *Painting and Experience*, 29; see also Baxandall, *Limewood Sculptors*, esp. 143–63.

24. On this topic, see Whyte, "Architecture and Experience."

25. The intermediary role of experience is discussed in Tygstrup, "Reading Space."

26. Baudelaire, "Painter of Modern Life." For Benjamin's reflections, see his "On Some Motifs," *Arcades Project*, and *Charles Baudelaire*.

27. Alter, *Imagined Cities*. On this subject, see also Havik et al., *Writingplace*. A rich corpus of theoretical works exists on the intersections of the built environment and literature. See, for example, Hamon, *Expositions*; Ferguson, *Paris as Revolution*; and Clarke and Crossley, *Architecture and Language*.

28. Paul Losensky ("Palace of Praise," 2–5) uses the phrase "urban topographical" in reference to both shahrashub works and versified travelogues.

29. In this approach I follow in the footsteps of scholars who have engaged literary materials in the field of Islamic art and architecture. An example of a comprehensive study of literary sources for art-historical purposes is Roxburgh, *Prefacing the Image*. See also Grabar and Robinson, *Islamic Art and Literature*, and Robinson, *In Praise of Song*, which draws on Arabic poetry to investigate palace architecture in eleventh-century Iberia. Another noteworthy study of literary sources is Hamadeh, *City's Pleasures*, on eighteenth-century Istanbul.

30. Afshar, "*Maktūb* and *Majmūʿa*," offers a concise introduction to these sources.

31. For overviews, see Stevens, "European Visitors," and Matthee, "Safavids Under Western Eyes."

32. An example of this approach to European travelogues is Roxburgh, "Ruy González de Clavijo's Narrative."

33. The basic visual tools of architectural history are orthogonal drawings (plans and sections) and isometric

projections. These representational conventions have their own limitations, but they are more than ornamental additions to studies of sociocultural context, and should be carefully considered in tandem with textual evidence.

34. My reading of the Kaempfer materials (British Library, London) builds upon the pioneering work of Mahvash Alemi. See, by Alemi, "Giardino persiano," "Royal Gardens of the Safavid Period," and "Safavid Royal Gardens."

35. Coste's drawings are preserved in Bibliothèque de l'Alcazar, Marseille, MS 1132–34. Compared with the lithographs in Coste, *Monuments modernes*, the on-site drawings are more detailed and reflect direct engagements with the built environment. On Coste's materials, see Alemi, "Giardini reali," and Brignoli, "Pascal Coste."

36. The bulk of these photographs were taken by Ernst Höltzer (also spelled Hoeltzer; 1835–1911), a German employee of the British Indo-European Telegraph Department who resided in Isfahan between 1863 and 1897. See Höltzer, *Persien*, and Höltzer, *Hizār jilva-yi zindagī*. A large corpus of old photographs of Isfahan, including an album by Armenian-Iranian photographer Joseph Papazian, is kept at the Gulistan Palace Photo Archive, Tehran. Another major collection is at Leiden University Library, which includes the 1890–91 photographs taken or collected by the Dutch merchant Albert Hotz (1855–1930).

37. A host of foreign and local commentators have long blamed Masʿud Mirza Zill al-Sultan (Qajar governor of Isfahan, 1874–1907) for the destruction of Safavid monuments. Yet a nuanced study also points to other factors, such as urban modernization. On Isfahan's history and urban transformations in the 1800s, see Walcher, *In the Shadow*, and Walcher, "Faces of the Seven Spheres."

38. Canby, *Rebellious Reformer*; Farhad, "Safavid Single Page Painting."

39. The reconstructed plans offered in this book are based on an examination of cartographic, photographic, and textual evidence. I build upon previous reconstructions by Golombek, "Urban Patterns"; Gaube and Wirth, *Bazar*; Gaube and Klein, "Das safavidische Isfahan"; Bagher Ayatollahzadeh Shirazi (published in the Ministry of Culture and Arts of Iran's *Isfahan, City of Light*); Mohammad Amin Mirfendereski and partners (Cultural Heritage Organization, Isfahan); and Alemi, "Bāghhā-yi shahrī." A useful overview of the available maps of Isfahan is offered in Emrani, "Role of Gardens," 18–23.

Chapter 1

1. Awhadi, *Tazkira*, 1:104–5.

2. On Isfahan in the early Islamic period, see Kamaly, "Four Moments." On the early medieval period, see Durand-Guédy, *Iranian Elites*. For the Timurid and early Safavid periods (ca. 1400–1600), see Quiring-Zoche, *Isfahan*. The eleventh through fifteenth centuries are discussed in Durand-Guédy, "Isfahan During the Turko-Mongol Period."

3. Iskandar Beg, *Tārīkh-i ʿālam-ārā*, 1:544.

4. Junabadi, *Rawżat al-Ṣafaviyya*, 714.

5. See Avi, *Tarjuma-yi maḥāsin-i Iṣfahān*, 30. Isfahan is described as the "head of the Iranian land" in Abdi Beg, *Jannāt-i ʿAdn*, 156.

6. Quoted in Durand-Guédy, *Iranian Elites*, 24.

7. Ibid., 30.

8. On these cosmological notions, see Karamustafa, "Cosmographical Diagrams."

9. Amanat, *Iran*, 84, and Walcher, "Faces of the Seven Spheres," part 1, 342.

10. Razi, *Tazkira-yi haft iqlīm*, 2:887.

11. Ibid., 1:84.

12. For Jayy, see Duva, "Gay in the Sasanian Period." On the Sasanian round cities of Gur and Darabgird, see Huff, "Archaeological Survey," and Morgan, "Some Remarks."

13. Gaube, "Iranian Cities," 165. On Isfahan's topography in the early Islamic period, see Golombek, "Urban Patterns," and Gaube and Wirth, *Bazar*, esp. 31–49.

14. For patterns of urbanization in the early Islamic period and further literature, see Jayyusi et al., *City in the Islamic World*, esp. 47–139. See also Wheatley, *Places Where Men Pray Together*.

15. Abu Nuʿaym, *Dhikr akhbār Iṣbahān*, 1:14.

16. Mihryar, "Iṣfahān dar hizār sāl-i pīsh."

17. None of Isfahan's extant synagogues seems to date from the pre-1700s, but some were likely built on the sites of earlier structures. For a study, see Gharipour and Sedighpour, "Synagogues of Isfahan."

18. Tusi, *ʿAjāʾib al-makhlūqāt*, 179. Muqaddasi, *Aḥsan al-taqāsīm*, 389, reports that the city had twelve gates. On the city's gates in Safavid and Qajar periods, see Floor, "Gates of Isfahan."

19. On the four main axes of old Isfahan, see Gaube, "Iranian Cities," 167. According to a fourteenth-century source (Mustawfi, *Geographical Part*, 55), Isfahan had four quarters: Karran, Kushk, Jubara, and Dardasht.

20. Wendell, "Baghdâd." On the rivalry between Isfahan and Baghdad, see Durand-Guédy, *Iranian Elites*, 44–52.

21. Golombek, "Urban Patterns," 25.

22. Chardin, *Voyages*, 7:486–87.

23. Ibn al-Athir, *Annals*, 189.

24. Razi, *Tazkira-yi haft iqlīm*, 2:887. Razi's assertion was likely based on Mustawfi's account (*Geographical Part*, 54). However, Ibn al-Athir, who wrote in the early 1200s, reports that Isfahan's city walls were built in 1037–38 (429 H) by the Kakuyid ruler Ala al-Dawla. To resolve this anomaly, David Durand-Guédy (*Iranian Elites*, 56–57) postulates that the walls and gates were laid out under the Buyids but were constructed as fortified ramparts in the early eleventh century by Ala al-Dawla.

25. Biruni, *Book of Instruction*, 220–21; Tusi, *ʿAjāʾib al-makhlūqāt*, 67.

26. Chardin, *Voyages*, 7:484.

27. Durand-Guédy, "Location of Rule."

28. Javeri, "Excavations of Atiq Square." The existence of a church is implied by an anecdote related in an early eleventh-century history of Isfahan, *Dhikr akhbār Iṣbahān*. See Golombek, "Urban Patterns," 22.

29. On the Old Mosque, see Grabar, *Great Mosque*. For a comprehensive archeological study, see Galdieri, *Iṣfahān: Masǧid-i Ǧumʿa*. For the inscriptions, see Hunarfar, *Ganjīna*, 67–128.

30. Melvin-Koushki, "Early Modern Islamicate Empire."

31. This messianic ethos is reflected in Shah Ismaʿil's Turkish poetry. See Minorsky, "Poetry of Shāh Ismāʿīl I." Recent studies have questioned Minorsky's literal interpretations, calling for a more nuanced understanding of Shah Ismaʿil's poetry and its Sufi underpinnings. See Karamustafa, "In His Own Voice."

32. Aubin, "Chiffres," 39, 43; Durand-Guédy, "Isfahan During the Turko-Mongol Period," 280.

33. In 1524 a Portuguese traveler, while visiting Isfahan, saw "mounds of dirt with bones sticking out that were reportedly the remains of 5,000 people killed by the Safavids." Cited in Haneda and Matthee, "Isfahan, vii: Safavid Period."

34. Khvandamir, *Tārīkh-i ḥabīb al-siyar*, 4:482; Kaempfer, *Exotic Attractions*, 229–31. A similar minaret is still extant in Khuy (province of Azerbaijan), where Shah Ismaʿil had built a palace. See Szuppe, "Palais et jardins," 158.

35. On the Harun-i Vilayat shrine, see Hillenbrand, "Safavid Architecture," 762–63; Babaie, "Building on the Past," 32–35; and Emami, "Religious Architecture," 258–61.

36. Hunarfar, *Ganjīna*, 360–73.

37. See ibid., 372.

38. See Durand-Guédy, "Isfahan During the Turko-Mongol Period," 292–300. On the rise of sayyids in the post-Mongol period, see Pfeiffer, "Confessional Ambiguity," and Mancini-Lander, "Subversive Skylines."

39. Mirza Beg Junabadi (*Rawżat al-Ṣafaviyya*, 714) refers to the shrine as an *imāmzāda*.

40. Humaʾi, *Tārīkh-i Iṣfahān*, 187–88.

41. Dihkhuda, *Lughatnāma*, s.v. *ḥārūn*.

42. Chardin, *Voyages*, 7:450; Kaempfer, *Exotic Attractions*, 228.

43. On Takhtgah, see Emami, "Coffeehouses," 198–99.

44. See Mirza Shah Husayn's biographical entry in Awhadi, *Taẕkira*, 3:1908–9.

45. Khvandamir, *Tārīkh-i ḥabīb al-siyar*, 4:500; Melville, "New Light," 161.

46. Astarabadi, *Tārīkh-i sulṭānī*, 33.

47. According to Abu Nuʿaym, *Dhikr akhbār Iṣbahān*, 1:34, the Old Mosque stood on the side of a square known as the Maydan-i Sulayman. However, the exact shape and size of this maydan and its relation to the Maydan-i Harun-i Vilayat remain unclear.

48. The recent reconstruction of the Old Maydan accurately reflects its Safavid-era blueprint except for the present courtyard in front of the shrine's portal, which was a nineteenth-century addition. The recently constructed arcaded walls of the Old Maydan are based on a modern design.

49. On the history and functions of the naqqara-khana, see Lambton, "Naḳḳāra-Khāna."

50. Chardin, *Voyages*, 7:442. Per Mirza Hasan Khan Jabiri Ansari (*Tārīkh-i Iṣfahān*, 116), a mosque (Masjid-i Aqasi) that stood until 1928 on the Old Maydan's northeastern corner contained an iwan, known as the "naqqara-khana of [the Seljuq ruler] Malikshah," that was adorned with "tiles depicting the stars, moon, and sun in their zodiac houses."

51. Natanzi, *Nuqāvat*, 234. Engelbert Kaempfer (*Exotic Attractions*, 140) refers to "ruins of what was once the royal palace" around the Old Maydan.

52. See Hunarfar, *Ganjīna*, 90–94.

53. André Godard ("Iṣfahān," 26) dates the tile decoration on the inner walls of the qibla iwan of the Old Mosque to the late 1400s, when Isfahan was controlled by the Aq Quyunlu ruler Uzun Hasan (r. 1457–78). This assumption is based on an inscription (installed on the ceiling) stating that in 1475–76 (880 H) the mosque was renovated and the iwan's crumbled ceiling was reconstructed. See Hunarfar, *Ganjīna*, 95–96. The inscription's wording, though, suggests that this campaign concerned restoration (*iṣlāḥ*) and rebuilding (*tajdīd*), rather than ornamentation (*tazʿīn*), which is the undertaking highlighted

in Safavid inscriptions. The calligraphic style of the Aq Quyunlu inscription is also markedly different from the inscriptions on the lower parts of the iwan's inner walls. These inscriptions also include a specifically Shiʿi prayer (*Nād-i ʿAlī*), confirming their Safavid origin.

54. On the calligrapher, Kamal al-Din Husayn, see Hunarfar, *Ganjīna*, 91; Qumi, *Calligraphers and Painters*, 152.

55. Sheila Canby (*Golden Age*, 46; based on Savory, "Principal Offices," 80) first suggested that the "Muhammad al-Isfahani" mentioned in the inscription was likely Amir Muʿizz al-Din Muhammad Isfahani, who held the post of *ṣadr* about 1531–37. Abdi Beg Shirazi (*Takmilat al-akhbār*, 72) refers to Muhammad Isfahani as *naqīb*. The inscriptions also carry the name of a woman, Aqa Sultan, as sponsor of the renovation project. As her title suggests, she was probably a Safavid princess married to a local Isfahani notable; such marital alliances were common in the sixteenth century.

56. These mosques have almost entirely disappeared, but the remaining fragments attest to their lavish decoration. See Hunarfar, *Ganjīna*, 380–88, and Godard, "Iṣfahān," 72–80.

57. Awhadi, *Taẕkira*, 4:2191; Razi, *Taẕkira-yi haft iqlīm*, 2:887, 969.

58. Haneda, "Maydan et Bagh," 93.

59. Fazli, *Chronicle*, 1:74; Yazdi, *Tārīkh-i ʿAbbāsī*, 358, 442.

60. Quoted in Jafarian, *Sīyāsat va farhang*, 2:1403–4.

61. According to Mahmud Afushtaʾi Natanzi (*Nuqāvat*, 539), Shah Abbas observed the ceremonies held at the Maydan-i Naqsh-i Jahan in 1593 from the roof of the madrasa of Khvaja Malik Mustawfi, which was "located opposite the Naqsh-i Jahan Garden."

Chapter 2

1. Natanzi, *Nuqāvat*, 451–53. Jalal al-Din Yazdi (*Tārīkh-i ʿAbbāsī*, 125–27) notes that the journey marked Shah Abbas's fourth visit to Isfahan. Although Yazdi reports the event in the account of the following year (1002 H), a chronogram yields the year 1001 H, suggesting that Yazdi conflated the accounts of two successive visits.

2. Safavid state records were reportedly destroyed in the aftermath of the fall of Isfahan in 1722. See Asaf, *Rustam al-tavārīkh*, 210.

3. On the chronological systems of Safavid historiography, see Blake, *Time*, 109–16. As Charles Melville notes, some of the discrepancies in the sources might issue from the fact that authors refer to different stages in the building process. The very act of preparing the designs took some time, too. Poetic chronograms (suggesting a date through the *abjad* numerical values attributed to Arabic letters) appear to be more reliable sources. But these chronograms need to be used with caution, as the dates of both the design (*ṭarḥ andākhtan*) and the completion of projects were recorded. On poetic chronograms, see Losensky, "Coordinates in Space and Time."

4. My narrative expands upon the pioneering work of Robert McChesney ("Four Sources") as well as subsequent contributions by Stephen Blake (*Half the World*, 15–27) and Charles Melville ("New Light"). I propose new dates for the planning and completion of Safavid Isfahan and reexamine the social dynamics of urban plans and processes.

5. Fazli, *Chronicle*, 74; Melville, "New Light," 159.

6. Natanzi, *Nuqāvat*, 233, 239–40.

7. On the itineraries of Shah Abbas, see Melville, "From Qars."

8. Junabadi, *Rawżat al-Ṣafaviyya*, 714, translated and discussed in McChesney, "Postscript," and in Blake, *Half the World*, 19. In this passage, Junabadi's statement that Isfahan became the *dār al-mulk* (abode of dominion) does not mean that the city was designated the capital (*pāytakht*) or royal seat (*maqarr / takhtgāh-i salṭanat*) at this time, as Blake inferred. The distinction between *dār al-mulk* and these latter expressions is clearly conveyed in several period descriptions. For instance, in his note about Shah Abbas's journey to Isfahan in 1592–93, Natanzi relates that the shah set off for Isfahan (to which he refers as "dār al-mulk-i ʿIrāq") after leaving the "seat of the throne" (*takhtgāh-i salṭanat*, i.e., Qazvin). Indeed, *dār al-mulk* appears to have been

Isfahan's honorific title, bestowed on the city under the Great Seljuqs in a deliberate reference to *dār al-khilāfa* (abode of the caliphate), the official title of Baghdad, the seat of the Abbasid caliphs.

9. Natanzi, *Nuqāvat*, 376.

10. See Hunarfar, *Ganjīna*, 163. The mosque's adjacent areas (particularly the so-called Safavid Hall) likely date from the same period. See Galdieri, *Iṣfahān: Masǧid-i Ǧumʿa*, 3:72–77.

11. Yazdi, *Tārīkh-i ʿAbbāsī*, 113–14. The poem evokes a ruined status (*vīrān*, *kharāb*), and its rhyming phrase of refrain (*radīf*) is *maʿmūr* (renovated/developed), revealing that the chronogram marks the renovation of an existing edifice.

12. Blake first suggested that the accounts of Junabadi, Yazdi, and Natanzi concerned the renovation of the Maydan-i Harun-i Vilayat, not the construction of the Maydan-i Naqsh-i Jahan, as McChesney had assumed. Yet both Natanzi and Awhadi refer to renovations *and* construction of new shops and buildings, which indicates that the initial plan was not limited to the Maydan-i Harun-i Vilayat. Blake's hypothesis that the building of the Maydan-i Naqsh-i Jahan began in 1602 cannot be sustained either. This date, given by Junabadi alone, is contradicted by all other sources. Writing in 1617, Junabadi aimed to offer a synthetic narrative of the city's construction rather than to provide precise dates (see chapter 8). Unlike other chroniclers, Junabadi does not follow an annalistic structure and is sparing with dates. The simultaneous development of the two maydans proposed here is the only hypothesis that accounts for all other pieces of evidence.

13. Natanzi, *Nuqāvat*, 376; for a slightly different translation, see McChesney, "Four Sources," 106.

14. Yazdi, *Tārīkh-i ʿAbbāsī*, 113.

15. See Fazli, *Chronicle*, 1:120, and Melville, "New Light," 160.

16. Natanzi, *Nuqāvat*, 376, translated somewhat otherwise in Blake, *Half the World*, 18, and McChesney, "Four Sources," 106.

17. Roemer, "Safavid Period," 266–67.

18. Natanzi, *Nuqāvat*, 170.

19. Yazdi, *Tārīkh-i ʿAbbāsī*, 203; Natanzi, *Nuqāvat*, 538–39.

20. On the post of *naqīb*, see Bosworth and Burton-Page, "Naḳīb," and Keyvani, *Artisans*, 67–68.

21. Kashifi, *Futuvvatnāma-yi sulṭānī*, 89–90. This discussion expands on McChesney, "Four Sources," 117–18.

22. The role of the *naqīb*s in Isfahan is evident in an incident that transpired in 1548–49, during the revolt of Alqas Mirza, brother of Shah Tahmasp; when the forces of the rebellious prince reached Isfahan, city residents, led by Muhammad Amin's father and uncle (who held the post of *naqīb*), shut the city gates and resisted the assault. See Abdi Beg, *Takmilat al-akhbār*, 101, and Haneda and Matthee, "Isfahan, vii: Safavid Period."

23. Nasrabadi, *Taẕkira*, 1:137.

24. Per Natanzi (*Nuqāvat*, 233), when the Safavid ruler Muhammad Khudabanda and his retinue visited Isfahan in 1587–88 (shortly before Shah Abbas's accession), they lodged in the mansions (*manāzil*) of Husayniyya. According to Iskandar Beg Munshi (*Tārīkh-i ʿālam-ārā*, 1:359–60), during this trip "Husayniyya became the royal residence [*dawlatkhāna*]." See Blake, *Half the World*, 184–85. Cf. Babaie, *Isfahan*, 124–25.

25. Fazli, *Chronicle*, 1:30.

26. Iskandar Beg, *Tārīkh-i ʿalam-ārā*, 1:438; Natanzi, *Nuqāvat*, 374.

27. Junabadi, *Rawżat al-Ṣafaviyya*, 759; McChesney, "Four Sources," 112.

28. Natanzi, *Nuqāvat*, 577.

29. In 1590–91 plans were made for a *khīyābān* and several other edifices in Qazvin, suggesting that the city was at the time the main focus of royal patronage. See Fazli, *Chronicle*, 1:90, and Melville, "New Light," 159. For Herat, see Natanzi, *Nuqāvat*, 600.

30. Iskandar Beg, *Tārīkh-i ʿālam-ārā*, 1:544. An anonymous chronology of Safavid history (National Library of Iran, MS 20197), datable to the early seventeenth century, also gives the date 1006 H (1597–98) for the designation of Isfahan as capital (*maqarr-i salṭanat*). See Jafarian, *Yāddāshthā-yi tārīkhī*, 30.

31. Junabadi, *Rawżat al-Ṣafaviyya*, 762; McChesney, "Four Sources," 114.

32. Fazli, *Chronicle*, 1:146, with modifications based on Melville, "New Light," 162–63.

33. Cf. Melville, "New Light," 162, where the sentence "bāz-ṭarrāḥīhā bi khāṭir-i ashraf rasīd" is mistranslated as "more planners then came to the shah's attention." The term in the manuscript is clearly "design" (ṭarrāḥī), not "designer/planner" (ṭarrāḥ).

34. Galdieri, "Two Building Phases."

35. McChesney, "Four Sources," 114–15.

36. Ibid., 114. It appears that in the first stage only the arcades on the north side of the maydan were double-storied. In its initial configuration the Maydan-i Naqsh-i Jahan thus resembled the Maydan-i Ganjali Khan in Kerman, built during the tenure of the eponymous Ganjali Khan as governor (1596–1622).

37. Junabadi, *Rawżat al-Ṣafaviyya*, 760, attests to the purpose of the maydan's upper-floor chambers (manāzil).

38. Yazdi, *Tārīkh-i ʿAbbāsī*, 236; Junabadi, *Rawżat al-Ṣafaviyya*, 760.

39. Yazdi, *Tārīkh-i ʿAbbāsī*, 236; Kaempfer, *Exotic Attractions*, 142.

40. Natanzi, *Nuqāvat*, 577; McChesney, "Four Sources," 107. Natanzi's description implies that these paintings were likely derived from the geographical-cosmological books of Ajāʾib (Marvels), particularly the illustrated compendium penned by Zakariyya al-Qazvini (d. 1283).

41. Natanzi, *Nuqāvat*, 577–78.

42. Alemi, "Urban Spaces," 104.

43. Fazli, *Chronicle*, 2:584.

44. On the Ali Qapu's construction phases, see Galdieri, *Eṣfahān*, esp. 9–15.

45. The date 1016 H (1607–8) is given in a poem on the "date of the construction of the Ali Qapu" by Shafaʾi Isfahani (*Divān*, 170). The later addition of the fifth story is attested by the fact that it is structurally unrelated to the floors below. See Galdieri, *Eṣfahān*, 19–23.

46. Iskandar Beg, *Tārīkh-i ʿalam-ārā*, 2:1111.

47. On the functions of the Ali Qapu and other palace gates, see Babaie, *Isfahan*, 113–49.

48. Fazli, *Chronicle*, 1:146, 2:617–18; Melville, "New Light," 170.

49. Shaykh Luftallah, "Risālat al-Iʿtikāfiyya"; Abisaab, *Converting Persia*, 82–87.

50. Babaie, "Sacred Sites of Kingship," 187.

51. Shaykh Luftallah, "Risālat al-Iʿtikāfiyya," 336.

52. For more on the Shaykh Lutfallah Mosque and the sacred axis of the maydan, see Emami, "Religious Architecture," and Emami, "Inviolable Thresholds," 169–72.

53. See Abisaab, *Converting Persia*.

54. A late seventeenth-century source (Astarabadi, *Tārīkh-i sulṭānī*, 134) attributes the foundation of the Tawhidkhana to Shah Abbas I. Per Jean Chardin (*Voyages*, 7:370), the Sufi disciples who served as guardians of the Ali Qapu were stationed at the qūrchīkhāna, on the building's lower floor.

55. Junabadi, *Rawżat al-Ṣafaviyya*, 759; McChesney, "Four Sources," 112.

56. See Melville, "New Light," 160. Although Fazli refers to the order for the demolition of the old qaysariyya in the context of the construction of the new one, it likely occurred at the time of the redesigning of the new maydan.

57. Yazdi, *Tārīkh-i ʿAbbāsī*, 237.

58. Ibid., 151. For the poem on the bridge, see Hunarfar, "Tārīkh-i banā-yi pul-i Allāhverdī Khān." Composed by Ali Naqi Kamarʾi (d. 1621), the five-verse poem names a certain Aqa Husayn as the architect; he may have been the father of the architect Muhammad Riza whose signature appears at the Shaykh Lutfallah Mosque, as Hunarfar notes. However, Fazli (*Chronicle*, 1:466) reports the construction of the bridge in the annal of 1016 H (1607–8), noting that it was finished in five years. The chronogram appears to be more reliable. Allahverdi Khan was appointed governor of Iran's southern provinces in 1595 and might have been entrusted with the task of constructing the bridge around the same time.

59. Yazdi, *Tārīkh-i ʿAbbāsī*, 163.

60. Ibid., 236–37. Two later Safavid sources also record the date 1011 H (1602–3) for the development (ābādān sākhtan) of the maydan and its markets. See Jafarian, *Yāddāshthā-yi tārīkhī*, 31, and Dihgan, *Tārīkh-i Ṣafavīyān*, 59.

61. The want of a foundation inscription makes it difficult to pin down the exact date of the qaysariyya's construction. Yazdi's narrative suggests that the main components of the maydan—bathhouses, coffeehouses, and caravanserais—were completed by late 1602, when the complex was inaugurated. For the endowment deed (vaqfnāma) of 1604–5 (1013 H), see Shamlu, *Qiṣaṣ al-khāqānī*, 1:185–91, and McChesney, "Waqf and Public Policy," 171. Yazdi refers to the endowment following his account of the maydan's inauguration.

62. Per Godard ("Iṣfahān," 96), a tile fragment kept in the mosque's basement (shabistān) bears the date 1011 H (1602–3). This date does not mark the beginning of the mosque's construction; it indicates the inscription's date and, hence, the partial completion of the facade's tile decoration. The still-extant foundation inscription, signed by calligrapher Ali Riza Abbasi, is dated 1012 H (1603–4). In 1596–97 Shah Abbas dismissed the painter Sadiqi Beg and appointed Ali Riza Abbasi as head of the royal atelier/library (kitābkhāna); see Welch, *Artists for the Shah*, 69. Ali Riza's role in designing architectural inscriptions was a likely factor that prompted this appointment.

63. Yazdi, *Tārīkh-i ʿAbbāsī*, 237.

64. Fazli, *Chronicle*, 2:617; Melville, "New Light," 170.

65. Chardin, *Voyages*, 7:352, 8:2.

66. Shaykh Luftallah, "Risālat al-Iʿtikāfiyya," 334.

67. Golombek, "Anatomy of a Mosque."

68. Necipoğlu, *Age of Sinan*, 34.

69. McChesney, "Waqf and Public Policy," esp. 178–81.

70. For this thesis, see Babaie, *Isfahan*, chap. 3, where the construction of Safavid Isfahan is interpreted as embodying "a rigorous conceptualization of a capital city and its constituent parts as a perfect mirror of the ideal shariʿa-based, Perso-Shiʿi imperial order" (71). Babaie criticizes the view that describes the development of Isfahan "as a series of random architectural-urban events," but does

not offer a sustained reading of texts or spaces in support of an alternative hypothesis and dismisses the idea that local notables had any considerable agency or impact on urban development.

71. See Amanat, "Nuqtawi Movement," and Babayan, *Mystics*, 57–117.

72. Melville, "Shah 'Abbas and the Pilgrimage to Mashhad"; Mawer, "Shah 'Abbās and the Pilgrimage to Mashhad."

73. For the convent of Haydari dervishes, see chapter 5.

74. Matthee, *Politics of Trade*.

75. See Braudel, *Mediterranean*, 1:344–52.

76. Kafescioğlu, *Constantinopolis/Istanbul*, esp. 130–42.

77. Petruccioli, *Fatehpur Sikri*; also noted in Rizvi, "Architecture and Representations of Kingship," 383.

78. Gangler, Gaube, and Petruccioli, *Bukhara*; McChesney, "Economic and Social Aspects."

79. Nauraspur was a circular city laid out in 1599 by Sultan Ibrahim II (r. 1580–1627) of the Adil Shah dynasty. See Hutton, *Art of the Court*, 107–10, and Sardar, "Circular Cities." Hyderabad, the capital of the Qutb Shahi sultanate (ca. 1496–1687), was founded in 1591 on a monumental cross-axial plan. See Wagoner, "Charminar." Planned almost simultaneously with Isfahan, Hyderabad and Nauraspur were both laid out on the environs of preexisting cities (Golconda and Bijapur, respectively). As several recent studies have noted, the flow of influence between early modern South Asia and Iran was reciprocal and multidirectional.

80. The nature and scope of sixteenth-century mercantile interactions between Portuguese Hormuz and the Iranian mainland remain hazy. The sources give little indication of contacts between the Safavid court in Tabriz and Qazvin and the Portuguese settlers in Hormuz and in the Indian Ocean in general. Yet this does not mean that there were no commercial interactions with cities such as Isfahan. On this topic, see Matthee and Flores, *Portugal*. On Portuguese-controlled Hormuz, see Floor, *Persian Gulf*, 7–138.

81. Floor, *Persian Gulf*, 2.

Chapter 3

1. Kinneir, *Geographical Memoir*, 112–13.

2. Chardin, *Voyages*, 7:287; Bembo, *Travels*, 321.

3. The primary sources for the visual reconstruction of the Safavid palace quarter are Kaempfer's drawings (discussed in Alemi, "Royal Gardens"), the bird's-eye view published in Kaempfer's Latin-language book (*Amoenitatum exoticarum*), and his descriptions (*Exotic Attractions*, 147–57). Major studies include Galdieri, "Relecture"; Babaie, *Isfahan*, 113–56; Necipoğlu, "Framing the Gaze"; Blake, *Half the World*, 55–71; and Brignoli, "Les palais royaux."

4. According to Yazdi (*Tārīkh-i 'Abbāsī*, 335), the floor area that the shah allocated to different components of the palace complex at Farahabad were as follows: the harem and its garden, two *jarībs*; the *khalvat-khāna* and its garden, three *jarībs*; workshops or *buyūtāt*, two *jarībs*; and so on.

5. Fazli, *Chronicle*, 1:472.

6. For a description of the harem, see Kaempfer, *Exotic Attractions*, 163–68.

7. Tahvildar Isfahani, *Jughrāfiyā-yi Iṣfahān*, 24.

8. Alemi, "Royal Gardens," 74, 87, 94; Qazvini, *Tārīkh-i jahān-ārā*, 645–49.

9. See Babashahi, "Barrasī-yi manābi'-i tārīkhī."

10. Minorsky, *Tadhkirat al-Muluk*; Ansari, *Dastur al-Moluk*.

11. Necipoğlu, "Framing the Gaze."

12. Kaempfer, *Exotic Attractions*, 154.

13. For further discussion, see Emami, "Royal Assemblies."

14. Kaempfer, *Exotic Attractions*, 154.

15. For the location of the Bagh-i Badamistan, see Jabiri Ansari, *Tārīkh-i Iṣfahān*, and Tahvildar Isfahani, *Jughrāfiyā-yi Iṣfahān*, 25.

16. Jabiri Ansari, *Tārīkh-i Iṣfahān*, 153.

17. Iskandar Beg, *Tārīkh-i 'ālam-ārā*, 2:1111.

18. The accessible image of Shah Abbas is discussed in Necipoğlu, "Framing the Gaze."

19. For Kaempfer's drawings and a reconstruction, see Alemi, "Royal Gardens," 75, 89–91, and Alemi, "Giardino persiano," 47–49.

20. Della Valle, *Viaggi*, 1:457; trans., 25.

21. See chapter 5 for a detailed description of the Chaharbagh and its gardens. The names of the gardens are recorded by Kaempfer in British Library, MS Sloane 5232, fol. 42r; 2920, fols. 70v, 71r. See Alemi, "Safavid Royal Gardens," 10, 12. Translations of Safavid official titles are based on Floor, *Safavid Government Institutions*.

22. Wilber, *Persian Gardens*, fig. 14.

23. On the etymology of the term *khīyābān* and the earliest textual references, see Matini, "Khīyābān," and Dabir-Siyaqi, "Khīyābān." For the khiyabans of Herat, see Allen, *Timurid Herat*, esp. 32–33.

24. Allen, *Timurid Herat*, 32.

25. I borrow the phrase "funerary promenade" from Marefat, "Beyond the Architecture of Death."

26. Abdi Beg, *Jannāt-i 'Adn*, 126, 214. On Safavid Qazvin, see Szuppe, "Palais et jardins"; Wirth, "Qazvin, safavidische Stadtplanung"; and Alemi, "Garden City of Shah Tahmasb." It is commonly assumed that the dawlat-khana, or royal residence, at Qazvin was the same as or part of the Sa'adatabad Garden. However, Abdi Beg's poems clearly indicate that these two were discrete entities linked by a khiyaban.

27. Abdi Beg, *Jannāt-i 'Adn*, 38.

28. Ibid., 75; noted in Alemi, "Garden City of Shah Tahmasb," 99.

29. For a general introduction, see Ruggles, *Islamic Gardens*, 39–49.

30. Chardin, *Voyages*, 8:29; Kaempfer, *Exotic Attractions*, 142.

31. Alemi, "Chahar Bagh."

32. See chapter 5 for a fuller discussion.

33. The Chaharbagh-i Qushkhana is also discussed in Emrani, "Role of Gardens," 134–35. Known as the Masjid-i Baba Sukhta or Masjid-i Musalla, the mosque is datable to the 1300s on stylistic grounds. Only the mosque's minaret stands today. See Hunarfar, *Ganjīna*, 291–95.

34. Tafrishi, *Tārīkh-i Shāh Ṣafī*, 31–32 and 88.

35. Iskandar Beg, *Tārīkh-i 'ālam-ārā*, 2:854.

36. Kleiss, "Die safavidischen Schlösser."

37. Iskandar Beg, *Tārīkh-i ʿalam-ārā*, 2:1111; Fazli, *Chronicle*, 1:465, 476; Kleiss, "Safavidische und qadjarische Brücken," 318–20.

38. Iskandar Beg, *Tārīkh-i ʿalam-ārā*, 2:1111; Fazli, *Chronicle*, 1:472.

39. De Goeje, *Ibn Rusta*, 155.

40. Thackston, *Naser-e Khosraw's Book of Travels*, 125.

41. Shafaghi, *Jughrāfiyā-yi Iṣfahān*, 173–80.

42. See Lambton, "Regulation of the Waters."

43. Ansari, *Dastur al-Moluk*, 89–90.

44. For more on the management of Isfahan's water system, see Mahmoudian and Qayyoomi, "Norm of *Mādī*."

45. Yazdi, *Tārīkh-i ʿAbbāsī*, 162–63. Kaempfer, *Exotic Attractions*, 158, records the name of the canal that irrigated the Hizar Jarib as "Tjuhusja" (*jūy-i shāh*).

46. Muhammad Mahdi, *Niṣf-i jahān*, 100.

47. See Ahari, *Maktab-i Iṣfahān* (1380), 261–90.

48. Habibi, *Az shār tā shahr*, 93–107. For a comprehensive analysis of Isfahan's urban design along these lines, see Ahari, *Maktab-i Iṣfahān* (1380). The following discussion of Isfahan's urban design was inspired by these studies.

49. Fazli, *Chronicle*, 1:244; Melville, "New Light," 164–65.

50. Guattari, *Three Ecologies*.

Chapter 4

1. The phrase is from Benjamin, "On Some Motifs," 168.

2. Qazvini, "Sāqī-nāma," 94. The poem survives in a single manuscript (University of Tehran, MS 4344), whose initial folios are missing. The references in this book are to the page numbers on the manuscript. For the identification of the work as Qazvini's "Sāqī-nāma," see Gulchin Maʿani, *Shahrāshūb dar shiʿr-i Fārsī*, 207–25. The text has recently been published in Jafarian, *Maṣnavī-yi Shahrāshūb*.

3. Qazvini, "Sāqī-nāma," 99–101.

4. De Bruyn, *Travels*, 1:195–96.

5. In the burgeoning interdisciplinary field of sensory studies, the soundscapes of medieval and early modern European cities have received extensive scholarly attention. See, inter alia, Atkinson, *Noisy Renaissance*, and Garrioch, "Sounds of the City."

6. Qazvini, "Sāqī-nāma," 71.

7. For a detailed description of the maydan's markets, see Chardin, *Voyages*, 7:360–68.

8. Alemi, "Urban Spaces," 101.

9. Ibid., 107n12.

10. Ibid., 100.

11. Qazvini, "Sāqī-nāma," 70–71.

12. The qaysariyya portal is discussed in Ritter, "Das königliche Portal."

13. M. S. Qazvini, *Navādir*, 389; Jafarian, *Ṣafaviyya dar ʿarṣa-yi dīn*, 2:792.

14. For a discussion of this and other similar inscriptions, see Ritter, "Monumental Epigraphy."

15. Chardin, *Voyages*, 7:366.

16. For further discussion, see Emami, "Coffeehouses," 190–98. The location of these coffeehouses is confirmed particularly by Della Valle's sketch plan of the maydan. See Alemi, "I 'teatri,'" 21, 25n14.

17. Olearius, *Voyages*, 298.

18. Della Valle, *Viaggi*, 2:22–28.

19. Kotov, "Journey to the Kingdom," 19.

20. Della Valle refers to the complex as the Lala Beg caravanserai, named after Muhibb Ali Beg, the tutor (*lala*) of the *ghulām*s and the supervisor (*sarkār*) of the royal building projects, whose career is discussed in Babaie et al., *Slaves of the Shah*, 89–91. Della Valle's sketch plan (reproduced in Alemi, "I 'teatri,'" 21) reveals, however, that the Lala Beg caravanserai mentioned by Della Valle designated what has become known as Sara-yi Shah, which was likely sponsored by Muhibb Ali Beg.

21. Della Valle, *Viaggi*, 2:22–28.

22. See Eiwziwk'chean, *Nkaragrut'iwn*, 25–26 (trans. in *Vaṣf-i banāhā-yi mashhūr-i Iṣfahān*, 34–36).

23. Kotov, "Journey to the Kingdom," 17–18.

24. Olearius, *Voyages*, 222–23.

25. Tavernier, *Six voyages*, 1.402.

26. Chardin, *Voyages*, 7:357. The French traveler Jean de Thévenot (*Travels*, 2:79) also notes that the bell "was taken out of a Monastery of Nuns" at Hormuz. However, he records the inscription on the bell as "Ave Maria gratia plena," which is different from Chardin's; Ritter, "Das königliche Portal," 368n47.

27. Gemelli Careri, "Voyage Round the World," 132.

28. See Ritter, "Das königliche Portal," 367–73.

29. Ritter, "Zum Siegesmonument." The stylistic features of the qaysariyya mural paintings, including the scene of Uzbek-Safavid battle, suggest that they most likely date from the mid-1600s rather than the time of the portal's construction. They were probably added sometime after 1642, for a label in the central painting refers to Shah Abbas I as "Shah Abbas the Great." Use of the epithet "great" (*buzurg*) for Shah Abbas I became common only after the 1642 accession of his namesake Shah Abbas II. Three arched windows in the rear wall of the portal were walled up to create more surface for wall painting, which further suggests that the paintings were later additions.

30. Ross, *Sir Anthony Sherley*, 158–59; Floor, "Clocks."

31. Kurz, *European Clocks*, 62.

32. Fazli, *Chronicle*, 2:888; Kurz, *European Clocks*, 63.

33. Sayılı, *Observatory in Islam*, 289–305.

34. Cited in Dohrn–van Rossum, *History of the Hour*, 161–62.

35. This is suggested particularly by De Bruyn's drawing (fig. 29), the most precise of all the available renditions.

36. On the iconography of Sagittarius, see Kuehn, *Dragon*, 133–44.

37. Lambton, "Regulation of the Waters," 664.

38. Augustinian missionaries were given the land by Shah Abbas I in 1602. See Flannery, *Mission*, 79.

39. See Carswell, *New Julfa*.

40. For a comprehensive history of mechanical clocks in Europe, see Dohrn–van Rossum, *History of the Hour*.

41. Isfahani, *Sih risāla*, 3–75.

42. Since no biographical information on Muhammad Hafiz Isfahani has come to light, his exact dates remain unclear. Internal evidence suggests that the volume of three treatises

(titled *Natījat al-dawla*) was written in the 1520s or 1530s. See Floor, "Clocks"; Nurbakhsh, "Sāʿat-i mikānīkī dar Irān"; Mohebbi, "Hafez Esfahani"; and Kheirandish, "From Maragha to Samarqand," 166–69.

43. Isfahani, *Sih risāla*, 11–19.

44. Yazdi (*Tārīkh-i ʿAbbāsī*, 442) reports that Shah Abbas once sat on the roof of the qaysariyya.

45. Melville, "Mechanical Clock," 138.

46. Fazli, *Chronicle*, 2:579–80; translated in Melville, "Mechanical Clock," 136. In a line crossed out in the manuscript of Fazli's chronicle, he notes that "the clock revolved for sixty minutes and indicated all the minutes."

47. Fazli, *Chronicle*, 2:579–80; Melville, "Mechanical Clock," 136.

48. Membré, *Mission*, 33.

49. Jazari, *Book of Knowledge*.

50. Fazli alludes to "falling weights" suspended from ropes in the back of the pavilion.

51. Dohrn-van Rossum, *History of the Hour*, 133.

52. Concina, *History of Venetian Architecture*, 148–49; Muraro, "Moors of the Clock Tower."

53. A gilt copper disk, described as an astronomical dial and kept at the V&A Museum, London (accession no. 1577-1904), may have belonged to one of the maydan's clocks. The dial bears an image of the Zodiac Man, modeled on a Venetian print. See https://collections.vam.ac.uk/item /O87285/dial-unknown. I thank Moya Carey for this observation.

54. Tavernier, *Six voyages*, 154.

55. Chardin, *Voyages*, 7:357.

56. For examples of the guldasta in Safavid and Qajar mosques of Isfahan, see Haji-Qassemi, *Ganjname*, 2. For the Shiʿi tradition regarding the performance of the call to prayer from the rooftop (rather than from a minaret), see Bloom, *Minaret*, 99–100. A version of this tradition (attributed to Imam Ali) should have been known to the clerics who were involved in the construction of mosques in Isfahan.

57. Chardin, *Voyages*, 7:355.

58. Shamlu, *Qiṣaṣ al-khāqānī*, 1:280; Babaie, *Isfahan*, 182.

59. Qazvini, "Sāqī-nāma," 99–101.

60. Chardin, *Voyages*, 7:355–56.

61. Kaempfer, *Exotic Attractions*, 141.

62. Membré, *Mission*, 33.

63. The clock pavilion was likely dismantled about 1800. In 1809 the British diplomat and author James Morier "saw no traces of the pavilion of the clock, which, in the time of Chardin, so much amused the people by the mechanism of its puppets." See Morier, *Journey Through Persia*, 174. The pavilion's removal probably occurred in the context of urban renovations begun in the 1790s by the Qajar governor of Isfahan. See Walcher, "Faces of the Seven Spheres," part 2, 117–19. Morier did not see any trace of the qaysariyya clock either.

64. Saeednia, "Rāz-i sang-i sāʿat."

65. Kaempfer, *Exotic Attractions*, 108.

Chapter 5

1. Della Valle, *Viaggi*, 2:30.

2. Yazdi, *Tārīkh-i ʿAbbāsī*, 361. The phrase "zanān-i ahl-i ḥirfa" can also be translated as the "wives of the vendors."

3. Major previous studies and reconstructions of the Chaharbagh include Wilber, *Persian Gardens*, 39–53; Alemi, "Royal Gardens"; and Ahari, "Khīyābān-i Chahārbāgh."

4. See Necipoğlu, *Topkapı Scroll*.

5. Ruggles, "Humayun's Tomb," 175.

6. Tavernier, *Six voyages*, 155.

7. For an account of a 1619 reception on the Ali Qapu's rooftop, see Silva y Figueroa, *L'ambassade*, 328–29.

8. Chardin, *Voyages*, 8:25.

9. Ibid.

10. Tavernier, *Six voyages*, 155.

11. One of the gardens laid out by Timur in Samarqand contained a pavilion known as Jahan-nama. See Golombek, "Gardens of Timur," 140. In Edirne, the Ottoman sultan Mehmed II built a tower of the same name (Cihannüma in Turkish) in 1450–51. All were high structures offering panoramic views, as was the Jahan-nama of Safavid Isfahan.

12. Abdi Beg, *Jannāt-i ʿAdn*, 99–101.

13. Ibid., 100. This talar is noted in Qumi, *Khulāṣat al-tavārīkh*, 676, 692. Shah Abbas also had two facing edifices named Jahan-nama built on the sides of the Maydan-i Saʿadatabad, another

major square of Qazvin. See Iskandar Beg, *Tārīkh-i ʿālam-ārā*, 1:500, and Ross, *Sir Anthony Sherley*, 155.

14. Muhammad Mahdi, *Niṣf-i jahān*, 41.

15. Della Valle, *Viaggi*, 1:450.

16. Chardin, *Voyages*, 8:23–24.

17. See Galdieri, *Eṣfahān*; also noted in Babaie, *Isfahan*, 79.

18. Iskandar Beg, *Tārīkh-i ʿālam-ārā*, 1:545. For Riza Abbasi's work, see Canby, *Rebellious Reformer*.

19. For a detailed discussion of these tile panels, see Emami, "All the City's Courtesans."

20. Babaie, "Visual Vestiges."

21. Fryer, *New Account*, 286.

22. Another well-known example is the still-extant mural painting at the entrance portal of the qaysariyya market, discussed in Babaie, "Frontiers of Visual Taboo."

23. Qazvini, "Sāqī-nāma," 59–67. The subsection is entitled "Description of the Fall, Chaharbagh, Hizar Jarib, and Suffa Mountain."

24. Ibid., 62.

25. Roxburgh, *Prefacing the Image*, 110–11.

26. Qazvini, "Sāqī-nāma," 63.

27. The Chaharbagh's *ṭāq-i sabz* is noted in Kaempfer, *Exotic Attractions*, 143, 227.

28. Silva y Figueroa, *L'ambassade*, 231. In 1840 Coste also observed that only the axial walkway was paved with durable stone and that the unpaved lateral paths were used by horse riders. See Coste, *Monuments modernes*, 29.

29. Alemi, "Royal Gardens," 76.

30. Chardin, *Voyages*, 8:22.

31. Qazvini, "Sāqī-nāma," 62.

32. Fryer, *New Account*, 286.

33. Della Valle, *Viaggi*, 1:455; trans., 24.

34. The name of the garden is recorded as *musamman* (sweet smelling) in a Persian-language note that was apparently written by a native and was inserted into one of Kaempfer's notebooks (British Library, MS Sloane 2920, fol. 70v). Chardin, *Voyages*, 8:26, mistranslates the name as Octagonal Garden (*jardin octogone*); although the two forms of the term *musamman* (one with the letter *sīn*, the other with *thā*)

are pronounced differently in Arabic, the Persian pronunciation is the same.

35. Alemi, "Royal Gardens," 74.

36. The definition of *khargāh* is derived from a 1651–52 dictionary. See Burhan, *Burhān-i qāṭiʿ*, s.v. *khargāh*.

37. Tahvildar Isfahani, *Jughrāfiyā-yi Iṣfahān*, 31.

38. Silva y Figueroa, *L'ambassade*, 232.

39. Yazdi, *Tārīkh-i ʿAbbāsī*, 237–38; translation, with modifications, from McChesney, "Four Sources," 109, where the couplet is omitted. Yazdi describes the *chahār ṣuffa* in the context of his account of the construction of the Chaharbagh, and the Tent Garden was indeed located next to the harem.

40. This reconstruction of the building's original function is supported by its peculiar design; it does not feature a central double-height hall, and the lower and upper floors are not spatially linked.

41. Tavernier, *Six voyages*, 65.

42. According to Chardin (*Voyages*, 7:25–26), the pool was 120 feet in circumference. But as the drawings by Kaempfer and Coste indicate, Chardin had mixed up the order of the pools in his description. The platform at the pool's center is partially rendered in Kaempfer's plan (fig. 52).

43. Jabiri Ansari, *Tārīkh-i Iṣfahān*, 163.

44. Asaf, *Rustam al-tavārīkh*, 101.

45. Kaempfer, *Exotic Attractions*, 156.

46. On the architecture and tile decoration of the Hasht Bihisht, see Ferrante, "Pavillon des Hašt Bihišt," and Luschey-Schmeisser, *Pictorial Tile Cycle*.

47. Chardin, *Voyages*, 8:26.

48. Known as the Madar-i Shah Madrasa or Sultani Madrasa, the complex sponsored by Shah Sultan Husayn consisted of a madrasa-cum-mosque, a caravanserai, and a bazaar. See Hunarfar, *Ganjīna*, 685–722, and Siroux, *Anciennes voies*, 284–89.

49. For a detailed reconstruction and further discussion, see Emami, "Coffeehouses," 181–89.

50. Awhadi, *Taẕkira*, 3:2017.

51. Ibid. As Rudi Matthee has shown, public consumption of wine was generally allowed by the Safavids. See Matthee, *Pursuit of Pleasure*, 37–96.

52. Nasrabadi, *Taẕkira*, 1:213–14.

53. Kaempfer, *Exotic Attractions*, 142–43.

54. De Bruyn, *Travels*, 1:197–98.

55. Chardin, *Voyages*, 8:26–27.

56. For an overview, see Karamustafa, "Antinomian Sufis." Major studies include Karamustafa, *God's Unruly Friends*, and Shafiʿi Kadkani, *Qalandariyya*.

57. See Algar and Burton-Page, "Niʿmat-Allāhiyya," and Quinn, "Rewriting Nimatallahi History."

58. Abdi Beg, *Jannāt-i ʿAdn*, 54–55, 80.

59. Constructing lodges to patronize Sufi orders and wandering dervishes was a hallmark of princely patronage across the medieval Islamic lands. By building Sufi convents on Isfahan's main promenade, Shah Abbas thus partook in an established tradition. Yet seen in the broader context of the centralizing policies of the reign of Shah Abbas, these convents also represent an attempt at subduing and co-opting Sufi orders. Similar strategies were adopted by the Ottomans with regard to dervish groups active in eastern Anatolia. See Yürekli, *Architecture and Hagiography*.

60. On the Haydari and Niʿmati factional division, see Mirjafari and Perry, "Ḥaydarī-Niʿmatī Conflicts"; Perry, "Toward a Theory"; and Calmard, "Shiʿi Rituals."

61. Yazdi, *Tārīkh-i ʿAbbāsī*, 131.

62. Ibid., 237.

63. For an overview, see Clayer, "Tekke." See also Shafiʿi Kadkani, *Qalandariyya*, 278. The *takiyya* as the physical setting for institutionalized dervish groups flourished particularly in Ottoman lands.

64. Yazdi, *Tārīkh-i ʿAbbāsī*, 237.

65. The caption to Papazian's photograph reads *qaṣr-i shīr-khāna* ("the lion-house palace"). Other sources suggest the garden and pavilion were known by this name in the Qajar period. The 1851 map of Isfahan (prepared under the supervision of the Russian colonel Chirikov) labels the pool in the same area of the Chaharbagh as *ḥawż-i shīr-khāna* ("the lion-house pool"). Muhammad Mahdi (*Niṣf-i jahān*, 56) also mentions *bāgh-i shīr-khāna* as

one of the gardens along the Chaharbagh. In 1884–85, Zill al-Sultan had the pavilion transformed into a military barracks named Fathabad. Rajaei, *Tārīkh-i ijtimāʿī-yi Iṣfahān*, 93. For a photograph of the building after its conversion into a military barracks, see "Album of Zill al-Sultan," Majlis Library, MS 11772. A comparison of Papazian's photograph with later photographic documents reveals its exact location.

66. Kotov, "Journey to the Kingdom," 24–25.

67. Tavernier, *Six voyages*, 155.

68. De Bruyn, *Travels*, 1:278.

69. Kotov, "Journey to the Kingdom," 24–25.

70. Nasrabadi, *Taẕkira*, 402. Awhadi (*Taẕkira*, 3:1755) also alludes to Baba Sultan's knowledge and authority in Sufi practices (*ṣāḥib-i shad, yad, va bayʿat*).

71. Nasrabadi, *Taẕkira*, 402.

72. Shafiʿi Kadkani, *Qalandariyya*, 284.

73. Kotov, "Journey to the Kingdom," 25.

74. A recent study has also argued for a broader urban presence of Qalandars in Safavid urban society. See Ridgeon, "Short Back and Sides."

75. Chardin, *Voyages*, 8:26: "des Mûriers" and "Jardin des Vignes." According to Alemi ("Safavid Royal Gardens," 11n44), these correspond to the *tūtistān* (Garden of Mulberries) and the *tākistān* (Vineyard) on Kaempfer's plan of the Chaharbagh (fig. 71). Chardin's description, however, suggests that these two gardens were located north of the Sufi gardens, i.e., on the site of the coffeehouses.

76. See, for instance, Mustawfi, *Geographical Part*, 55–56.

77. Chardin, *Voyages*, 8:28; Fryer, *New Account*, 287; Kaempfer, *Exotic Attractions*, 109; Bembo, *Travels*, 346–47.

78. Qazvini, *Tārīkh-i jahān-ārā*, 654–56; Danishpazhuh, "Isfahan va Ṭāvūskhāna-yi ān," 199.

79. Ansari, *Dastur al-Moluk*, 196–99.

80. Kaempfer, *Exotic Attractions*, 177.

81. Farhad, "Artist's Impression."

82. Ibid., 117.

83. For an architectural study of the bridge, see Ferrante, "Quelques précisions graphiques."

84. Thévenot, *Travels*, 2:81.

85. Ibid., 82.

86. Junabadi, *Rawżat al-Ṣafaviyya*, 761; translation, with modifications, from McChesney, "Four Sources," 114.

87. Judging from later accounts, these lower-level chambers were decorated with figural murals. See Ouseley, *Travels*, 3:48–49.

88. Qazvini, "Sāqī-nāma," 63–64.

89. Nijat Isfahani, "Vaṣf-i Iṣfahān," 374.

90. Junabadi, *Rawżat al-Ṣafaviyya*, 761.

91. The pavilion of the Zirishk Garden was preserved, in part, because in 1865 it became the station of the Indo-European telegraph line. In 1874 a German expedition for the astronomical observation of Venus resided at the pavilion. See Walcher, "Faces of the Seven Spheres," part 2, 124.

92. It is also likely that these pavilions were meant to function as principal gateways to the neighborhoods of New Julfa and Gabrabad, which lay on either side of the south Chaharbagh. See chapter 6.

93. Coste's drawing is confirmed by De Bruyn's description and also by the observation of the English traveler Robert Binning (*Journal*, 2:112), who refers to "seven pairs of handsome imārets," "at intervals," "all the way up" the "upper division" of the Chaharbagh, a mile-long stretch that has a "fine palace [standing] at each end."

94. This phrase is used in a poem inscribed on a Timurid copper vessel. See Komaroff, "'Thousand Designs,'" 27.

95. A close look at the panoramic photograph (fig. 75) reveals that Höltzer's photograph depicts the third pavilion from the north on the east side.

96. Junabadi, *Rawżat al-Ṣafaviyya*, 760.

97. Herbert, *Some Yeares Travels*, 159.

98. Beazley, "Pigeon Towers."

99. Herbert, *Some Yeares Travels*, 159.

100. Kotov, "Journey to the Kingdom," 21–25.

101. Vala Qazvini Isfahani, *Īrān dar zamān-i Shāh Ṣafī*, 246.

102. Ibid.

103. Qazvini, "Sāqī-nāma," 65.

104. Losensky, *Welcoming Fighānī*, 149.

105. See Roxburgh, *Prefacing the Image*.

106. Soucek, "Calligraphy in the Safavid Period."

107. Fryer, *New Account*, 287, 290.

108. For more on the practice of *quruq*, see Matthee, "Safe Space."

109. See Ghereghlou, "Zaynab Begum."

Chapter 6

1. Kocks, *Esfahan Master Plan*, 23.

2. Sheikh Bahai is the modern name of the Avenue of the Royal Canal (*khīyābān-i jūy-i shāh*), the principal artery of Abbasabad (see fig. 82).

3. For the Russian map, see Mihryar et al., *Asnād-i taṣvīrī*, 169–77.

4. On these urban transformations, see Rajaei, *Taḥavvulāt-i ʿumrān*.

5. Kostof, *City Shaped*, 9.

6. Della Valle, *Viaggi*, 1:463.

7. Ibid., 453–54. In his diary, Della Valle drew a schematic sketch to illustrate this four-part configuration of the city. See Alemi, "I 'teatri,'" 20.

8. Silva y Figueroa, *L'ambassade*, 195.

9. Fazli, *Chronicle*, 1:372–73; translation, with modifications, from Melville, "New Light," 167, where the phrase *mutafarriqa-yi Tabrīzī* (scattered Tabrizi people) is mistranslated as the name of a person.

10. Ibid.

11. Iskandar Beg, *Tārīkh-i ʿālam-ārā*, 1:545. Iskandar Beg mentions this in his account of the construction of Isfahan (written before 1615), noting that the city of Abbasabad was "laid out and completed." Writing in 1617, Junabadi also alludes to the planning and building of the new quarters. Yazdi (*Tārīkh-i ʿAbbāsī*, 413), however, reports the planning of Abbasabad in his annal of the year 1611–12 (1020 H).

12. The four-quartered scheme was deployed in Herat. See Gaube, *Iranian Cities*, 31–63.

13. Della Valle, *Viaggi*, 1:453–54.

14. Yazdi, *Tārīkh-i ʿAbbāsī*, 413; translation, with modifications, from McChesney, "Four Sources," 110, 130.

15. Ibid.

16. Nasrabadi, *Tazkira*, 1:618; Ansari, *Dastur al-Moluk*, 128–29; Sipanta, *Tārīkhcha-yi awqāf*, 222.

17. Nasrabadi (*Tazkira*, 1:194–95, 316) refers to *kadkhudāyān-i muʿtabar-i tujjār* (esteemed representatives of merchants).

18. This can be gleaned from scattered references in the sources. See Maliha, *Muzakkir al-aṣḥāb*, 506; Nasrabadi, *Tazkira*, 1:301; and Nawras, "Divān," fol. 168v.

19. Muhammad Mahdi, *Niṣf-i jahān*, 47–48.

20. Ibid., 48.

21. Yazdi, *Tārīkh-i ʿAbbāsī*, 413; translation, with modifications, from McChesney, "Four Sources," 110.

22. Asaf, *Rustam al-tavārīkh*, 95.

23. Maliha Samarqandi, *Muzakkir al-aṣḥāb*, 505.

24. For a comprehensive study of the community and their extensive mercantile networks, see Aslanian, *From the Indian Ocean*. Other studies include Herzig, "Deportation of the Armenians"; Ghougassian, *Emergence of the Armenian Diocese*; and Shafaghi, *Jughrāfiyā-yi Iṣfahān*, 578–94.

25. Herzig, "Armenian Merchants," 60–61.

26. Junabadi, *Rawżat al-Ṣafaviyya*, 772.

27. Matthee, *Politics of Trade*, esp. 61–90.

28. See Aslanian, *From the Indian Ocean*, 44–85.

29. Ibid., 3.

30. Junabadi, *Rawżat al-Ṣafaviyya*, 772.

31. Fazli, *Chronicle*, 1:373.

32. Junabadi, *Rawżat al-Ṣafaviyya*, 772.

33. Ghougassian, *Emergence of the Armenian Diocese*, 201–3.

34. Bedik, *Man of Two Worlds*, 346.

35. See Ter Hovhaniants', *Tārīkh-i Julfā*, 26; originally published in Armenian in 1880.

36. Tavernier, *Six voyages*, 157–58.

37. This date is suggested by a chronogram in a poem that was once inscribed on the bridge. See Eiwziwk'chean, *Nkaragrut'iwn*, 39–40 (trans., 51–52).

38. Ter Hovhaniants', *Tārīkh-i Julfā*, 26.

39. Chardin, *Voyages*, 8:105.

40. On the churches of New Julfa, see Carswell, *New Julfa*; Hakhnazarian and Mehrabian, *Nor/Djulfa*; and Landau and Van Lint, "Armenian Merchant Patronage."

41. Carswell, *New Julfa*, 50–51.

42. Landau, "European Religious Iconography."

43. Landau and Van Lint, "Armenian Merchant Patronage," 332.

44. Quoted in Landau, "European Religious Iconography," 426.

45. Ghereghlou, "Margins of Minority Life," 58.

46. Ibid.

47. Della Valle, *Viaggi*, 1:485; trans., 9:32.

48. See Firby, *European Travellers*, 21–80.

49. See chapter 7.

50. Arak'el, *History*, 2:340.

51. For an account of the eviction of Armenians, see Arak'el, *History*, 2:336–44. According to Arak'el (342), Armenians were settled in four other quarters both inside and outside of the walled city: Tarvaskan, Shaykh Sha'ban, Takht-i Gharaja, and Baghat.

52. Kafescioğlu, *Constantinopolis/Istanbul*, 5.

53. Necipoğlu, *Age of Sinan*.

54. See Northedge, *Historical Topography of Samarra*.

55. Kostof, *City Shaped*, 98.

56. Bonine, "Morphogenesis of Iranian Cities." Even an inspection of the layout of medieval Isfahan has revealed that its seemingly haphazard fabric comprised a series of orthogonal configurations developed over time. See Gaube and Wirth, *Bazar*, 36–41.

57. Necipoğlu, *Topkapı Scroll*.

58. Mustawfi Bafqi, *Jāmi'-i mufīdī*, 3:480.

59. Della Valle, *Viaggi*, 2:26; trans., 883.

60. Bembo, *Travels*, 345. Per Giovanni Francesco Gemelli Careri ("Voyage Round the World," 133), Armenians had shops in a caravanserai near the maydan.

61. Iskandar Beg, *Tārīkh-i 'ālam-ārā*, 2:788, 838.

62. The accounts of Ab-pashan are discussed in Falsafi, *Zindigānī*, 699–702.

63. Calmard, "Shi'i Rituals," 151–54; Rahimi, "Rebound Theater State."

64. Kotov, "Journey to the Kingdom," 30.

65. Kaempfer, *Exotic Attractions*, 173.

66. Ibid., 46.

67. Bedik, *Man of Two Worlds*, 347.

68. Chick, *Chronicle of the Carmelites* (2012), 1:245.

69. Shafaghi, *Jughrāfiyā-yi Iṣfahān*, 455; Nawras Damavandi, "Dīvān," fol. 168v.

70. Jafarian, *Ṣafaviyya dar 'arṣa-yi dīn*, 2:793–94.

71. Landau and Van Lint, "Armenian Merchant Patronage," 311.

72. For an elaborate exposition of the Orientalist view, see Von Grunebaum, "Structure of the Muslim Town." For critiques and further literature, see Jayyusi et al., *City in the Islamic World*.

Chapter 7

Portions of this and the following chapter were previously published in Farshid Emami, "Discursive Images," *Journal for Early Modern Cultural Studies* 18, no. 3 (Summer 2018): 154–86.

1. On Shah Safi's coronation ceremony, see Khvajigi Isfahani, *Khulāṣat al-siyar*, 41.

2. Haneda, "Character of the Urbanization."

3. Chardin, *Voyages*, 8:134. Some of Chardin's figures and descriptions may be exaggerated, though, considering the hinterland, a population of around half a million for seventeenth-century Isfahan is plausible. According to a Dutch record, a Safavid government census conducted in 1710 set Isfahan's population at 550,000. Floor, *Economy of Safavid Persia*, 3. See also Blake, *Half the World*, 36–41.

4. Richard, *Raphaël du Mans*, 2:262, quoted in Matthee, *Persia in Crisis*, 151.

5. Kaempfer, *Exotic Attractions*, 135.

6. On Safavid history in this period, see Newman, *Safavid Iran*, 73–116.

7. After the accession of Shah Safi, for instance, the monopoly on the export of silk was lifted. See Matthee, *Politics of Trade*, 119.

8. Haneda, "Character of the Urbanization."

9. Babaie, *Isfahan*, 182–86.

10. For seventeenth-century references to the Khiyaban-i Khvaju, see Kaempfer, *Exotic Attractions*, 138, and Nawras, "Dīvān," fol. 168v. Later authors, such as Muhammad Mahdi (*Niṣf-i jahān*, 47), however, date the avenue's construction to the early 1800s. And yet, evidence from several Safavid sources indicate that the avenue was a Safavid creation renovated under the Qajars. Already ubiquitous in the new quarters, the khiyaban turned into a full-fledged component of urban development. A poem with a chronogram, for instance, records the construction of a new khiyaban in 1689–90 (1101 H); it was described as a major pathway (*shāhrāh*) that opened onto the Chaharbagh. Najib Kashani, *Kulliyyāt*, 608.

11. Chardin, *Voyages*, 8:43–44.

12. Qazvini, *Tārīkh-i jahān-ārā*, 683–84.

13. A poem with a chronogram records the foundation of a dam (*sad*) in 1654–55 (1065 H). Nasrabadi, *Tazkira*, 2:702. Three year later, in 1657–58 (1068 H), the partially ruined dam was dismantled and integrated into the Hasanabad Bridge, inaugurated one year later, in the spring of 1659. Qazvini, *Tārīkh-i jahān-ārā*, 634, 667–69.

14. Qazvini, *Tārīkh-i jahān-ārā*, 634.

15. Ibid., 635.

16. Ta'sir Tabrizi, *Dīvān*, 170–71; Ramzi Kashani, "Ramz al-rayāḥīn."

17. Luschey, "Pul-i Khwājū."

18. Qazvini, *Tārīkh-i jahān-ārā*, 584.

19. Danishpazhuh, "Iṣfahān va Ṭāvūskhāna-yi ān," 180.

20. Ta'sir Tabrizi, *Dīvān*, 174–76.

21. On the Bagh-i Burj, see Najib Kashani, *Kulliyyāt*, 594–95.

22. Losensky, "'Equal of Heaven's Vault,'" 214.

23. On the concept of "emblematic portrait," see Sumi, *Description*, esp. chap. 5.

24. Losensky, "'Equal of Heaven's Vault,'" 214.

25. Schimmel, *Two-Colored Brocade*, 3.

26. Losensky, *Welcoming Fighānī*, 10.

27. Rizvi and Keshavmurthy, "Introduction: Framing Bedil."

28. Quoted in the editor's introduction in Varasta, *Muṣṭalaḥāt al-shuʿarā*, 15.

29. The genesis and diffusion of the shahrashub, and its development over time and space, deserve to be fully investigated beyond linguistic and regional divisions. For brief overviews, see Sharma, "Shahrâshub," and Bernardini, "*Masnavī-shahrāshūb*s." For a chronological survey and an anthology of Persian-language shahrashub poems, see Gulchin Maʿani, *Shahrāshūb*. On South Asian Persian-language examples, see Sharma, "City of Beauties," and Sharma, *Mughal Arcadia*, esp. chap. 3. For Ottoman Turkish *şehrengīz*, see Levend, *Türk Edebiyatında şehr-engizler*.

30. Sharma, *Persian Poetry at the Indian Frontier*.

31. Gulchin Maʿani, *Shahrāshūb*, 14.

32. For a discussion of the Sufi practice of *shāhid-bāzī* (literally, "playing the witness") and further references, see Ridgeon, "Controversy of Shaykh Awḥad al-Dīn."

33. Nasrabadi, *Tazkira*, 445, 473, 554, 605.

34. On this topic, see Gulchin Maʿani, *Maktab-i vuqūʿ*, and Losensky, "Poetics and Eros."

35. See Roemer, "Inshāʾ." On the culture of insha in Safavid diplomatic correspondence, see Mitchell, *Practice of Politics*.

36. For examples of such poems, see Shafaʿi Isfahani, *Dīvān*, 34–46 (on Isfahan), 166–67 (on an unnamed maydan), and 170 (on the Ali Qapu).

37. Winter, "'Seat of Kingship,'" 38–39.

38. Meisami, "Palaces and Paradises," 42.

Chapter 8

1. On these aspects of a historical narrative, see White, *Content of the Form*.

2. Junabadi, *Rawżat al-Ṣafaviyya*, 758–59.

3. Ibid., 761, translation, with modifications, from McChesney, "Four Sources," 113. Except for the opening paragraphs, Junabadi's account is translated by McChesney (112–14).

4. Yazdi, *Tārīkh-i ʿAbbāsī*, 236.

5. Qazvini, *Shahrāshūb*, 16.

6. Necipoğlu, *Topkapı Scroll*, esp. 3–39.

7. My translation is based on the text reproduced and translated in Ghougassian, *Emergence of the Armenian Diocese*, 204–7.

8. Dihgan, *Tārīkh-i Ṣafavīyān*, 63.

9. Herbert, *Some Yeares Travels*, 158–59.

10. Chardin, *Voyages*, 8:118; Kaempfer, *Exotic Attractions*, 43.

11. Kaempfer, *Exotic Attractions*, 160. For a nineteenth-century description, see Tahvildar, *Jughrāfiyā-yi Iṣfahān*, 36.

12. Qazvini, "Sāqī-nāma," 66.

13. Ibid., 67.

14. Barthes, *Eiffel Tower*, 9.

15. Dihkhuda, *Lughatnāma*, s.v. savād.

16. Qazvini, *Shahrāshūb*, 16.

17. Nijat Isfahani, "Vaṣf-i Iṣfahān," 369.

18. Qazvini, "Sāqī-nāma," 62.

19. On Muhammad Zaman, see Landau, "Man, Mode, and Myth."

20. Trachtenberg, *Dominion of the Eye*, 254.

21. Barthes, "Semiology and the Urban," 172.

22. The published version of *Nūr al-mashriqayn* is based on a manuscript at the Malek Library, Tehran. An edited version of *Muḥīṭ-i kawnayn* is published in its author's collected works; for the section on Isfahan, see M. I. S. Qazvini, *Dīvān*, 541–55. In terms of literary form, these works were composed as responses (s. *javāb*) to *Tuḥfat al-ʿIrāqayn* (The Gift of the two Iraqs) by Khaqani Shirvani (d. 1190). See Beelaert, *Cure for the Grieving*.

23. M. I. S. Qazvini, *Dīvān*, 541; Bihishti Haravi, *Nūr al-mashriqayn*, 217.

24. M. I. S. Qazvini, *Dīvān*, 545.

25. Bihishti Haravi, *Nūr al-mashriqayn*, 221.

26. For the published edition of the work, preserved in several manuscripts, see Danishpazhuh, "Isfahan va Ṭavūskhāna-yi ān," 164–72.

27. Ibid., 170.

28. Ibid., 171.

29. On the uses of prosopopoeia, see Purjavadi, *Zabān-i ḥāl*.

30. Nasrabadi, *Tazkira*, 583–84. I have not been able to find any trace of Nasrabadi's responses in manuscript collections.

31. Danishpazhuh, "Isfahan va Ṭavūskhāna-yi ān," 174.

32. If the composition was indeed a veiled satire, it was a poignant one, as it mocks not only the social practices of Isfahan's elites and their profligate lifestyle but also the convoluted figural language that characterizes the "fresh style." (The text indeed alludes to the poets [Muhammad Ali] Saʾib and Talib Amuli, who were seen by their contemporaries as towering figures of this fashionable style of poetry.)

33. Danishpazhuh, "Isfahan va Ṭavūskhāna-yi ān," 193.

34. The composition is included in the autograph manuscript of the poet's *dīvān* (collected works): Nawras Damavandi, "Dīvān," British Library, London, MS Or. 3644, fols. 168v–69r; Rieu, *Supplement to the Catalogue*, 210. "Shahrāshūb-i khīyāl" is the work's title in the *dīvān*. The composition is preserved in several miscellany collections (*majmūʿa*). In these manuscripts, the work is titled "Shahrāshūb-i Nawras," after the pen name of the author. For a biographical notice about Nawras, see Nasrabadi, *Tazkira*, 1:581–82.

35. Nawras Damavandi, "Dīvān," fol. 168v.

36. Ibid.

37. In the poems of Hafiz, for instance, the *kharābāt* (literally, the "ruins") was not only the site of the Zoroastrian wine tavern but also where the antinomian seeker of the divine love could find his spiritual master, the Magian elder (*pīr-i mughān*).

38. Lynch, *Image of the City*.

39. Ramzi Kashani, "Ramz al-rayāḥīn."

40. Taʾsir Tabrizi, *Dīvān*, 168–82. For a recent study, see Shahidi Marnani, "Bāgh-i Saʿādatābād-i Iṣfahān." The poem contains a chronogram on the construction of a polo ground (*maydān*) by order of Shah Sultan Husayn; it yields the year 1108 H (1696–97), which likely denotes the date of the composition as well.

41. This work survives in a single manuscript in a private collection and is only partially published. See Nijat

Isfahani, "Vaṣf-i Iṣfahān." A secretary at the court of Shah Sulayman, Mir Nijat (after his pen name *nijāt*, or "salvation") attended courtly assemblies and served in the royal library (*kitābkhāna*) under Shah Sultan Husayn. *Masīr al-sālikīn* was apparently composed before the poet's tenure in the Safavid bureaucracy.

42. Nijat Isfahani, "Vaṣf-i Iṣfahān," 373–74.

43. Ibid., 369–70.

44. Emami, "Coffeehouses," 200–201.

45. De Certeau, *Practice of Everyday Life*, 93.

Chapter 9

1. In the bureaucratic lingo of scribes, a specific mode of insha' was categorized under the rubric of the *ikhvāniyyāt* (from the Arabic term *ikhwān*, meaning "brothers/friends"), distinguished from other administrative compositions that were collected and copied as models. Like other aspects of the Arabic and Persian culture of insha', the roots of the *ikhvāniyyāt* reach back to the early Islamic period. At least from the tenth century onward, such letters were known as a distinct genre and were valued for their literary merits. For an overview, see Arazi and Ben-Shammay, "Risāla, v: Letters." For a late Safavid manual of letter writing, see Jafarian, *Munsha'āt-i Sulaymānī*. In her recent book *City as Anthology*, Kathryn Babayan has also examined Safavid fraternal epistles.

2. For the letter, see Danishpazhuh, "Iṣfahān va Ṭāvūskhāna-yi ān," 204–12. The text is transcribed twice in the University of Tehran, MS 8235, fols. 168v–170r, 271v–274r; Danishpazhuh, *Fihrist-i nuskhahā-yi khaṭṭī*, 17:74, 79.

3. The idea of composing a *dastūr al-ʿamal* probably derived from the epistolography manuals. The extant works of Semnani and biographical notices (discussed below) suggest that he was particularly known for his compositions (*munsha'āt*).

4. In 1971 Danishpazhuh ("Iṣfahān va Ṭāvūskhāna-yi ān," 213–43) edited and published the text together with Rukn al-Din's letter and a number of prose works about Safavid Isfahan.

The published text contains errors and typographical mistakes and is based on two later redactions that show substantial variations from the earliest known manuscript at the Malek Library (MS 5403, fols. 53r–57r, dated 1688 [1100 H]). The text is preserved in at least five other manuscripts: another late Safavid miscellany (*jung*) at the Malek Library (MS 4671, fols. 162v–167v); an epistolary collection (*munsha'āt*) at the University of Tehran (MS 8235, fols. 274r–277v, dated 1798 [1213 H]), which contains Semnani's other prose works; and three anthologies—in the Majlis Library (MS 13063 [Sena 1116], fols. 233r–240v); the Danishkada-yi Ilahiyyat va Maʿarif-i Islami, Ferdowsi University, Mashhad (MS 18658, dated 1722 [1132 H]); and a private collection (Miftah, used by Danishpazhuh in his edition). This chapter's discussion is based on a critical edition of the text prepared by myself (for which, see the appendix), based on the first four manuscripts listed above, with the 1688 [1100 H] version at the Malek Library serving as the base manuscript (only significant variations are noted here). The text has recently garnered the attention of Jafarian (http://historylib .com/articles/1874) and Babayan. In addition to providing an English translation, this book offers a more accurate discussion of the text and an in-depth analysis of its literary, spatial, and sociocultural implications.

5. One clue is the reference to the inaugural ceremony for the Hasanabad Bridge in Rukn al-Din's letter, which dates the correspondence approximately to shortly after the spring of 1659. The other clue is the reference to Muhammad Taqi Majlisi as the preacher of the Old Mosque. Majlisi died in 1659–60; hence the text must reflect Semnani's experience before this date. Semnani also alludes to the Shiʿi cleric Muhsin Fayz Kashani (d. 1680) as the preacher of the Shah Mosque; the cleric was appointed to the post in 1655.

6. See Yarshater, "Theme of Wine-Drinking."

7. Ahmadi, "Chahār vaqfnāma," 96.

8. Emami, "Coffeehouses," 195.

9. Kaempfer, *Exotic Attractions*, 148.

10. Matthee, *Pursuit of Pleasure*, 160, 144.

11. Gaube and Wirth, *Bazar*, 282–83.

12. Chardin, *Voyages*, 4:27.

13. Included in an album, the paintings were commissioned by Kaempfer from a local Isfahani artist named Jani, son of Bahram, who used the epithet *farangī-sāz* (painter in the European style).

14. Kotov, "Journey to the Kingdom," 19–20.

15. Chardin, *Voyages*, 4:69; Matthee, *Pursuit of Pleasure*, 169–70.

16. This passage is recorded differently in the manuscripts. The latter phrase appears in Malek MS 5403, fol. 54v. A slightly different one is recorded in Malek MS 4671, fol. 164r: "beholding the [beautiful] countenances of the European monastery" (*tamāshā-yi laqā-yi dayr-i farang*). "European images" (*taṣāvīr-i farang*) appears in other manuscripts.

17. See Floor, "Talar-i Tavila."

18. Cited in Ibid., 152.

19. Sims, "Āīna-kārī."

20. Chardin, *Voyages*, 7:344.

21. Maliha Samarqandi, *Muzakkir al-aṣḥāb*, 344; Chardin, *Voyages*, 7:449–50.

22. The differing significance of Isfahan's new and old congregational mosques in Semnani's guide is echoed in the divergent treatment of their respective preachers. Venerated as a saint, Muhammad Taqi Majlisi belonged to a cast of clerics who incorporated Sufism and aspects of popular piety into mainstream Shiʿi discourse. Fayz Kashani, by contrast, upheld a strict view of public morality. In a poem, for instance, he castigated seminary students for frequenting coffeehouses such as the Qahva-yi Saz. Fayz Kashani, *Kulliyyāt*, 1:301–4.

23. For the meaning of *gul-i badnāmī* (flower of notoriety), or *ātashak* (literally, "small fire"), as syphilis, see Siyalkoti Mal Varasta (d. 1766), *Muṣṭalaḥāt al-shuʿarā*, 524. Varasta compiled this glossary of Safavid literary terms in Lahore in the early 1700s.

24. Ibid., 536, 274. For other references to Kucha-yi Naw, see Vala

Qazvini Isfahani, *Irān dar zamān-i Shāh Ṣafī*, 422, and Danishpazhuh, "Iṣfahān va Ṭavūskhāna-yi ān," 187. Varasta describes Kucha-yi Naw as *maḥalla-yi lūlīyān* (a quarter of gypsies); gypsies (also referred to as *kawlī*) were involved in prostitution. See Matthee, "Prostitutes," 124–25.

25. Chardin, *Voyages*, 7:364, 416–17.

26. University of Tehran, MS 8235, fol. 155v.

27. Kaempfer, *Exotic Attractions*, 140; Tavernier, *Six voyages*, 1:441.

28. Matthee, "Prostitutes," 132.

29. Ibid., 142.

30. See, for example, the letter addressed to "Salima Khanum Isfahani" and attributed to Mirza Tahir Nasrabadi; University of Tehran, MS 8235, fols. 154v–155v.

31. Cited in Matthee, "Prostitutes," 134.

32. Some manuscripts contain lines that describe the breast and navel of the subject as well. See Danishpazhuh, "Iṣfahān va Ṭāvūskhāna-yi ān," 240.

33. De Bruijn, "Beloved." For conceptions of the body in lyric poetry, see Meisami, "Body as Garden."

34. On the works and life of Afzal, see Farhad, "Safavid Single Page Painting," 1:85–119.

35. Canby, *Rebellious Reformer*, 32.

36. Maliha Samarqandi, *Muẕakkir al-aṣḥāb*, 275–76.

37. Shamlu, *Qiṣaṣ al-khāqānī*, 2:124. Curiously, there is no entry on Semnani in the comprehensive compendium compiled in 1672–80 by Nasrabadi. Except for some scattered verses, no collection (*dīvān*) of Semnani's poetry seems to have survived.

38. "Jung-i Aslan Beg," University of Tehran, MS 3098, p. 313.

39. Ahmad Beg Gorji Akhtar, "Taẕkira-yi jahān-ārā," Majlis Library, MS 118, fols. 95v–96r.

40. Mahmud Mirza Qajar, *Safīnat al-Maḥmūd*, 601–2.

41. For a list of these letters, see Danishpazhuh, *Fihrist-i nuskhahā-yi khaṭṭī*, 17:74–78.

42. In three manuscripts (Majlis, Miftah, Mashhad), the composition is attributed to Muhammad Tahir Vahid Qazvini. In *Muṣṭalaḥāt al-shuʿarā*, the work is attributed to yet another poet. The references to the pen name Ashiq and Rukn al-Din's letter, among other clues, leave no doubt about Semnani's authorship. The misattributed copies and quotations nevertheless reveal that the work had entered the period literary canon in Iran and beyond.

43. Regarding Mir Fuzuni (Semnani's father), Nasrabadi (*Taẕkira*, 1:373) states that he came from the sayyid families of Semnan.

44. Perry, "Cultural Currents," 90.

45. In a transcription of Rukn al-Din's letter (MS 8235, fol. 168v), his full name is recorded as "Rukn al-Din Muhammad Semnani," suggesting that he, too, came from Semnan.

46. Shamlu, *Qiṣaṣ al-khāqānī*, 2:124.

47. Maliha Samarqandi, *Muẕakkir al-aṣḥāb*, 276.

48. Nasrabadi, *Taẕkira*, 1:237.

49. On dual temporal aspects of narrative, see Chatman, *Story and Discourse*.

50. On prosimetrical forms in classical Persian literature, see Meisami, "Mixed Prose and Verse."

51. See Barthes, "Reality Effect."

52. Arazi and Ben-Shammay, "Risāla, V: Letters."

53. Seen as an emblem of urban modernity and the epitome of the subjective experience of the metropolis, the flaneur has inspired countless critical studies. Moving beyond the figure's traditional time and place, recent works have criticized the bourgeois class and masculine gender associations of the Parisian prototype, revealing the presence of analogous characters in other metropolitan contexts. Within the vast

scholarly literature, see Tester, *Flâneur*; Wrigley, *Flâneur Abroad*; and D'Souza and McDonough, *Invisible Flâneuse?*

54. Benjamin, *Reflections*, 156.

55. In that sense, it comes closer to the conception of the Parisian flaneur in the early 1800s. See Ferguson, *Paris as Revolution*, chap. 2.

56. Benjamin, *Charles Baudelaire*, 69.

57. For a critique of the vision-centered conception of the flaneur, see Boutin, "Rethinking the Flâneur."

Conclusion

1. Hazin, *Tārīkh-i Ḥazīn*, 52.

2. Krusiński, *History of the Late Revolutions*, 2:89.

3. See "Jung-i Ahmad-i Ghulam," Majlis Library, Tehran, MS 3455, and Shukrullahi, "Aḥmad-i Ghulām."

4. Kinneir, *Geographical Memoir*, 111.

5. Binning, *Journal*, 2:111.

6. Ibid., 115.

7. Curzon, *Persia and the Persian Question*, 2:39.

Appendix

1. Armenian bole (*gil-i Armanī*) is a reddish clay with medicinal properties and the source of the tomato red in Ottoman underglaze Iznik tiles.

2. Presumably mocking a *mullā*, a lascivious mode of dance; Varasta, *Muṣṭalaḥāt al-shuʿarā*, 348.

3. The last three verses pun on musical expressions.

4. Khizr is a Qur'anic figure associated with immortality; see Wensinck, "al-Khaḍir (al-Khiḍr)." The reference to Khizr is also related to coffee's black color, which makes it similar to the dark spring of life (*āb-i ḥayāt*).

5. The phrase in brackets appears in later manuscripts except for the 1688 Malek manuscript.

Abbreviations

EIr *Encyclopaedia Iranica Online.* Edited by Ehsan Yar-shater. Available online at https://referenceworks.brillonline.com/entries/encyclopaedia-iranica-online.

EI2 *Encyclopaedia of Islam.* 2nd ed. Edited by P. Bearman, Th. Bianquis, C. E. Bosworth, E. van Donzel, and W. P. Heinrichs. 11 vols. Leiden: Brill, 1960–2009. https://referenceworks.brillonline.com/browse/encyclopaedia-of-islam-2.

IsMEO Associazione Internazionale di Studi sul Mediterraneo e l'Oriente

Archival and Manuscript Sources

BIBLIOTHÈQUE DE L'ALCAZAR, MARSEILLE
Coste, Pascal. "Album de dessins du voyage en Perse." Dessins originaux des Fonds anciens de la Bibliothèque municipale de Marseille, MSS 1132–34.

BRITISH LIBRARY, LONDON
Engelbert, Kaempfer. MSS Sloane 2910, 2920, 5232.
Nawras Damavandi. "Dīvān." MS Or. 3644.

GULISTAN PALACE PHOTO ARCHIVE, TEHRAN
Album nos. 199 and 168.

MAJLIS LIBRARY (KITĀBKHĀNA-YI MAJLIS-I SHAWRĀ-YI ISLĀMĪ), TEHRAN
Ahmad Beg Gorji Akhtar. "Taẕkira-yi jahān-ārā." MS 118.
Ahmad Ghulam. "Jung-i Ahmad-i Ghulam." MS 3455.
"Album of Zill al-Sultan." MS 11772.
"Miscellany collection (*jung*)." MS 13063 (Sena 1116).

MALEK NATIONAL LIBRARY AND MUSEUM, TEHRAN
"Miscellany collection (*jung*)." MS 5403.
"Munshaʾat." MS 4671.

UNIVERSITY OF TEHRAN, CENTRAL LIBRARY (KITĀBKHĀNA-YI MARKAZĪ), TEHRAN
"Jung-i Aslan Beg." MS 3098.
"Munshaʾat." MS 8235.
Qazvini, Muhammad Tahir Vahid. "Sāqī-nāma." MS 4344.

Printed Primary Sources

Abdi Beg Shirazi. *Jannāt-i ʿAdn.* Edited by Ehsan Eshraqi and Mehrzad Parhizkari. Tehran: Sukhan, 1396 [2017].
———. *Takmilat al-akhbār: Tārīkh-i Ṣafaviyya az āghāz tā 978 hijrī-yi qamarī.* Edited by Abdul Husayn Navaʾi. Tehran: Nashr-i nay, 1369 [1990].

Abu Nuʿaym Isfahani. *Dhikr akhbār Iṣbahān / Geschichte Iṣbahāns.* Edited by Sven Dedering. 2 vols. Leiden: Brill, 1931–34.

Ansari, Mohammad. *Dastur al-Moluk: A Safavid State Manual.* Translated by Willem M. Floor and Mohammad H. Faghfoory. Costa Mesa, CA: Mazda, 2007.

Arakʿel, Dawrizhetsʿi. *The History of Vardapet Aṛakʿel of Tabriz.* Translated by George A. Bournoutian. 2 vols. Costa Mesa, CA: Mazda, 2005–6.

Asaf, Muhammad Hashim. *Rustam al-tavārīkh.* Edited by Muhammad Mushiri. Tehran: Taban, 1348 [1969].

Astarabadi, Sayyid Hasan b. Murtaza Husayni. *Tārīkh-i sulṭānī: Az Shaykh Ṣafī tā Shāh Ṣafī.* Edited by Ehsan Eshraqi. Tehran: Ilmi, 1366 [1987].

Avi, Husayn b. Muhammad. *Tarjuma-yi maḥāsin-i Iṣfahān.* Edited by Abbas Iqbal Ashtiyani. Tehran: Shirkat-i sahami-yi chap, 1349 [1970].

Awhadi, Taqi al-Din Muhammad Daqaqi Balyani. *Taẕkira-yi ʿarafāt al-ʿāshiqīn va ʿaraṣāt al-ʿārifīn.* Edited by Muhsin Naji Nasrabadi. 7 vols. Tehran: Asatir, 1388 [2009].

Bedik, Petrus [Pedros]. *A Man of Two Worlds: Pedros Bedik in Iran, 1670–1675.* Translated by Colette Ouahes and Willem M. Floor. Washington, DC: Mage, 2014.

Bembo, Ambrosio. *The Travels and Journal of Ambrosio Bembo.* Translated by Clara Bargellini. Edited by Anthony Welch. Berkeley: University of California Press, 2007.

Bihishti Haravi, Abd Allah Sani. *Nūr al-mashriqayn: Safarnāma-yi manẓūm az ʿahd-i Ṣafavī.* Edited by Najib Mayil Haravi. Mashhad: Astan-i quds-i razavi, 1377 [1998].

Binning, Robert B. M. *A Journal of Two Years' Travel in Persia, Ceylon, Etc.* 2 vols. London: W. H. Allen, 1857.

Biruni, Muhammad b. Ahmad. *The Book of Instruction in the Elements of the Art of Astrology.* Translated by Robert Ramsay Wright. London: Luzac, 1934.

Burhan, Muhammad Husayn b. Khalaf Tabrizi. *Burhān-i qāṭiʿ.* Edited by Muhammad Muʿīn. Tehran: n.p., 1332 [1953].

Chardin, Jean. *Voyages du chevalier Chardin, en Perse, et en autres lieux de l'Orient.* New ed. Edited by Louis Langlès. 10 vols. Paris: Le Normant, 1811.

Chick, Herbert, ed. *A Chronicle of the Carmelites in Persia and the Papal Mission of the XVIIth and XVIIIth Centuries.* 2 vols. London: Eyre & Spottiswoode, 1939. (New edition, London: I. B. Tauris, 2012.)

Coste, Pascal. *Monuments modernes de la Perse, mesurés, dessinés et décrits par Pascal Coste.* Paris: A. Morel, 1867.

Curzon, George N. *Persia and the Persian Question.* 2 vols. London: Longmans, Green, 1892.

Danishpazhuh, Muhammad Taqi, ed. "Iṣfahān va Ṭāvūskhāna-yi ān." *Farhang-i Īrān-zamīn* 18 (1350 [1971]): 157–243.

de Bruyn, Cornelis. *Travels into Muscovy, Persia, and Part of East-Indies.* 2 vols. London: A. Bettesworth et al., 1737.

de Goeje, M. J., ed. *Ibn Rusta's "Kitāb al-A'lāq al-nafīsa" and "Kitāb al-buldān" by al-Ya'qūbī.* Leiden: Brill, 1891. Reprint, 2014.

Della Valle, Pietro. *Viaggi di Pietro Della Valle, il pellegrino.* Edited by G. Gancia. 2 vols. Brighton: Gancia, 1843. (Excerpts translated into English in *A General Collection of the Best and Most Interesting Voyages and Travels*, edited by John Pinkerton, vol. 9. London: Longman, Hurst, Rees, & Orme [etc.], 1811.)

Dihgan, Ibrahim, ed. *Tārīkh-i Ṣafavīyān, Khulāṣat al-tavārīkh, Tārīkh-i Mullā Kamāl.* Arak: Farvardin, 1335 [1956].

Eiwziwk'chean, Vrdanis. *Nkaragrut'iwn Parskastani ereweli shinuatsots'.* Constantinople: I Tparani Hovhannu Miwhēntisean, 1854. (Translated into Persian in *Vaṣf-i banāhā-yi mashhūr-i Iṣfahān* by Leon Minasian. Isfahan: Ghazal va Mutarjim, 1377 [1998].)

Fayz Kashani, Mulla Muhammad Muhsin. *Kulliyyāt-i Mullā Muḥsin Fayż Kāshānī.* Edited by Mustafa Fayzi Kashani. 3 vols. Qum: Usva, 1371 [1992].

Fazli Beg Khuzani Isfahani. *A Chronicle of the Reign of Shah ʿAbbas.* Edited by Kioumars Ghereghlou. 2 vols. Cambridge: Gibb Memorial Trust, 2015.

Fryer, John. *A New Account of East-India and Persia in Eight Letters.* London: R. R. for Ri. Chiswell, 1698.

Gemelli Careri, Giovanni Francesco [John Francis]. "A Voyage Round the World." In *A Collection of Voyages and Travels, Some Now First Printed from Original Manuscripts, Others . . . Now First Publish'd in English*, translated by Awnsham Churchill and John Churchill, 4:5–606. London: H. C. for Awnsham & Churchill, 1704.

Hazin, Muhammad Ali. *Tārīkh-i Ḥazīn: Shāmil-i avākhir-i Ṣafaviyya, fitna-yi Afghān, salṭanat-i Nādir Shāh va-aḥvāl-i jamʿī az buzurgān.* Isfahan: Taʾid, 1332 [1953].

Herbert, Thomas. *Some Yeares Travels into Divers Parts of Asia and Afrique.* Rev. and enl. ed. London: Iacob Blome & Richard Bishop, 1638.

Ibn al-Athir. *The Annals of the Saljuq Turks: Selections from al-Kāmil fī'l-Taʾrīkh of 'Izz al-Dīn Ibn al-Athīr.* Translated by D. S. Richards. London: Routledge-Curzon, 2002.

Isfahani, Muhammad Hafiz. *Sih risāla dar ikhtirāʿāt-i ṣanʿatī: Sāʿat, āsīyā, dastgāh-i rawghan-kishī, natījat al-dawla.* Edited by Taqi Binish. Tehran: Bunyad-i Farhang-i Iran, 1350 [1971].

Iskandar Beg Munshi. *Tārīkh-i ʿālam-ārā-yi ʿAbbāsī.* Edited by Iraj Afshar. 2 vols. Tehran: Amir Kabir, 1350 [1971].

Jabiri Ansari, Mirza Hasan Khan. *Tārīkh-i Iṣfahān va Ray va hama-yi jahān.* Edited by Jamshid Mazaheri. Isfahan: Mashʿal, 1378 [1999].

Jafarian, Rasool, ed. *Maṣnavī-yi Shahrāshūb-i Vaḥīd-i Qazvīnī.* Qum: Muvarrikh, 1398 [2019].

———. *Munshaʾāt-i Sulaymānī.* Tehran: Majlis-i Shawra-yi Islami, 1388 [2009].

———. *Yāddāshthā-yi tārīkhī az rūzgār-i Ṣafavī.* Qum: Muvarrikh, 1395 [2016].

Jazari, Ismaʿil b. al-Razzaz. *The Book of Knowledge of Ingenious Mechanical Devices.* Translated by Donald R. Hill. Dordrecht: Reidel, 1974.

Junabadi, Mirza Beg. *Rawżat al-Ṣafaviyya.* Edited by Ghulam Riza Tabatabaʾi Majd. Tehran: Bunyad-i Mawqufat-i Duktur Mahmud Afshar, 1378 [1999].

Kaempfer, Engelbert. *Exotic Attractions in Persia, 1684–1688: Travels and Observations.* Translated by Willem M. Floor and Colette Ouahes. Washington, DC: Mage, 2018.

Kashifi, Husayn Vaʿiz. *Futuvvatnāma-yi sulṭānī.* Edited by Muhammad Jaʿfar Mahjub. Tehran: Bunyad-i Farhang-i Iran, 1971.

Khvajigi Isfahani, Muhammad Maʿsum. *Khulāṣat al-siyar: Tārīkh-i rūzgār-i Shāh Ṣafī Ṣafavī.* Tehran: Ilmi, 1368 [1989].

Khvandamir. *Tārīkh-i ḥabīb al-siyar.* Edited by Muhammad Dabir Siyaqi. 4 vols. Tehran: Kitabfurushi-yi Khayyam, 1983–84.

Kinnier, John Macdonald. *A Geographical Memoir of the Persian Empire.* London: J. Murray, 1813.

Kotov, Fedot Afanasiyev. "Of a Journey to the Kingdom of Persia." In *Russian Travellers to India and Persia, 1624–1798: Kotov, Yefremov, Danibegov*, translated and edited by P. M. Kemp, 1–42. Delhi: Jiwan Prakashan, 1959.

Krusinski, Judasz Tadeuz. *The History of the Late Revolutions of Persia.* 2 vols. London, 1728.

Mahmud Mirza Qajar. *Safīnat al-Maḥmūd.* Edited by Abd al-Rasul Khayyampur. Tabriz: Danishkada-yi Adabiyyat-i Tabriz, 1968.

Maliha Samarqandi, Muhammad Badiʿ. *Muẕakkir al-aṣḥāb.* Edited by Muhammad Taqavi. Tehran: Majlis-i Shawra-yi Islami, 1390 [2011].

Membré, Michele. *Mission to the Lord Sophy of Persia (1539–1542).* Translated by A. H. Morton. London: School of Oriental and African Studies, University of London, 1993.

Minorsky, Vladimir, ed. *Tadhkirat al-Mulūk, a Manual of Ṣafavid Administration (Circa 1137/1725), Persian Text in Facsimile (B. M. Or. 9496).* London: Luzac, 1943.

Morier, James. *A Journey Through Persia, Armenia, and Asia Minor, to Constantinople, in the years 1808 and 1809.* London: Longman, Hurst, Rees, Orme, and Brown, 1812.

Muhammad Mahdi b. Muhammad Riza al-Isfahani. *Niṣf-i jahān fī taʿrīf al-Iṣfahān.* Edited by Manuchihr Sutuda. Tehran: Taʾyīd, 1340 [1961].

Muqaddasi (Maqdisi), Shams al-Din Muhammad b. Ahmad Bashshari. *Aḥsan al-taqāsīm fī maʿrifat al-aqālīm.* Edited by M. J. de Goeje. Leiden: Brill, 1906. Reprint, 1967.

Mustawfi, Hamd Allah. *The Geographical Part of the Nuzhat-al-qulub Composed by Hamd-Allāh Mustawfī of Qazwīn in 740 (1340).* Translated and edited by G. Le Strange. Vol. 2. Leiden: Brill, 1919.

Mustawfi Bafqi, Muhammad Mufid b. Mahmud. *Jāmiʿ-i mufīdī*. Edited by Iraj Afshar, 3 vols. Tehran: Asadi, 1340–42 [1961–63].

Najib Kashani, Nur al-Din Muhammad Sharif. *Kulliyyāt-i Najīb Kāshānī*. Edited by Asghar Dadba and Mahdi Sadri. Tehran: Miras-i Maktub, 1382 [2003].

Nasrabadi, Muhammad Tahir. *Tazkira-yi Naṣrābādī: Tazkirat al-Shuʿarā*. Edited by Muhsin Naji Nasrabadi. 2 vols. Tehran: Asatir, 1378 [1999].

Natanzi, Mahmud b. Hidayat Allah Afushtaʾi. *Nuqāvat al-āṣār fī zikr al-akhyār: Dar tārīkh-i Ṣafaviyya*. Edited by Ehsan Eshraqi. Tehran: Ilmi va Farhangi, 1373 [1994].

Nijat Isfahani, Mir Abd al-Maʿali. "Vaṣf-i Iṣfahān." Edited by Ahmad Gulchin Maʿani. In *Majmūʿa maqālāt-i kungiri-yi jahānī-yi buzurgdāsht-i Iṣfahān*, edited by Fazlullah Salavati, 367–76. Tehran: Ittilaʿat, 1385 [2006].

Olearius, Adam. *The Voyages and Travels of the Ambassadors Sent by Frederick Duke of Holstein*. London: Thomas Dring and John Starkey, 1662.

Ouseley, Sir William. *Travels in Various Countries of the East; More Particularly Persia*. 3 vols. London: Rodwell & Martin, 1819–23.

Qazvini, Muhammad Ibrahim Salik. *Dīvān-i Sālik Qazvīnī*. Edited by Ahmad Karami and Abd al-Samad Haghighat. [Tehran]: Intisharat-i Ma, 1372 [1994].

Qazvini, Muhammad Salih. *Navādir*. Edited by Ahmad Mujahed. Tehran: Surush, 1371 [1993].

Qazvini, Muhammad Tahir Vahid. *Shahrāshūb*. Edited by Bihdad. Qazvin: Taha, 1379 [2000].

———. *Tārīkh-i jahān-ārā-yi ʿAbbāsi*. Edited by Seyyed Saʿid Mir Mohammad Sadeq. Tehran: Pazhuhishgah-i ulum-i insani va mutaliʿat-i farhangi, 2005.

Qumi, Qazi Ahmad b. Sharaf al-Din Husayn Husayni. *Calligraphers and Painters: A Treatise by Qāḍī Aḥmad*. Translated by Vladimir Minorsky. Washington, DC: Freer Gallery of Art, Smithsonian Institution, 1959.

———. *Khulāṣat al-tavārīkh*. Edited by Ehsan Eshraqi. 2 vols. Tehran: Danishgah-i Tehran, 1359 [1980].

Ramzi Kashani, Muhammad Hadi. "Ramz al-rayāḥīn." In *Daftar-i tārīkh*, vol. 4, edited by Iraj Afshar, 275–307. Tehran: Bunyad-i Mawqufat-i Duktur Mahmud Afshar, 1380 [2001].

Razi, Amin Ahmad. *Tazkira-yi haft iqlīm*. Edited by Mohammad Reza Taheri. 3 vols. Tehran: Surush, 1378 [1999].

Richard, Francis, ed. *Raphaël du Mans, missionaire en Perse au XVIIᵉ s.* 2 vols. Paris: Société d'histoire de l'Orient, L'Harmattan, 1995.

Ross, Edward Denison, ed. *Sir Anthony Sherley and His Persian Adventure*. London: G. Routledge & Sons, 1933.

Shafaʾi Isfahani, Hakim Sharaf al-Din Hasan. *Dīvān*. Edited by Lutfali Banan. Tabriz: Idara-yi Kull-i Irshad-i Islami-i Azarbayjan-i Sharqi, 1362 [1983].

Shamlu, Vali Quli. *Qiṣaṣ al-khāqānī*. Edited by Hasan Sadat Nasiri. 2 vols. Tehran: Vizarat-i Farhang va Irshad-i Islami, 1371–74 [1992–95].

Shaykh Luftallah al-Maysi. "Risālat al-Iʿtikāfiyya." In *Mīrāṣ-i Islāmī-yi Īrān*, edited by Rasool Jafarian, 1:316–37. Qum: Kitabkhana-yi Ayat Allah Marʿashi Najafi, 1373 [1994].

Silva y Figueroa, Garcia de. *L'ambassade de D. Garcias de Silva Figueroa en Perse*. Paris: Lovis Billaine, 1667.

Tafrishi, Abu al-Mafakhir b. Fazl Allah al-Husayni. *Tārīkh-i Shāh Ṣafi: Tārīkh-i taḥavvulāt-i Īrān dar sālhā-yi 1038–1052 H. Q.* Edited by Muhsin Bahram-nizhad. Tehran: Miras-i Maktub, 2010.

Tahvildar Isfahani, Mirza Husayn Khan. *Jughrāfiyā-yi Iṣfahān*. Edited by Manuchihr Sutuda. Tehran: Danishgah-i Tehran, 1342 [1963].

Taʿsir Tabrizi, Muhsin. *Dīvān*. Edited by Amin Pasha Ejlali. Tehran: Markaz-i Nashr-i Danishgahi, 1994.

Tavernier, Jean-Baptiste. *Les six voyages de Jean Baptiste Tavernier, ecuyer baron d'Aubonne, qu'il a fait en Turquie, en Perse, et aux Indes*. 2 vols. Paris: G. Clouzier, 1676–77.

Ter Hovhaniantsʿ, Harutʿiwn T. *Tārīkh-i Julfā-yi Iṣfahān*. Translated by Leon Minasian and Muhammad Ali Musavi Faridani. Isfahan: Zindarud, 1379 [2000].

Thackston, Wheeler M., Jr., ed. *Naser-e Khosraw's Book of Travels*. Costa Mesa, CA: Mazda, 2001.

Thévenot, Jean de. *The Travels of Monsieur de Thevenot into the Levant*. Translated by A. Lovell. 3 vols. in 1. London: H. Clark, 1687.

Tusi, Muhammad b. Mahmud. *ʿAjāʾib al-makhlūqāt*. Edited by Manuchihr Sutuda. Tehran: Ilmi va Farhangi, 1382 [2003].

Vala Qazvini Isfahani, Muhammad Yusuf. *Īrān dar zamān-i Shāh Ṣafi va Shāh ʿAbbās-i duvvum (1030–1071 H. Q.) ḥadīqa-yi shishum va haftum az rawża-i shishum-i Khuld-i barīn*. Edited by Muhammad Riza Nasiri. Tehran: Anjuman-i asar va mafakhir-i farhangi, 1380 [2001].

Varasta, Siyalkuti Mal. *Muṣṭalaḥāt al-shuʿarā*. Edited by Sirous Shamisa. Tehran: Mitra, 1396 [2017].

Willis, Charles James. *In the Land of the Lion and Sun*. London: Macmillan, 1891.

Yazdi, Mulla Jalal al-Din Munajjim. *Tārīkh-i ʿAbbāsī yā rūznāma-yi Mullā Jalāl*. Edited by Sayfallah Vahidniya. Tehran: Vahid, 1366 [1987].

Secondary Sources

Abisaab, Rula Jurdi. *Converting Persia: Religion and Power in the Safavid Empire*. London: I. B. Tauris, 2004.

Afshar, Iraj. "*Maktūb* and *Majmūʿa*: Essential Sources for Safavid Research." In *Society and Culture in the Early Modern Middle East: Studies on Iran in the Safavid Period*, edited by Andrew J. Newman, 51–61. Leiden: Brill, 2003.

Ahari, Zahra. "Khīyābān-i Chahārbāgh-i Iṣfahān, mafhūmī naw az fażā-yi shahrī." *Gulistān-i Hunar* 5 (2006): 48–59.

———. *Maktab-i Iṣfahān dar shahrsāzī: Dastūr-i zabān-i ṭarrāḥī-yi shālūda-yi shahrī*. Tehran: Vizarat-i Farhang, 1385 [2006].

———. *Maktab-i Isfahān dar shahrsāzī: Zabānshināsī-i ʿanāṣir va faẓāhā-yi shahrī*. Tehran: Danishgah-i Hunar, 1380 [2001].

Ahmadi, Nozhat. "Chahār vaqfnāma az madāris-i dawra-yi Ṣafavī." In *Dar bāb-i awqāf-i Ṣafavī: Majmūʿa-yi maqālāt*, 85–127. Tehran: Majlis-i Shawra-yi Islami, 2011.

Alemi, Mahvash. "Bāghhā-yi shahrī-yi ʿahd-i Ṣafavī va ravābiṭ-i ānhā bā shahr." *Miʿmārī va shahrsāzī* 42/43 (1377 [1998]).

———. "Chahar Bagh." *Environmental Design* 1 (1986): 38–45.

———. "The Garden City of Shah Tahmasb Reflected in the Words of His Poet and Painter." In *Interlacing Words and Things: Bridging the Nature-Culture Opposition in Gardens and Landscape*, edited by Stephen Bann, 95–113. Washington, DC: Dumbarton Oaks, 2012.

———. "Giardini reali e disegno del paesaggio ad Esfahan e nel territorio iraniano alla luce dei documenti inediti di Pascal Coste." *Opus: Quaderno di storia dell'architettura e restauro* 7 (2003): 411–24.

———. "Il giardino persiano: Tipi e modelli." In *Il giardino islamico: Architettura, natura, paesaggio*, edited by Attilio Petruccioli, 39–62. Milan: Electa, 1994.

———. "The Royal Gardens of the Safavid Period: Types and Models." In *Gardens in the Time of the Great Muslim Empires: Theory and Design*, edited by Attilio Petruccioli, 72–96. Leiden: Brill, 1997.

———. "Safavid Royal Gardens and Their Urban Relations." In *A Survey of Persian Art*, vol. 18, edited by Abbas Daneshvari and Jay Gluck, 1–24. Costa Mesa, CA: Mazda, 2005.

———. "I 'teatri' di Shah Abbas nella Persia del XVII secolo dai disegni inediti del diario di Pietro Della Valle." *Storia della città* 46 (1988): 19–26.

———. "Urban Spaces as the Scene for the Ceremonies and Pastimes of the Safavid Court." *Environmental Design* 1–2 (1991): 98–107.

Algar, Hamid, and J. Burton-Page. "Niʿmat-Allāhiyya." In *EI2*.

Allen, Terry. *Timurid Herat*. Wiesbaden: Reichert, 1983.

Alter, Robert. *Imagined Cities: Urban Experience and the Language of the Novel*. New Haven: Yale University Press, 2005.

Amanat, Abbas. *Iran: A Modern History*. New Haven: Yale University Press, 2017.

———. "The Nuqtawi Movement of Mahmud Pisikhani and His Persian Cycle of Mystical Materialism." In *Mediaeval Ismaʿili History and Thought*, edited by Farhad Daftary, 281–98. Cambridge: Cambridge University Press, 1996.

Arazi, A., and H. Ben-Shammay. "Risāla, v: Letters." In *EI2*.

Ardalan, Nader, and Laleh Bakhtiar. *The Sense of Unity: The Sufi Tradition in Persian Architecture*. Chicago: University of Chicago Press, 1973.

Aslanian, Sebouh David. *From the Indian Ocean to the Mediterranean: The Global Trade Networks of Armenian Merchants from New Julfa*. Berkeley: University of California Press, 2011.

Atkinson, Niall. *The Noisy Renaissance: Sound, Architecture, and Florentine Urban Life*. University Park: Pennsylvania State University Press, 2016.

Aubin, Jean. "Chiffres de population urbaine en Iran occidental autour de 1500." *Moyen Orient & Océan Indien* 3 (1986): 37–54.

Babaie, Sussan. "Building on the Past: The Shaping of Safavid Architecture, 1501–76." In *Hunt for Paradise: Court Arts of Safavid Iran, 1501–1576*, edited by Jon Thompson and Sheila R. Canby, 27–47. London: Thames & Hudson, 2003.

———. "Frontiers of Visual Taboo: Painted 'Indecencies' in Isfahan." In *Eros and Sexuality in Islamic Art*, edited by Francesca Leoni and Mika Natif, 131–56. Burlington, VT: Ashgate, 2013.

———. *Isfahan and Its Palaces: Statecraft, Shiʿism, and the Architecture of Conviviality in Early Modern Iran*. Edinburgh: Edinburgh University Press, 2008.

———. "Sacred Sites of Kingship: The Maydan and Mapping the Spatial-Spiritual Vision of the Empire in Safavid Iran." In *Persian Kingship and Architecture: Strategies of Power in Iran from the Achaemenids to the Pahlavis*, edited by Sussan Babaie and Talinn Grigor, 175–218. London: I. B. Tauris, 2015.

———. "Visual Vestiges of Travel: Persian Windows on European Weaknesses." *Journal of Early Modern History* 13, no. 2 (2009): 105–36.

Babaie, Sussan, Kathryn Babayan, Ina Baghdiantz-McCabe, and Massumeh Farhad. *Slaves of the Shah: New Elites of Safavid Iran*. London: I. B. Tauris, 2004.

Babashahi, Maryam. "Barrasī-yi manābiʿ-i tārīkhī dar murid-i banā-yi Tālār-i Taymūrī." *Aṣar* 3, nos. 7–9 (1982): 187–231.

Babayan, Kathryn. *The City as Anthology: Eroticism and Urbanity in Early Modern Isfahan*. Stanford: Stanford University Press, 2021.

———. *Mystics, Monarchs, and Messiahs: Cultural Landscapes of Early Modern Iran*. Cambridge: Center for Middle Eastern Studies of Harvard University, 2003.

Bakhtiar, Ali. "The Royal Bazaar of Isfahan." *Iranian Studies* 7, nos. 1–2 (1974): 320–47.

Barthes, Roland. *The Eiffel Tower and Other Mythologies*. Translated by Richard Howard. Berkeley: University of California Press, 1997.

———. "The Reality Effect." In *The Rustle of Language*, translated by Richard Howard, 141–48. New York: Hill & Wang, 1986.

———. "Semiology and the Urban." In *Rethinking Architecture: A Reader in Cultural Theory*, edited by Neil Leach, 166–72. London: Routledge, 1997.

Baudelaire, Charles. "The Painter of Modern Life." In *Baudelaire: Selected Writings on Art and Literature*, translated and edited by P. E. Charvet, 390–435. London: Penguin Books, 1992.

Baxandall, Michael. *The Limewood Sculptors of Renaissance Germany*. New Haven: Yale University Press, 1980.

———. *Painting and Experience in Fifteenth Century Italy: A Primer in the Social History of Pictorial Style.* Oxford: Oxford University Press, 1974.

Beaudouin, Eugène-Elie. "Ispahan sous les grands chahs (XVIIᵉ siècle)." *Urbanisme, revue mensuelle de l'urbanisme français* 2, no. 10 (1933).

Beazley, Elisabeth. "The Pigeon Towers of Iṣfahān." *Iran* 4 (1966): 105–9.

Beelaert, Anna Livia Fermina Alexandra. *A Cure for the Grieving: Studies on the Poetry of the 12th-Century Persian Court Poet Khāqānī Širwānī.* Leiden: Nederlands Instituut voor het Nabije Oosten, 2000.

Benjamin, Walter. *The Arcades Project.* Translated by Howard Eiland and Kevin McLaughlin. Cambridge: Belknap Press of Harvard University Press, 1999.

———. *Charles Baudelaire: A Lyric Poet in the Era of High Capitalism.* Translated by Harry Zohn. London: Verso, 1997.

———. "On Some Motifs in Baudelaire." In *Illuminations: Essays and Reflections*, translated by Harry Zohn and edited by Hannah Arendt, 155–200. New York: Schocken Books, 1968. Reprint, 2007.

———. *Reflections: Essays, Aphorisms, Autobiographical Writings.* Translated by Edmund Jephcott. New York: Schocken Books, 1978.

Bernardini, Michele. "The *masnavī-shahrāshūb*s as Town Panegyrics: An International Genre in Islamic Mashriq." In *Narrated Space in the Literature of the Islamic World*, edited by Roxane Haag-Higuchi and Christian Szyska, 81–94. Wiesbaden: Harrassowitz, 2001.

Blair, Sheila S. "Inscribing the Square: The Inscriptions on the Maidān-i Shāh in Iṣfahān." In *Calligraphy and Architecture in the Muslim World*, edited by Mohammad Gharipour and İrvin Cemil Schick, 13–28. Edinburgh: Edinburgh University Press, 2013.

Blake, Stephen P. *Half the World: The Social Architecture of Safavid Isfahan, 1590–1722.* Costa Mesa, CA: Mazda, 1999.

———. *Time in Early Modern Islam: Calendar, Ceremony, and Chronology in the Safavid, Mughal, and Ottoman Empires.* New York: Cambridge University Press, 2013.

Bloom, Jonathan A. *Minaret: Symbol of Islam.* Oxford: Oxford University Press, 1989.

Bonine, Michael E. "The Morphogenesis of Iranian Cities." *Annals of the Association of American Geographers* 69, no. 2 (1979): 208–24.

Bosworth, C. E., and J. Burton Page. "Naḳīb." In *EI2.*

Boutin, Aimée. "Rethinking the Flâneur: Flânerie and the Senses." *Dix-neuf* 16, no. 2 (2012): 124–32.

Braudel, Fernand. *The Mediterranean and the Mediterranean World in the Age of Philip II.* Translated by Siân Reynolds. 2 vols. Berkeley: University of California Press, 1995.

Brignoli, Jean-Dominique. "Les palais royaux safavides (1501–1722): Architecture et pouvoir." 4 vols. PhD diss., Université d'Aix-Marseille I, 2009.

———. "Pascal Coste et la Perse: L'apport des dessins d'un orientaliste à la recherche sur l'architecture palatiale; Le cas d'Isfahan." In *L'Orient des architectes*, edited by Nathalie Bertrand, 33–50. Aix-en-Provence: Université de Provence, 2006.

Calmard, Jean. "Shi'i Rituals and Power, II: The Consolidation of Safavid Shi'ism; Folklore and Popular Religion." In Melville, *Safavid Persia*, 139–90.

Canby, Sheila R. *The Golden Age of Persian Art, 1501–1722.* New York: Harry N. Abrams, 2000.

———. *The Rebellious Reformer: The Drawings and Paintings of Riza-yi Abbasi of Isfahan.* London: Azimuth Editions, 1996.

———, ed. *Shah 'Abbas: The Remaking of Iran.* London: British Museum Press, 1999.

Carswell, John. *New Julfa: The Armenian Churches and Other Buildings.* Oxford: Clarendon Press, 1968.

Chatman, Seymour. *Story and Discourse: Narrative Structure in Fiction and Film.* Ithaca: Cornell University Press, 1978.

Clarke, Georgia, and Paul Crossley, eds. *Architecture and Language: Constructing Identity in European Architecture, c. 1000–c. 1650.* Cambridge: Cambridge University Press, 2000.

Clayer, Nathalie. "Tekke." In *EI2.*

Concina, Ennio. *A History of Venetian Architecture.* Translated by Judith Landry. Cambridge: Cambridge University Press, 1998.

Cowan, Alexander, and Jill Steward, eds. *The City and the Senses: Urban Culture Since 1500.* London: Routledge, 2007.

Dabir-Siyaqi, Muhammad. "Khīyābān." *Khurāsān-pazhūhī* 3, no. 1 (1379 [1990]): 199–208.

Dadlani, Chanchal B. *From Stone to Paper: Architecture as History in the Late Mughal Empire.* New Haven: Yale University Press, 2018.

Danishpazhuh, Muhammad Taqi. *Fihrist-i nuskhahā-yi khaṭṭī, Kitābkhāna-yi Markazī va Markaz-i Asnād-i Dānishgāh-i Tehran.* 18 vols. Tehran: Danishgah-i Tehran, 1332–64 [1953–85].

de Bruijn, J. T. P. "Beloved." In *EIr.*

de Certeau, Michel. *The Practice of Everyday Life.* Translated by Steven Rendall. Berkeley: University of California Press, 1984.

Dihkhuda, Ali Akbar. *Lughatnāma.* Edited by Muhammad Mu'in and Ja'far Shahidi. 15 vols. Tehran: Danishgah-i Tehran, 1372–73 [1993–94]. Available online at https://dehkhoda.ut.ac.ir/fa/dictionary.

Dohrn–van Rossum, Gerhard. *History of the Hour: Clocks and Modern Temporal Orders.* Translated by Thomas Dunlap. Chicago: University of Chicago Press, 1996.

D'Souza, Aruna, and Tom McDonough, eds. *The Invisible Flâneuse? Gender, Public Space, and Visual Culture in Nineteenth-Century Paris.* Manchester: Manchester University Press, 2006.

Durand-Guédy, David. *Iranian Elites and Turkish Rulers: A History of Iṣfahān in the Saljūq Period.* London: Routledge, 2010.

———. "Isfahan During the Turko-Mongol Period (11th–15th Centuries)." *Eurasian Studies* 16 (2018): 253–312.

———. "Location of Rule in a Context of Turko-Mongol Domination." In *Turko-Mongol Rulers, Cities and City Life*, edited by David Durand-Guédy, 1–20. Leiden: Brill, 2013.

Duva, Federica. "Gay in the Sasanian Period: Some Preliminary Notes on Its Circular Urban Plan." *Vicino Oriente* 22 (2018): 163–76.

Emami, Farshid. "All the City's Courtesans: A Now-Lost Safavid Pavilion and Its Figural Tile Panels." *Metropolitan Museum Journal* 54 (2019): 62–86.

———. "Coffeehouses, Urban Spaces, and the Formation of a Public Sphere in Safavid Isfahan." *Muqarnas* 33 (2016): 177–220.

———. "Discursive Images and Urban Itineraries: Literary Form and City Experience in Early Modern Iran." *Journal for Early Modern Cultural Studies* 18, no. 3 (2018): 154–86.

———. "Inviolable Thresholds, Blessed Palaces, and Holy Friday Mosques: The Sacred Topography of Safavid Isfahan." In *The Friday Mosque in the City: Liminality, Ritual, and Politics*, edited by A. Hilâl Uğurlu and Suzan Yalman, 159–95. Bristol: Intellect, 2020.

———. "Religious Architecture of Safavid Iran." In *The Religious Architecture of Islam*, edited by Hasan-Uddin Khan and Kathryn Blair Moore, vol. 1, *Asia and Australia*, 256–73. Turnhout: Brepols, 2021.

———. "Royal Assemblies and Imperial Libraries: Polygonal Pavilions and Their Functions in Mughal and Safavid Architecture." *South Asian Studies* 35, no. 1 (2019): 63–81.

Emrani, Seyed Mohammad Ali. "The Role of Gardens and Tree-Lined Streets in the Urban Development of Safavid Isfahan (1590–1722)." PhD diss., Technische Universität, Munich, 2012.

Falsafi, Nasrullah. *Zindigānī-yi Shāh ʿAbbās-i avval*. 5 vols. Tehran: Ilmi, 1364 [1985].

Farhad, Massumeh. "An Artist's Impression: Muʿin Musavvir's *Tiger Attacking a Youth*." *Muqarnas* 9 (1992): 116–23.

———. "Safavid Single Page Painting, 1629–1666." 2 vols. PhD diss., Harvard University, 1987.

Ferguson, Priscilla Parkhurst. *Paris as Revolution: Writing the Nineteenth-Century City*. Berkeley: University of California Press, 1994.

Ferrante, Mario. "Čihil Sutūn: Études, relevés, restaurations." In Zander, *Travaux de restauration*, 293–322.

———. "Notes graphiques sur des monuments islamiques de la règion d'Ispahan: Le pavillon des Hašt Bihišt, ou les Huit Paradis, a Ispahan ; Relevés et problèmes s'y rattachant." In Zander, *Travaux de restauration*, 399–420.

———. "Quelques précisions graphiques au sujet des ponts séfévides d'Isfahan." In Zander, *Travaux de restauration*, 441–64.

Firby, Nora Kathleen. *European Travellers and Their Perceptions of Zoroastrians in the 17th and 18th Centuries*. Berlin: D. Reimer, 1988.

Flannery, John M. *The Mission of the Portuguese Augustinians to Persia and Beyond (1602–1747)*. Leiden: Brill, 2013.

Floor, Willem M. "Clocks." In *EIr*.

———. *The Economy of Safavid Persia*. Wiesbaden: Reichert, 2000.

———. "The Gates of Isfahan in the Safavid and Qajar Periods." *Studia Iranica* 49, no. 2 (2020): 243–74.

———. *The Persian Gulf: A Political and Economic History of Five Port Cities, 1500–1730*. Washington, DC: Mage, 2006.

———. *Safavid Government Institutions*. Costa Mesa, CA: Mazda, 2001.

———. "The Talar-i Tavila or Hall of Stables, a Forgotten Safavid Palace." *Muqarnas* 19 (2002): 149–63.

Floor, Willem M., and Edmund Herzig, eds. *Iran and the World in the Safavid Age*. London: I. B. Tauris, 2012.

Foucault, Michel. *Discipline and Punish: The Birth of the Prison*. Translated by Alan Sheridan. New York: Vintage Books, 1977.

Galdieri, Eugenio. *Eṣfahān, ʿĀlī Qāpū: An Architectural Survey*. Rome: IsMEO, 1979.

———. *Isfahān: Masǧid-i Ǧumʿa*. 3 vols. Rome: IsMEO, 1972–84.

———. "Relecture d'une gravure allemande du XVIIᵉᵐᵉ siècle comme introduction à une recherche archéologique." *Archäologische Mitteilungen aus Iran* 6 (1979): 560–70.

———. "Two Building Phases of the Time of Šāh ʿAbbās I in the Maydān-i Šāh of Isfahan: Preliminary Note." *East and West* 20, nos. 1–2 (1970): 60–69.

Galdieri, Eugenio, and Roberto Orazi. *Progetto di sistemazione del Maydān-i Šāh*. Rome: IsMEO, 1969.

Gangler, Anette, Heinz Gaube, and Attilio Petruccioli. *Bukhara, the Eastern Dome of Islam: Urban Development, Urban Space, Architecture, and Population*. Stuttgart: Menges, 2004.

Garrioch, David. "Sounds of the City: The Soundscape of Early Modern European Towns." *Urban History* 30, no. 1 (2003): 5–25.

Gaube, Heinz. *Iranian Cities*. New York: New York University Press, 1979.

———. "Iranian Cities." In Jayyusi et al., *City in the Islamic World*, 1:159–80.

Gaube, Heinz, and Rüdriger Klein. "Das safavidische Isfahan." Map. In *Tübinger Atlas des Vorderen Orients*, vol. 6, pt. B VII, 14.5. Wiesbaden: L. Reichert, 1986.

Gaube, Heinz, and Eugen Wirth. *Der Bazar von Isfahan*. Wiesbaden: L. Reichert, 1978.

Gharipour, Mohammad, and Rafael Sedighpour. "Synagogues of Isfahan: The Architecture of Resignation and Integration." In *Sacred Precincts: The Religious Architecture of Non-Muslim Communities Across the Islamic World*, edited by Mohammad Gharipour, 178–202. Leiden: Brill, 2015.

Ghereghlou, Kioumars. "On the Margins of Minority Life: Zoroastrians and the State in Safavid Iran." *Bulletin of the School of Oriental and African Studies* 80, no. 1 (2017): 45–71.

———. "Zaynab Begum." In *EIr*.

Ghougassian, Vazken S. *The Emergence of the Armenian Diocese of New Julfa in the Seventeenth Century*. Atlanta, GA: Scholars Press, 1998.

Godard, André. "Iṣfahān." *Athār-é Īrān, annales du service archéologique de l'Īrān* 2, no. 1 (1937): 7–176.

Golombek, Lisa. "The Anatomy of a Mosque." In *Iranian Civilization and Culture*, edited by Charles J. Adams, 5–11. Montreal: McGill University, Institute of Islamic Studies, 1973.

———. "The Gardens of Timur: New Perspectives." *Muqarnas* 12 (1995): 137–47.

———. "Urban Patterns in Pre-Safavid Isfahan." *Iranian Studies* 7, nos. 1–2 (1974): 18–44.

Golombek, Lisa, and Ebba Koch. "The Mughals, Uzbeks, and the Timurid Legacy." In *A Companion to Islamic Art and Architecture*, edited by Finbarr Barry Flood and Gülru Necipoğlu, 2:811–45. Hoboken, NJ: Wiley-Blackwell, 2017.

Grabar, Oleg. *The Great Mosque of Isfahan*. New York: New York University Press, 1990.

Grabar, Oleg, and Cynthia Robinson, eds. *Islamic Art and Literature*. Princeton: Markus Wiener, 2001.

Guattari, Félix. *The Three Ecologies*. Translated by Ian Pindar and Paul Sutton. London: Continuum, 2000.

Gulchin Maʿani, Ahmad. *Maktab-i vuqūʿ dar shiʿr-i Fārsī*. Mashhad: Danishgah-i Firdawsi, 1375 [1996].

———. *Shahrāshūb dar shiʿr-i Fārsī*. Edited by Parviz Gulchin Maʿani. Tehran: Rivayat, 1380 [2001].

Habibi, Seyed Mohsen. *Az shār tā shahr: Taḥlīlī tarīkhī az mafhūm-i shahr va sīmā-yi kālbadī-yi ān*. Tehran: Danishgah-i Tehran, 1378 [1999].

Haji-Qassemi, Kambiz, ed. *Ganjname, Cyclopaedia of Iranian Islamic Architecture*. 20 vols. Tehran: Danishgah-i Shahid Bihishti, 1996–.

Hakhnazarian, Armen, and Vahan Mehrabian. *Nor/Djulfa*. Venice: OEMME, 1991.

Hamadeh, Shirine. *The City's Pleasures: Istanbul in the Eighteenth Century*. Seattle: University of Washington Press, 2008.

Hamon, Philippe. *Expositions: Literature and Architecture in Nineteenth-Century France*. Translated by Katia Sainson-Frank and Lisa Maguire. Berkeley: University of California Press, 1992.

Haneda, Masashi. "The Character of the Urbanization of Isfahan in the Later Safavid Period." In Melville, *Safavid Persia*, 369–87.

———. "Maydan et Bagh: Reflexion à propos de l'urbanisme du Šah ʿAbbas." In *Documents et archives provenant de l'Asie Centrale: Actes du colloque franco-japonais, Kyoto*, edited by Akira Haneda, 87–99. Kyoto: Association franco-japonaise des études orientales, 1990.

Haneda, Masashi, and Rudi Matthee. "Isfahan, vii: Safavid Period." In *EIr*.

Havik, Klaske, Jorge Mejía Hernández, Susana Oliveira, Mark Proosten, and Mike Schäfer, eds. *Writingplace: Investigations in Architecture and Literature*. Rotterdam: nai010, 2016.

Herzig, Edmund M. "The Armenian Merchants of New Julfa, Isfahan: A Study in Pre-modern Asian Trade." PhD diss., University of Oxford, 1991.

———. "The Deportation of the Armenians in 1604–1605 and Europe's Myth of Shāh ʿAbbās I." In *History and Literature in Iran: Persian and Islamic Studies in Honour of P. W. Avery*, edited by Charles Melville, 59–71. London: British Academic Press, 1998.

Hillenbrand, Robert. "Safavid Architecture." In *The Cambridge History of Iran*, vol. 6, *The Timurid and Safavid Periods*, edited by Peter Jackson and Laurence Lockhart, 759–842. Cambridge: Cambridge University Press, 1986.

Holl, Steven, Juhani Pallasmaa, and Alberto Pérez-Gómez. *Questions of Perception: Phenomenology of Architecture*. 2nd ed. San Francisco: William Stout, 2006.

Holod, Renata, ed. *Studies on Isfahan: Proceedings of the Isfahan Colloquium Sponsored by the Fogg Museum of Art*. Chestnut Hill, MA: Society for Iranian Studies, 1974.

Höltzer, Ernst. *Hizār jilva-yi zindagī: Taṣvīrhā-yi Irnist Hūlstir az ʿahd-i Nāṣirī*. Tehran: Sazman-i Miras-i Farhangi, 1382 [2004].

———. *Persien vor 113 Jahren: Text und Bilder, 1. Teil, Esfahan*. Compiled and translated by Mohammad Assemi. Tehran: Kultur- und Kunstministeriums, Zentrum für die Persische Ethnologie, 1975.

Howes, David, ed. *The Varieties of Sensory Experience: A Sourcebook in the Anthropology of the Senses*. Toronto: University of Toronto Press, 1991.

Huff, Dietrich. "An Archaeological Survey in the Area of Firuzabad, Fars." In *Proceedings of the 2nd Annual Symposium on Archaeological Research in Iran . . . 1973*, edited by Firouz Bagherzadeh, 155–79. Tehran: Iranian Centre for Archaeological Research, 1974.

Huma'i Shirazi Isfahani, Jalal al-Din. *Tārīkh-i Iṣfahān: Abniyya va ʿimārāt*. Tehran: Pazhuhishgah-i ulum-i insani va mutalaʿat-i farhangi, 1390 [2011].

Hunarfar, Lutfullah. *Ganjīna-i āsār-i tārīkhī-yi Iṣfahān*. Isfahan: Saqafi, 1344 [1965].

———. "Tārīkh-i banā-yi pul-i Allāhverdī Khān." *Hunar va mardum* 109 (1971): 4–9.

Hutton, Deborah. *Art of the Court of Bijapur*. Bloomington: Indiana University Press, 2006.

Jafarian, Rasool. *Ṣafaviyya dar ʿarṣa-yi dīn, farhang, va siyāsat*. 3 vols. Qum: Pazhuhishkada-yi hawza va danishgah, 1379 [2000].

———. *Sīyāsat va farhang-i rūzgār-i Ṣafavī*. 2 vols. Tehran: Nashr-i ʿilm, 1388 [2009].

Javeri, Mohsen. "The Excavations of Atiq Square, Isfahan." In *ADAMJI Project: From the Excavation (1972–1978) to the Archive (2003–2010) in the Masjed-e Jom'e, Isfahan*, edited by Bruno Genito and Fariba Saiedi Anaraki, 117–22. Tehran: Embassy of Italy, 2011.

Jay, Martin. "Scopic Regimes of Modernity." In *Vision and Visuality*, edited by Hal Foster, 3–23. Seattle: Bay Press, 1988.

Jayyusi, Salma Khadra, Renata Holod, Attilio Petruccioli, and André Raymond, eds. *The City in the Islamic World*, 2 vols. Leiden: Brill, 2008.

Kafescioğlu, Çiğdem. *Constantinopolis/Istanbul: Cultural Encounter, Imperial Vision, and the Construction of the*

Ottoman Capital. University Park: Pennsylvania State University Press, 2009.

———. "Picturing the Square, Streets, and Denizens of Early Modern Istanbul: Practices of Urban Space and Shifts in Visuality." *Muqarnas* 37 (2020): 139–77.

Kamaly, Hossein. "Four Moments in the Early Islamic History of Isfahan." PhD diss., Columbia University, 2004.

Karamustafa, Ahmet T. "Antinomian Sufis." In *The Cambridge Companion to Sufism*, edited by Lloyd Ridgeon, 101–24. Cambridge: Cambridge University Press, 2015.

———. "Cosmographical Diagrams." In *Cartography in the Traditional Islamic and South Asian Societies*, edited by J. B. Harley and David Woodward, 71–89. Chicago: University of Chicago Press, 1992.

———. *God's Unruly Friends: Dervish Groups in the Islamic Later Middle Period, 1200–1550*. Salt Lake City: University of Utah Press, 1994.

———. "In His Own Voice: What Hatayi Tells Us About Şah İsmail's Religious Views." In *L'ésotérisme shi'ite: Ses racines et ses prolongements / Shi'i Esotericism: Its Roots and Developments*, edited by Mohammad Ali Amir-Moezzi, with Maria De Cillis, Daniel De Smet, and Orkhan Mir-Kasimov, 601–12. Turnhout: Brepols, 2016.

Karapetian, Karapet. *Isfahan, New Julfa: Le case degli armeni; Una raccolta di rilevamenti architettonici / The Houses of the Armenians; A Collection of Architectural Surveys*. Rome: IsMEO, 1974.

Keyvani, Mehdi. *Artisans and Guild Life in the Later Safavid Period: Contributions to the Social-Economic History of Persia*. Berlin: Klaus Schwarz, 1982.

Kheirandish, Elaheh. "From Maragha to Samarqand and Beyond: Revisiting a Quartet of Scientific Traditions in Greater Persia (ca. 1300s–1500s)." In *The Timurid Century*, edited by Charles Melville, 161–88. London: I. B. Tauris, 2020.

Khera, Dipti. *The Place of Many Moods: Udaipur's Painted Lands and India's Eighteenth Century*. Princeton: Princeton University Press, 2020.

Kleiss, Wolfram. "Die safavidischen Schlösser am Königsweg von Isfahan nach Farahabad/Ashraf am Kaspischen Meer." *Archäologische Mitteilungen aus Iran* 21 (1988): 223–32.

———. "Safavidische und qadjarische Brücken in Iran II." *Archäologische Mitteilungen aus Iran* 19 (1986): 313–38.

Kocks, F. H. *Esfahan Master Plan: Prepared for the City of Esfahan, Iran*. [Tehran]: United States Operations Mission to Iran, 1961.

Komaroff, Linda. "'A Thousand Designs for the Sake of the Bowl': A Wine Vessel with Persian Inscriptions at LACMA." *Artibus Asiae* 67, no. 1 (2007): 25–38.

Kostof, Spiro. *The City Shaped: Urban Patterns and Meanings Through History*. Boston: Bullfinch Press, 1991.

Kuehn, Sara. *The Dragon in Medieval East Christian and Islamic Art*. Leiden: Brill, 2011.

Kurz, Otto. *European Clocks and Watches in the Near East*. London: Warburg Institute, University of London, 1975.

Lambton, Ann K. S. "Naḳḳāra-Ḵẖāna." In *EI2*.

———. "The Regulation of the Waters of the Zāyande Rūd." *Bulletin of the School of Oriental Studies* 9, no. 3 (1938): 663–73.

Landau, Amy S. "European Religious Iconography in Safavid Iran: Decoration and Patronage of *Meydani* Bet'ghehem (Bethlehem of the Maydan)." In Floor and Herzig, *Iran and the World*, 425–46.

———. "Man, Mode, and Myth: Muhammad Zaman ibn Haji Yusuf." In *Pearls on a String: Artists, Patrons, and Poets at the Great Islamic Courts*, edited by Amy S. Landau, 166–203. Baltimore: Walters Art Museum, 2015.

Landau, Amy S., and Theo Maarten van Lint. "Armenian Merchant Patronage of New Julfa's Sacred Spaces." In *Sacred Precincts: The Religious Architecture of Non-Muslim Communities Across the Islamic World*, edited by Mohammad Gharipour, 308–33. Leiden: Brill, 2015.

Levend, Agâh Sırrı. *Türk Edebiyatında şehr-engizler ve şehr-engizlerde İstanbul*. Istanbul: Baha Matbaasi, 1957.

Losensky, Paul E. "Coordinates in Space and Time: Architectural Chronograms in Safavid Iran." In *New Perspectives on Safavid Iran: Empire and Society*, edited by Colin P. Mitchell, 198–219. New York: Routledge, 2011.

———. "'The Equal of Heaven's Vault': The Design, Ceremony, and Poetry of the Ḥasanābād Bridge." In *Writers and Rulers: Perspectives on Their Relationship from Abbasid to Safavid Times*, edited by Beatrice Grundler and Louise Marlow, 195–216. Wiesbaden: Reichert, 2004.

———. "The Palace of Praise and the Melons of Time: Descriptive Patterns in ʿAbdi Bayk Šīrāzī's Garden of Eden." *Eurasian Studies* 2, no. 1 (2003): 1–30.

———. "Poetics and Eros in Early Modern Persia: *The Lovers' Confection* and *The Glorious Epistle* by Muḥtasham Kāshānī." *Iranian Studies* 42, no. 5 (2009): 745–64.

———. *Welcoming Fighānī: Imitation and Poetic Individuality in the Safavid-Mughal Ghazal*. Costa Mesa, CA: Mazda, 1998.

Luschey, Heinz. "The Pul-i Khwājū in Isfahan: A Combination of Bridge, Dam, and Water Art." *Iran* 23 (1985): 143–51.

Luschey-Schmeisser, Ingeborg. *The Pictorial Tile Cycle of Hašt Behešt in Iṣfahān and Its Iconographic Tradition*. Rome: IsMEO, 1978.

Lynch, Kevin. *The Image of the City*. Cambridge, MA: Technology Press, 1960.

Mahmoudian, Safa, and Mehrdad Qayyoomi Bidhendi. "The Norm of *Mādī*: Managing Water in Safavid Isfahan." In *Beiträge zur Islamischen Kunst und Archäologie*, vol. 5, edited by Markus Ritter und Ilse Sturkenboom, 57–69. Wiesbaden: Dr. Ludwig Reichert, 2017.

Mancini-Lander, Derek J. "Subversive Skylines: Local History and the Rise of the Sayyids in Mongol Yazd." *Bulletin of the School of Oriental and African Studies* 82, no. 1 (2019): 1–24.

Marefat, Roya. "Beyond the Architecture of Death: The Shrine of the Shah-i Zinda in Samarqand." PhD diss., Harvard University, 1991.

Matini, Jalal. "Khīyābān." *Irān nāma, majalla-yi taḥqīqāt-i Irānshināsī* 1, nos. 1–2 (1361 [1982]): 57–99.

Matthee, Rudi. *Persia in Crisis: Safavid Decline and the Fall of Isfahan.* London: I. B. Tauris, 2012.

———. *The Politics of Trade in Safavid Iran: Silk for Silver, 1600–1730.* Cambridge: Cambridge University Press, 1999.

———. "Prostitutes, Courtesans, and Dancing Girls: Women Entertainers in Safavid Iran." In *Iran and Beyond: Essays in Middle Eastern History in Honor of Nikki R. Keddie*, edited by Rudi Matthee and Beth Baron, 121–50. Costa Mesa, CA: Mazda, 2000.

———. *The Pursuit of Pleasure: Drugs and Stimulants in Iranian History, 1500–1900.* Princeton: Princeton University Press, 2005.

———. "The Safavids Under Western Eyes: Seventeenth-Century European Travelers to Iran." *Journal of Early Modern History* 13, no. 2 (2009): 137–71.

———. "A Safe Space for the Shah and His Women: The Practice of Quruq in the Safavid Period." *Studia Litteraria Universitatis Iagellonicae Cracoviensis* 14 (2019): 113–33.

Matthee, Rudi, and Jorge Flores, eds. *Portugal, the Persian Gulf, and Safavid Persia.* Leuven: Peeters, 2011.

Mawer, Caroline. "Shah ʿAbbās and the Pilgrimage to Mashhad." *Iran* 49 (2011): 123–47.

McChesney, Robert D. "Economic and Social Aspects of the Public Architecture of Bukhara in the 1560's and 1570's." *Islamic Art* 2 (1987): 217–42.

———. "Four Sources on Shah ʿAbbas's Building of Isfahan." *Muqarnas* 5 (1988): 103–34.

———. "Postscript to 'Four Sources on Shah ʿAbbas's Building of Isfahan.'" *Muqarnas* 8 (1991): 137–38.

———. "Waqf and Public Policy: The Waqfs of Shah ʿAbbas, 1011–1023/1602–1614." *Asian and African Studies* 15 (1981): 165–90.

Meisami, Julie Scott. "The Body as Garden: Nature and Sexuality in Persian Poetry." *Edebiyât* 6, no. 2 (1995): 245–74.

———. "Mixed Prose and Verse in Medieval Persian Literature." In *Prosimetrum: Crosscultural Perspectives on Narrative in Prose and Verse*, edited by Joseph Harris and Karl Reichl, 295–319. Cambridge: D. S. Brewer, 1997.

———. "The Palace-Complex as Emblem: Some Samarran Qaṣīdas." In *A Medieval Islamic City Reconsidered: An Interdisciplinary Approach to Samarra*, edited by Chase F. Robinson, 69–78. Oxford: Oxford University Press, 2001.

———. "Palaces and Paradises: Palace Description in Medieval Persian Poetry." In Grabar and Robinson, *Islamic Art and Literature*, 21–54.

Melville, Charles. "From Qars to Qandahar: The Itineraries of Shah ʿAbbas I (995–1038/1587–1629)." In *Études safavides*, edited by Jean Calmard, 195–224. Paris: Institut français de recherche en Iran, 1993.

———. "A Mechanical Clock in Kashan in the Early 17th Century." *Studia Litteraria Universitatis Iagellonicae Cracoviensis* 14 (2019): 135–41.

———. "New Light on Shah ʿAbbas and the Construction of Isfahan." *Muqarnas* 33 (2016): 155–76.

———, ed. *Safavid Persia: The History and Politics of an Islamic Society.* London: I. B. Tauris, 1996.

———. "Shah ʿAbbas and the Pilgrimage to Mashhad." In Melville, *Safavid Persia*, 191–229.

Melvin-Koushki, Matthew. "Early Modern Islamicate Empire: New Forms of Religiopolitical Legitimacy." In *The Wiley Blackwell History of Islam*, edited by Armando Salvatore, Roberto Tottoli, and Babak Rahimi, 353–75. Hoboken: John Wiley & Sons, 2018.

Merleau-Ponty, Maurice. *Phenomenology of Perception.* Translated by Donald A. Landes. New York: Routledge, 2012.

Mihryar, Muhammad. "Iṣfahān dar hizār sāl-i pīsh." *Farhang-i Isfahān* 35 (2007): 30–41.

Mihryar, Muhammad, Shamil Fath Allah'yuf, Farhad Fakhar Tehrani, and Bahram Qadiri. *Asnād-i taṣvīrī-yi shahrhā-yi Irān, dawra-yi Qājār.* Tehran: Danishgah-i Shahid Bihishti, Sazman-i Miras-i Farhangi, 1378 [1999].

Ministry of Culture and Arts of Iran. *Isfahan, City of Light.* Tehran: Ministry of Culture and Arts of Iran, 1976.

Minorsky, V. "The Poetry of Shāh Ismāʿīl I." *Bulletin of the School of Oriental and African Studies* 10, no. 4 (1942): 1006a–53a.

Mirjafari, Hossein, and J. R. Perry. "The Ḥaydarī-Niʿmatī Conflicts in Iran." *Iranian Studies* 12 (1979): 135–62.

Mitchell, Colin P. *The Practice of Politics in Safavid Iran: Power, Religion, and Rhetoric.* London: I. B. Tauris, 2009.

Mohebbi, Parviz. "Hafez Esfahani." In *EIr.*

Morgan, Peter H. "Some Remarks on a Preliminary Survey in Eastern Fars." *Iran* 41 (2003): 323–38.

Muraro, Michelangelo. "The Moors of the Clock Tower of Venice and Their Sculptor." *Art Bulletin* 66, no. 4 (1984): 603–9.

Necipoğlu, Gülru. *The Age of Sinan: Architectural Culture in the Ottoman Empire.* London: Reaktion, 2005.

———. "Framing the Gaze in Ottoman, Safavid, and Mughal Palaces." *Ars Orientalis* 23 (1993): 303–42.

———. "The Scrutinizing Gaze in the Aesthetics of Islamic Visual Cultures: Sight, Insight, and Desire." *Muqarnas* 32 (2015): 23–61.

———. *The Topkapı Scroll: Geometry and Ornament in Islamic Architecture.* Santa Monica, CA: Getty Center for the History of Art and the Humanities, 1995.

Newman, Andrew J. *Safavid Iran: Rebirth of a Persian Empire.* London: I. B. Tauris, 2006.

Norberg-Schulz, Christian. *Genius Loci: Towards a Phenomenology of Architecture.* New York: Rizzoli, 1980.

Northedge, Alastair. *The Historical Topography of Samarra.* London: British School of Archaeology in Iraq, 2005.

Nurbakhsh, Muhammad Riza. "Sāʿat-i mikānīkī dar Irān." *Āyanda* 13 (1366 [1987]): 395–408.

Pallasmaa, Juhani. *The Eyes of the Skin: Architecture and the Senses*. London: Academy Editions, 1996.

Perry, John R. "Cultural Currents in the Turco-Persian World of Safavid and Post-Safavid Times." In *New Perspectives on Safavid Iran: Empire and Society*, edited by Colin P. Mitchell, 84–96. New York: Routledge, 2011.

———. "Toward a Theory of Iranian Urban Moieties: The Ḥaydariyyah and Niʿmatiyyah Revisited." *Iranian Studies* 32, no. 1 (1999): 51–70.

Petruccioli, Attilio. *Fatehpur Sikri*. Berlin: Ernst & Sohn, 1992.

Pfeiffer, Judith. "Confessional Ambiguity vs. Confessional Polarization: Politics and the Negotiation of Religious Boundaries in the Ilkhanate." In *Politics, Patronage, and the Transmission of Knowledge in 13th–15th Century Tabriz*, edited by Judith Pfeiffer, 129–67. Leiden: Brill, 2014.

Promey, Sally M., ed. *Sensational Religion: Sensory Cultures in Material Practice*. New Haven: Yale University Press, 2014.

Purjavadi, Nasrullah. *Zabān-i ḥāl dar ʿirfān va adabīyyāt-i Pārsī*. Tehran: Hermes, 1385 [2006].

Quinn, Sholeh A. "Rewriting Nimatallahi History in Safavid Chronicles." In *The Heritage of Sufism*, vol. 3, *Late Classical Persianate Sufism (1501–1750), the Safavid and Mughal Period*, edited by Leonard Lewisohn and David Morgan, 201–22. Oxford: Oneworld, 1999.

———. *Shah ʿAbbas: The King Who Refashioned Iran*. London: Oneworld, 2015.

Quiring-Zoche, Rosemarie. *Isfahan im 15. und 16. Jahrhundert*. Freiburg: Schwarz, 1980.

Rafiʿi Mihrabadi, Abu al-Qasim. *Āsār-i millī-yi Iṣfahān*. Tehran: Anjuman-i asar-i milli, 1352 [1974].

Rahimi, Babak. "The Rebound Theater State: The Politics of the Safavid Camel Sacrifice Rituals, 1598–1695 C.E." *Iranian Studies* 37, no. 3 (2004): 451–78.

Rajaei, Abdol Mahdi. *Taḥavvulāt-i ʿumrān va mudīrīyat-i shahrī-i Iṣfahān dar dawra-yi Pahlavī-i avval (1300–1320)*. Isfahan: Sazman-i farhangi-tafrihi-yi shahrdari-yi Isfahan, 1387 [2008].

———. *Tārīkh-i ijtimāʿī-yi Iṣfahān dar ʿaṣr-i Ẓill al-Sulṭān: Az nigāh-i rūznāma-yi Farhang-i Iṣfahān*. Isfahan: Danishgah-i Isfahan, 2004.

Ridgeon, Lloyd. "The Controversy of Shaykh Awḥad Al-Dīn Kirmānī and Handsome, Moon-Faced Youths: A Case Study of *Shāhid-Bazi* in Medieval Sufism." *Journal of Sufi Studies* 1, no. 1 (2012): 3–30.

———. "Short Back and Sides: Were the Qalandars of Late Safavid Iran Domesticated?" *Journal of Sufi Studies* 6, no. 1 (2017): 82–115.

Rieu, Charles. *Supplement to the Catalogue of the Persian Manuscripts in the British Museum*. London: British Museum, 1895. Reprint, London: British Museum Publications for the British Library, 1977.

Ritter, Markus. "Das königliche Portal und die Nordseite des Maidāns von Shah ʿAbbās I. im safawidischen Iṣfahān." In *Iran und iranisch geprägte Kulturen: Studien zum 65. Geburtstag von Bert G. Fragner*, edited by Markus Ritter, Ralph Kauz, and Birgitt Hofmann, 357–76. Wiesbaden: Dr. Ludwig Reichert, 2008.

———. "Monumental Epigraphy in Iran: Paired Panels with Square Kufic Script and Saʿdī Verses in Safavid and Previous Islamic Architecture." *Eurasian Studies* 8, nos. 1–2 (2010): 51–71.

———. "Zum Siegesmonument in islamischer Kunst: Schlachtenbild und Trophäen an einem Portal im safawidischen Isfahan, Iran 17. Jahrhundert." In *Inszenierung des Sieges—Sieg der Inszenierung: Interdisziplinäre Perspektiven*, edited by Michaela Fahlenbock, Lukas Madersbacher, and Ingo Schneider, 181–98. Innsbruck: StudienVerlag, 2011.

Rizvi, Kishwar, ed. *Affect, Emotion, and Subjectivity in Early Modern Muslim Empires: New Studies in Ottoman, Safavid, and Mughal Art and Culture*. Leiden: Brill, 2018.

———. "Architecture and the Representations of Kingship During the Reign of the Safavid Shah ʿAbbas I." In *Every Inch a King: Comparative Studies on Kings and Kingship in the Ancient and Medieval Worlds*, edited by Lynette Mitchell and Charles Melville, 371–97. Leiden: Brill, 2013.

Rizvi, Sajjad, and Prashant Keshavmurthy. "Introduction: Framing Bedil, Arguing the Indo-Persian Self." *Journal of South Asian Intellectual History* 2, no. 1 (2020): 3–12.

Robinson, Cynthia. *In Praise of Song: The Making of Courtly Culture in Al-Andalus and Provence, 1005–1134 A.D.* Leiden: Brill, 2002.

Roemer, Hans R. "Inshāʾ." In *EI2*.

———. "The Safavid Period." In *The Cambridge History of Iran*, vol. 6, *The Timurid and Safavid Periods*, edited by Peter Jackson and Laurence Lockhart, 189–350. Cambridge: Cambridge University Press, 1986.

Roxburgh, David J. *Prefacing the Image: The Writing of Art History in Sixteenth-Century Iran*. Leiden: Brill, 2001.

———. "Ruy González de Clavijo's Narrative of Courtly Life and Ceremony in Timur's Samarqand, 1404." In *The "Book" of Travels: Genre, Ethnology, and Pilgrimage, 1250–1700*, edited by Palmira Brummet, 113–58. Leiden: Brill, 2009.

Ruggles, D. Fairchild. "Humayun's Tomb and Garden: Typologies and Visual Order." In *Gardens in the Time of the Great Muslim Empires: Theory and Design*, edited by Attilio Petruccioli, 173–86. Leiden: Brill, 1997.

———. *Islamic Gardens and Landscapes*. Philadelphia: University of Pennsylvania Press, 2008.

———. "Making Vision Manifest: Frame, Screen, and View in Islamic Culture." In *Sites Unseen: Landscape and Vision*, edited by Dianne Harris and D. Fairchild Ruggles, 131–56. Pittsburgh: University of Pittsburgh Press, 2007.

Saeednia, Ahmad. "Rāz-i sang-i sāʿat-i Masjid-i Imām (Shah ʿAbbāsī) Iṣfahān." *Hunarhā-yi Zībā* 35 (1387 [2008]): 5–14.

Sardar, Marika. "The Circular Cities of the Deccan." In *The Visual World of Muslim India: The Art, Culture, and*

Society of the Deccan in the Early Modern Era, edited by Laura E. Parodi, 3–30. London: I. B. Tauris, 2014.

Sarre, Friedrich Paul Theodor. *Denkmäler persischer Baukunst: Geschichtliche Untersuchung und Aufnahme muhammedanischer Backsteinbauten in Vorderasien und Persien*. Berlin: E. Wasmuth, 1901–10.

Savory, Roger. *Iran Under the Safavids*. Cambridge: Cambridge University Press, 1980.

———. "The Principal Offices of the Ṣafawid State During the Reign of Ṭahmāsp I (930–84/1524–76)." *Bulletin of the School of Oriental and African Studies* 24, no. 1 (1961): 65–85.

Sayılı, Aydin. *The Observatory in Islam and Its Place in the General History of the Observatory*. Ankara: Türk Tarih Kurumu, 1991.

Schimmel, Annemarie. *A Two-Colored Brocade: The Imagery of Persian Poetry*. Chapel Hill: University of North Carolina Press, 1992.

Schmarsow, August. "The Essence of Architectural Creation." In *Empathy, Form, and Space: Problems in German Aesthetics, 1873–1893*, translated and edited by Harry Francis Mallgrave and Eleftherios Ikonomou, 281–97. Santa Monica, CA: Getty Center for the History of Art and the Humanities, 1994.

Seamon, David. "A Way of Seeing People and Place: Phenomenology in Environment-Behavior Research." In *Theoretical Perspectives in Environment-Behavior Research*, edited by Seymour Wapner, Jack Demick, Takiji Yamamoto, and Hirofumi Minami, 157–78. New York: Plenum, 2000.

Shafaghi, Sirus. *Jughrāfiyā-yi Iṣfahān*. Isfahan: Danishgah-i Isfahan, 1381 [2003].

Shafi'i Kadkani, Muhammad Reza. *Qalandariyya dar tārīkh*. Tehran: Sukhan, 1386 [2007].

Shahidi Marnani, Nazanin. "Bāgh-i Saʿādatābād-i Iṣfahān dar āyīna-yi maṣnavī-yi Gulzār-i Saʿādat." *Muṭāliʿāt-i miʿmārī-yi Īrān* 9 (2016): 67–84.

Sharma, Sunil. "The City of Beauties in the Indo-Persian Poetic Landscape." *Comparative Studies of South Asia, Africa, and the Middle East* 24, no. 2 (2004): 73–81.

———. *Mughal Arcadia: Persian Literature in an Indian Court*. Cambridge: Harvard University Press, 2017.

———. *Persian Poetry at the Indian Frontier: Masʿûd Saʿd Salmân of Lahore*. New Delhi: Permanent Black, 2000.

———. "Shahrâshub." In *Persian Lyric Poetry in the Classical Era, 800–1500: Ghazals, Panegyrics, and Quatrains*, edited by Ehsan Yarshater, 569–78. London: I. B. Tauris, 2019.

Shukrullahi Taliqani, Ihsanullah. "Aḥmad-i Ghulām, ʿamala-yi khazāna." *Payām-i Bahāristān* 22–23 (1382 [2003]): 2–17.

Sims, Eleanor G. "Āīna-kārī." In *EIr*.

Sipanta, Abd al-Husayn. *Tārīkhcha-yi awqāf-i Iṣfahān*. Isfahan: Intisharat-i Idara-yi Kull-i Awqaf, mantaqa-yi. Isfahan, 1346 [1967].

Siroux, Maxime. *Anciennes voies et monuments routiers de la région d'Ispahân*. Cairo: IFAO, 1971.

Soucek, Priscilla. "Calligraphy in the Safavid Period 1501–76." In *Hunt for Paradise: Court Arts of Safavid Iran, 1501–1576*, edited by Jon Thompson and Sheila R. Canby, 49–72. London: Thames & Hudson, 2003.

Stevens, Sir Roger. "European Visitors to the Safavid Court." *Iranian Studies* 7, nos. 3–4 (1974): 421–57.

Stierlin, Henri. *Ispahan, image du paradis*. Geneva: Sigma, 1976.

Sumi, Akiko Motoyoshi. *Description in Classical Arabic Poetry: Waṣf, Ekphrasis, and Interarts Theory*. Leiden: Brill, 2004.

Szuppe, Maria. "Palais et jardins: Le complexe royal des premiers Safavides à Qazvin, milieu XVIᵉ–début XVIIᵉ siècles." *Res Orientales* 8 (1996): 143–77.

Tester, Keith, ed. *The Flâneur*. London: Routledge, 1994.

Trachtenberg, Marvin. *Dominion of the Eye: Urbanism, Art, and Power in Early Modern Florence*. Cambridge: Cambridge University Press, 1997.

Tygstrup, Frederik. "Reading Space: Cultural Analysis of Territoriality and Experience." In *Experiencing Space—Spacing Experience: Concepts, Practices, and Materialities*, edited by Nora Berning, Philipp Schulte, and Christine Schwanecke, 25–37. Trier: Wissenschaftlicher Verlag Trier, 2014.

von Grunebaum, Gustave E. "The Structure of the Muslim Town." In *Islam: Essays in the Nature and Growth of a Cultural Tradition*, 141–58. Menasha, WI: American Anthropological Association, 1955.

Wagoner, Phillip B. "The Charminar as *Chaubara*: Cosmological Symbolism in the Urban Architecture of the Deccan." In *The Architecture of the Indian Sultanates*, edited by Abha Narian Lambah and Alka Patel, 104–13. Mumbai: Marg, 2006.

Walcher, Heidi A. "Between Paradise and Political Capital: The Semiotics of Safavid Isfahan." In *Transformations of Middle Eastern Natural Environments*, edited by Jeff Albert, Magnus Bernhardsson, and Roger Kenna, 330–48. New Haven: Yale University, 1998.

———. "Faces of the Seven Spheres: Urban Morphology and Architecture in Nineteenth-Century Isfahan," part 1, *Iranian Studies* 33, nos. 3–4 (2000): 327–47, and part 2, *Iranian Studies* 34, nos. 1–4 (2001): 117–39.

———. *In the Shadow of the King: Zill al-Sultān and Isfahān Under the Qājārs*. London: I. B. Tauris, 2008.

Welch, Anthony. *Artists for the Shah*. New Haven: Yale University Press, 1976.

Wendell, Charles. "Baghdâd: *Imago Mundi*, and Other Foundation-Lore." *International Journal of Middle East Studies* 2, no. 2 (1971): 99–128.

Wensinck, A. J. "al-Khaḍir (al-Khiḍr)." In *EI2*.

Wheatley, Paul. *The Places Where Men Pray Together: Cities in Islamic Lands, Seventh Through the Tenth Centuries*. Chicago: University of Chicago Press, 2001.

White, Hayden. *The Content of the Form: Narrative Discourse and Historical Representation*. Baltimore: Johns Hopkins University Press, 1987.

Whyte, William. "Architecture and Experience: Regimes of Materiality in the Nineteenth Century." In *Experiencing Architecture in the Nineteenth Century: Buildings and Society in the Modern Age*, edited by Edward Gillin and H. Horatio Joyce, 15–28. London: Bloomsbury, 2019.

Wilber, Donald N. *Persian Gardens and Garden Pavilions*. 2nd ed. Washington, DC: Dumbarton Oaks, 1979.

Winter, Irene J. "'Seat of Kingship' / 'A Wonder to Behold': The Palace as Construct in the Ancient Near East." *Ars Orientalis* 23 (1993): 27–55.

Wirth, Eugene. "Qazvin, safavidische Stadtplanung und qajarischer Bazar." *Archäologische Mitteilungen aus Iran* 29 (1997): 462–504.

Wrigley, Richard, ed. *The Flâneur Abroad: Historical and International Perspectives*. Newcastle upon Tyne: Cambridge Scholars, 2014.

Yarshater, Ehsan. "The Theme of Wine-Drinking and the Concept of the Beloved in Early Persian Poetry." *Studia Islamica* 13 (1961): 43–53.

Yürekli, Zeynep. *Architecture and Hagiography in the Ottoman Empire: The Politics of Bektashi Shrines in the Classical Age*. Farnham, Surrey: Ashgate, 2012.

Zander, Giuseppe, ed. *Travaux de restauration de monuments historiques en Iran*. Rome: IsMEO, 1968.

sporting events, 75, *75*
See also ceremony
flâneur ("saunterer"), 10, 187, 206–7, 236n53
food, 55, 78, 106–7, 189–90
"fresh style" (*shīva-yi tāza*), 161, 162
Friday Mosque of Samarqand (Bibi Khanum Mosque), 49
friendly letters (*ikhvāniyyāt*), 164, 185, 201, 202
Fryer, John, 104, 130

Gabrabad quarter, 143–44
Galdieri, Eugenio, 42
Garden of the Grand Vizier (*i'timād al-dawla*), 122
gardens
 Almond Garden (*bādāmistān*), 57
 Bagh-i Burj (Tower Garden), 180
 Bagh-i Dilgusha (Heart-Exhilarating Garden), 59
 Bagh-i Khalvat (Garden of Seclusion/Retreat), 55
 Bagh-i Nazar (Viewing Garden), 160, 180
 Bagh-i Qushkhana (Garden of the Abode of Falcons), 61
 Barberry (*zirishk*) Garden, 60, 120, 122, *123*
 Garden of the Grand Vizier (*i'timād al-dawla*), 122
 Grape Garden (*angūristān*), 57
 Guldasta Garden, 41, *41*, 57
 Hizar Jarib Garden, 4, 47, 57–61, 123, 125–27, *125–28*
 Naqsh-i Jahan Garden, 32–33, 36, 39–40, 41, 44, 54, 55
 Nightingale (*bulbul*) Garden, 57, 60, 104, 107, 108, *108*
 in poetry, 179–80
 royal gardens, 105–9, *105–9*
 Sa'adatabad Garden, 158, 159–61, 179
 Sweet-Smelling (*musamman*) Gardens, 60, 104, 105, 108, 230n34
 Tent (*khargāh*) Garden, 57, 60, 104, 105, 106, 107, *107*, 108
 Throne (*takht*) Garden, 60, 63, 104, 107, 108
Gemelli Careri, Giovanni Francesco, 81
Ghalzay Afghan insurrection, 209–10
ghazal (short lyrical poem), 161, 162
glass mirrors, 193–94
Grand Bazaar of Isfahan, 37
Grape Garden (*angūristān*), 57

Great Mosque of Isfahan (Old Mosque). *See* Old Mosque (Great Mosque of Isfahan)
Grélot, Guillaume Joseph, 89, 90, 91, 137, *138*
Guattari, Félix, 66
"Guide for Strolling in Isfahan" (Semnani), *187*, 235n4, 236n42
 author and audience, 186, 201–4
 centering human subjectivity, 6, 8, 207–8
 daylong journey, 187–201, *188*, *191–94*, *196–98*, *200*
 describing qaysariyya portal, 83
 friendly letters, 1, 185–86
 praising Harun-i Vilayat shrine, 30
 representing space and time, 204–5
 solitary wandering, 205–8
 translated text, 213–22
Guldasta Garden, 41, *41*, 57
"Gulzār-i sa'ādat" (Ta'sir Tabrizi), 179–80, *183*

Habibi, Mohsen, 65
Harun-i Vilayat shrine
 construction under Shah Isma'il, 28, 29–30, *29–30*
 in Semnani's "Guide for Strolling in Isfahan," 2, 30, 219
 within medieval city, 23, *24*
 See also Maydan-i Harun-i Vilayat (Old Maydan)
Hasanabad (Khvaju) Bridge, *xviii*, *4*, 24, 158, *158*, 161, 179
Hasht Bihisht ("eight paradises") pavilion, 57, 60, 104, 107, *108*
Haydariyya (Qalandar Sufi order), 51, 111, 113
Hazin Lahiji, 209–10
Herat, 40, 59, 85, 176–77
Herbert, Sir Thomas, 127, *128*, 169
Hizar Jarib Garden, 4, 47, 57–61, 123, 125–27, *125–28*
Hofsted van Essen, Gerard, 72, 75, 79
Höltzer, Ernst, 224n36, 232n95
 photographs: *43*, *94*, *124*
homoeroticism, 163–64, 189, 191–92, 200
Hotz, Albert, 224n36
 photographs: *98*, *117*, *120*
hookah (*qalyān*), 188, 190, 195
 See also tobacco
Hunarfar, Lutfullah, 7
Husayniyya (quarter), 39, 84, 226n24
hydraulic systems, 62–65, *63–64*, 66
 See also water

Ibn Sina, 25
I'jaz Herati, "Ta'rīf-i Iṣfahān," 176–77
illuminations
 of maydan coffeehouses, 78–79, 92
 at Maydan-i Harun-i Vilayat, 19
 See also ceremony; festivals and rituals
Imam Ali. *See* Ali b. Abi Talib
"Indian style" (*sabk-i hindī*), 161
insha' (ornate composition), 164, 175, 177–78, 202, 235n1
Isfahan
 in allegory, 176–79
 as *dār al-mulk* (abode of dominion), 226n8
 as early modern city, 209–12
 in existing scholarship, 6–8
 as imperial urban plan, 2–6, *4*, *5*
 kinetic experiences of, 179–82, *182*
 lyricism and civic image, 164–65
 modes of urban design, 65–66
 old and new, and civic identity, 148–50
 urban image and function as capital, 49–52
 urban subjectivity, 182–84, 207–8
 urbanism and design, 167–68
 vistas and prospects, 168–75, *170–71*
 visual impressions, 11–13
 See also architecture and literature; construction under Shah Abbas; eco-urban design; extramural quarters; "Guide for Strolling in Isfahan" (Semnani); medieval Isfahan; time and sound; visual and verbal engagement; visual experience
Isfahani, Muhammad Hafiz, 85–86, *86*
Iskandar Beg Munshi, 21, 44, 98, 135, 146
Isma'il (Safavid shah), 19, 27, 28, 31
Istanbul, 51, 79, 81, 144–45
iwans
 Hizar Jarib gateway, 125, *127*
 Jahan-nama pavilion, 95, *96*, 96
 Old Mosque, 26–27, *27*, 31, *32*, *33*, 89
 Shah Mosque, 48, 49, *49*

Jahan-nama ("world-revealing") pavilion, 95–99, *96*, *98*, *100*, *101*, 104
Jannāt-i 'Adn (Abdi Beg), 165
Jayy (Sasanian round city), 22–23, *24*
Jubara (Jewish quarter, Isfahan), 23, *24*
Junabadi, Mirza Beg, 21, 36, 39, 46, 125, 138, 166–67
Juy-i Shah (canal), 63, 64, 137